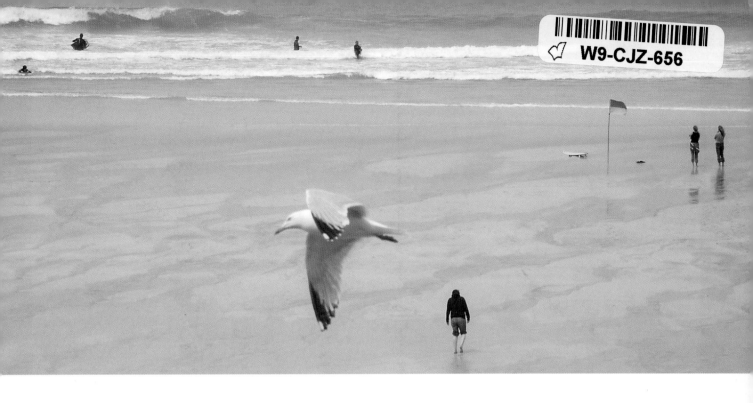

DIGITAL PHOTOGRAPHY

DIGITAL PHOTOGRAPHY

Michael Wright

METRO BOOKS
NEW YORK

Metro Books
122 Fifth Avenue
New York, NY 10011

ISBN-13: 978-1-4351-0912-4

Printed and bound in China.

1 3 5 7 9 10 8 6 4 2

The Hylas name and logo are trademarks of Hylas Publishing, LLC.

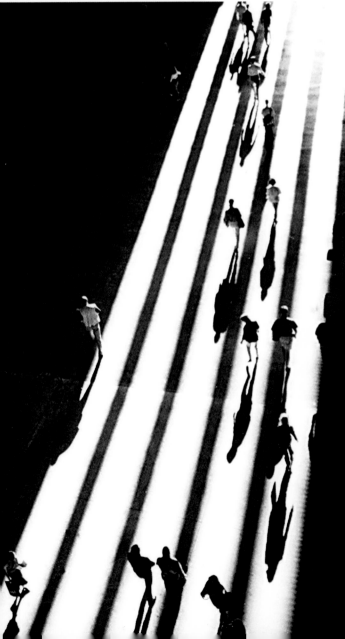

CONTENTS

INTRODUCTION

THE BENEFITS OF DIGITAL PHOTOGRAPHY

Digital photography will liberate the creative photographer in you! The greatest single advantage of digital photography is that it allows you the freedom to practice and experiment with image making in ways that only the professional or the committed amateur could once afford. The spontaneous desire to photograph has always been constricted by the cost of film and processing. Now you can take hundreds—or even thousands—of photographs and experiment without thought to either of these factors. By using the editing software, you can now explore a world of visual possibilities without inhibition. With digital printing, you can print and enlarge pin-sharp images in brilliant color and do a great deal more. You can make albums and books, create photo essays, amazing slide shows and cards, as well as merge text with images and email images via the Internet.

DO YOU SUFFER FROM TECHNOPHOBIA?

Many people are initially delighted with the ease of handling a digital camera, but are intimidated by the editing software and even further baffled by the technical explanation. Their solution is to put off the editing until a later date: "I'll tackle that later, when I have a month to spare to learn all that stuff" (which means never!) If this sounds familiar, this book is for you.

PLEASE, JUST SHOW ME

Because photography is a visual art, this book provides the most intuitive and natural process to learn about it. Three simple and effective visual models are employed for maximum ease of learning. The **Exploded View** with thumbnails lets you see where things are and what they do. The **Slide Show** works like an illustrated lecture, explaining and inspiring you with galleries of creative ideas. Lastly, **Step-**

by-Step works like a comic-book sequence of easy-to-follow actions. Symbols and visual imagery are used to replace text wherever possible, so that you can see how a process works and easily copy the process on screen without the tedium of trying to follow repetitive and convoluted textual instruction. The combination of these visual presentation techniques will allow you to easily navigate and absorb all of the ideas you will need to work confidently and creatively with digital photograph—from the camera, to the computer, to the presentation. This book is a comprehensive introduction to the world of digital photography. You will be guided through all of the skills you will need to create and share your photographs. The book is divided into seven learning sections: Equipment, Lens and Focusing, Light, Composition, Basic editing, Advanced editing and finally Printing and Sharing your images on the web. Each of the sections is color coded and organized in an ascending order of skill level—from the basic, through to advanced. Whether you have considerable or limited experience of using a camera and software, the book has been designed so that you can move between the sections with ease, learning what you want as you need it. Once you've got the essentials at the beginning of each section, you can try out more interesting and advanced techniques.

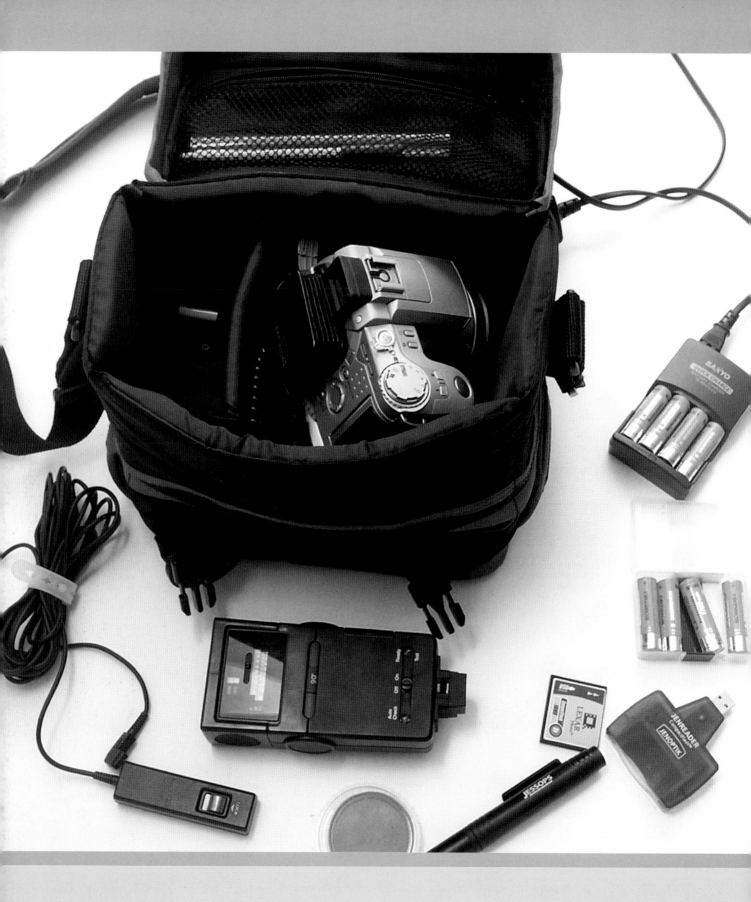

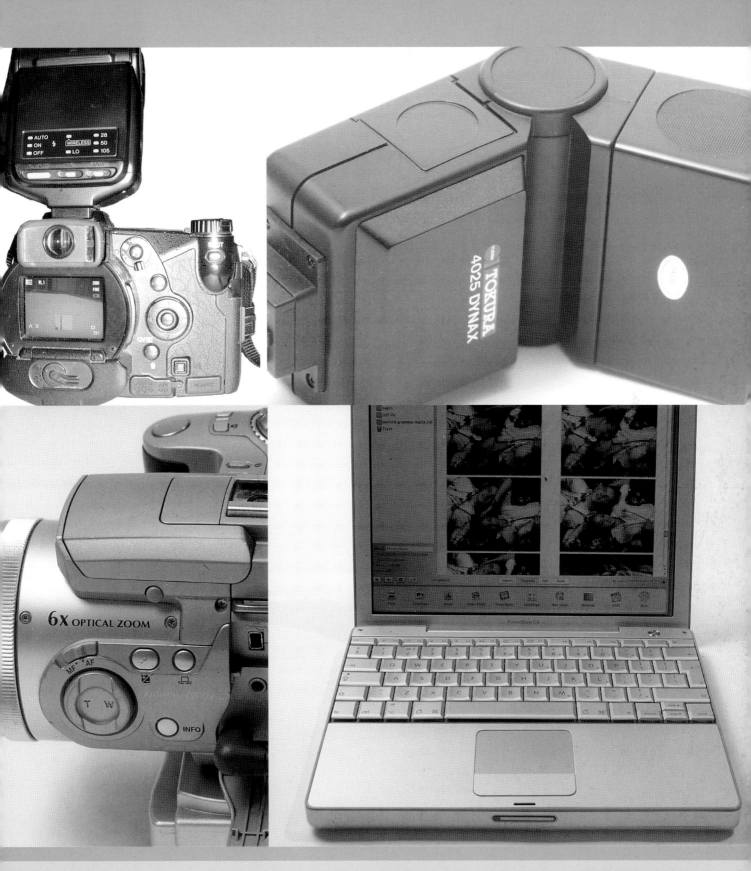

EQUIPMENT

HOW TO CHOOSE EQUIPMENT

Before you choose equipment, you need to consider how many of the amazing capabilities of digital photography you want to use. Ask yourself how far you want to develop your creative involvement. Once you have some idea of the answer to that question, you then need to balance that against how much you are willing to invest in the technology. You may have a very clear idea of exactly what you want—to keep things very simple. On the other hand, if you are obsessed with photography, you will probably want to explore all of the available options in cameras and accessories and experiment with them. If so, then the best answer will be to try to get as much equipment as possible while keeping within your budget. To help you decide on the myriad of possibilities, here is a look at the range of cameras and accessories available by cost and capability.

GETTING STARTED

OPTION ONE: JUST A CAMERA

To enter the realms of digital photography, all you need is a camera. The imagery is saved on a memory card, which you can take to a camera store and they will print the images for you. This arrangement is not much different from working with an SLR or automatic camera in film-based photography. Although it is easy enough to use, the camera alone does not give you any options for editing or printing. For that—you will need more equipment.

OPTION TWO: A CAMERA AND A PRINTER

Depending on the printer, you can plug the camera into a printer with a connection lead or put the memory card into the slot in the printer. It's best to buy a camera and printer built to work together; Cannon and Kodak specialize in this arrangement. [1] Switch your camera to **Review Mode** to view your images on the LCD screen [liquid crystal display] on the back of your camera. [2] Pick which images you want to print. [3] On the printer, select the **Size** and **Resolution** and print!

OPTION THREE: A CAMERA, A COMPUTER WITH CD BURNER AND/OR WEB CONNECTION

With a camera, a computer and some digital-editing software, you can edit your images. This opens up many possibilities for creative manipulation. You can then burn your images onto a CD and have them professionally printed, either at the store or through an internet-printing facility, where you email your images and the prints are mailed back to you.

OPTION FOUR: A CAMERA, COMPUTER, CD BURNER, A PRINTER, AND A CONNECTION TO THE WEB.

This arrangement is for the real digital aficionado. You have everything you need to create interesting and creative photographs that will last forever. This complete setup gives you control over the entire digital-photography process, from taking the image to editing, storing and printing your images, as well as sharing them on the web.

CHOOSING A CAMERA

There are many digital cameras on the market, and models are being updated by the week. The diversity can be confusing, making it very difficult to decide which camera is right for you. Friends who have digital cameras will be able to give you some advice about where to begin. Ask a friend to let you try their camera. Get a sense of how it feels in your hands, as well as how it feels when you look through the viewfinder. Also, get your friend to show you the camera's output capabilities, both on-screen and in-print. This basic experience of handling a camera will give you a clearer idea of what to look for. Now, find a reputable camera store with a sales staff adept at explaining the basic features of the different cameras. While you're there, look at the camera pamphlets the store provides. Amateur photography magazines also explain which cameras are the best buys. Now, go home and think about it. Don't rush.

COMPACT POINT AND SHOOT

Point-and-shoot compacts have a fixed lens, usually at a wide angle of 35mm. They have no controls other than the shutter-release button. The viewer will be a rangefinder, which is offset to the lens. The point and shoot might also have a built-in flash. These cameras are the equivalent of the old instamatics that were once so popular. Like the instamatic, they require no expertise to handle and produce an adequate quality image, suitable for the web and small-scale printing. Their small size also makes them easy to take around and the reasonable price makes this the perfect camera for nervous beginners or for those who want to keep it simple.

COMPACT WITH ZOOM LENS

These compact cameras with the zoom lens are probably the most popular digitals. This range of camera varies in quality, depending on the make of the lens, which determines the overall quality of the camera and therefore, also the price. Upper-end models will give excellent images. Recent developments have produced remarkably compact slimline cameras that have a high enough resolution to produce high-quality prints. This camera is for the more serious photographer who wants the flexibility the zoom lens will give them, and the quality of a fine lens.

ZOOM-LENS REFLEX (ZLR)

These zoom-lens reflex cameras are very similar to the film-based 35mm SLR cameras—which were the most popular camera for the press and amateur photographer. Zoom-lens reflex means that you view the scene through the actual camera lens rather than an offset viewfinder. The difference is that these cameras have a single lens system that is capable of zooming from wide angle to telephoto. The top models have an extensive range of controls, offer excellent image definition and fulfill almost all of the needs of the amateur photographer who really wants to explore the creative possibilities of in camera composition.

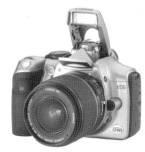

PROFESSIONAL SINGLE-LENS REFLEX (SLR)

These cameras are built to the top specifications and can be phenomenally expensive. However, some of the major companies are bringing Prosumer versions of these cameras down in price to compete for the expanding amateur-photographer market. These cameras represent the digital replacement for the single-lens reflex cameras. The resolution is similar to or higher than that of the ZLR. They all have a detachable-lens system, perfect for those with a good collection of professional lenses acquired for film-based photography.

WHERE DO I FIND OUT ABOUT COMMON SPECIFICATIONS?

Camera specification is the list of all the features of any make of camera. There is a wealth of online and magazine based information for you to access. **www.dpreview.com** contains thorough reviews of cameras and a buying guide that identifies all the available cameras that have the features you want.

PRICE WATCH

There are great sites on the Internet that list all the companies selling your preferred make and model, with comparisons on cost and company reliability. Investigating these sites is worth the effort, as the prices of cameras vary wildly. With a bit of careful research you may find a real bargain. [Suggested sites include **reviews.cnet.com** and **www.bhphotovideo.com**].

DIGITAL PHOTOGRAPHY BASICS

Before the advent of digital photography, you snapped your pictures and then sent the film off to be processed, hoping for the best. Sometimes the film wouldn't even turn out, leaving you with no record of the important event or moment you had hoped to capture. If your pictures did come out, your choices were to put them straight into an album or shoebox, as the case may be, or you could have them cropped or enlarged at some cost. That was basically all you could do without taking a photography class, finding access to expensive equipment, and then spending hours in a damp darkroom learning the mysterious alchemy of photographic processes. By contrast, digital photography gives you the digital equivalent of all these processes—and a great many more—through a combination of camera technology and digital editing software, all without the inconvenience or expense of film-based processing and enlarging.

THE SENSOR

At the heart of digital camera technology lies the innovation of the image sensor. In film-based photography, light is projected onto light-sensitive film that is then chemically processed. In digital photography, the image sensor records the pattern of the light, which is then translated into a stream of numerical digital information. This sensor is called a CCD and is a fraction of the size of of a negative.

The heart of the camera; the sensor.

THE PHYSICAL SENSOR

The CCD sensor is made of rows of microscopic light-sensitive cells that record the light in a matrix, recording the brightness of the light on each cell. This information is all translated numerically and stored as a digital stream, which is then downloaded to the memory card in the camera as an image file. This image file can in turn be downloaded to the computer or printer.

The sensor's small size allows the lens system to be small and light. Modern research and technology have refined the processes of lens production to achieve remarkable degrees of sharpness in a smaller lens. The quality of the camera is a combination of the size of the CCD sensor, lens technology, and, most important, the quality of the in-camera computing that undertakes the color interpolation.

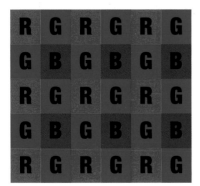

The CCD Monitor.

PIXEL IMAGE

The CCD, or charge-coupled device, records the light. Each of the squares pictured represents a micro-sized light sensor that electronically imprints the light falling at that point. The CCD sensor captures an image in black and white and then passes it through red, green and blue filters organized in a matrix to form a color image. The camera software then interpolates and translates this digital information to form as pixels on the camera and computer monitor.

A **Pixel** is short for "picture element." When viewed together on a screen, pixels create a coherent image in the same way that a printed image is comprised of dots of color mixed optically to form smooth and even tones. The more pixels there are in an image file, the more detail there will be in your photograph and the bigger the print can be. Some cameras list a pixel count interpolated by electronic processing. Make sure yours is in "true pixels."

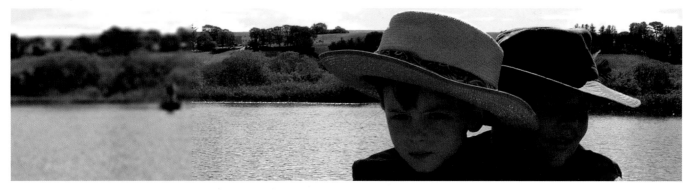

The more pixels in an image file, the more detail in the photograph.

PIXELS AND RESOLUTIONS

The first thing you will be asked when you go into a store to buy a camera is, "What resolution are you looking for?" Each camera will be listed as having a particular pixel count, that is, the maximum number of pixels that make up the image. The pixel count determines the resolution of the image, which will add up to so many million pixels called **Megapixels**.

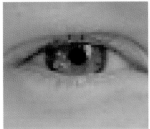
72 pixels per inch

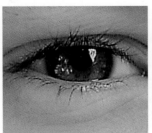
150 pixels per inch

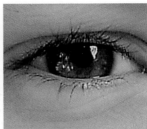
300 pixels per inch

How many pixels do you need? That depends on what kind of output (print quality and size) you want. If you want to print large images at high-quality resolution, you need at least 150, and ideally 300, pixels per inch. To print a 6x8 image at 300 ppi adds up to 6x8x300x300 pixels per inch=4,300,000, which is 4 million pixels or 4 Megabytes.

A SIMPLE GUIDE TO RESOLUTION AND IMAGE SIZE

Hold onto the idea that the best resolution is at least 150 ppi and ideally 300 pixels per inch when you print an image from your camera.

WEB CAMERA
The web cams are the lowest resolution of all the digital cameras and are only suitable for viewing on screen at 72 ppi or printing at the lowest resolutions.

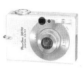

HIGH-END COMPACT
The high-end compact camera's 4 Megapixels will guarantee a 6x8 image at 300 ppi and up to an 8x10 at 150 ppi.

POINT AND SHOOT
The cheapest point-and-shoot cameras will have around1 Megapixel, which gives a relatively small image at a resolution of 200 ppi, with a maximum of 4x5 inches.

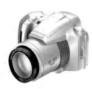

ZOOM LENS REFLEX
The high-end Zoom-Lens Reflex camera will have 5 to 6 Megapixels and will print brilliant images at 6x8, and very good resolution at 8x10 inches.

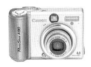

LOW-END COMPACT
The low-range compact cameras have 2–3 Megapixels and will print 4x6 images at 300 ppi.

SINGLE LENS REFLEX
The professional and Prosumer Single-Lens Reflex cameras will have 6–8 Megapixels and will print brilliant 8x10 and 11x16 images. At the highest—8–13 Megapixels, you can print up to 16x32 photo-quality images.

FILE SIZE IN CAMERA

In the **Image** menu settings, you can save your images at different levels of definition. The more definition, the more memory an image will require. The camera uses a compression system called JPEG, which compresses the information to take up less memory. To gain the highest picture definition, use **Super Fine. Extra Fine, Fine** and **Standard** options compress information in increasing amounts. As you increase the compression, you have a corresponding loss of detail. Selecting image quality is a matter of balancing how many pictures you want to take with how much memory you have and which images you want to have maximum definition.

Film Grain
An image in a film-based photographic print is made up of tiny light-sensitive chemical spots that appear as smooth color and tone to the eye.

Pixels
An image on screen is constructed of pixels, which are actually small squares of colored light. These, too, appear smooth in color and tone.

COMPACT CAMERAS

EXTERNAL CONTROLS

The compact camera is aptly named as it exemplifies the innovation of digital photography in that so many features are compacted within the reduced size of the compact camera body. In the compact camera design the controls that were the external dials on film based cameras have been moved off of the exterior and into the camera. This means that most all of the settings and functions adjustments are accessed through the camera menu and viewed on the camera LCD screen. The other outstanding design feature of the camera are the zoom lens optics which have been housed within the compact and light weight camera body.

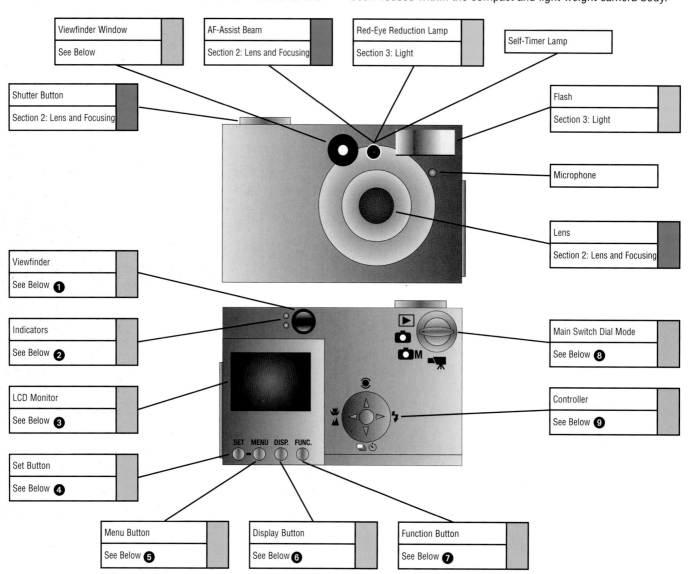

Viewfinder Window	AF-Assist Beam	Red-Eye Reduction Lamp	Self-Timer Lamp
See Below	Section 2: Lens and Focusing	Section 3: Light	

Shutter Button — Section 2: Lens and Focusing

Flash — Section 3: Light

Microphone

Lens — Section 2: Lens and Focusing

Viewfinder — See Below ❶

Indicators — See Below ❷

LCD Monitor — See Below ❸

Set Button — See Below ❹

Main Switch Dial Mode — See Below ❽

Controller — See Below ❾

Menu Button — See Below ❺

Display Button — See Below ❻

Function Button — See Below ❼

❶ Viewfinder lens for viewing the scene as it will be framed in camera.
❷ Indicator for camera and flash readiness for shot.
❸ LCD Liquid Crystal Display. In shooting mode provides a live image of the scene. In review mode provides view of image files stored on camera.
❹ Set button is for setting dates, times, and sound.
❺ Menu button calls up shooting mode and review mode menu.
❻ Display button turns on menu and image information display viewed on the LCD. Information is displayed in camera and review mode. Turning off LCD and shooting using the viewfinder prolongs battery life.
❼ Functions Button. Used for single image erase and to call up the menu of Function options
❽ Main Switch Dial Mode. Used to switch between shooting automatic, shooting manual, review and video mode.
❾ Controller dial. Used to scroll through the options within shooting and review mode, settings.

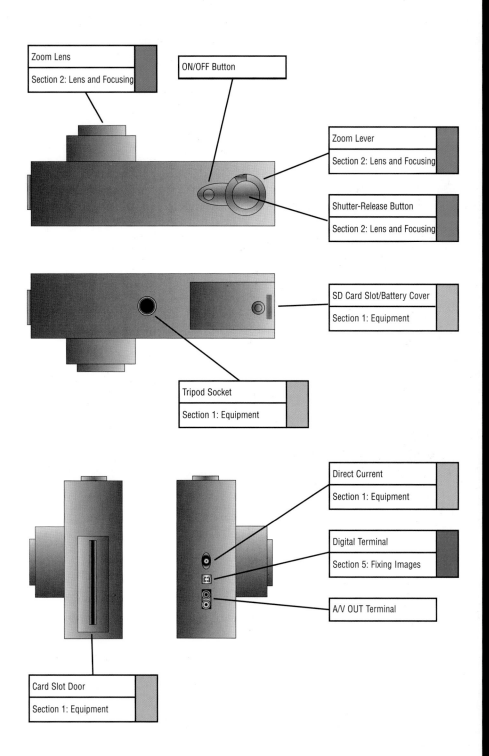

Zoom Lens
Section 2: Lens and Focusing

ON/OFF Button

Zoom Lever
Section 2: Lens and Focusing

Shutter-Release Button
Section 2: Lens and Focusing

SD Card Slot/Battery Cover
Section 1: Equipment

Tripod Socket
Section 1: Equipment

Direct Current
Section 1: Equipment

Digital Terminal
Section 5: Fixing Images

A/V OUT Terminal

Card Slot Door
Section 1: Equipment

AUTOMATIC FOCUSING AND EXPOSURE

Compact cameras are fully automatic, assessing and setting the correct exposure and focus for the scene. Zoom lens is a motarised zoom lens system, operated by the zoom lever, which can be zoomed from wide angle to telephoto.

Flash: Built in flash projects a burst of light illuminating low level light scenes to a distance of approximately 15 feet . Options in flash settings include red eye reduction and fill flash. In some models flash is automatically applied in low level lighting situations.

Setting Image Dimensions: Image dimensions are measured in pixels which can vary between 2560x1920 for a maximum size image on a 5 megapixel camera down to 640x480 pixels at the most basic small size.

Setting Image Quality provides options to shoot your images at different levels of definition using more or less memory. The camera software uses a compression system called JPEG which compresses the information so as to use less memory. To gain the highest picture definition you need to use Super Fine or Extra Fine. Fine and Standard options compress information in increasing amount

Memory Compact Digital cameras will use either Smart media cards or Type I or II Compact Flash cards. You will need to purchase extra memory cards as the card sold with the camera will have a limited amount of memory.

Video: some cameras will have a video facility which allows you to take low resolution video sequences with or without sound.

ZOOM LENS REFLEX CAMERAS

EXTERNAL CONTROLS

The similarity between the Zoom- and Single-Lens Reflex cameras is that the view presented through the viewer and LCD monitor correspond to the camera lens view of the scene. The difference between ZLR AND SLR cameras is that the ZLR has a single lens system that can be zoomed from wide angle to telephoto, whereas the SLR models have a digital body that accepts separate zoom, wide-angle and telephoto lenses. The SLR cameras are the top-end professional range of digital cameras. Both

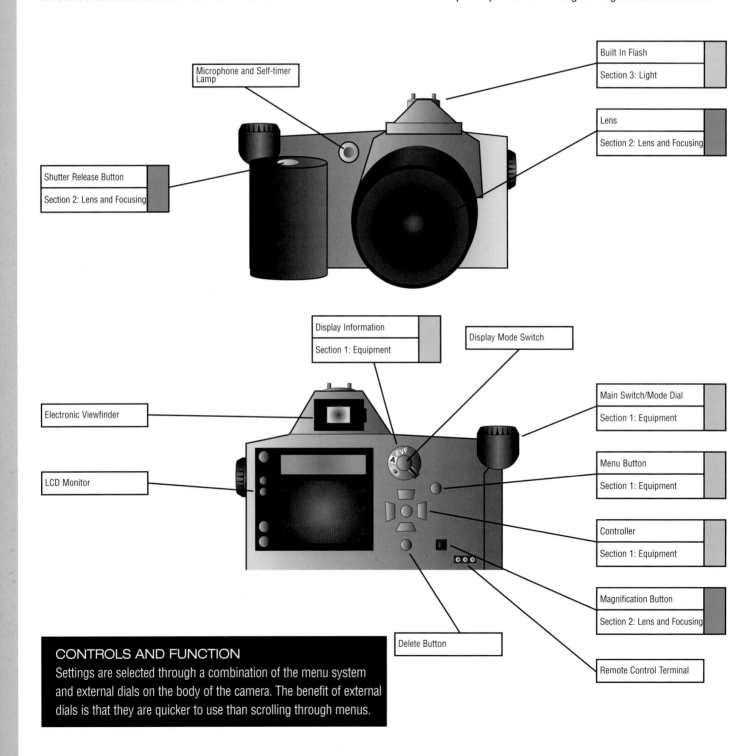

Microphone and Self-timer Lamp

Built In Flash
Section 3: Light

Lens
Section 2: Lens and Focusing

Shutter Release Button
Section 2: Lens and Focusing

Display Information
Section 1: Equipment

Display Mode Switch

Electronic Viewfinder

Main Switch/Mode Dial
Section 1: Equipment

Menu Button
Section 1: Equipment

LCD Monitor

Controller
Section 1: Equipment

Magnification Button
Section 2: Lens and Focusing

Delete Button

Remote Control Terminal

CONTROLS AND FUNCTION

Settings are selected through a combination of the menu system and external dials on the body of the camera. The benefit of external dials is that they are quicker to use than scrolling through menus.

the ZLR and SLR cameras will have an extensive range of controls, offer excellent image definition and fulfill the needs of the professional, semi-professional and amateur photographers who really want to explore all the creative possibilities of in

camera composition. **Image Quality:** The high-end models will have a facility for 16 bit Raw image files. These files sizes require large amounts of memory.

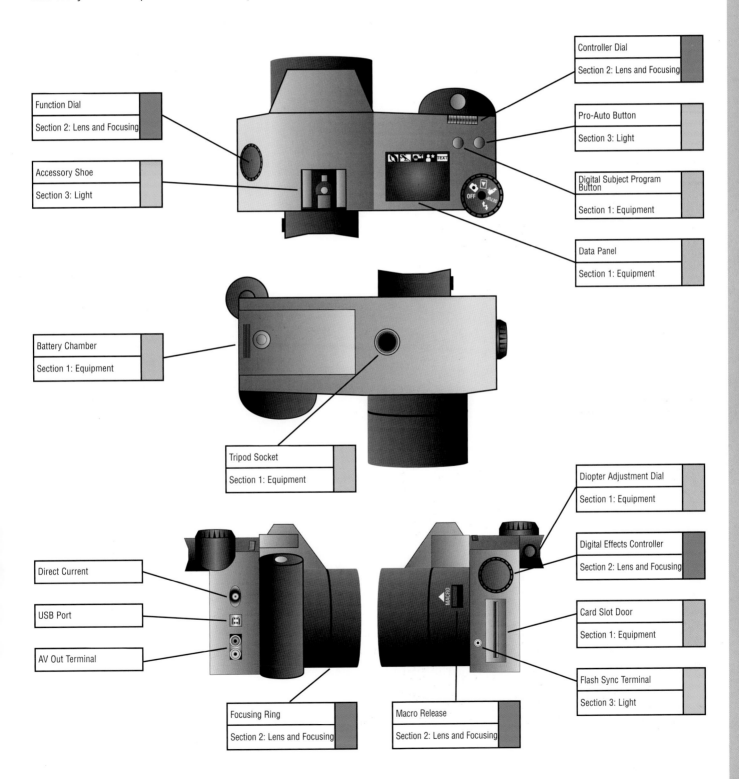

Controller Dial
Section 2: Lens and Focusing

Function Dial
Section 2: Lens and Focusing

Pro-Auto Button
Section 3: Light

Accessory Shoe
Section 3: Light

Digital Subject Program Button
Section 1: Equipment

Data Panel
Section 1: Equipment

Battery Chamber
Section 1: Equipment

Tripod Socket
Section 1: Equipment

Diopter Adjustment Dial
Section 1: Equipment

Digital Effects Controller
Section 2: Lens and Focusing

Direct Current

USB Port

Card Slot Door
Section 1: Equipment

AV Out Terminal

Flash Sync Terminal
Section 3: Light

Focusing Ring
Section 2: Lens and Focusing

Macro Release
Section 2: Lens and Focusing

CAMERA MENUS AND DISPLAY

Below are the icons displayed when Display mode is selected on the camera. The icons are displayed when a function is in operation or selected. As either you or the camera alters settings in **Auto** mode, both the compact and ZLR/SLR cameras will display information on the LCD screen. The additional display on the top of the camera is a feature of the ZLR/SLR and some compact cameras that allows you to view information when the information is turned off on the LCD monitor. Each of the functions is cross-referenced by both color code and name to the sections where the function is referenced for the first time.

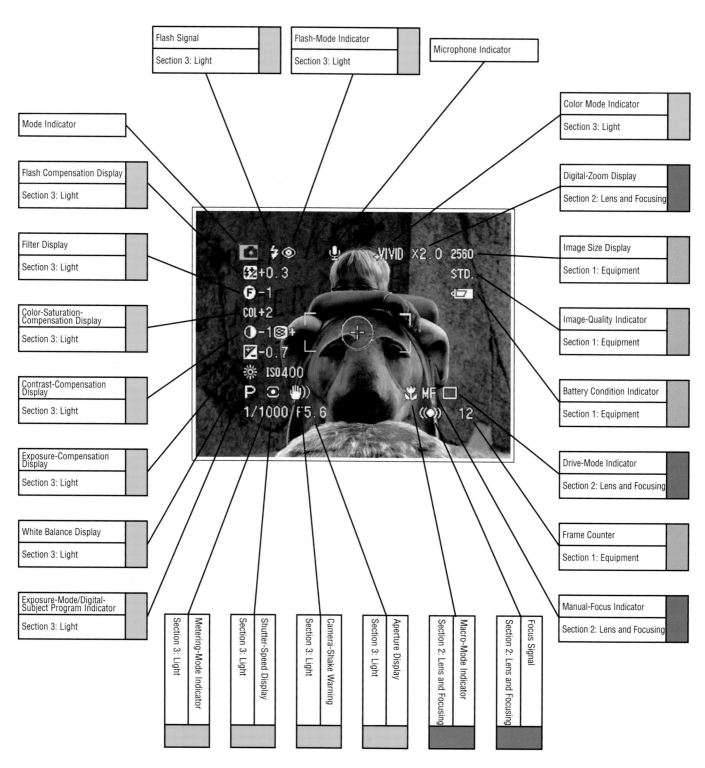

Flash Signal — Section 3: Light

Flash-Mode Indicator — Section 3: Light

Microphone Indicator

Color Mode Indicator — Section 3: Light

Mode Indicator

Flash Compensation Display — Section 3: Light

Digital-Zoom Display — Section 2: Lens and Focusing

Filter Display — Section 3: Light

Image Size Display — Section 1: Equipment

Color-Saturation-Compensation Display — Section 3: Light

Image-Quality Indicator — Section 1: Equipment

Contrast-Compensation Display — Section 3: Light

Battery Condition Indicator — Section 1: Equipment

Exposure-Compensation Display — Section 3: Light

Drive-Mode Indicator — Section 2: Lens and Focusing

White Balance Display — Section 3: Light

Frame Counter — Section 1: Equipment

Exposure-Mode/Digital-Subject Program Indicator — Section 3: Light

Manual-Focus Indicator — Section 2: Lens and Focusing

Metering-Mode Indicator — Section 3: Light

Shutter-Speed Display — Section 3: Light

Camera-Shake Warning — Section 3: Light

Aperture Display — Section 3: Light

Macro-Mode Indicator — Section 2: Lens and Focusing

Focus Signal — Section 2: Lens and Focusing

SPECIAL SUBJECT SETTINGS

Portrait	
Section 4: Composition	

Motion	
Section 2: Lens and Focusing	

Sunset	
Section 3: Light	

Night Portrait	
Section 3: Light	

Add Text	
Section6: Advaced Editing	

Battery Level	
Section 1: Equipment	

Program, Aperture, Shutter Speed Priority and Manual	
Section 2: Lens and Focusing	

Shutter Speed	
Section 3: Light	

Aperture Size	
Section 3: Light	

WHITE BALANCE

Sunlight	
Section 3: Light	

Tungsten	
Section 3: Light	

Fluorescent	
Section 3: Light	

Cloudy	
Section 3: Light	

Custom	
Section 3: Light	

Film Sensitivity	
Section 3: Light	

Flash Mode	
Section 3: Light	

Wireless Remote Flash Indicator	
Section 3: Light	

Bracketing	
Section 3: Light	

Timer	
Section 2: Lens and Focusing	

Drive Mode	
Section 2: Lens and Focusing	

Image Quality	
Section 1: Equipment	

Image Size	
Section 1: Equipment	

Flash Compensation	
Section 3: Light	

Available Shots	
Section 1: Equipment	

Manual Focus	
Section 2: Lens and Focusing	

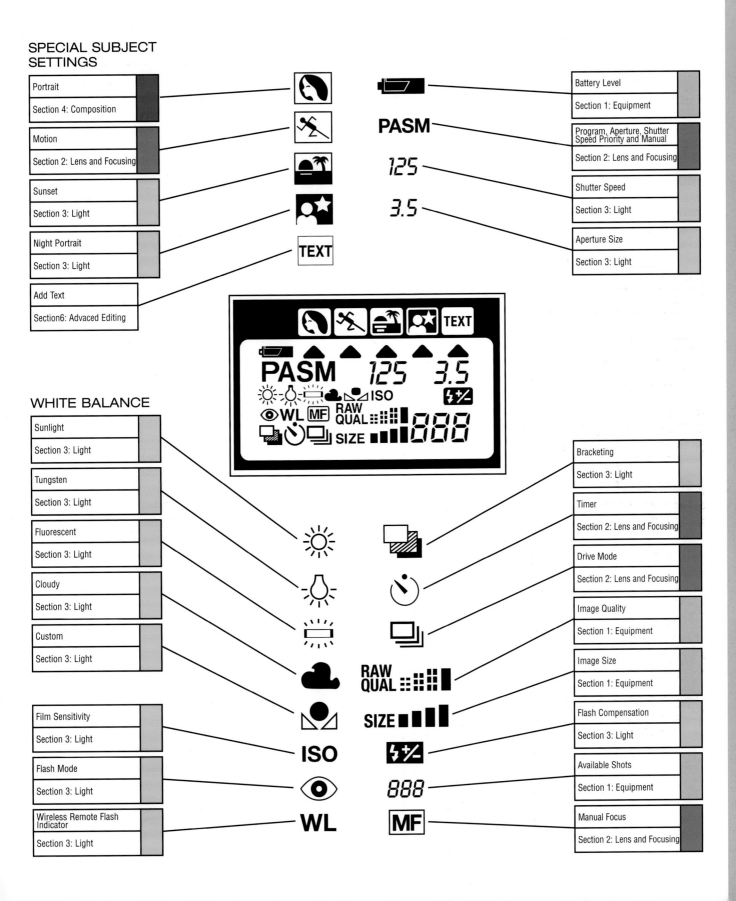

DESKTOP AND PORTABLE EQUIPMENT

You are probably used to replacing the batteries in your film-based camera only once or twice a year. Digital cameras are completely different in that respect. Depending on how much you are photographing, you should expect to replace your digital camera's batteries once, twice, or even several times a day. This can be a problem when you are documenting a long event such as a wedding, if you are away on vacation, or off taking pictures in more remote areas. Battery power is non-negotiable. It is essential that you have enough with you or you will miss out on the chance to document moments that cannot be duplicated. In addition to extra battery power, you may want to invest in a storage system for your image files, a scanner, and if you are spending a lot of time in front of the screen, a LCD monitor.

POWER SOURCES

RECHARGEABLE BATTERIES

The most common battery set up in digital cameras is 2 AA batteries in the smaller compacts and four AA batteries in the Prosumer models. Your best bet is to buy several sets of NiMH rechargeable batteries and a battery recharger. This requires a greater outlay at the beginning, but makes for major savings in the long run, as a set of rechargeable batteries can be recharged up to a thousand times.

MODEL-SPECIFIC BATTERIES

Some camera models have their own unique make of battery with a specific voltage. This can be inconvenient, as they can be hard to find. Therefore, you will need to buy a couple of extra rechargeable batteries for when you are in more remote locales. These can be relatively expensive.

DIRECT SOURCE

If you intend to use your camera on a regular basis for extended shoots in the studio, you can use the camera on a tripod with the camera's transformer and an extension to an outlet.

EXTERNAL BATTERY PACK

If you need to work on-the-move, you can buy rechargeable external battery packs. They have a much longer life than batteries. The Prosumer camera models will often have their own make of external battery. You can also get Quantum battery packs that fit a range of models. Make sure that it is the correct voltage. An incorrect power input will damage the camera.

REDUCING BATTERY CONSUMPTION
Your battery power is depleted rapidly when reviewing images using the LCD screen on the back plate of the camera. To save power, try to get into the habit of reviewing your images using the electronic viewfinder (EVF).

STORAGE SYSTEMS

As you discover the great freedom and ease of shooting digital photographs, you will quickly amass enough photographs to fill the greater part of your computer's memory. You will not want to keep the photographs on your hard drive, as it will slow down your computer. It is best to store them as soon as you have finished reviewing editing and printing the images. These are the different storage systems available.

CDs

For digital photography, CDs are the answer. They are the cheapest and most reliable means of storing your images. Written to CD, your images are safe, won't deteriorate, collect dust or fade. You can edit, copy and distribute them endlessly without loss or damage, and at next to no expense.

CD BURNING

If your computer doesn't have a CD burner built in, you will need to get one if you want to keep taking and storing photographs. This is not a great expense and the CD burner can easily be installed in your computer by taking it to a computer store or by buying an external CD burner that can be connected to your computer by either Firewire or USB port. Firewire is best, as it's much faster.

CD BURNING SOFTWARE

If you have a built-in CD burner, the software will already have been installed on your computer. If you are connecting or installing a burner, you will need to purchase suitable software for burning your images to disk.

EXTERNAL HARDRIVE

If you want to keep large quantities of images at hand without burning them to CD, you can buy an external hard drive. You attach this to your

computer by Firewire. They are relatively inexpensive, reliable and can hold 20 to 120 gigabytes and more. As they are quite compact, it is a very useful way to transport large quantities of visual material.

GRAPHIC TABLETS

The graphic tablet allows you to control detailed editing with much greater ease and precision. You can also use it to trace over images and photographs to create drawings on the computer, as well as to write and draw freehand on your images.

PORTABLE STORAGE SYSTEMS

If you are traveling, or away from your desktop computer for an extended period, you will have a problem storing all of your images. An ideal solution is to invest in one of the small, portable photo-storage systems. They are the size of a palm pilot and the cheaper models don't cost much more than a gigabyte memory card

or micro drive. Some of these systems will have an LCD display, allowing you to review and delete images in preparation for downloading.

PERIPHERALS
LCD MONITOR

With an LCD monitor, the definition is pin sharp and easier on the eyes than is a conventional TV-type monitor. If you intend to spend substantial time editing images, consider buying an LCD monitor, as they are becoming more affordable.

SCANNERS

Film Scanners

The best scanners will combine a flatbed scanner with a film scanner. The flatbed is for photographs and for making contact sheets. For scanning slides and negatives, it has an adapter. Film Scanners are your best bet if you intend to translate a large archive of film-based negatives and slides to digital format.

Dust and scratch detection

If you intend to scan slides or negatives in quantity, you should consider buying a model that does a double pass over the slides and negatives, eliminating dust and scratches.

ADDITIONAL EQUIPMENT

EQUIPMENT FOR WORK IN THE FIELD

Working in the field is the term for working outside. You will need to consider additional supplies to help you function effectively in various conditions. Digital cameras are sensitive to harsh treatment—one severe knock is enough to cause camera failure, so keep the camera strap around your neck to avoid dropping it onto hard surfaces. Leaving the camera exposed either to rain, sand, saltwater or excessive heat will damage the camera. So it's best to invest in a good-quality camera bag to protect your camera from the elements.

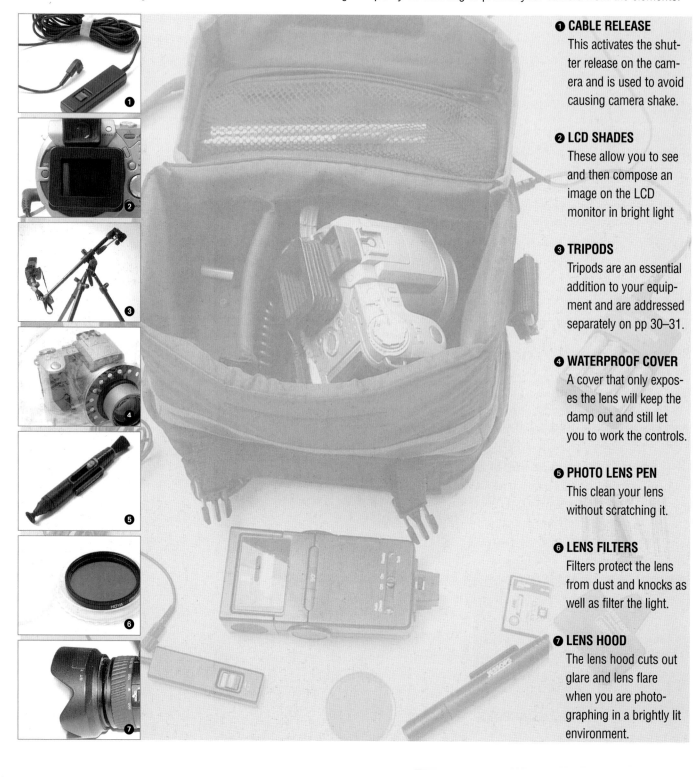

❶ CABLE RELEASE
This activates the shutter release on the camera and is used to avoid causing camera shake.

❷ LCD SHADES
These allow you to see and then compose an image on the LCD monitor in bright light

❸ TRIPODS
Tripods are an essential addition to your equipment and are addressed separately on pp 30–31.

❹ WATERPROOF COVER
A cover that only exposes the lens will keep the damp out and still let you to work the controls.

❺ PHOTO LENS PEN
This clean your lens without scratching it.

❻ LENS FILTERS
Filters protect the lens from dust and knocks as well as filter the light.

❼ LENS HOOD
The lens hood cuts out glare and lens flare when you are photographing in a brightly lit environment.

EQUIPMENT FOR CREATING A TEMPORARY STUDIO

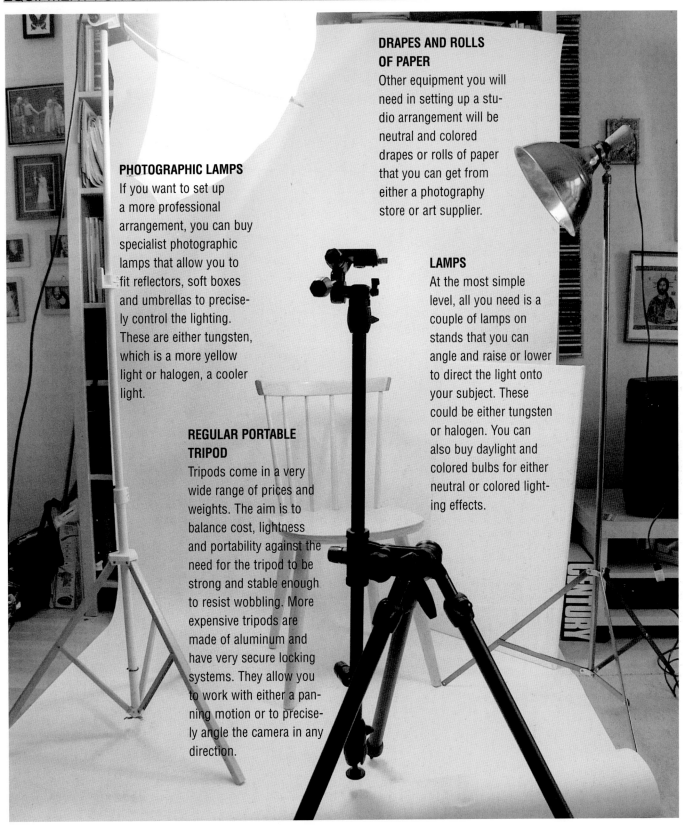

PHOTOGRAPHIC LAMPS

If you want to set up a more professional arrangement, you can buy specialist photographic lamps that allow you to fit reflectors, soft boxes and umbrellas to precisely control the lighting. These are either tungsten, which is a more yellow light or halogen, a cooler light.

REGULAR PORTABLE TRIPOD

Tripods come in a very wide range of prices and weights. The aim is to balance cost, lightness and portability against the need for the tripod to be strong and stable enough to resist wobbling. More expensive tripods are made of aluminum and have very secure locking systems. They allow you to work with either a panning motion or to precisely angle the camera in any direction.

DRAPES AND ROLLS OF PAPER

Other equipment you will need in setting up a studio arrangement will be neutral and colored drapes or rolls of paper that you can get from either a photography store or art supplier.

LAMPS

At the most simple level, all you need is a couple of lamps on stands that you can angle and raise or lower to direct the light onto your subject. These could be either tungsten or halogen. You can also buy daylight and colored bulbs for either neutral or colored lighting effects.

LENS AND FOCUSING

FOCUS: LENSES

In digital cameras, the image is focused on a CCD sensor rather than film. **Focal Length** refers to the distance from the point of focus in the center of the lens to the CCD sensor, (i.e., the plane on which the image is focused). The type and quality of the lens will determine both the sharpness of the image and the angle of vision that the lens will cover.

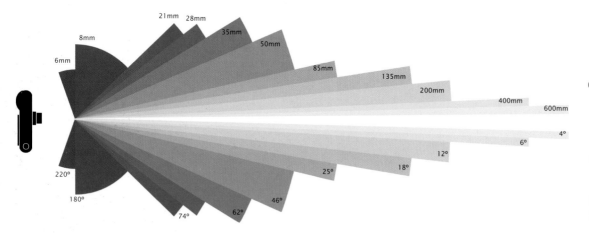

A wide-angle lens of 28mm will cover an angle of 74 degrees and a telephoto lens of 85mm will cover a much smaller angle of 25 degrees. A zoom-lens system, which is the most common digital-lens arrangement, will normally be from 28mm to 85mm, but can be over 200mm.

ZOOM!

A **zoom-lens system** allows you to frame an image by moving in or pulling away from the subject—without doing so physically. It includes wide angle and telephoto lens capabilities in a single system.

The zoom lens is frequently used by portrait photographers to isolate the subject from too much distracting background detail.

Using a zoom or full-telephoto lens compresses the space, making near and far appear closer to each other than they actually are.

A wide-angle setting brings both the foreground and background into sharper focus than would a telephoto setting.

An interesting and dramatic motion effect can be achieved by rapidly zooming in or out on a subject as you take the photograph.

A wide-angle setting in close-up portrait photography creates distortion of scale between near and far, adding to the expressive power of an image. In this photograph, the distortion causes the man's hand to appear bigger than his head.

STEADYING A CAMERA

Using a tripod or applying a technique to steady the camera is needed to photograph in low light to avoid camera shake, and is essential for macro and extreme-telephoto photography.

The Tripod: Tripods come in a wide range of prices and weights. The aim is to balance cost, weight, and portability against the need for strength and stability.

The Monopod: The monopod is light and easy to transport. When you lean on it with your feet apart, you have essentially created a tripod.

Table Tripods: These mini tripods can be positioned on the floor, a table, chair, shelf, window-sill, a low wall or a car roof. You can then angle the camera up or down. These tripods are conveniently small, lightweight and inexpensive.

Bean bags: The bean bag holds the camera in a stable position, even at an angle.

[See the photographs below for manual-camera steadying techniques].

Rest the camera in the palm of one hand and grip the side with your other. Pull your arms in.

Rest on your elbows and pull the camera in against your cheek.

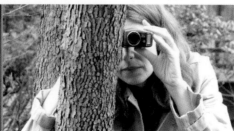

Crouch down and rest on one knee. Press your camera arm against the inside of raised knee.

Lean into a stable structure to create maximum hold on the camera.

CAMERAS AND THEIR LENSES

INTRO-LEVEL CAMERAS
Basic intro-level digital cameras have a fixed lens that is usually set to a focal length of 28mm to 35mm, which is a wide-angle lens. This limits the camera to simple point-and-shoot photography.

MID-RANGE
Mid-range cameras offer a lens system that operates between wide angle and telephoto function within one lens system. This zoom-lens arrangement is the most creatively flexible and convenient camera-lens arrangement on the market and is featured in most compacts, and all ZLR (zoom-lens reflex) cameras.

PROSUMER
Top-range Prosumer cameras work with interchangeable lenses. This has advantages for photographers who have invested in good-quality lenses before going digital. With this system you can switch between normal, wide-angle, telephoto, and zoom lenses. The only downfall: you'll be carrying around a substantial amount of extra equipment.

SOME TRIPOD CAUTIONS
Digital cameras are very sensitive. To avoid falls:
- Always check that your camera is firmly mounted.
- Secure the tripod joints.
- If you are on an incline, use a counterweight so the tripod doesn't topple over. A backpack works well.

IF AUTO FOCUS DOESN'T WORK

Auto focus is a very helpful camera function that assesses the subject's distance from the lens and automatically adjusts the lens to bring your subject into focus. This capability allows you to concentrate on composing your images without having to refocus for each new shot. The default focus setting is for the camera to auto focus through a small area in the middle of the lens. Sometimes, the nature of the subject will cause the auto-focus system to focus on the wrong part of the scene.

SUBJECT IS OFF-CENTER

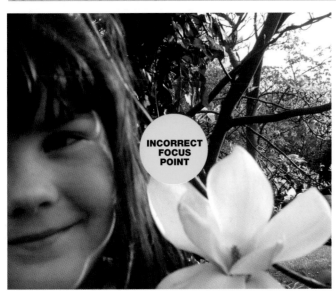

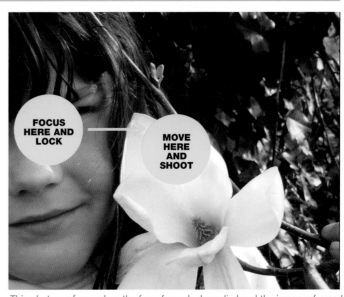

Auto focus has missed the subject and focused on the background.

This shot was focused on the face, focus lock applied and the image reframed.

Using Focus Lock to focus on off-center subjects: When your subject is positioned away from the center point of the composition, you need to use the **Focus Lock**. [1] Focus the center point of the lens on your main subject and semi-depress the **Shutter-Release** Button. This correctly focuses the subject. [2] Keep the shutter-release button semi-depressed to maintain the correct focus, and reframe the subject in the composition. [3] Fully depress the shutter-release button to take the photograph.

REFLECTIVE SURFACES

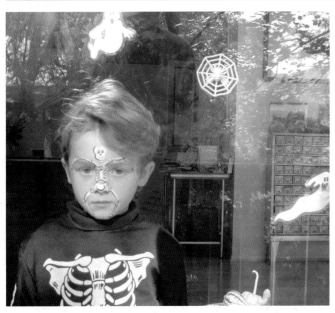

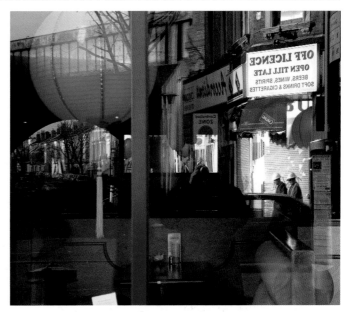

Focusing through glass: In this image, the camera was switched to manual focus, so that the child behind the glass could be accurately focused.

Focusing on a reflection: The camera was only 4 feet from the glass, but was set to 30 feet to manually focus on the reflected image of the street.

LOW LIGHT

Focusing on low-light objects in front of or behind your subject, makes them appear closer to each other than they actually are.

FOG

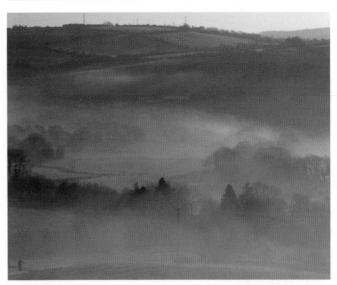

The beautiful yet vaporous natures of fog and mist diffuse light and obstruct form, which may require switching to manual focus.

SMOKE

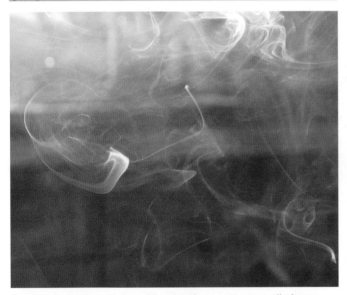

The formless nature of the subject requires you to manually focus on a point in space where the smoke is drifting.

MOVEMENT

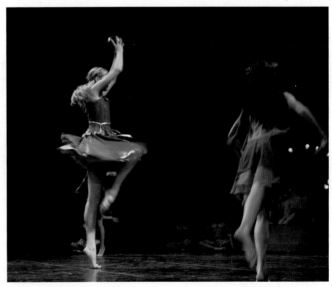

Rapid movement can cause shutter lag, which delays the shot. Switch to manual focus to catch the action.

USING MANUAL FOCUS

Most cameras have a setting that allows you to alternate between manual- and auto-focusing with the touch of a button. Manual focus allows you to have full creative control, focusing on a precise point in the field of vision. Press the **Manual Focus** button and then focus the image by using the manual-focus ring on the lens. You will see the image focusing in the viewer, and also, if you use the display information option, you will see the distance altering numerically on the screen. Some cameras will have a zoom facility that displays as a magnified center square in the viewer. This is very useful, as the increased detail allows for precise focusing.

WARNING!

The longer your lens, the more you increase the likelihood of camera shake. If you are photographing from a distance, use a tripod to reduce camera shake.

When using telephoto lenses, make sure that your **Aperture** is set at least one stop away from maximum or minimum aperture for best image definition.

DEPTH OF FIELD

"Depth of field" refers to the amount of a scene that is in focus. If a scene is composed of a foreground, middle distance and background, depth of field is the distance between the foreground point at which the scene comes into focus and the furthest point into the background where the scene goes out of focus. To understand how a camera focuses, consider the method that your eye uses to focus. If you hold up your finger a few inches from your eye and focus on it, you'll see that the scene behind your finger blurs. If you focus on the scene, then your finger suddenly blurs. The eye cannot focus on near and far at the same time. When photographing a scene with something close to the lens, the image will have a similar blurring. The object closest to the lens will be in sharp focus, while the rest of the image will be blurred. However, the camera differs from the eye by allowing you to photograph everything from near to far in sharp focus. With a bit of camera control, you can achieve a much greater depth of field than the eye sees. If you reduce the depth of field to the minimum, you can focus on the most interesting part of the image, and the rest of it will be slightly out of focus. By using the **Zoom** lens or by changing the **Aperture** setting, you can manipulate the depth of field, decreasing or increasing the amount of your scene that stays in focus.

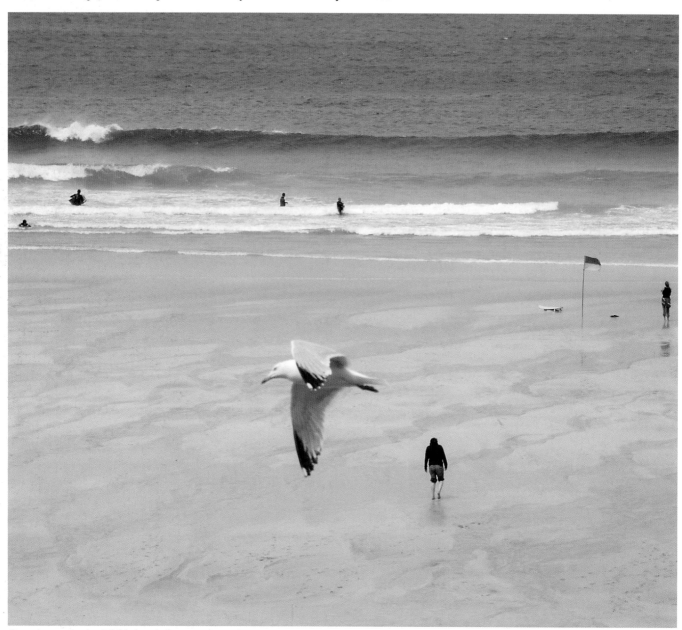

A maximum depth of field sharply focuses everything in the image—from the seagull to the horizon.

WHAT IS APERTURE?

The aperture is the size of the opening behind the lens. This opening functions as a diaphragm, controlling the amount of light that falls onto the sensor. You control the aperture setting by switching your camera to **Aperture Priority** in the **PSAM** settings using the control dial. Aperture is increased and decreased in measures referred to as Stops. With each stop up or down, the amount of light entering the lens is either doubled or halved.

Blurring the foreground objects puts focus on the psychological point of interest.

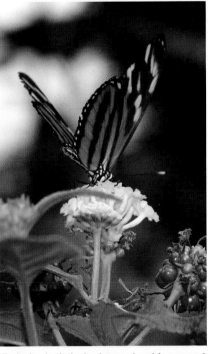

Reducing both the background and foreground detail brings the butterfly into sharp focus.

A shallow depth of field distinguishes between a high-definition form and soft-definition area.

The contrast between textures heightens awareness of color in the blurred objects.

REDUCING DEPTH OF FIELD

If you are taking a portrait shot against a busy scene, zooming in and setting a wide aperture will reduce the depth of field. The portrait stays in focus and the distracting background detail blurs.

INCREASING DEPTH OF FIELD

By setting a wide angle and a narrow aperture, you will have maximum depth of field. The foreground, middle distance and background will all be in focus.

LESS BLURRING IN DIGITAL PHOTOGRAPHY

Depth of field blurring occurs less in digital photography thanks to the focal length, lens configuration and smallness of the CCD chip that records the light from the lens.

APERTURE AND THE RULE OF RECIPROCITY

- The aperture range in your camera will be between f2.8 and f3.5 at the widest and f22 at the smallest.
- Aperture also affects shutter speed. As you decrease the aperture, the camera will select a slower speed to maintain the correct amount of exposure–this relationship is known as **Reciprocity**. Just as the stops on aperture half or double the amount of exposure, so too the shutter speed doubles or halves with each stop.

MACRO PHOTOGRAPHY

Many mid-range and Prosumer digital cameras now feature zoom-lens systems with a macro setting. The macro lens magnifies forms close up, allowing you to capture small worlds in amazing detail.

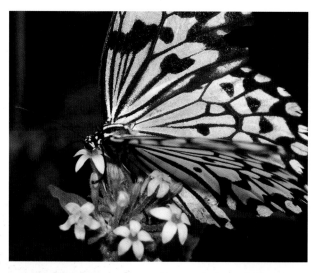

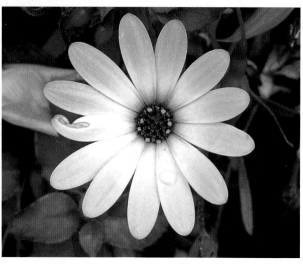
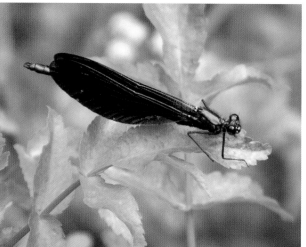

MACRO SETTING CAN BE USED TO CAPTURE:

- Nature [flora, fauna, insects, lichen, frost, dew, etc]
- Needlework
- Jewelry
- Mechanical parts
- Circuitry
- Small print

LOW-LIGHT REMEDIES

- Increase your ASA
- Use a reflective surface to redirect the ambient light
- Shine a light directly onto the subject
- Set a slow exposure for a static subject while using a tripod
- Set a wide aperture for a slow-moving object

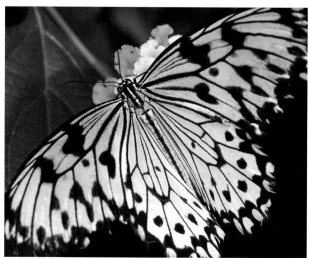

WARNING!
You and the camera's auto focus may experience difficulty in focusing unless you move slowly when framing the image for the composition.

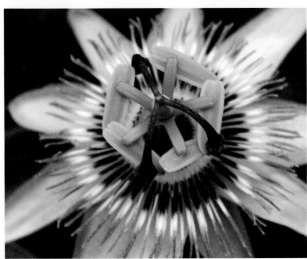

FOCUSING IN MACRO
The depth of field is greatly reduced in macro mode—from feet down to inches. The camera will only work in macro when it is within a certain range of the subject, approximately 2–8 inches.

USE A TRIPOD
Using a tripod will help you focus, eliminate camera movement and maximize the sharpness of your photography.

ZLR AND MANUAL FOCUS
Using a Zoom-Lens Reflex camera, you normally extend or retract the zoom lens fully and then press the **Macro** button to reconfigure the lens system to focus in macro mode. The auto focusing should focus for you if you hold the camera stable within the range of distance in which the macro lens can focus. If the auto focus experiences difficulty switch to **Manual** focus, which will let you find and hold the precise point of focus you want on your subject.

MANIPULATING APERTURE
You can increase or decrease the depth of field by manipulating the **Aperture**. [For more on aperture, see pp 46–47].

FAST-MOVING OBJECTS
If you have a fast-moving object, using your flash at such a close distance will bleach out the subject. There are ways to remedy this situation:
- With a built-in flash—set your shutter speed at the highest setting and the aperture at the smallest.
- With an external flash unit—angle the flash away from the object or use it at a distance to minimize its effect. [For more on external-flash photography, see pp 62–63].

PHOTOGRAPHING MOVEMENT

Images of life in motion fascinate us because they allow us to reflect on what would otherwise be just a blur to the naked eye. This is because so much of the character of a subject is revealed only when it is in motion. The challenge of capturing motion is not just to freeze the action, but to catch the essential and most interesting aspect of the subject.

ITS ALL ABOUT SHUTTER SPEED

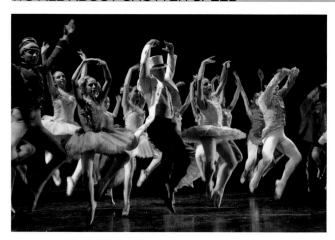

Capturing a subject in motion is a matter of timing. You can effectively catch a moving subject by setting a faster shutter speed. A scene caught on a fast shutter speed has the sense of time suspended. To set a higher shutter speed, you can either use the **Subject Settings Menu** and select the running-figure symbol, or alter the camera mode in **PSAM** to **S**, which is **Shutter Priority**. You will then be able to use the control dial to increase the shutter speed. Also, in motion photography, you can exaggerate the appearance of movement and creatively play with composition by deliberately moving the camera while on a long exposure setting.

WHAT SHUTTER SPEED DO I NEED?

The speed you choose depends on the action and the distance of the subject from the camera. The closer your subject, the quicker it passes through the field of vision. To catch a gentle gesture requires a slower shutter speed than does a fast action. As a rule of thumb, think of a shutter speed of 1/125th to 1/250th to capture gestures and a shutter speed of 1/500th and upwards to catch extremely fast action. Your camera will have shutter speeds that may be as high as 1/4000th of a second.

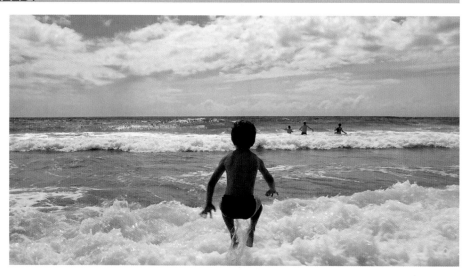

WARNING: AVOID SHUTTER LAG!

When the camera is on Auto Focus and Auto Exposure, it can take time to adjust to the new shutter settings. This can cause a delay called Shutter Lag. To avoid this: [1] Set a higher shutter speed in **Shutter Priority** mode. [2] Focus on the area where you anticipate the action. [3] Semi-depress the **Shutter-Release** button to apply **Focus Lock**. [4] Press the **AEL** (auto-exposure lock) button, which holds this exposure.[5] Switch your camera to **Manual-Focus** mode. [6] Shoot. The camera will respond instantly, taking the shot at the moment you fully depress the shutter-release button.

FOCUSING ON A MOVING SUBJECT

If the movement you are trying to capture is up and down, (i.e., a child on a trampoline), you don't have to change your focus setting when your subject moves, because the distance between you and your subject remains the same. However, if the action is coming toward you or moving away from you, you will get blurring as it moves past the point of focus. Trying to refocus may make you miss the shot or add a great deal of blur to the shot. To avoid this, focus on a spot where the action is going to pass, and when you press the shutter-release button, the subject will be in focus.

CATCHING MOVEMENT

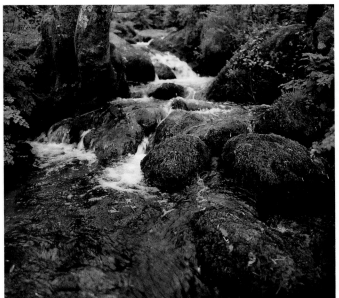

In a landscape scene, to achieve maximum depth of field, that is, to have from near to far in focus, a smaller aperture is used. This will cause the shutter speed to decrease. If you are photographing movement, as in the case of the water movement illustrated here, you will need to balance how much you decrease the **Aperture** against the **Shutter Speed**. The slower the shutter speed, the more blurring will occur in the image. The faster the shutter speed, the more sharply the forms will be defined.

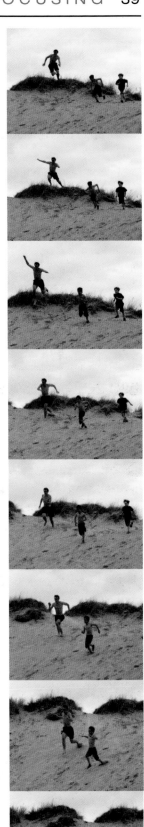

You can use your flash to freeze the action in a burst of light. This is a good way to add definition to the shot—even in daylight. Note that the effectiveness of the flash is very high for subjects within a range of 12 feet, but not much more. The flash fires within a speed of less than 1/1000th of a second, so you are guaranteed to catch the action. Or, experiment with the **Rear-Sync** flash. This will incorporate some motion blur with a sharply focused image at the end of the blurred action. [for more, see the sections on flash photography, pp 60–63]

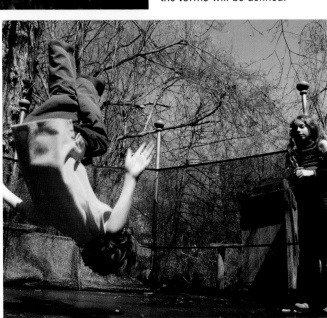

CONTINUOUS SHOOTING
When the action is unpredictable or too fast, use the **Continuous-Shooting** mode to capture the action in a rapid sequence of continuous shots. Select it under **Drive** in the menu. It is indicated by a symbol of overlapping rectangles. You can shoot 3 pictures in high resolution or select Continuous Shooting, which keeps firing as you press the shutter-release button.

PLAN AHEAD
Alternatively, you can arrange to be in the right place at the right time with the correct camera settings. To anticipate the action, study the scene. Watch the movement until you recognize a pattern, then concentrate on catching the most expressive movement as it is repeated. This works whether you are photographing the flow of water, dancing, or a sports event.

PHOTOGRAPHING MOVEMENT II

Life is perceived as a flow of movement. It is your tendency, however, to feel as if you have missed the shot if there is any amount of blur in the photograph. In reality, though, to freeze a subject in movement is unnatural. When photographing motion shots, try experimenting with exposure times and camera movement. On longer exposures, the images will hold the traces of the movement and form surprisingly beautiful painting-like compositions.

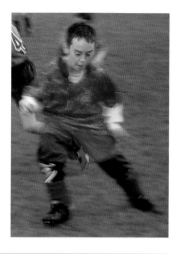

FOLLOWING THE MOTION: PANNING

In action shots, some amount of blurring will occur. Allowing a level of blur in your photograph can actually make the action look more natural. If you are photographing a subject in motion, try moving the camera to follow the subject, shooting with the camera on the move. Although this is an imprecise art, the results can be very successful, as the subject will be in focus and the surroundings will be slightly blurred. This adds to the drama of the photograph as we can almost experience the subject moving through a space at speed.

VARYING EXPOSURE TIMES

These shots are examples of varying exposure times catching the fireworks in movement. The first image captures the moment of the explosion, while each successive image illustrates what you can achieve with lengthened exposure times and camera movement.

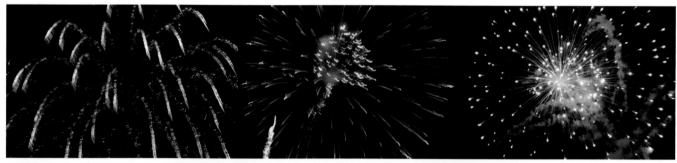

Fireworks are brilliant subjects for motion-shot compositions, because the traces of light create striking patterns.

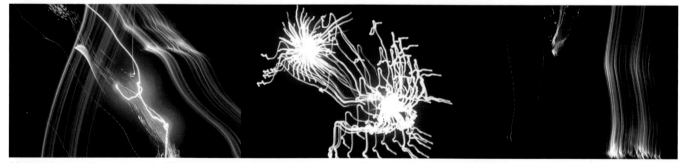

Motion photography captures the light as it streaks across the sky, a feature that make fireworks so beautiful.

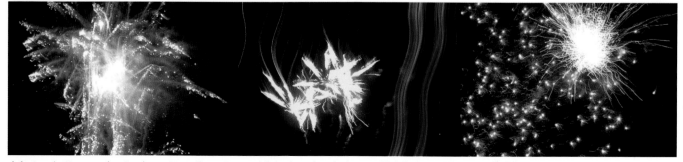

A faster shutter speed not only captures the patterns of light, but also the burst of brightness at the center of the fireworks.

CREATIVE USE OF BLUR

When we think of photographing motion, we think of trying to avoid blur while achieving maximum sharpness. However, such sharpness in motion shots can actually make an image look unnaturally frozen, adding a sort of surreal quality to the image. Capturing a slight degree of blur in an image is much more natural to our way of seeing. Thinking in such a way can free you up creatively. In a really successful image, you will then have the expressive contrast between areas of high resolution and extreme blur. This tells the story of the action very effectively.

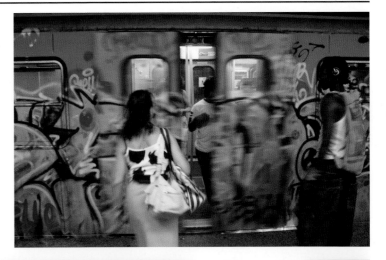

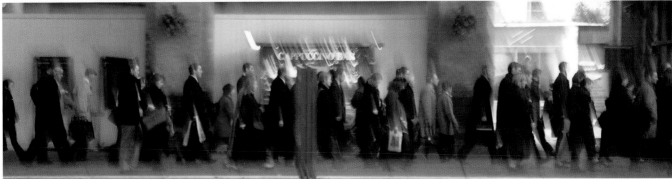

The overall blurring amplifies the continuous movement of the people.

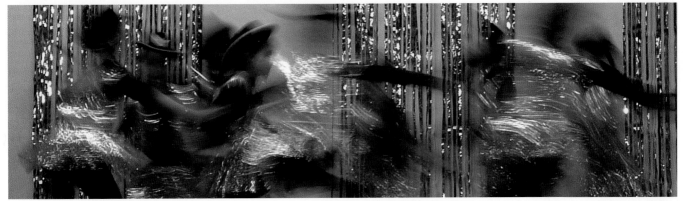

Shutter speed counts: if you look carefully, the foreground dancers' rapid arm movements are so fast that the arms have not registered in the shot.

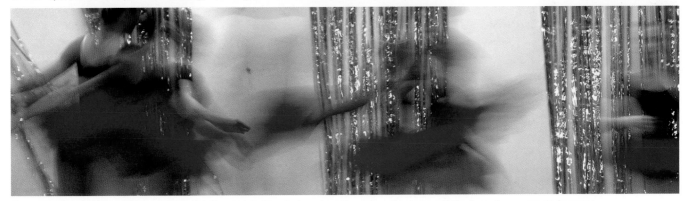

By setting a longer exposure, you lose detail and definition but capture the expressive traces of the forms' movements in space.

LIGHT

AN INTRODUCTION TO LIGHT

A compelling quality of photography is the faithfulness with which it can record light and atmosphere. While the camera responds to light with mechanical accuracy, people respond with emotion. This is because humans are both biologically and psychologically primed to be sensitive to the moods created by different lighting. As a photographer, you will be drawn to record and explore the poetics of light through the various permutations of mood and atmosphere. When you focus your attention on the quality of the light, you will find that your awareness of detail and form are equally enhanced. How you handle and capture the light of a scene will create the difference between a photograph being just another shot, and a moving composition.

DIRECTIONAL LIGHT

You can dramatically effect the way light works in your composition through where you stand while taking the shot, or where you position your subject in relation to the direction of the light. Moving yourself or the subject relative to the light source allows you to explore the possibilities of lighting. By moving around your subject, you can completely alter the feeling of the shot. Whether the subject is lit from the front, side or back affects the mood of the shot, allowing the light to play off the subject in various ways. Once you have a sense of how the subject ought to be lit in the shot, you can then play with other themes of composition, adding color and creating a specific theme within the frame. The direction of the light becomes vital to the shot.

REFLECTIVE LIGHT

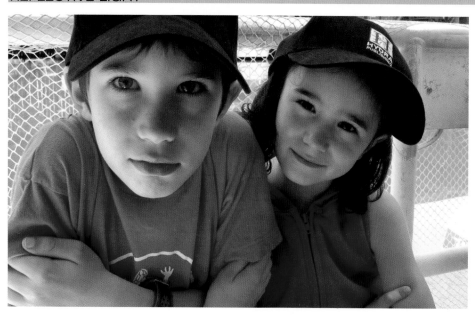

Whatever the light source, it will most likely be reflected in a scene by any reflective surface that the light falls on. The subject itself, the floor, a table or an adjacent wall will bounce light back into the shadows. As the shadows are lightened, the contrast between the light and shadow areas will diminish, and you will be able to see more detail in the shadow areas. In this image, the kids are sitting at a white table. Their faces are illuminated by the sunlight bouncing off the table surface. While the hats block the directional sunlight and darken their faces, the reflective light adds detail to shadow areas.

HARD LIGHT

Hard lighting is a way to describe the effect of strong directional light. This lighting is characterized by hard edges and a sharp division between light and shadow. The strong contrasting shapes will create an abstract sense of pattern, which will add drama to a composition. The negative aspect of this form of lighting is that you will lose detail in the shadows, making it inappropriate for most portrait work, unless you apply **Fill Flash** or use a reflector to bounce light back into the shadow.

SOFT LIGHT

Soft lighting occurs when light is diffused by atmosphere and clouds, or by reflective surfaces, such as a wall or water. This produces a softer effect that is more atmospheric. A reduction of contrast between the light and the shadow areas leads to a softer definition of form and more definition of detail in the shadows. Soft lighting is a characteristic of a lower level of direct lighting in a landscape, and is particularly suitable to portrait work.

AMBIENT LIGHT

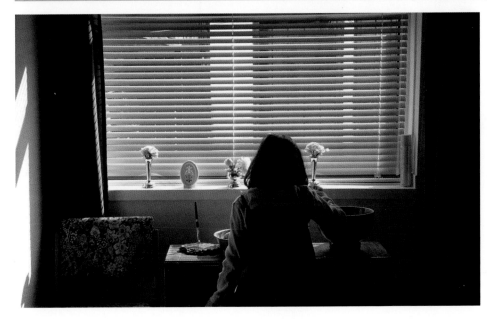

Every aspect of a photograph will be affected by the ambient or overall lighting in a scene. Think of the effect of opening the curtains in a room: the light, depending on the time of day, will be suffused throughout the room, changing the form and texture in every detail of the scene. If you look at a neutral element in an image, such as a wall that has no inherent color, whatever color the wall appears to have, will be the result of the color in the ambient lighting. Ambient lighting refers to the atmospheric light of a scene, either created naturally by the sun or through artificial light.

THE RULES OF LIGHT

Light is the essential medium of photography. Think of the photograph as a faithful imprint of the light falling on a scene. For the camera to make an accurate image, the camera has to adjust the exposure (i.e., how much light falls on the sensor that records the image in the camera). The level of light varies from scene to scene, for example there is an enormous difference in the amount of light falling in full sunlight compared to the same scene at dusk. If the camera lets in too much light, the image will be overexposed—it will appear very pale and bleached out. If not enough light is let in, the image will be underexposed and appear too dark. On a setting of Auto Exposure, the camera's built-in light meter will automatically take a light reading and set the correct exposure. While auto exposure works for most images, there will be many occasions when you will need to adjust how the camera exposes for the light—techniques you will explore in the following pages.

ISO (ASA) CAMERA SENSITIVITY TO LIGHT

In film-based photography, you would use films with different levels of sensitivity to light. Similarly, in digital photography, the camera can be set to different levels of sensitivity to light. This is necessary, because in very low-level light you need a higher level of sensitivity to record the scene. This sensitivity is altered under the acronyms of either ISO or ASA, and will typically range from ISO 50 to ISO 800. The normal setting for daylight is ISO 100, and you would step up the sensitivity as the light in the scene decreases—to ISO 200 in a dull interior, and between ISO 400–800 for nighttime photography. The camera's built-in light meter will detect the levels of light in a scene, and on Automatic ISO, will automatically adjust the camera sensitivity to a higher ISO when photographing in low-level light.

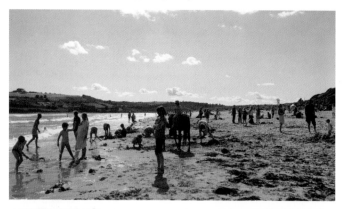

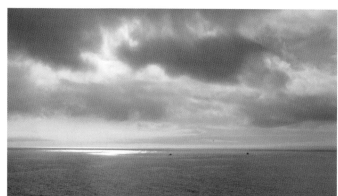

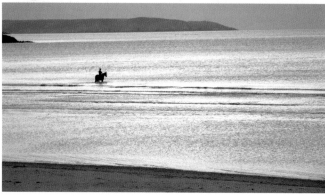

EXPOSURE CONTROLS AND PSAM

The light meter measures the amount of light in the scene, and then Auto Exposure sets the right exposure in the camera by adjusting two variables: the Aperture, which is the size of the opening that lets light onto the sensor, and Shutter Speed, which determines how long the shutter will stay open. For some special-lighting situations and subjects (such as night photography or motion shots) you can use the Special-Subject Settings option, in which the aperture and shutter speed are configured to the needs of these subjects. For some techniques and subjects you will need to intervene in the auto exposure process by setting the aperture or the shutter speed. Use the function dial or the camera menu to select PSAM, which stands for Program, Shutter priority, Aperture priority and Manual control. Program is the default setting which switches the camera back to auto exposure. When using Aperture priority, Shutter priority or Manual, use the control dial to raise or lower the aperture or shutter-speed settings, which you will see changing numerically in the viewer and camera data panel.

APERTURE (F STOP) AND APERTURE PRIORITY

Aperture range will usually extend from a maximum of f2.8 to a minimum of f22. A small aperture is set when shooting a subject in bright light or an image in which you want the greatest depth of field. When using a small aperture, the Auto Exposure will adjust the shutter speed to a slower speed. A larger aperture is set in low light or set to create an image with a narrow depth of field.

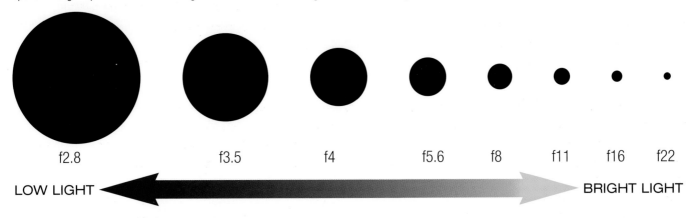

| f2.8 | f3.5 | f4 | f5.6 | f8 | f11 | f16 | f22 |

LOW LIGHT ← — — — — — — → BRIGHT LIGHT

SHUTTER SPEED AND SHUTTER SPEED PRIORITY

Shutter speed will extend from a B setting (which means that the lens stays open for as long as you hold your finger on the **Shutter-Release** button) to 4 seconds, increasing in increments of double the speed up to 1/4000th second. A fast shutter speed is set to shoot a fast-moving subject or a subject in bright light. Using a fast shutter speed, the Auto Exposure will adjust to a larger aperture. A slower shutter speed is set in low light or used when the aperture is set to the smallest to create an image with a greater depth of field.

| B | 4 | 2 | 1 | $\frac{1}{2}$ | $\frac{1}{4}$ | $\frac{1}{8}$ | $\frac{1}{15}$ | $\frac{1}{30}$ | $\frac{1}{60}$ | $\frac{1}{125}$ | $\frac{1}{500}$ | $\frac{1}{1000}$ | $\frac{1}{2000}$ | $\frac{1}{4000}$ |

LOW LIGHT ← — — — — — — → BRIGHT LIGHT

COMBINING APERTURE AND SHUTTER SPEED

As you alter either aperture or shutter speed, the other will automatically be adjusted to maintain the correct exposure. The smaller the aperture, the slower the shutter speed, and vice versa. This relationship is known as **Reciprocity**. These alterations are measured in stops and half stops. Each stop up will double and each stop down will halve the amount or aperture or shutter speed. Depending on the light reading and ISO setting, there will be a range of aperture and shutter speeds that you can use in combination to make the same exposure. It is important to understand that the combination of aperture and shutter speeds is adjusted for every shot you take in a new light.

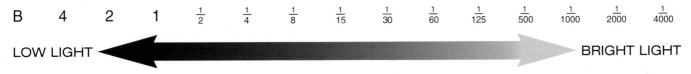

1 BRIGHT LIGHT

							f22	f16	f11	f8	f5.6	f4	f3.5	f2.8	Aperture
B	4	2	1	$\frac{1}{2}$	$\frac{1}{4}$	$\frac{1}{8}$	$\frac{1}{15}$	$\frac{1}{30}$	$\frac{1}{60}$	$\frac{1}{125}$	$\frac{1}{500}$	$\frac{1}{1000}$	$\frac{1}{2000}$	$\frac{1}{4000}$	Shutter Speed

When photographing a subject in bright light, the aperture range will move up to the higher range of shutter speeds—the absolute extreme being f22 over 4000th sec. If you want to increase your depth of field in the shot, you will need a smaller aperture, which will decrease the shutter speed.

2 LOW LIGHT

	f22	f16	f11	f8	f5.6	f4	f3.5	f2.8	Aperture					
B	4	2	1	$\frac{1}{2}$	$\frac{1}{4}$	$\frac{1}{8}$	$\frac{1}{15}$	$\frac{1}{30}$	$\frac{1}{60}$	$\frac{1}{125}$	$\frac{1}{500}$	$\frac{1}{1000}$	$\frac{1}{2000}$ +	Shutter Speed

When photographing a subject in low light, the aperture range will move down to the lowest range of shutter speeds—the absolute extreme being f2.8 over the B setting. If you want to decrease your depth of field in the shot, you will need a larger aperture, which will increase the shutter speed.

SETTING THE RIGHT EXPOSURE

The camera's built-in light meter assesses the light in the scene, then sets the aperture and shutter speed to give the best image definition. Auto Exposure will make a perfect assessment for most images. However, when there is high-contrast lighting, you will need to set the way the light meter reads the scene. Using the camera's **Optometry** settings under **Functions**, you can control the way the light meter takes a reading of the scene, so as to expose for either the light or the shadows.

EXTREMES OF LIGHT AND SHADOW

Use the light metering controls under **Optometry**. **Center-weighted** (symbol: dot within two brackets) is the default setting. You need to alter the setting to **Average** (symbol: two empty brackets), which sets the camera to take a shot averaging between the extremes of the brightness and darkness values in the composition. This will work for scenes with moderate contrast. However, for scenes of extreme contrast, you will need to switch to **Spot metering**, which gives a correct exposure for a precise spot in the composition.

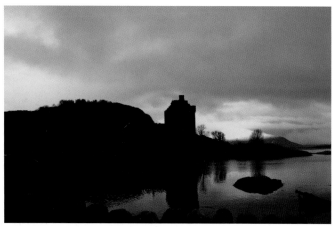

In center-weighted mode the light meter has accurately exposed for the sky, but the land is too dark.

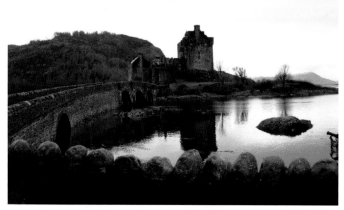

In this second shot, the light meter set the exposure accurately for the castle, but the sky is bleached out.

BACKLIGHTING

Backlighting occurs in situations when your subject is framed against a light source, either a window, lamp or bright sunlight. To counter underexposure in shaded areas, select the **Spot Meter** option under **Photometry**. Position the center point of your viewer on the the shadow area of your subject and semi-depress the **Shutter-Release** button. The exposure is adjusted, and the shadows brighten. Now lock the exposure by pressing the **AEL** button (Auto Exposure Lock), and then reframe your subject and take the shot.

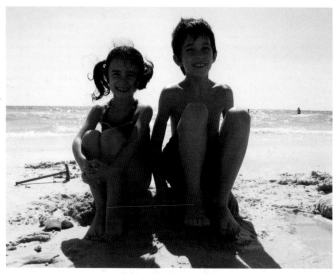

Using the default meter setting of center weighted, the backlit figures are underexposed and in shadow, limiting the visibility of details in the form.

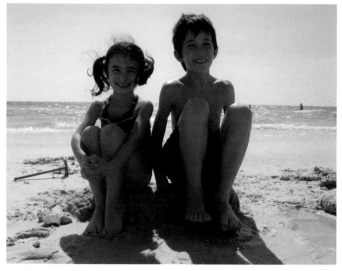

The spot meter has correctly exposed for the shadow areas in the figures. The tones have lightened, revealing the form and color in their features.

BRACKETING

There are frequent situations when you will either be unable to decide which exposure is correct, or not have the time to go through the process of setting **Average** or **Spot Metering**. A simple and fast solution is to switch your camera's setting to **Drive** under **Functions** and select the **Auto-Bracketing** mode. In this setting, three shots are automatically taken—one at a stop of underexposure, one in the middle, and one at a stop of overexposure. In postproduction, you can digitally edit the best exposed image.

EXPOSURE FOR DIFFERENT LIGHTING

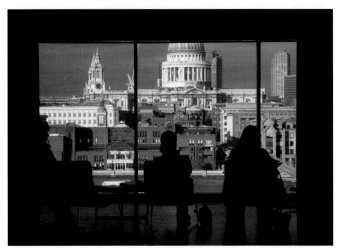
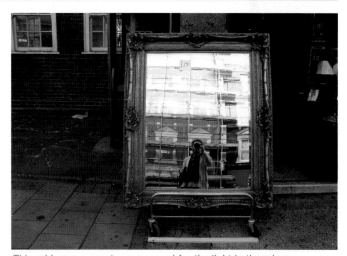

Set against a window, the backlit figures reduce to extreme silhouette.

This odd arrangement was exposed for the light in the mirror.

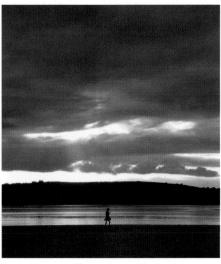

This scene was spot metered for the bridge.

An average reading was used here.

The carving was spot metered.

NATURAL LIGHT

Natural light shifts direction and temperature depending on the time of day or year, and can also be affected by atmospheric and weather conditions. Clouds move—diffusing, blocking and reflecting the light of day, providing endless variations of light quality, which evoke different emotions. To explore natural light is to investigate subtle nuances of atmosphere or dramatic extremes of light and shadow.

OUTSIDE LIGHT

The light outside will be brighter and yet more diffused than the light inside. Outside, the light is bounced off of and reflected through the moisture and a myriad of other surfaces. Overcast days can be some of the best days to photograph outside. The reduced shadows allow you to explore color and detail without the scene being broken up by the strident light and shadow characterized by a sunny day.

INSIDE LIGHT

The light inside of a room during the day will be more subdued. It will also be more directional as it comes from a window. Use the window like a lamp illuminating the subject. Drawing the curtains will narrow the light source. Photographing with the window behind you will provide even lighting. Facing the window will put forms in silhouette. Parallel to the window, as below, forms will be rim lit.

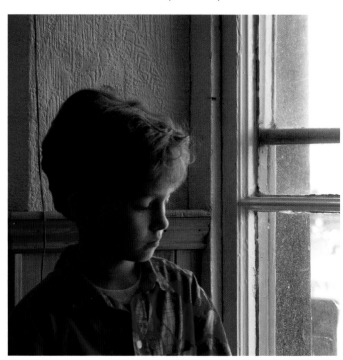

TIMES OF THE DAY AND COLOR TEMPERATURE

Light has a color temperature, depending on the time of day and the season. Rarely is the light of day pure white, but at midday it is at its whitest. At sunrise, sunset and in the summer, the color is usually biased towards either yellow or red. At dawn, at dusk and in the winter, light tends toward blue. This fluctuation in color is determined by whether the infrared waves or ultraviolet rays are dominant. When the sun is closest to the horizon, less ultraviolet light and more infrared dominates, illustrated by the orange light of sunset.

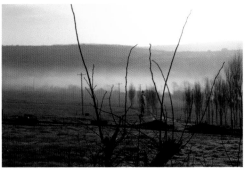

Early morning sunlight through mist.

Mid-morning bright sunlight

Midday overhead light

SEASONAL LIGHT

The seasons are characterized by very different atmospheres and therefore different qualities of light. Spring light is sharp and bright on cloudless days. Summer light is generally softer and warmer in tone, even on the clearest days. Autumn light tends to be more golden and diffused. Winter light is cooler in tone, and the shadows are longer as the sun is lower in the sky.

POLARIZING FILTERS

The **Polarizing** filter reduces haze, cutting the glare from reflective surfaces, such as water or glass. It provides additional clarity in form and beautiful depth of color in landscape photography. Filters have the added advantage of protecting your lens from dust and scratches.

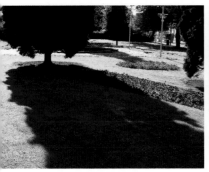
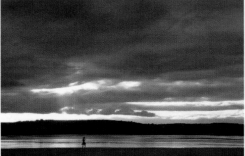
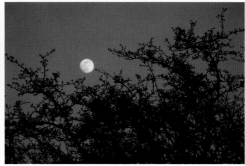

Shadows stretch in afternoon light. The dramatic light of sunset. The quietude of dusk and night light.

LOW-LEVEL LIGHT

Low light is some of the best light in which to photograph. Early morning and twilight are known as the magic hours for photographers when the light creates a visual harmony across a scene. It is in these low-level light conditions that photography feels closest to the art of painting. You can capture all low light has to offer by adjusting a few settings on your camera, by using a tripod or other camera steadying means and by studying the different color and highlighting effects of low light.

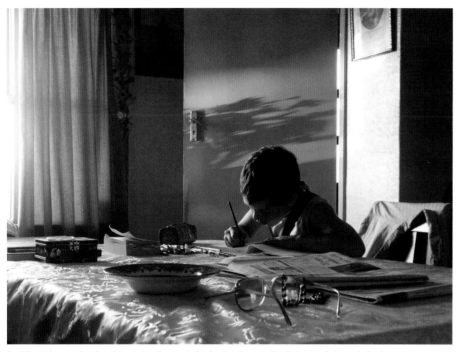

In this early morning interior scene, the cast shadows create a play between light and shadow.

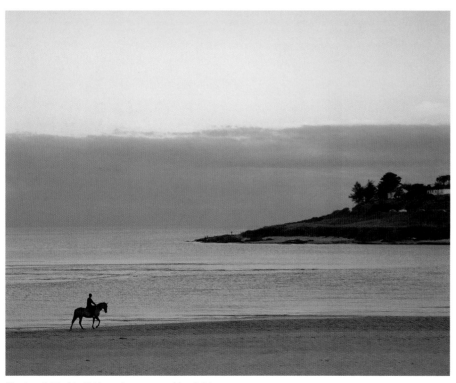

The low light of twilight produces a very blue light.

LOW LIGHT INTERIOR

The light inside a room will be much less, as compared to the light outside. This, too, has its expressive advantages. As shadows are reduced to darkness, any form that is facing the light will be thrown into relief against the shadow, creating a dramatic chiaroscuro effect. This can be a very poignant device in portrait photography.

TECHNIQUES

- **Auto Exposure** will automatically set the aperture and shutter speed. It will also warn you when the light is so low that camera shake is likely to occur with a hand symbol in the viewer. This happens when the camera drops the shutter speed below 1/60th of a second.
- In some cameras, you can set the camera to automatically adjust the **ISO/ASA**, **Aperture** and **Shutter Speed** for low light by selecting the **Special Settings** menu and moving the setting to **Low-light** photography, usually denoted by a crescent-moon symbol.
- You can override auto exposure and manually set the camera sensitivity to light through adjusting the ISO/ASA setting.
- Use a tripod or the techniques outlined in the section on holding your camera [p 31] for longer exposure times.

SILHOUETTE

In low light, the details of form become lost in ambiguous tones and shapes are cut to clear silhouettes. Both in natural and artificial light, low lighting generates enigmatic readings of forms, in turn stimulating reverie and reflection. What you lose in detail, you gain in poetic ambiguity.

Low-light, long-exposure blurring adds softness to the image.

The twilight forms are collapsing into silhouette.

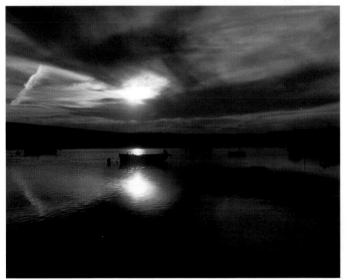

Sunset epitomizes the drama of low-light photography.

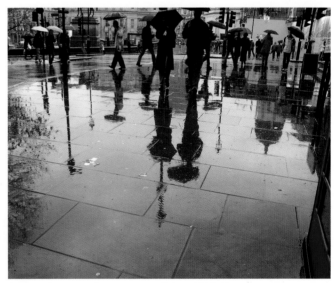

Damp and overcast days create equally beautiful light.

VISUAL NOISE

Noise is the appearance of speckled red, green and blue pixels in the shadows of an image. This is an unfortunate by- product of using a higher **ISO/ASA** setting. For some low-light images, especially if the subject is in motion, you will only be able to photograph by using a very high ISO setting. This is because in a lower ISO setting, the shot would be too slow to catch the action without excessive blurring. However, if the subject is in low light and if both the subject and camera are static, you will want to shoot on a longer exposure and a lower **ISO** setting to maintain the highest definition.

A low ISO setting of 100 ISO.

A higher ISO setting of 800 ISO.

ARTIFICIAL LIGHTING

People spend a great deal of time inside rather than outside and this means shooting in artificial light for a large part of the pictures they take. Every light has some expressive potential. In artificial lighting situations, there is a whole other world of lighting and color effects to explore. From the saturated hues of neon lights to the yellow glow of candlelight, artificial light creates a totally different atmosphere. Artificial light has a much wider spectrum of color temperature compared to daylight, and emphasizing extremes of expressive mood.

THE COLOR OF ARTIFICIAL LIGHTING : COLOR CAST

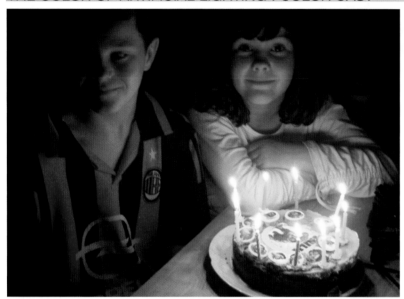

Artificial light will have a distinct color temperature. When you photograph in artificial light, you need to be aware that the color of the light source will affect every other compositional element in the photograph. The most common artificial-light source you will work with is the ordinary tungsten light bulb, which has a characteristic yellow cast. Fluorescent light varies between a yellow and a blue cast, depending on the make. Halogen lights give off a whiter light. Neon lights and colored spotlights make terrific colored imagery. You can also create an evocative warm-color atmosphere by using only candlelight. Before you immediately decide to use a flash, think about all of the different light sources around you. You will find that using available light will often provide a much more interesting effect than will a flash.

CORRECTING COLOR CAST WITH WHITE BALANCE CONTROLS

While a color cast from an artificial light source can enhance an image, it can also spoil a photograph. White balance, one of digital photography's most advanced features, is built into your camera. The white balance "color corrects" the bias in the ambient light towards white. Most cameras will be set at default to AWB: Auto White Balance. There are also settings you can set manually to adjust the degree of white-balance color correction. They are: daylight, tungsten, fluorescent 1, fluorescent 2, cloudy, or custom white balance. The right half of the image shows the correction.

Image before white balance.

Image after white balance.

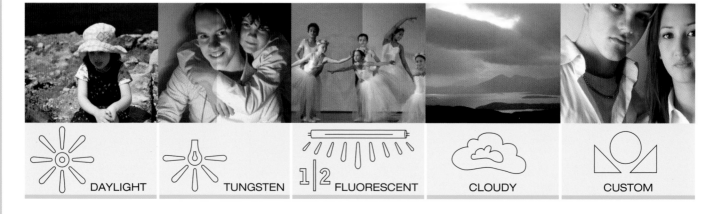

DAYLIGHT TUNGSTEN 1 2 FLUORESCENT CLOUDY CUSTOM

THE CREATIVE SIDE OF COLOR CAST

The local, or original colors in a scene will take on the temperature of the scene's artificial lighting. As the strength of the color increases, the effect of this light on the local color will be more radical. In some cases, local color will be replaced completely by the color of the light. You can explore the range of effects of artificial ambient lighting in your images. Try photographing subjects in a subdued atmosphere with soft lighting, in the exaggerated glow of neon light, and in the saturated color of a spotlight with a gel (colored transparent acetate) on it.

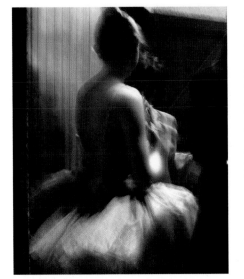
Blurred focus and colored light

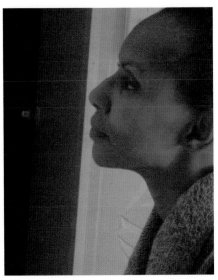
Subdued tungsten lighting.

Completely saturated color.

Extreme of color contrast caused by spotlight.

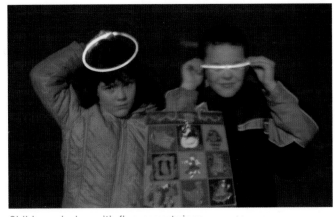
Children playing with fluorescent rings.

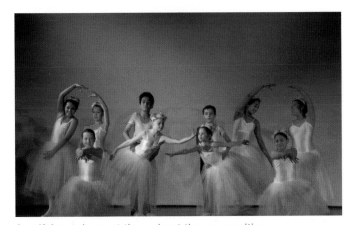
A unifying color cast throughout the composition.

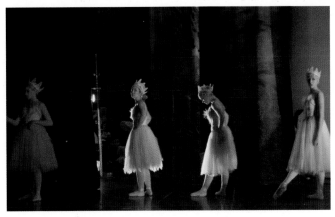
Low-level spotlights create dramatic lighting.

BUILT-IN FLASH

You will inevitably need to use flash in many situations. As well as getting enough light onto the subject, the use of flash is a creative way to change the atmosphere of a scene. The flash emits a burst of white light and when used carefully, it can create either dramatically directional or expressively subtle lighting effects. Because many cameras have a flash that automatically fires when the available light drops below a certain level, it is easy to think of flash as solely for low-light and nighttime photography.

FILL FLASH

The flash facility is also an important addition to daylight photography. Although it may seem paradoxical—the stronger the light, the more likely the need to use flash. This is because the strong light will cast equally dark shadows. By setting your camera to **Fill Flash**, you will be able to reduce the severity of contrast in the image and effectively fill the dark shadows with additional light.

The extreme contrast of the light and shadow has caused the shadows to darken to a point where the form is barely visible.

Setting the camera to Fill-Flash mode, the features are lit to a degree where all of the form is clearly illuminated, while still showing shadow.

FLASH RANGE AND FALL OFF

Most compact cameras automatically switch to flash mode when the ambient light is too low to achieve a good-definition image. In the mid-range cameras, you can choose whether or not to use flash.

The distance a flash will cover is limited, with few built-in flash units covering a distance of more than 10–13 feet. The light rapidly diminishes over distance, which is called the rate of **Fall Off**.

In this image of swans lit by flash against the void of night, you can clearly see that the fall-off rate declines exponentially into the distance.

A major problem with built-in flash is that at close quarters, the light will be too bright and bleach out the image.

REAR-SYNC FLASH

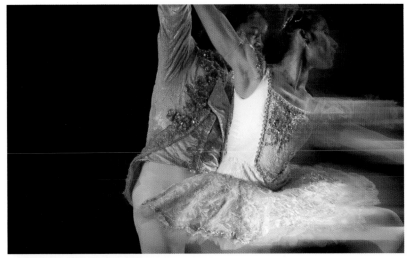

Rear-sync flash combines blurred movement and sharpness.

You can successfully add flash to a low-light scene by using the **Rear-Sync** flash setting, which first records the scene using the ambient light on a slow exposure and then caps the exposure with a flash to add sharpness of definition to foreground forms. In film-based photography, you will not know the effect of the flash until the film has been processed. One of the many advantages of digital photography is that you can immediately switch to **Review** mode, see the effect of the flash and then alter the exposure to achieve the correct level of lighting in the shot. You can also switch to either **Aperture** or **Shutter-Speed Priority** and then increase or decrease the amount of aperture or exposure time to get a correct exposure.

RED EYE

Red eye is a persistent feature of flash photography.

Fixing red eye with digital software is a quick and easy procedure.

Red eye occurs when the flash illuminates the retina of your subject's eye, giving it a spooky red glow. On the Red-Eye setting, either the flash fires twice in rapid succession or a light comes on at the front of the camera before the flash fires. On the first flash, the subject's iris contracts so that on the second flash, the surface area of the retina is covered by the closed iris, eliminating the incidence of red eye.

OTHER PROBLEMS WITH BUILT-IN FLASH

Move your subject away from a wall to avoid a strong outlined shadow.

The built-in flash unit allows no opportunity to angle the light away from the subject. This makes many shots taken in flash rather poor, creating a "deer-in-the-headlights" look in your subject, as well as red eye. Also, if you photograph a subject close to a wall, you will see the form echoed by a severe shadow. The solution: move the subject away from the wall.

TIP: When photographing a portrait, do not stand too close, or the flash will be too strong and will wash out the form of your subject. Step back and use the zoom lens to bring the subject closer while creating more distance between the flash and the subject.

EXTERNAL FLASH

An external flash unit, which you can attach directly to the hot shoe on your camera, will be an invaluable addition to your photography kit. Some cameras have dedicated flash units that connect directly to the metering system of the camera, but it is important to remember that they can only be used with the make, and sometimes the exact model of camera, for which they were made. A major advantage of external flash over the internal is that it can cover a distance of up to 30 feet or more.

BOUNCE FLASH

When buying an external flash unit, be sure that you can angle the flash head so as to bounce the light onto the subject in ways that are much more subtle and expressive. If you bounce the light off of a low ceiling or wall, a much more gentle quality of light will fall on the subject. Whatever light goes up will be halved in intensity as it comes down. Some flash attachments will come with a reflector.

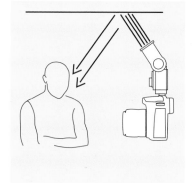

RING FLASH

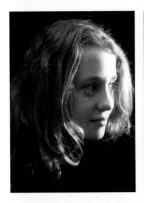
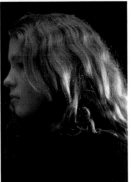

A ring flash is a specialized flash unit that attaches to the lens casing at the front of the camera. The ring lighting produces a soft even light, highly suitable to close-up portrait and macro photography. If your camera will not accept a ring flash, you can modify your existing flash with a plastic cover that will give you close to the same effect.

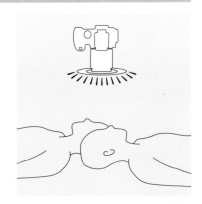

RIM FLASH

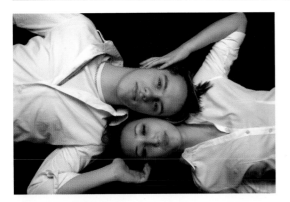

Rim flash is a dramatic lighting effect created by positioning the flash at an acute angle to your subject. When you position the flash on a tripod to the side and a little to the rear of your subject, the light from the flash will highlight the detail of the edge's of the form.

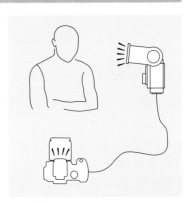

SLAVE FLASH

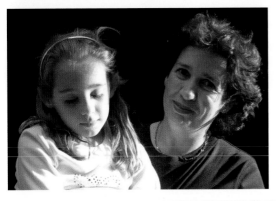

If your camera does not have a hot shoe or a sync lead connection, use a slave unit that is attached to the base or the side of the external flash. It has a light-sensitive cell and when you shoot, the built-in flash triggers the external flash via the cell in the slave unit. With this arrangement, you can have the external flash on a tripod at different angles and distances to the subject.

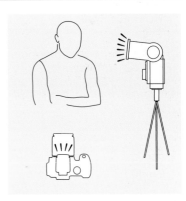

SYNC CHORD FLASH

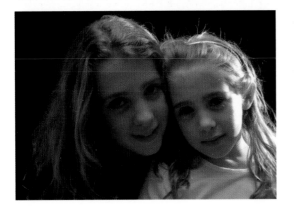

Another way to use the external flash is to attach the flash unit to a sync lead, which allows you to hold the flash unit away from the camera. If you use a longer sync lead, you can then position the flash unit on a tripod at another angle altogether to the subject. This arrangement can give you enormous flexibility in your lighting choices.

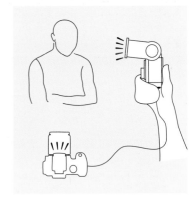

A SIMPLE HOME STUDIO

Explore expressive lighting arrangements by positioning the camera, subject and lighting in different relationships to each other. Asking your subjects to lie on the floor is another creative approach in the wealth of visual possibilities that are open to you.

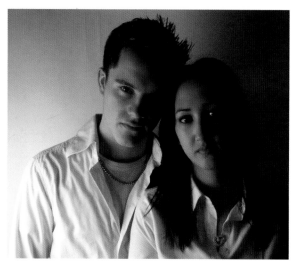

This studio quality photograph was shot with a regular tungsten light in front of a large sheet of paper.

Using a back cloth, lamps and a tripod, you can begin to explore many of the possibilities of professional studio photography. The studio arrangement helps you to control two key aspects of photography: the lighting and the surroundings. When you place your subject with a simple drape or length of paper suspended behind them to act as a visual foil, you have eliminated any distracting background detail. In terms of lighting, you can use lamps from around the house. Lamps that can be angled like reading lamps, are ideal, as are lamps that extend up or down. Hardware stores sell simple lamps on a cord with a clip that can be attached to furniture or to a stand. You can also rely on natural light, or a combination of the two. A lamp near your scene will soften shadows cast by the window light. This technique produces subtle differences in color temperature, as the artificial light will read as warm in tone and the daylight, by comparison, will be much cooler. Lighting candles will also create a very dramatic and warm light, especially when they are held by or placed close to your model.

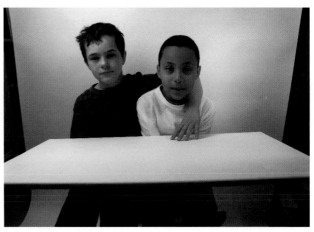

You can use any light surface as a reflector to bounce the light and eliminate the shadows in your scene.

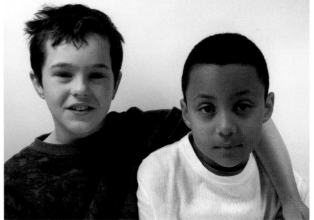

A studio can be a very simple, temporary arrangement of lamps with a roll of paper from the art store or a few additional drapes.

Here you can see the way in which the reflector has lightened the shadows and softened the contrast.

Your digital camera has built-in white balance, so you can use any household lamp and the camera will translate the color cast to daylight balanced light. The advantage of buying photographic lamps is their adjustable height. You can also attach umbrellas and lightboxes to soften the light, or use a screen of tracing paper to soften lamp light.

CLASSIC STUDIO LIGHTING ARRANGEMENTS

A classic studio-lighting effect is to reduce the ambient lighting and work solely with controlled artificial lighting. By positioning a primary light to illuminate the subject and then using reflectors to bounce the light back into the shadows, or by using secondary lights you can soften or eliminate the shadows.

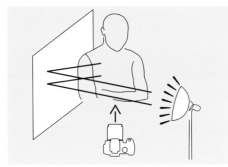

A single light source with a reflector bounces the light into the shadows.

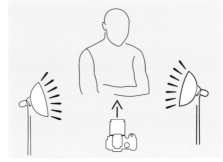

A second lamp at a distance softens the effect of the nearer lamp.

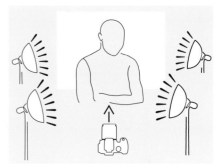

Two lamps focused on the background will eliminate cast shadows.

COMPOSITION

COMPOSITIONAL VARIATIONS

What is composition? It is the art of arrangement and positioning, creating an active relationship between the photographer and subject. Since the format of both the camera viewer and the paper you will print on are rectangular, you will use this rectangle to "frame" the subject. This rectangle usually conforms to the proportions of the Golden Section, and is pleasing to the eye. You can compose the picture so that the subject sits in harmony with this rectangle, or angle the shot so that it is in dynamic tension with the frame. The positioning of the subject within the frame will radically change the expressive character of a shot.

TRIANGLES

Many compositions will contain a triangular structure. This is most frequently caused in landscapes and interiors by the effect of perspective, which is where parallel lines converge into the distance.

These converging lines draw the eye into the composition. The other common appearance of the triangular structure will be in portraiture, where the head will form the natural apex of a triangle.

Triangles with their base on the bottom of the composition create stability.

Triangles running from the sides create dramatic interventions.

DIAGONALS

Diagonal lines in an image create the most dramatic effect in a composition: while lines that run parallel to the sides of the photograph echo the stable rectangular form, diagonals break from this stability, sending the eye shooting across the image.

This can create a chaotic fragmentation of the composition, but when used well, these lines lead the eye around the full image. By photographing a subject at an angle, you can introduce diagonal movements to energize an otherwise mundane subject.

The eye is taken on a journey around this composition from the psychological point-of-focus of the child's hand, through the line of the receding pond and back through the diagonal of the model boat's sail.

Diagonal lines intersect and divide the composition into a series of tessellated triangles, which add visual interest to an otherwise limited compositional theme.

With digital-editing software, it is possible to copy and flip images over and join them together as mirror images. This image was mirrored horizontally and then vertically to create the illusion of a lake.

This image is based on spatial and psychological tension. Although there is no actual diagonal line in the composition, there is a diagonal line of interest between the foreground figure and the distant figure.

Symmetry heightens the sense of cropping and proportion. The blue of the sky is a double square, echoing the rectangles of the windows.

This composition is all about division into positive and negative shapes. Notice the silhouetted figure breaking into the geometric shape of the sky.

Although photographs taken in a vertical format may feel constricted, the format also makes them more dynamic, as seen in these images. Conversely, images taken in horizontal formats are generally more stable and calm.

RULES OF COMPOSITION

In a successful photographic composition, you will have compelling visual qualities that hold your attention. **Harmony:** all the pictorial elements that make up the composition will work well together. The composition will be balanced, and the image will harmonize as a whole. **Dynamic arrangement:** a strong composition will also have something surprising and alive in the image. The composition will incorporate dynamic elements that add tension and contrast to the image. **Positioning:** where you position the subject in the frame will determine the expressive character of the composition. **Framing:** when you compose an image in the camera viewer, you are framing and cropping the scene, creating new shapes. These shapes will have proportions, creating movement and forming the geometry of the composition. On these pages, we will look at some basic rules of composition that you can apply in combination to achieve harmonious and dynamic compositions.

This composition combines several principles of composition, exploiting visual tensions that bring an image to life. Themes are being created between psychological focus, geometry and proportion, color and tone, positive and negative shape, rhythms and movement.

POINT OF FOCUS

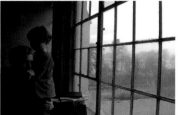

Wherever you place a person in a composition, they will be the psychological focus, even if they are not the largest or most striking part of the composition. You can create a dynamic tension between the visual and psychological focus by moving the figure away from the obvious center point of the image.

POSITIVE AND NEGATIVE

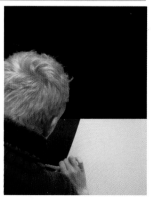

When you frame a composition, consider how you crop the scene to create dynamic and visually active negative shapes.

RULE OF THIRDS

Some cameras offer a display setting that divides the viewer or LED screen into thirds, both across and down the image. Dividing the composition in proportions of thirds, relates to the aesthetic device of the Golden Section, creating a far more interesting and dynamic balance of shapes. Remember: this is a general principle that you can explore, not a rule that has to be followed rigidly.

COUNTER BALANCE

Position your subject in the camera viewer to arrange the shapes in the scene to either harmonize or contrast with the rectangular frame. The horizontal and vertical lines in the scene will echo the sides of the frame, creating stability. The diagonal and curved lines will create a dynamic movement, forming a counter balance between stability and movement.

COMPLEMENTARY COLORS

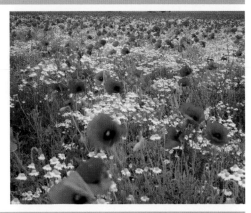

Complementary colors are the warm and cool color parings of red and green, orange and blue, yellow and violet. When you place these pairs next to each other in a composition, they will both energize and create points of focus in the composition. You can use either the dramatic contrast of fully saturated color, as seen in the red and green of the flowers, or a more subtle contrast, as in the warm tones of the face set against the blue background.

RHYTHM

Repetitive lines in a scene create a rhythm or movement that leads the eye through the composition. Vertical and horizontal lines create a sense of division, proportion and order, while curved and diagonal lines create movement in a composition. The eye will follow the rhythm of these lines as they echo each other throughout the composition.

TEXTURE

Both the natural and the man-made world are alive with the most phenomenal diversity of textures for you to enjoy and explore. Textures are mostly composed of raised surfaces that catch the light, making a pattern of light and shadow. If you concentrate on texture for a few photographic sessions, you will increase your appreciation of this quality. With your new found awareness of these details of form, you will find yourself consciously composing to include texture to add interest and expression to your photographs.

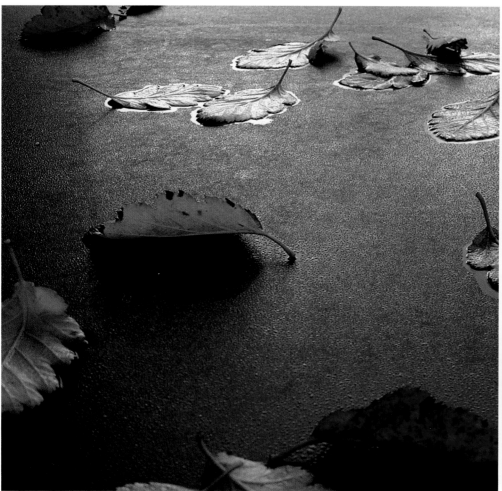

It is when the light is catching the surface of forms that the texture is really seen most sharply, as in this image of autumn leaves resting in the beads of dew on a car roof.

SENSORY AND TACTILE TEXTURE

Although photography is essentially a visual art, images that capture the texture of the subject make the photograph come alive to your other senses. For example, when viewing a picture of a cactus, you can *feel* the "ouch" of it without touching it. All of your senses connect to each other, and the visual arts trigger relative readings based on your experiences and memory. That is why sharp shapes are often associated with pain or surprise, and soft shapes are correlated with smoothness and pleasure. By incorporating certain textures in your composition, you can trigger the viewer's imagination, thereby manipulating their emotions.

To exploit the properties of texture in a landscape, you may need to wait until the light is strong enough, or at an angle that will catch the surface texture.

COMPOSITION: LIGHT AND FORM

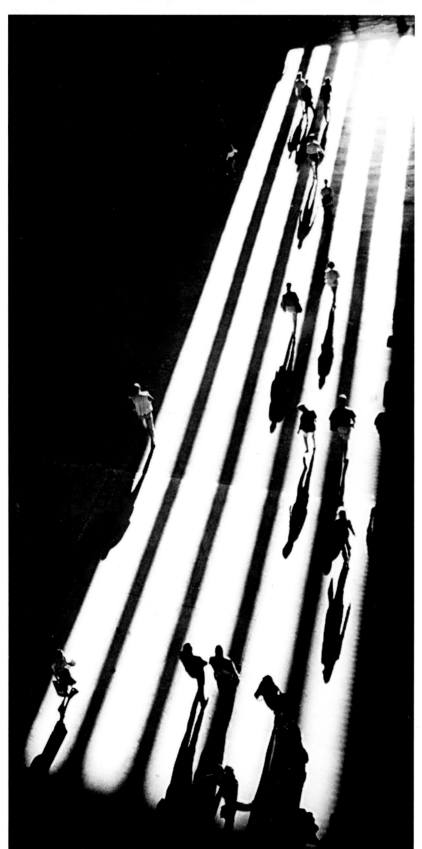

The light falling into a scene will be the single most powerful influence on the expressive feeling of a composition. The strength and direction of the light will determine how the forms are illuminated and reveal the subject in a distinctive way. You may hear critics saying,"The photographer has a *sculptural* sense of form," or "She has a *painterly* sense of light and color". This is because form is sculptural and color is painterly. Visual artists, including photographers, usually fall into one camp or the other. While the ideal is to be able to make an image work on levels of both form and color, it is much more common for an artist to tend to focus on one quality of an image. To determine which camp you are in, simply look at your work.

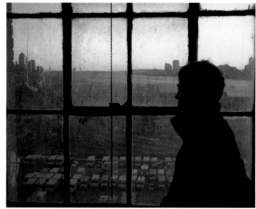

Backlighting, as in the image above, will diminish the detail of the subject, turning the form to silhouette.

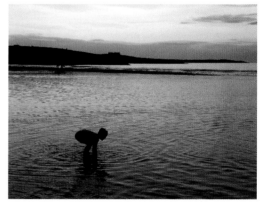

Here the light is low on the horizon, creating shadows behind the ripples on the water that echo throughout the composition. The form is also thrown into silhouette.

When a scene is lit at an angle, as in the one at left, the color will be diminished, but the sense of the form will be heightened, making the composition feel sculptural.

LIGHT REVEALS FORM

Light can either reveal or obliterate the detail in a form, depending on the strength of the light falling on a form. Either extreme of very low light or very bright light will reduce the detail in the shadows and the highlights. Surfaces on a form are referred to as planes by photographers and artists. The planes that face towards the light will have a similar brightness as will the planes in the shadows.

LIGHT OBSCURES FORM

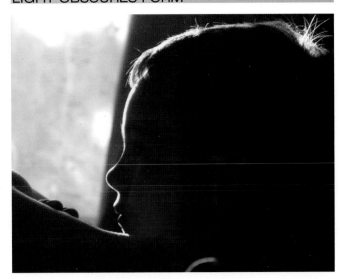

All the surfaces of the forms facing the light will be illuminated, and as the form turns away from the light, the form will turn into shadow. There is an edge along the form where the light turns to shadow and this can be very dramatic in strong lighting. This edge of transition between light and shadow is one of maximum tonal contrast in the image, which makes it the focal point.

MONOCHROME COMPOSITIONS

Your camera may have a setting which allows you to photograph in monochrome—that is, black-and-white photography. This is well worth exploring for many reasons, not the least of which is that it can help you appreciate the difference between color and form. If you take several shots switching from black and white to color, you will see their relationship of color in a composition. Sometimes the color helps the reading of the form and sometimes the color will be arbitrary and distract from the form. Reduced color tends to encourage spatial readings. This is why black-and-white photography is more like sculpture than it is like a painting. Another way to see this concept at work is to select **Color** from the filters menu and reduce the **Saturation** in increments.

COLOR THEORY

If form gives an image meaning, color gives it vitality. Colors can create harmony or dissonance in an image, functioning as a unifying theme or adding energy—making the eye jump from color to color. Strong color contrasts attract our attention and are useful as focal points, while subtle colors create mood and atmosphere. Because color can dramatically alter the expressive properties of an image, it is important to understand how color works.

Color Wheel

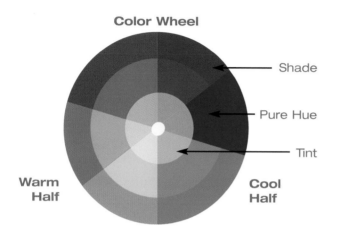

Shade

Pure Hue

Tint

Warm Half

Cool Half

Brightness Values

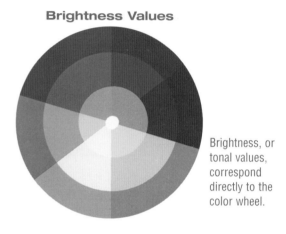

Brightness, or tonal values, correspond directly to the color wheel.

THE COLOR WHEEL

When you compose a scene in color, there are many different ways that you can create color harmonies. It helps to use the traditional structure of the color wheel to understand color relationships. One side of the wheel is cool: blue, green and violet. The other side is warm: yellow, orange and red. Each color has an opposite, or complementary color. Green is the opposite of red, blue is theopposite of orange, etc. Pairing complementary colors creates vibrancy and harmony. Within the hues are tints and shades. For instance, a shade of red is maroon, while a tint of red is pink.

THE LANGUAGE OF COLOR

Color has three key attributes: Hue, Brightness and Saturation. **Hue** is simply how you describe the the color on the spectrum, (i.e., red, green, or orange). **Brightness** refers to the tone of a color, whether it is light or dark. A tone towards black is known as a *shade*, while a tone towards white is known as a *tint*. Grouping tints and shades in a photograph creates unity. **Saturation** refers to the intensity of the hue. A fully-saturated hue is pure and undiluted. A de-saturated hue moves towards gray, as if mixed with its complementary color, (i.e., red in shadow will appear greener).

Photographed in color, the flowers reflect the hue value. Here you can see how the complementary colors yellow and violet work together in nature.

Photographed in black and white, the flowers illustrate brightness, or tonal values. Each color falls on the scale from white, through gray, to black.

HARMONY OF HUE

In the photo on the left, the predominant range of hues is in the warm half of the color wheel. Red and yellow mixed together make orange, which unites them in a family of hues. Each of these colors is also present as shades and tints.

On the right, the same family of colors is punctuated by notes of the yellow's complementary hue—violet.

HARMONY OF SATURATION

The photo on the left is composed of the strident complementary pair of orange and blue. This creates vibrant contrast. They are, however, linked by their similar intensity of saturation.

In the photograph on the right, the hues are complementary—violet and yellow, but are linked by their equal de-saturation to tints in the light and shades in the shadows.

HARMONY OF TONE

In the image on the left, (which is actually a red car roof), you will see that there is a harmony of tints and shades of red. The red also moves from a warm orange red to a cooler violet red.

The image on the right is a similar monochromatic harmony of variations of warm and cool yellows punctuated by the dark branches.

COMPOSITION AND COLOR

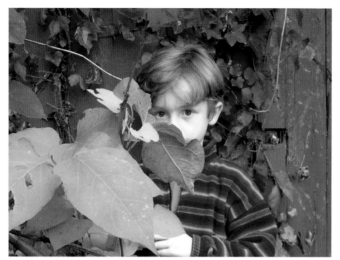

The complementary pairs of red/green and orange/blue dominate.

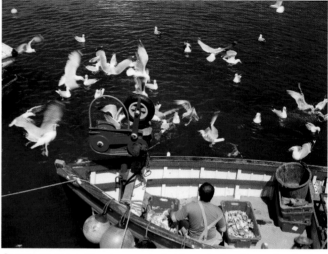

Complementary colors are punctuated by a single yellow note of color.

Don't think of black as just shadow; black is also a color note.

This composition is all de-saturated from the single yellow bright leaf.

A dominant blue is punctuated by a flash of complementary orange.

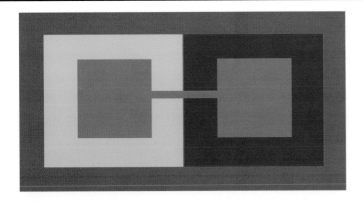

COLOR ALCHEMY

Have you ever noticed how some colors look great alone but awful next to another color, or vice versa? The secret lies in how colors interact. For example, a de-saturated yellow will look even more sad and dull when placed next to lemon yellow, but will look vibrant and vivid if put next to a dark purple. The same effects apply to all colors. If you surround a color with a darker color, the original color will appear more brilliant. Alternatively, when you surround a color with a brighter color, the original color will appear dulled. The same principle applies to color saturation—if a color is surrounded by a more saturated color, the original color will seem less saturated, and if a color is surrounded by a less saturated color, the original color will seem more saturated.

DE-SATURATING COLOR

Light and color are bound in a poetic and profound relationship. All of the colors of the spectrum are held in white light, only they are invisible to the eye until broken, as in a prism or a rainbow. When white light falls on a colored surface, all the colors of the spectrum are absorbed except the color that is present on the surface. For example, a red surface reflects its red wavelength. However, as that red surface turns away from the light, it will become de-saturated of red and appear as though it is being mixed with its complementary color of green.

ADDITIVE AND SUBTRACTIVE COLOR

When you print an image, the colors are mixed together by the printer, which adds spots of red, yellow, blue and black to create the tones in the image. This is called **Subtractive Color** because the more colors you mix, the less light is generated by the color. When you look at colors on your computer monitor, you are looking at colored light. With colored light, when you add all the colors together, you get pure white, hence the term **Additive Color**. Additive color is made up of three primaries: red, green, and blue. [Learn more about additive color on pp 146–147].

IN YOUR SOFTWARE
Digital image-editing software allows you to increase or decrease the saturation of the colors, remove or even replace colors with remarkable ease, giving you an unprecedented level of control over color.

SQUINT TO SEE COLOR
Wherever light falls, it creates a unity of similar degrees of brightness and saturation in color. If you squint your eyes at a scene so as to eliminate the detail, you will see this unifying effect at work!

IN YOUR CAMERA
The **Color Variations** setting in your camera's menu allows you to heighten or reduce the saturation of the colors in your composition.

SPATIAL COMPOSITION

When an image has more than one form, you need to think about spatial relationships between the forms. You can create different combinations of spatial relationships by the way you position your camera to frame something of interest. By angling the shot, you can heighten and amplify the sense of the spatial relationships in your composition as well as your own spatial relationship to your subject.

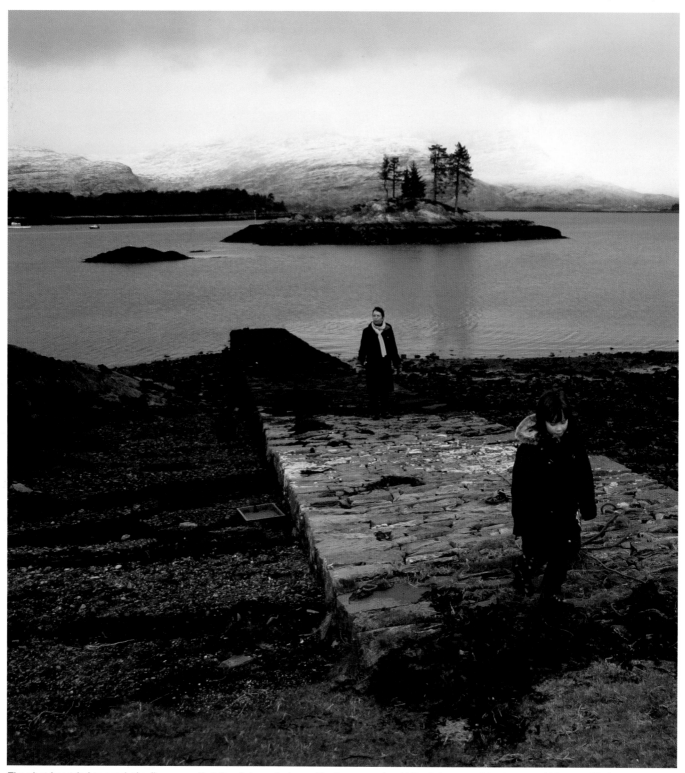

The shot has tried to catch the figures so that the distance between the foreground, middle distance and horizon would be amplified.

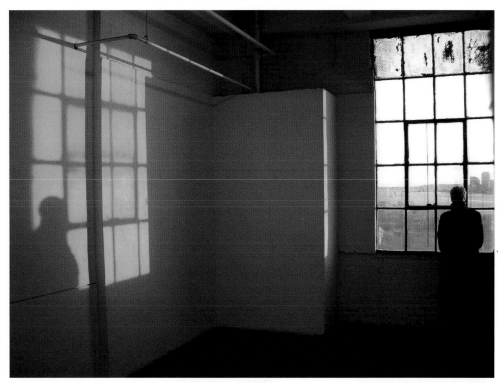

The light projects the subject's shadow, creating a spatial echo.

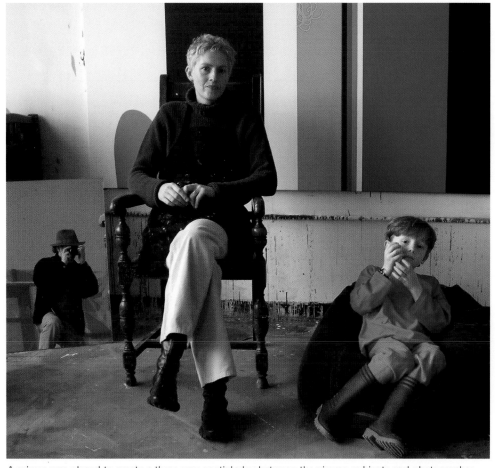

A mirror was placed to create a three-way spatial play between the viewer, subjects and photographer.

FOREGROUND, MIDDLE DISTANCE AND BACKGROUND

Think of a composition as consisting of a foreground, middle distance and background. You can alter the spatial emphasis of the composition based on where the main subject is positioned.

LATERAL ANGLING

Instead of moving your subject, altering the angle you photograph from will affect the spatial alignment of your form.

EMOTIONAL EXPRESSION

You can express emotional relationships between people, such as intimacy, estrangement or longing, based on where you situate them in your composition.

VERTICAL ANGLING

The height at which a scene is captured dramatically affects the spatial alignment of the composition. Explore how shifting the vertical view affects the spatial relationship between the forms by photographing with your camera at waist height or holding the camera above your head.

SWIVELING LCD

Some cameras have an LCD monitor that swivels, helping you compose a shot that is at an extreme angle either near the ground or held high.

COMPOSITION: SETTINGS

The setting you choose will dominate the mood of the photograph. Develop your eye by thinking about all of the possible ways in which you can frame the subject against different backgrounds. Moving a subject from one background to another will completely transform the atmosphere and visual theme of a composition. Although you can construct a setting in a studio, selecting a scene from your immediate surroundings often creates the most powerful image. You can also try simply shifting your point of view to provide a different background, as in the example below of the flowers, entirely recomposing your photograph.

Image shot from above has a dark background.

Image shot from below has a light background.

INFORMAL SETTINGS

Compose in steps. While photographing people, first choose the setting, then consider your lighting. Choose your angle of view, frame the composition and then settle into catching the posture and expression of your subject.

Diverse textures, patterns and color combinations make a successful setting.

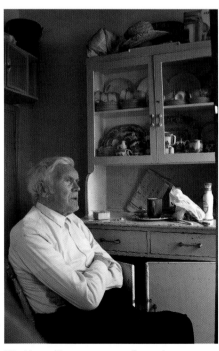

Working with your surroundings gives you more choices than you might imagine.

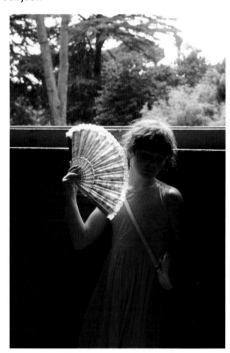

Try following your subject around the house and you will find a variety of settings.

URBAN SETTINGS / ENVIRONMENTS

Try different settings from natural to man-made. Urban environments offer very exciting backgrounds.

These colorful patterns and vibrant colors make a powerful setting for the form of a figure.

Take your subject on a walk and put them against different backgrounds.

Use your imagination and keep your eyes peeled for interesting settings.

Giving your subject something to hold will put her at ease.

CREATING SETTINGS

Show your subject's best features by creating a visual theme. You can approach your environment like a studio. Arrange your subject in appropriate lighting against a neutral or complementary background. Consider using a few props that add color and texture, creating contrast and adding interest to the shot.

CREATING THE MOMENT

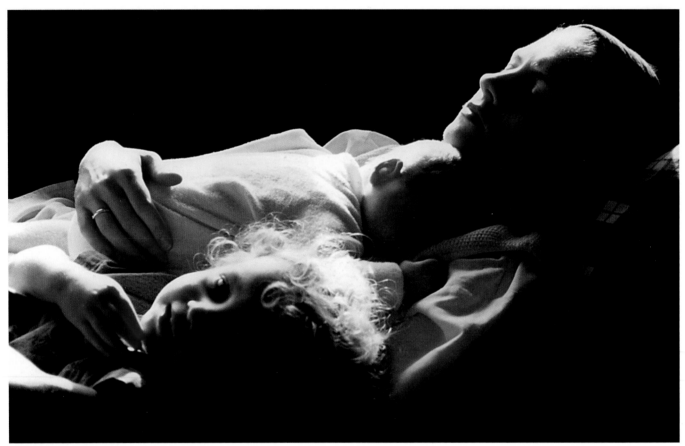

By carefully selecting settings and lighting, you can create both contrast and harmony in the composition. Choose a setting with a color and tonal range that complement the skin complexion of your subject.

The child was arranged with her favorite stuffed animals set on a black cloth and the image was shot from above.

A portrait can take on a dynamic presence when set against an abstract play of shapes.

FORMAL SETTINGS

This image works because of the discreet formality of the arrangement. You can use subtle relationships, such as between the texturing of the model's top, dried flowers and the mirror edge set against a uniform color background.

By setting a formal pose and using a patterned sheet, you can evoke a particular era or culture, such as Victoriana.

MINIMAL PROPS

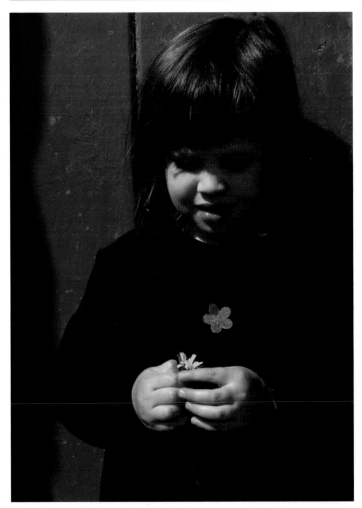

Sometimes a simple prop of a small object such as bright flower or a toy will prompt a visual color theme.

Use props to create a visual foil to the subject, as in the contrast of the patterned textile and sitter.

SPONTANEOUS PEOPLE

While there are occasions when you will want to create a formally contrived arrangement by posing your subject in a directed way, another successful strategy is to photograph your subject unobtrusively. You can catch some intimate and expressive shots just by observing life in action with the camera ready. Explore capturing the face at rest and in quiet moments. You can also create your own scenarios and photograph your subject's expressions as they evolve out of a situation.

Children epitomize spontaneous expression, as they readily express their surprise and delight without inhibition.

In portrait composition, your challenge is to be responsive and not controlling. People spontaneously create wonderfully expressive compositions when they are communicating with each other or when engaged in play. Watch how people use their eyes and gesture with their hands when they are together. The creative challenge for you is to be attentive to the mood and expression of your subject or subjects, and to respond to the moment. Try not to be inhibited. Keep shooting until you have caught your subject's essential expression.

The camera can be obtrusive and cause the subject to freeze. Observe your subject in quiet reflection without calling attention to the camera.

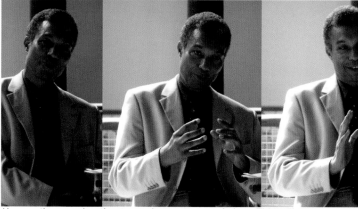

Use continuous shooting to catch a sequence of shots This will create

STUDY OF THE MOVEMENT OF HANDS

Hands are a subject in themselves as they can often say more than the face about a subject's frame of mind. Watch how people use their hands to express their emotions involuntarily. Gestures can form an elegant and balletic sequence of movements and add to the intensity of expression in a photograph. Take time to make a study of the hands of someone with whom you are intimate.

DOUBLE PORTRAITS

If you think of the definition of a couple as two individuals who are close to each other, you then realize there are as many kinds of couples as there are individuals. A couple is really defined by their relationship. This is the challenge of the double portrait: to make an expressive photograph in celebration of the unique relationship between two individuals.

The most expressive images of friends are often when their attention is focused on each other. In the initial shots at least, encourage your subjects to relate to one another. This also makes the shoot more fun for them.

Encourage your subjects to arrange themselves into a comfortable position. They may very naturally fall into a pose that gives full expression to the depth of their relationship.

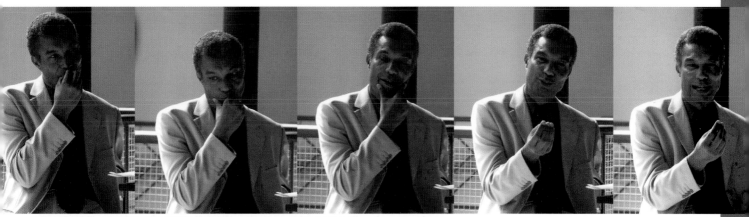

an illuminating narrative, eloquently illustrating the expressive personality of your subject.

CLOSE-UP PORTRAITURE

Portrait photography is about capturing the unique qualities of your subject's individual character. If you examine your best images of people, you will see that they carry and express a high level of attentiveness to the details of an individual's posture and expression. It is the quality of detail and timing that makes portrait photography so compelling. There is an unspoken level of communication illustrated by the details of a good photograph. It is important to give yourself enough time to see these moments, to settle into composing the subject within the frame, and to stay with the subject for long enough to record their full range of expressions. Sometimes you can capture the character of your subject in a couple of shots, but you will probably need to take a succession of photographs over a period of time. It can take several shots before you begin to see the possibilities, and also before your subject relaxes and loses their initial self-consciousness. Very often you will find that the last images in a long series of shots capture the subject in their most natural and expressive state. Always be ready for one more photograph.

Above: Let go of the belief that if you haven't got someone's face fully in the frame, it isn't a good record of them. An enormous amount of expression is held just in a person's posture. You don't need to see all of a person's face to read the complexities of their attitude.

Top: When you are taking a frontal portrait, focus the lens carefully on the eyes, as they will form the natural focal point of the photograph.

TURN OFF SHUTTER SOUND

In a photo shoot, the sound of the shutter can add to the tension, making the sitter more self-conscious. In **Settings**, you can turn the sound off.

Vary the angle of your shots and you will become aware of the most expressive view of the pose.

Move in close and explore all the different possibilities of arranging your subject in the frame.

Don't use wide-angle in close-up. Shoot at a slight angle to avoid exaggerating the features.

Don't be scared to crop right into the face, as this will focus attention on the eyes, which always adds intensity to the image.

To get the most expressive shots in close-up portrait work, you need a few strategies to get your subjects to relax. Encourage them to communicate either with each other, with you, or with someone you have enlisted off-camera.

GROUP PHOTOGRAPHY

Group shots are the most challenging of all the forms of portrait photography. You must organize people of different temperament, gain the attention of each member and manage them into a pleasing arrangement. At the same time, you need to think about the setting, lighting, framing and focusing of the shot. Try to be both assertive and responsive to the possibilities created by the group dynamics.

Organizing group shots can feel like herding cattle, as people's attention wanders.

Be prepared to fire off a number of shots quickly so that you have a better chance at getting everyone at their best.

SETTING UP A GROUP SHOT

Encourage your group to take poses that feel natural to them. You can have some standing or sitting or kneeling. Children can sit on the floor or on someone's lap. Bring the group as close together as possible without blocking your view of anyone. Try to arrange the group to fill the frame—avoid having them in a uniform line. Also, bear in mind that with the digital-imaging software, you can also use the **Crop Tool** and create oval or round compositions.

TRICKS OF THE TRADE

CHOOSING THE RIGHT SETTING

While setting up a group shot, choose a setting with a suitable background and lighting. Look at the possibilities of both indoors and outdoor settings to attractively frame the composition. It is a good idea to choose a setting where the group can feel the most comfortable and relaxed—like in their home, yard, or their usual meeting place.

MOVE AROUND AND GET COMFORTABLE

Unless you want a very formal shot, get your group to move around. Encourage them to use the space to get comfortable. They may surprise you with expressive arrangements, so be open to the possibilities created by the dynamics of the people in the group.

PREPARATION IS KEY TO GETTING THE SHOT

It is important to be prepared so that you can start shooting immediately. Set up the camera and the tripod, take a light reading and plan the arrangement before you pose the group. Be as efficient as possible. If the shot goes too long, people begin to get bored and restless.

ENLISTING SOME OUTSIDE HELP

if it doesn't suit your temperament to make everyone look at the camera, enlist an extrovert to hold the group's attention while you focus on the composition and taking the shots. This can be particularly helpful when photographing children.

PHOTO ESSAYS

When you begin to put photos together, you are constructing a photo essay. As little as three or four carefully selected frames can depict the essential moments of an occasion or event. Taking a photographic sequence of shots is a method of telling a story visually. The key is to try to catch the action as it unfolds. Many events naturally form a photo essay. A wedding is a classic example of a long narrative unfolding throughout the day. Equally, a photo essay can be as brief as someone expressing apprehension, surprise and then delight while opening a gift. The prolific number of shots available in digital photography allows you to really explore this format without inhibition.

When the professional photographer has finished, ask if you can take a few shots while people are still posed.

In an interesting photo essay, you can alternate between formal and informal.

Prepare your camera and flash so that you can catch the moment.

Your less formal shots may feel more happy and relaxed.

Shoot from different angles to catch the celebrations as they unfold.

A CLASSIC DIGITAL WEDDING

Creating a photo essay from a wedding can be very challenging: it is usually comprised of a string of events running over a very full day, and can be the cause of great anxiety for the photographer, who does not want to disappoint the couple. This is where digital photography is a real benefit; with enough memory and battery power, you can shoot hundreds of shots to ensure that you have fully covered the event. You can also review your images as you shoot, resetting an unsatisfactory composition until you have caught the couple looking at their best. If you download the images to a laptop at intervals as you go through the day, you know the images are safely stored.

THE COMPLETE PICTURE

You can complement the formal shots of the professional wedding photographer with shots taken of all related events: bachelor parties and bridal showers, preparations at the house, the rehearsal dinner, speeches, gift giving, dancing and extended family meetings. All of these special moments need photographing after the professional photographer has finished their work of photographing the formal shots.

COLLECTING GREAT SHOTS

Make a list of shots to take, as well as who and what the bride and groom will want photographed. Assess the best vantage points to take discreet shots. Do some pre-focusing and pre-exposure setting so that you can catch those key moments, such as the archetypal images of the bride and groom exiting the ceremony. There are some lovely informal moments to catch while everyone is waiting for the formal shots, such as the surprise and joy between old acquaintances reunited. Finally, photograph the rest of the event after the bride and groom have left, as they will want to see how the evening ended.

PHOTO ESSAYS

Stories always have an order, whether it is thematic or chronological. We are used to seeing pictures displayed in a line or a collage. A grouped arrangement is a simple but powerful format that allows you to see all of the elements of the story at the same time. A successful approach to editing a photo essay is by discarding the uninteresting and imprinting the memorable images. Some tips: Use cropping to remove unwanted areas of the image and focus attention on the key dramatic elements of the image. Using the **Continuous-Shooting** mode on your camera, you can create narratives that unfold over seconds. Alternatively, you can stretch out a narrative over hours, days or weeks by photographing a subject over time.

THE WORLD AROUND US

Thinking compositionally helps you to see opportunities for interesting or beautiful photographs wherever you go. If you carry a digital camera, you will be amazed at the number of interesting compositions you will find. This is one of the great delights of digital photography: freed from the worries of waste and expense, you are able to explore endless possibilities of composition. You will find yourself looking through the eye of the camera viewer, framing the world around you into compositions. Having a camera for company encourages a kind of creative detachment where you are able to step back and see the world for the extraordinary place that it is, full of surprise and beauty. The camera provides us with the the means to articulate the depth of our potential for empathy and poetic interpretation. The images you take of the world around you will complement your family photographs and be a fascinating document for the next generation.

RESPECT FOR YOUR SUBJECT

The camera is a provocative tool. In some cultures, the camera was originally feared as a magical box that stole something of your soul and held it in the image. Whenever possible, one should try to ask permission before taking a picture. If you are traveling and lack the language to ask, simply point to the camera and smile. You will quickly see whether or not a person is willing to grant permission.

In this picture, I smiled at the girl and her mother, and they in turn smiled back at me, which granted me permission for the shot.

One of the great advantages of digital is that you can show your subject the shot and if they don't approve, you can delete it.

By opening your eyes to the world around you, you will see poignant scenes that ask to be photographed.

You will find many incongruous and amusing juxtapositions of imagery that cause you to do a double-take.

THEATRE OF THE ABSURD

A subject displaced by time and space creates surreal imagery.

In the city, the virtual is juxtaposed with the real.

A confusion of scale causes a double-take.

The sacred and profane meet in the market.

What is normal in one context is absurd in another.

A surreal image created by cropping and timing.

PHOTOGRAPHING FOR COMPOSITE IMAGES

When you download and view the images at full size on the computer, it is then that you can see all of the details of expression and fully assess the quality of the composition. It frequently happens that you have a really important photograph or potentially great composition, but you can see that it needs major editing. The software will let you fix most things that can go wrong in a photograph, but for certain kinds of editing, you will need to have extra images of your scene. This might be when you need to change the background or replace a figure. Then you think, "I wish I had taken just one more shot." When photographing on these occasions, it's best to think in terms of worst-case scenario and take extra shots as a fail-safe measure. All this may seem a little excessive, but there will be times when you will grateful that you took enough permutations to make a composite image.

BEFORE: Although set against a poor background, the children struck an interesting combination of poses, but the grandmother and young child were distracted.

AFTER: The image of the children was superimposed by an image of the grandmother with child lifted from a different photograph and then the combined images were pasted onto another background.

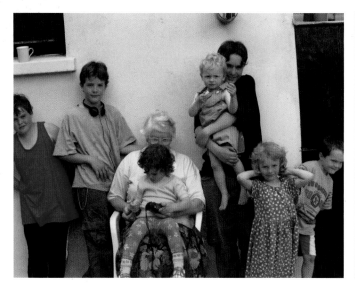

These variations of the same scene had attractive elements in the composition, but were rejected as a whole. However, note that the grandmother with child in the image on the right are in the most expressive pose. This image was lifted to the first image to make the composite.

The grandmother with child were carefully extracted using the selection tools and pasted into the second image. [For the digital-editing method, see pp 180–181].

A NEW APPROACH TO PICTURE-TAKING

The way you take photographs will be influenced by your knowledge of what you can do to an image in the digital-editing software. So often in film-based photography, a really good composition is spoiled by some small distracting detail, or maybe a passing car entering the picture just at the wrong time. Now you can photograph digitally, knowing that a partially pleasing or promising scene can be adjusted to make a completely unified composition. You will also find yourself photographing objects, people and scenes with the idea of putting them together in the software later.

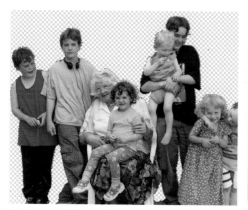

The image of the children was carefully erased across all of the background to remove the unsympathetic setting and then pasted into a more appealing landscape setting [see pp 174–175].

Using the digital-editing software, you can explore endless permutations of combining images.

GROUP MANAGEMENT

The quality of the photograph will largely depend on your ability to organize the group. There is a fine balance between sustaining the group's attention and getting them to focus on the camera while encouraging them to be natural and relaxed. You must also arrange the group to form a visually pleasing or interesting composition. Start with small group shots, as these are more manageable and intimate.

A COMMON SCENARIO

A really common situation is a rare gathering of relatives brought together for a family photograph in which one member inevitably is caught in an unflattering pose. It would be hurtful and embarrassing to distribute this much-wanted group shot when one member will be upset with how they look for posterity.

TAKE EXTRA SHOTS

To give yourself the best possible chance of getting all of the imagery you may need, you can vary your angle of view and take shots from different positions. This allows you to select not just the shots with the best expressions, but also the shot with the most pleasing relation to the setting.

A NO-PEOPLE SHOT

Take a shot of the scene without people, so that you have a spare background in case you later decide to delete people or move them around. As you remove anything from a scene, you create of a hole in the image. If you have a spare background shot set in a layer behind the image you are editing, as you cut away a figure, the background layer will show through.

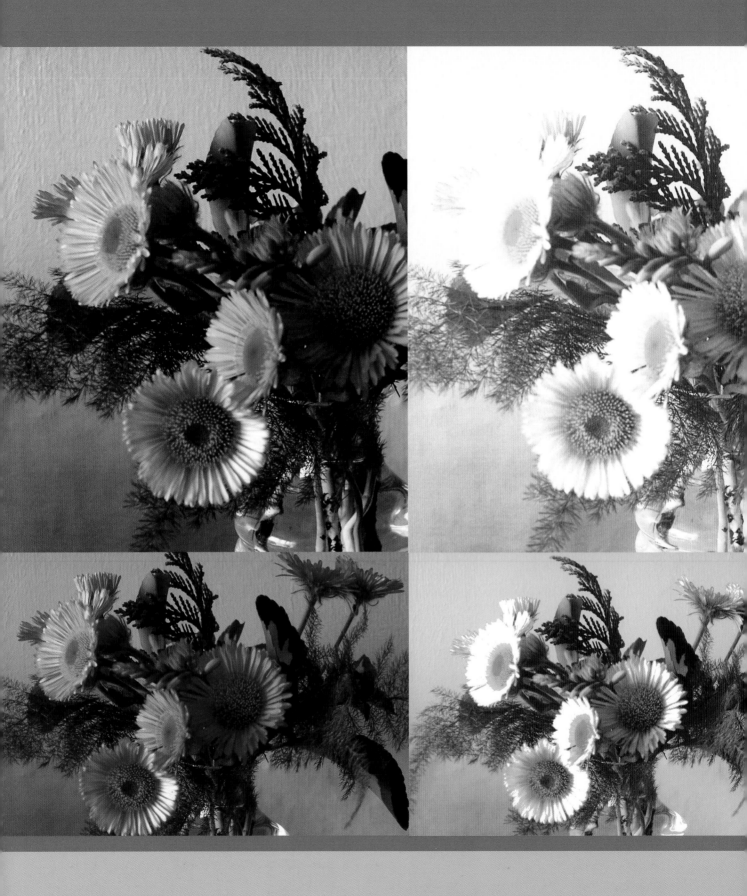

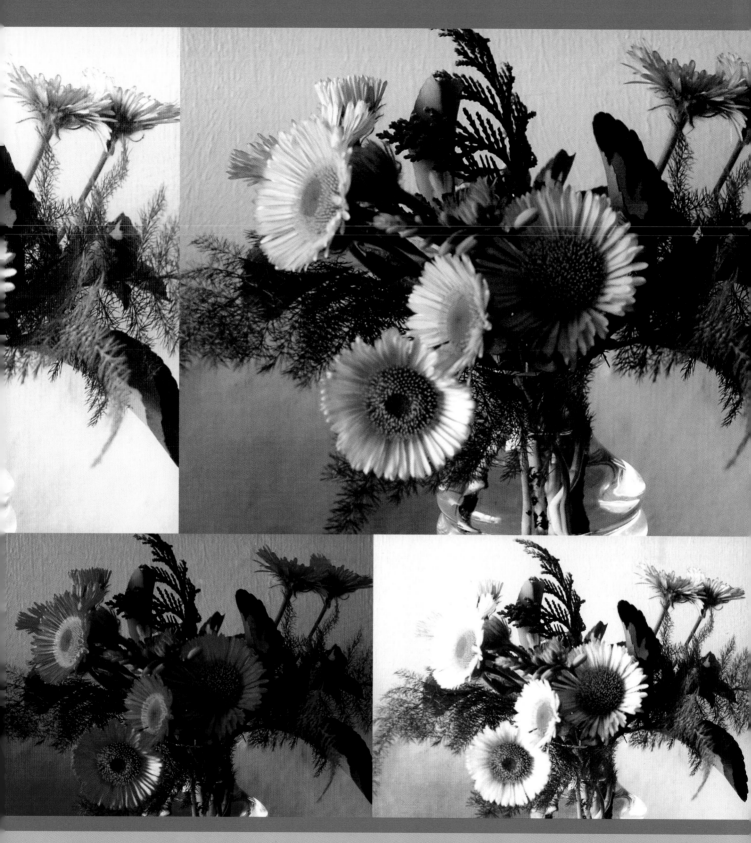

FIXING YOUR IMAGES

YOUR COMPUTER AND SOFTWARE

Image-editing software is the program that you install to your hard drive and use to edit your photographs on the computer. There are a range of programs produced by different software manufacturers aimed at either PC and/or Mac computers and at different levels of complexity, from basic edits through to professional photographic editing and graphic design.

TYPES OF IMAGE-EDITING SOFTWARE
While there are many customized software systems that come with camera makes, there are essentially four main types of image-editing software.

CAMERA-DESIGNATED SOFTWARE
First, there is designated software that is specifically designed for a particular make of camera and this software will allow you to download images from only that camera make. It will help you organize the images into folders, do basic image editing and then print the images. It may also allow you to edit the high resolution raw images, which would be the main reason for retaining this software on the computer.

PROFESSIONAL IMAGE-EDITING SOFTWARE
The second type of software is specialized professional image editing software that you buy separately. It works with images downloaded from all camera makes, as well as images imported to your pc by a scanner. Of the professional quality photo-editing software Adobe Photoshop dominates the market. These software packages allow you to comprehensively edit your images on a professionally and creatively complex level, but are much more expensive.

POPULAR IMAGE-EDITING SOFTWARE
The third type of software are the professional quality software versions, such as Photoshop Elements. A modified version of the full program, it is, designed to be more user-friendly and affordable.

LIMITED-EDITION SOFTWARE
Finally, there are the limited-edition versions of the major software that come as free software bundles with equipment such as computers and printers. These have a limited use, but are a good way to try the software before committing to the full program.

CAMERA SOFTWARE FOR DOWNLOADING, SORTING AND BASIC EDITING OF IMAGES
When you buy a camera, you will get software bundled with the equipment. Once the software is installed, it will automatically download the images from your camera onto a file in the hard drive of your computer. The software will also help you to organize and save your images, allow you to make basic crops, alter brightness and make other alterations (such as removing red eye) and print your images. If you buy a printer, a scanner, or a computer, these will frequently be accompanied by software bundles that will also include image-editing software.

PHOTO MANAGEMENT SOFTWARE
You may want to use a program like Picasa in conjunction with Photoshop Elements for some of the other features these software offer. For instance, on Macintosh computers, Picasa will usually already be installed. This and other photo software is great for organizing and making a few basic edits. It imports your photographs and lets you organize and print individual or batches of images. It also lets you view your images in a picture show, which is a really great way to review and show your images without printing. You can then burn a file of images to a CD and send this to people. It also automatically formats images for printing albums and books, emailing, and putting images on the web.

WHAT IF I HAVE LEARNED TO USE ANOTHER SOFTWARE AND NOW I WANT TO USE PHOTOSHOP ELEMENTS?
You may well have installed image-editing software that has been bundled with your camera or printer software. This not a problem. The neat thing about digital photography and editing software is that there is a very high degree of overlap between how one camera and another works and between one software and another. So if you are using this software, it is fine, because you have begun the process of learning how to edit. Thankfully, there is a common use of design and what has emerged is a set of generic symbols for tools and many of the functions across all the different makes.

WHICH SOFTWARE SHOULD I USE IF I HAVE ALREADY INSTALLED CAMERA SOFTWARE?
If you have already installed camera software, unless you want to use the raw image facility, which is on the more advanced camera software, you are recommended to focus on Photoshop Elements if you have purchased or intend on purchasing this software. The reason for recommending this is that it gets confusing switching between camera and editing software. It is best to do all the processing in one software where possible, and Photoshop Elements will allow you to do all the essential processes of downloading images, sorting, reviewing, editing, printing, preparing for web, etc.

GETTING STARTED
Whichever software option you start with, you can begin the great pleasure of organizing, editing and sharing your images

with others. You will begin to discover the advantages of digital image-editing software—being able to create images with a depth of color that exceeds your processed photos, access your photographs within minutes, and create and store hundreds of images without expense. Once you have mastered the basics, you will want to explore some of the more advanced features of image-editing software's capacity to alter and refine images.

COLOR QUALITY

The quality of color is one of the most exciting features of digital photography. Digital photography has a vivid depth and saturation of color, both when viewed on the computer screen and in print. It is possible to edit and control color with an ease and precision that would be difficult, title consuming, and expensive in tradition- al film-based photographic processes. The computer-based soft- ware for editing images not only gives you the ability to edit in ways that are only available in a professional photographic color- printing studio, it also provides you with many possibilities of color manipulation that are impossible in film photography.

Initializing Plug-ins...

Version 4.0

© 1990-2005 Adobe Systems Incorporated. All rights reserved. Adobe, the Adobe logo and Photoshop are either registered trademarks of Adobe Systems Incorporated in the United States and/or other countries.

Protected by U.S. Patents 4837613, 5050103, 5146346, 5185818, 5200740, 5233336, 5237313, 5255357, 5546528, 5625711, 5634064, 5729637, 5737599, 5754873, 5781785, 5808623, 5819278, 5819301, 5832530, 5832531, 5835634, 5860074, 5870091, 5905506, 5929866, 5930831, 5943063, 5974198, 5995086, 5999649, 6023264, 6025850, 6028583, 6049339.

Adobe

PHOTOSHOP ELEMENTS

This book focuses on the use of Photoshop Elements for several important reasons: it is reasonably priced for what it offers, it has an amazing range of options from basic to advanced editing and works on both PC and Mac, which really covers most pho- tographers' needs. The great thing about Photoshop Elements is that once you have become familiar with all the possibilities in this software, it is a small step up to then use the full profes- sional photo suite in Photoshop 7 or CS, which is the most commonly used program in the business.

WHAT WILL IT LET ME DO?

The software allows you to make a host of precise alterations to your images. You can enhance, add, and delete to achieve a completely unified visual theme within a composition. You can also work creatively—transforming and montaging images, adding text or applying special color and texture effects. Once you have your images completed to your individual needs and taste, you can then format the image to print in stunning color from wallet to poster size, or view the images as a slide show. Then there is the possibility of organizing your images into albums, or onto a CD, or putting your images on the Internet— making a web gallery to show your friends and family. You can add images to an email or compose an image with text to make cards and invitations. The software really combines a darkroom and a graphic design studio with the additional facility of prepar- ing images for the web. In the coming sections, you will be methodically taken through all the essential skills so that you will understand and enjoy the enormous creative potential pre- sented by the software.

INSTALLING AND USING THE SOFTWARE

Installing is an uncomplicated procedure. The software comes as a CD that you install onto your hard drive. When you open the CD, it will give you instructions on how to install the soft- ware. You are required to restart your computer after the soft- ware has been installed. Once you have installed the software and opened it on the desktop, whether you are using a Mac or PC, the photo editing software is operated in almost identical commands. The minimal difference is that the Mac and PC keyboards are arranged a little differently and the command key has a different symbol.

PC OR MAC. WHAT'S THE DIFFERENCE?

Mac and PC have different operating systems. A few years ago, Mac had the major advantage of a more user-friendly system that used menu bars and drop-down windows. PCs were cheap- er but initially more difficult to navigate. Then Mac's system of visualizing folders was emulated by PCs. You can buy a basic PC for much less than a Mac, but the better PCs are comparable in price. The other key advantage of PCs is that they dominate the market—you can access support and purchase all peripher- als easily and usually for cheaper. The range of software is greater and often cheaper for PCs, especially if you are using your PC for other software systems, such as games.

PC AND DESIGN

For several years professional design and production was done primarily on a Mac. PCs were basically for office workers, game-players, and non-designers. But with PCs dominating the world of computing and advancements in the Windows operat- ing system, Mac use for serious design work has beenslipping away. But the myths still persist and designers are faced with making a decision about whether to go for a Mac or go ahead and prove that whatever the Mac can do, the PC can do.

DOWNLOADING IMAGES (MAC)

In order to edit your images using Photoshop Elements, you need to download them from your camera's memory card, where they are stored. You can do this in several ways: **Using the camera USB lead:** Plug the lead into the camera port and attach the other end to an available USB port on your computer, located either on the computer or the keyboard. The memory card folder may then automatically appear on your desktop. Alternatively, you may need to turn the command dial on your camera to the download symbol—a zigzag lightning rod—then scroll down your camera menu and press the **OK** button for the memory card folder to appear on your desktop. **Using a compact flash or Smartmedia card reader:** To use a card reader, you may need to download its software first. Connect the card reader to an available USB port, take the memory card out of the camera and gently push the card into the card reader ensuring that the card is facing the right way. The memory card folder will then appear on your desktop. Copy the images to the desktop by creating a new folder on your desktop and label it with the date and subject of your photographs. Open the memory card folder on the desktop, select the image files and drag these to the new folder. The image files will be copied from the memory card folder. You can now turn to page 116 to begin the editing process in Photoshop Elements using the **Browser.Using camera software or other image-organizing software:** If you have already installed camera or other image-organizing software on your computer, as you connect to the computer using either the camera USB lead or the card reader, this software will automatically open on the desktop. You can then proceed in either of two ways: either close this software and copy the card reader folder on the desktop to a new folder, or use the camera or other image-organizing software to import the images to that software. To access these image files using Photoshop Elements, you need then to copy the files from the software to a new folder on the desktop. Outlined below is the procedure for iPhoto. On the opposite page, the procedure for batch processing is explained, but it is recommended that you return to this option once you have become familiar with the basic editing software.

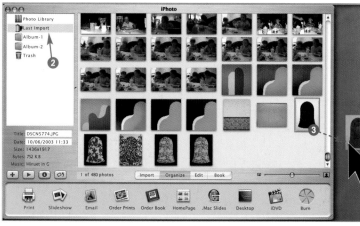

iPHOTO

As soon as you give the camera the command to download or put the card into the reader, the image file will appear on the desktop. If you have camera software installed or image-organizing software such as iPhoto, it will automatically open on the desktop and ask if you want to import the imagery. You can then download your photographs into this software by clicking on the **Import** button. You can then review the images and delete any you don't want to keep. It's also possible to put them into subfiles that you can name.

❶ When you connect your camera or card reader, iPhoto will automatically open on the desktop. Click on the Import button and the lower bar of the iPhoto window will show a camera and will state **Mass Storage Contains...** listing the number of image files on your memory card. You can click on the **Erase Images From The Card After Transfer** button and then click on the **Import** button to import the image files. On completion of download, the images will appear in the iPhoto window.

❷ Click on the **Last Import** folder to view only your imported images. Review the images and then create one or more new folders according to subject, typing in the name for the folder/s. Now select all or a selection of the images and drag them to the new folder/s and delete the image files you do not wish to keep.

❸ You need to drag the images you want to edit in Photoshop Elements from the iPhoto folder onto a new folder on the desktop. Either use command > A to select all the images or hold down the **Command** button and click on individual images in the folder to select them. Drag these images to the new folder on the desktop.

BATCH PROCESSING

The Batch command is an automated procedure for processing a group of images in a single go. Instead of formatting each individual photograph in turn, the batch command will apply a set format and file size to all the images. You can apply batch processing as you import images from your camera. You would also apply this command to a set of images that you wanted to print to the same size, or to a set of images that needed formatting for placing on the web. A key point to remember is that once you have batch processed a set of images for the web, this will be at a much lower resolution than for printing. Before applying batch processing for the web, ensure that you either batch process the images first for print or batch process copies of the original images.

To go to **Batch**, click **File** and scroll to **Batch Processing**.

SOURCE
Click **Source** to browse through you files for the folder containing the images you want to batch. If you check **Include All Subfolders**, the **Batch** will apply to any folders within the folder you choose.

CONVERSION OPTIONS
The drop menu under **Conversion Options** includes all the file types the batch can convert files into.

IMAGE SIZE
Within batch, you can also define the final file size of the image. By checking the **Convert Image Size** box, you open the **Width** and **Height** fields and the **Resolution** drop menu. Remember the **Width** and **Height** are defined in pixels only here.

OUTPUT OPTIONS
Click the **Destination** button to choose the folder you want your new batched images to be saved to.

FILE RENAMING
If you want to rename the files that you are batching, click the **Renaming Files** box and define the name and system for the new file names. If you want to make sure the file names will be compatible with other types of computers, check the appropriate box.

❶ **PSD** a native Photoshop file.

❷ **BMP** a bitmap file. This is the standard image format for Windows.

❸ **EPS** an Encapsulated PostScript file.

❹ **GIF** an 8-bit GIF file.

❺ **JPEG LOW QUALITY** a Joint Photographic Experts Group format as a low-quality web-ready file.

❻ **JPEG MEDIUM QUALITY** a Joint Photographic Experts Group format as a medium quality web-ready file.

❼ **JPEG HIGH QUALITY** a Joint Photographic Experts Group format as a high-quality web-ready file.

❽ **JPEG MAX QUALITY** a Joint Photographic Experts Group format as a maximum quality web-ready file.

❾ **PCX** a bitmap format most commonly created by PC Paintbrush.

❿ **PDF** a Portable Document file. This is a cross format, cross platform file accepted by many different programs including both imaging and web programs.

⓫ **PICT** a compressed file most effective when compressing large areas of solid color.

⓬ **PIXAR** a Pixar graphic file used with Pixar animations.

⓭ **PNG** a Portable Network Graphics file. This can be an alternative to a GIF file and is a compressed format.

⓮ **RAW** a flexible file format you can define for any computer.

⓯ **SCITEX CT** a format most often used in the prepress industry used in conjunction with a Scitex RIP.

⓰ **TARGA** for a Truevision® video board. Video game designers use this format.

⓱ **TIFF** a Tagged-Image File Format. The most common expanded-image file format. There are advance options for saving TIFFs in Photoshop Elements and Photoshop CS.

DOWNLOADING IMAGES (PC)

In order to edit your images using Photoshop Elements, you need to download them from your camera's memory card, where they are stored. You can do this in several ways: **Using the camera USB lead:** Plug the lead into the camera port and attach the other end to an available USB port on your computer, located either on the computer or the keyboard. The memory card folder may then automatically appear on your desktop. Alternatively, you may need to turn the command dial on your camera to the download symbol—a zigzag lightning rod—then scroll down your camera menu and press the **OK** button for the memory card folder to appear on your desktop. **Using a compact flash or Smartmedia card reader:** To use a card reader, you may need to download its software first. Connect the card reader to an available USB port, take the memory card out of the camera and gently push the card into the card reader ensuring the card is facing the right way. The memory card folder will then appear on your desktop. Copy the images to the desktop by creating a new folder on your desktop and label it with the date and subject of your photographs. Open the memory card folder on the desktop, select the image files, and drag these to the new folder. The images files will be copied from the memory card folder. **Using camera software or other image-organizing software:** If you have already installed camera or other image-organizing software on your computer, as you connect to the computer using either the camera USB lead or the card reader, this software will automatically open on the desktop. You can then proceed in one of two ways: either close this software and copy the card reader folder on the desktop to a new folder, or use the camera or other image-organizing software to import the images to that software. To access these image files using Photoshop Elements, you need to copy the files from the software to a new folder on the desktop.

Adobe Photoshop Elements–Photo Downloader will automatically detect the camera.

Click on the **Browse** to select the folder on your computer, where you want to save all the photos.

Click on the **Get Photos** to import photos from your camera's memory to the photo downloader.

PROCESS MULTIPLE FILES

The **Process Multiple Files** command is an automated procedure for processing a group of images in a single go. Instead of formatting each individual photograph in turn, the process multiple files command will apply a set format and file size to all the images. You can apply process multiple files as you import images from your camera. This command could also be applied to a set of images that you wanted to print at the same size, or to a set of images that needed formatting for placing on the web. A key point to remember is that once you have batch processed a set of images for the web, this will be at a much lower resolution than for printing. Before processing multiple files for the web, make sure that you either process multiple images first for print, or process multiple copies of the original images.

To go to **Process Multiple Files**, click **File** and scroll to **Process Multiple Files**.

SOURCE
Click **Browse** button to browse through your files for the folder containing the images you want to process. If you check **Include All Subfolders,** the **Process** will apply to any folders within the folder you choose.

DESTINATION
Click **Browse** button to choose the folder you want your new batched images to be saved to.

FILE RENAMING
If you want to rename the files that you are batching, click the **Rename Files** box and define the name and system for the new file names. If you want to make sure the file names will be compatible with other types of computers, check the appropriate box.

IMAGE SIZE
Within process, you can also define the final file size of the image. By checking the **Resize Image** Size box, you open the **Width** and **Height** fields and the Resolution drop menu. Remember the **Width** and **Height** are defined in pixels only here.

FILE TYPE
The drop menu under **File Type** includes all the file types the process can convert files into.

❶ **PSD** a native Photoshop file.

❷ **BMP** a bitmap file. This is the standard image format for Windows.

❸ **EPS** an Encapsulated PostScript file.

❹ **GIF** an 8-bit GIF file.

❺ **JPEG LOW QUALITY** a Joint Photographic Experts Group format as a low-quality web-ready file.

❻ **JPEG MEDIUM QUALITY** a Joint Photographic Experts Group format as a medium quality web-ready file.

❼ **JPEG HIGH QUALITY** a Joint Photographic Experts Group format as a high-quality web-ready file.

❽ **JPEG MAX QUALITY** a Joint Photographic Experts Group format as a maximum quality web-ready file.

❾ **PCX** a bitmap format most commonly created by PC Paintbrush.

❿ **PDF** a Portable Document file. This is a cross format, cross platform file accepted by many different programs including both imaging and web programs.

⓫ **PICT** a compressed file most effective when compressing large areas of solid color.

⓬ **PIXAR** a Pixar graphic file used with Pixar animations.

⓭ **PNG** a Portable Network Graphics file. This can be an alternative to a GIF file and is a compressed format.

⓮ **PHOTOSHOP RAW** a flexible file format you can define for any computer.

⓯ **SCITEX CT** a format most often used in the prepress industry used in conjunction with a Scitex RIP.

⓰ **TARGA** for a Truevision video board. Video game designers use this format.

⓱ **TIFF** a Tagged-Image File Format. The most common expanded-image file format. There are advance options for saving TIFFs in Photoshop Elements and Photoshop CS.

USING THE BROWSER (MAC)

The browser is a well-designed tool for viewing and organizing your photographs. You will find yourself using it a lot, since it lets you see all of your images as thumbnail images that you can increase or decrease in size depending upon your needs. Once your photographs are all laid out on the screen in front of you, you can organize them by title, in chronological order, or rank them according to importance.

1 To start the browser, choose **Browse for File** or go to **File** and scroll to **Browse**.

2 Click on the folders in the **Browser Window** to navigate to your images.

3 Enlarge the browser to fit to screen by clicking the **Green** button in the top left.

4 After you click on the image you want to use, it will show up in the preview area. Grab the top bar, pull up and the preview will grow.

5 If any images are oriented wrong, you can rotate them by using the **Quick Rotate** button.

6 If you double click on the image, it will open in Photoshop Elements.

7 To delete images, select the image in the browser window and click the **Trash** icon.

ALTERNATIVE NAVIGATION

You can also use the alternative folder browser. In this window, you navigate through the folders by the list of names. This way you can more readily see the location of folders.

BROWSER OPTIONS

❶ Filename Organizes images by filename.

❷ Width Organizes images by width.

❸ Height Organizes images by height.

❹ File Size Organizes images by file size.

❺ Resolution Organizes images by resolution.

❻ File Type Organizes images by file type.

❼ Date Created Organizes images according to the date on which they were created.

❽ Date Modified Organizes images according to the date on which they were modified.

❾ Ascending Order Organizes images by ascending or descending order.

❿ Small View
In Small View, you can view a large number of files all at once. They will fall in a list form, with only a small thumbnail of what the image actually looks like.

⓫ Medium View
This allows a large enough thumbnail view to see what the images looks like, while still being able to preview a large amount of files.

⓬ Large View
Large view lets you view your image files as though they were slides. **Large View** is best when looking for an image, or for comparing many images without opening them all.

⓭ Detail View
Detail View allows you to see specific attributes of every file. This view is especially valuable when you have similar images that have different file sizes, and resolutions.

⓮ Dock to Palette Wall Click on Dock to Palette Wall to clear and restore the browser. You can reset the palette to its default settings by going to **Windows** and clicking **Reset.**

⓯ Expanded View Click on Expanded View to expand the files and folders window to fit your browser window.

⓰ Open Click on Open to find files on the desktop or in other drives.

⓱ Select All Click on Select All to select all of your folders or files.

⓲ Deselect All Click on Deselect All to deselect all files and folders.

⓳ Rename Click on Rename to rename a file or a folder.

⓴ Batch Rename Click on Batch Rename to rename selected batch.

㉑ Delete Click on Delete to delete individual images or files.

㉒ New Folder Click on New Folder to create a new image folder.

㉓ Show Folders Click on Show Folders to show all of your file folders.

㉔ Rotate 180 Click on Rotate 180 to rotate your image 180 degrees.

㉕ Rotate 90 Right Click on Rotate 90 to rotate your image 90 degrees to the right.

㉖ Rotate 90 Left Click on Rotate 90 to rotate your image 90 degrees to the left.

㉗ Small Thumbnail Click on Small Thumbnail to create small thumbnail views.

㉘ Medium Thumbnail Click on Medium Thumbnail to create medium thumbnail views of your images.

㉙ Large Thumbnail Click on Large Thumbnail to create large thumbnail views of your images.

㉚ Details Click on Details to show details of images.

㉛ Refresh Desktop View Click on Refresh Desktop to update browser with additional files on your desktop.

㉜ Reveal Location in Finds Click on Reveal Location in Finds to reveal the whereabouts of files in your hard drive.

㉝ Purge Cache Click on Purge Cache to remove previous thumbnails and file information to free up disc space on your hard drive.

USING THE BROWSER (PC)

The browser is a well-designed tool for viewing and organizing your photographs. You will find yourself using it a lot, since it lets you see all of your images as thumbnail sketches that you can increase or decrease in size depending upon your needs. Once your photographs are all laid out on the screen in front of you, you can organize them by date, batch, or folder location.

1 To start the browser, click on the **Photo Browser** icon on the menu.

2 Select **From Files** and **Folder** from the File menu to browse images. You can also browse images from Camera, Scanner, or Mobile.

3 Select files which you want to browse and then press **Get Photos**.

4 All your selected files get imported in your browser.

5 You can use Attached Tags for all your selected images. Select from Tags list and press **OK**.

6 Browser will generate thumbnail view of all your selected images.

7 Move the **slider** to view enlarged version of the select image. By clicking the **Thumbnail** icon you may return to the thumbnail view. Clicking on the **Full Screen** icon the selected image will be visible in the full screen mode. The Single Photo View icon will zoom your selected image to fit in the browser window.

8 Click on the **Rotate Left** or **Rotate Right** icon to rotate any wrongly oriented image.

9 Image has been rotated to its correct orientation.

10 To delete images, select the image and right click then select **Delete** from the **Catalog** option on the list.

ALTERNATIVE NAVIGATION
You can also use the alternative folder browser. In this window, you can navigate through the folders by the list of names. This way you can more readily see the location of the folders.

1 Date (Newest First) Shows the most recently taken or imported photos first.

2 Date (Oldest First) Shows all the photos in chronological order.

3 Import Batch Imports photos in batches and displays how the photos were imported.

4 Folder Location Displays location of the photos in which they are stored.

5 Copy Copy selected files in the clipboard.

6 Delete from Catalog Deletes selected files from the catalog.

7 Rotate 90° Left Rotates selected image 90° to the left.

8 Rotate 90° Right Rotates selected image 90° to the right.

9 Auto Smart Fix Corrects the overall color balance and improves shadow and highlight detail of the image.

10 Auto Red Eye Fix Automatically fix red eye in the image.

11 Go to Quick Fix This option works as a toggle between Photo Browser and Quick Fix screen. You can use basic photo editing tools available in the Photoshop Elements.

12 Go to Standard Edit This option works as a toggle between Photo Browser and Standard Fix screen. The Standard Edit workspace has tools to correct color problems, create special effects, and enhance photos.

13 Adjust Date and Time This option can help you manually adjust Date and Time of the image.

14 Add Caption This option can help you add caption to the image.

15 Update Thumbnail This option updates thumbnails if you update any image using Photoshop Element or any other application.

16 Set as Desktop Wallpaper This option can make the selected image the background picture on your computer screen.

17 View Photos in Full Screen This option will enlarge the picture to the size of your browser window.

18 Play Video or Audio This option will play Video or Audio files.

19 Open in PDF Reader You can preview pages and images in the PDF Reader.

20 Edit 3GPP Movie You can edit images stored as 3GPP movies.

21 Stack Select images you want to stack. You can create a stack of similar photos.

22 Version Set Edited versions of photos that are automatically grouped together when you save edits in the Editor.

23 Attach Tag You can associate selected photo with the tag. You can attach multiple tags to a photo.

24 Remove Tag Clicking on remove tag will detach selected image from the tag.

25 Add to Collection Clicking on this option adds the selected image as a part of the collection.

26 Remove from Collection Clicking on this option removes the selected image from the collection.

27 Show Properties Displays properties pallet which contains image name, size, and dimensions.

THE TOOLBOX

Photoshop software effectively emulates a darkroom. The tools in the program are organized and illustrated with symbols that correspond to processes in a photographic lab: cropping and rotating images, basic color and tone adjustments, removing color casts, burning and dodging to darken and lighten areas of a composition, as well as masking areas of a composition to remove and add pictorial elements. In short, Photoshop gives you enormous control over the outcome of your image, without the expense of a professional lab, or the fuss of a darkroom. The tools in the toolbox are listed with a page numbers for where they are first introduced in the book.

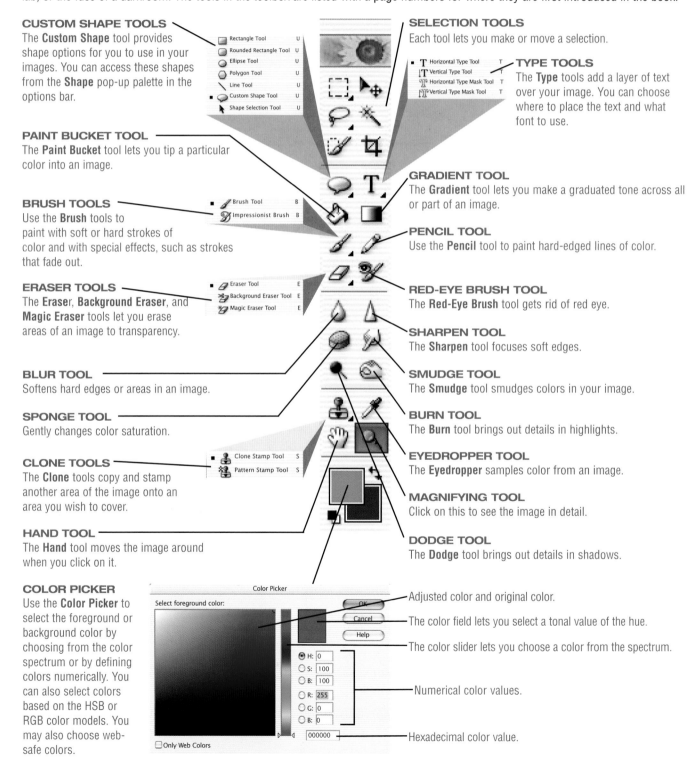

CUSTOM SHAPE TOOLS
The **Custom Shape** tool provides shape options for you to use in your images. You can access these shapes from the **Shape** pop-up palette in the options bar.

Rectangle Tool — U
Rounded Rectangle Tool — U
Ellipse Tool — U
Polygon Tool — U
Line Tool — U
Custom Shape Tool — U
Shape Selection Tool — U

PAINT BUCKET TOOL
The **Paint Bucket** tool lets you tip a particular color into an image.

BRUSH TOOLS
Use the **Brush** tools to paint with soft or hard strokes of color and with special effects, such as strokes that fade out.

Brush Tool — B
Impressionist Brush — B

ERASER TOOLS
The **Eraser**, **Background Eraser**, and **Magic Eraser** tools let you erase areas of an image to transparency.

Eraser Tool — E
Background Eraser Tool — E
Magic Eraser Tool — E

BLUR TOOL
Softens hard edges or areas in an image.

SPONGE TOOL
Gently changes color saturation.

CLONE TOOLS
The **Clone** tools copy and stamp another area of the image onto an area you wish to cover.

Clone Stamp Tool — S
Pattern Stamp Tool — S

HAND TOOL
The **Hand** tool moves the image around when you click on it.

COLOR PICKER
Use the **Color Picker** to select the foreground or background color by choosing from the color spectrum or by defining colors numerically. You can also select colors based on the HSB or RGB color models. You may also choose web-safe colors.

SELECTION TOOLS
Each tool lets you make or move a selection.

Horizontal Type Tool — T
Vertical Type Tool — T
Horizontal Type Mask Tool — T
Vertical Type Mask Tool — T

TYPE TOOLS
The **Type** tools add a layer of text over your image. You can choose where to place the text and what font to use.

GRADIENT TOOL
The **Gradient** tool lets you make a graduated tone across all or part of an image.

PENCIL TOOL
Use the **Pencil** tool to paint hard-edged lines of color.

RED-EYE BRUSH TOOL
The **Red-Eye Brush** tool gets rid of red eye.

SHARPEN TOOL
The **Sharpen** tool focuses soft edges.

SMUDGE TOOL
The **Smudge** tool smudges colors in your image.

BURN TOOL
The **Burn** tool brings out details in highlights.

EYEDROPPER TOOL
The **Eyedropper** samples color from an image.

MAGNIFYING TOOL
Click on this to see the image in detail.

DODGE TOOL
The **Dodge** tool brings out details in shadows.

Color Picker

Select foreground color:

OK
Cancel
Help

H: 0
S: 100
B: 100
R: 255
G: 0
B: 0

000000

Only Web Colors

Adjusted color and original color.

The color field lets you select a tonal value of the hue.

The color slider lets you choose a color from the spectrum.

Numerical color values.

Hexadecimal color value.

HINTS AND RECIPES

When you buy a copy of software like Adobe Photoshop, the software comes with a manual and help windows that open on your computer screen to explain the different functions of the software. You can also get CD tutorials on some software packages. You can follow these tutorials and menus on screen to accomplish any editing task. In addition to this help, you can access support via the web and call the support line if you get really stuck. Sometimes a really simple thing like not setting the clock to the correct time zone on your computer will stop a software system from operating. The help line can help you to identify and then solve your problem quickly.

THE HINTS BOX

THE HINTS PALETTE
The **Hints Palette** shows whichever palette or tool your mouse is on.

DESCRIPTIVE PARAGRAPH
This paragraph explains in detail all of the functions of the what the tool in question does.

MORE
Click on **More** for a list of Help Contents, Keyboard Shortcuts and access to Tutorials and Adobe Online.

LINKS
Each Hints Palette has a link that connects you with information about how to use the tool in question.

THE RECIPE BOX

SELECT A RECIPE
This box leads you to a step-by-step guide to processes and techniques.

MORE
Click on **More** to close palette or to access **Help** or **Help Contents**.

HELP CONTENTS
The **Help Contents** outlines everything you will find in Help.

THE HOW TO PALETTE
The **How To Palette** guides you through typical image-editing tasks, like removing adding effects to text, creating GIF animations, merging photos and removing red eye.

HOW TO
How To contains user-friendly guides that take you through each step of the process or technique you want to use.

ROTATING AND STRAIGHTENING

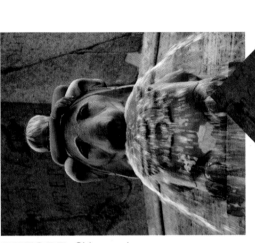

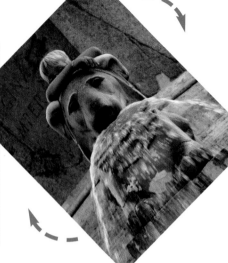

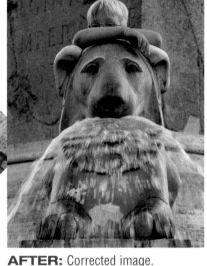

BEFORE: Sideways image.

AFTER: Corrected image.

ROTATING WITHIN THE BROWSER

❶ Open the **File Browser.**

❷ Locate your pictures by double clicking on the folder icons.

❸ Click on the image you'd like to rotate.

❹ Hold down the **Command key** as you click to select multiple images.

❺ Click on the **Rotate** symbol.

❻ Click **OK** in the dialog box.

ROTATING USING QUICK FIX

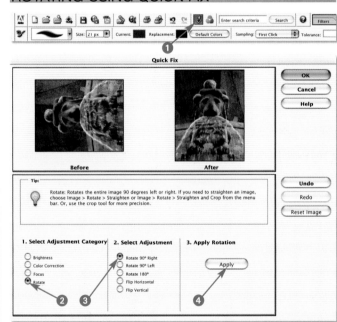

Quick Fix

Before After

Tip: Rotate: Rotates the entire image 90 degrees left or right. If you need to straighten an image, choose Image > Rotate > Straighten or Image > Rotate > Straighten and Crop from the menu bar. Or, use the crop tool for more precision.

1. Select Adjustment Category
- Brightness
- Color Correction
- Focus
- Rotate

2. Select Adjustment
- Rotate 90° Right
- Rotate 90° Left
- Rotate 180°
- Flip Horizontal
- Flip Vertical

3. Apply Rotation
- Apply

❶ Click on the **Quick Fix Icon.**

❷ Select **Rotate.**

❸ Select the appropriate direction of your rotation.

❹ Click **Apply.**

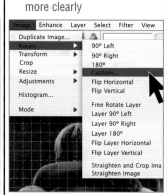

BEFORE: Image is slanted.

AFTER: Image is straight.

① Activate the **Grid**. This will allow you to see the verticals more clearly

② Go to **Image** and select **Custom** from the **Rotate** submenu.

CUSTOM ROTATING

This method of rotation is useful for rotation by a few degrees.

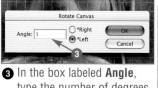

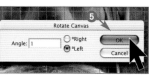

③ In the box labeled **Angle**, type the number of degrees you wish to rotate.

④ Click either **Right** or **Left**, depending on which way you wish to rotate.

⑤ Click **OK** to apply. You will need to crop the image.

⑥ Select the **Crop Tool**.

⑦ Click and drag to define your desired crop.

⑧ Press the **Return key** to crop.

FLIPPING

Sometimes, images actually benefit from being flipped to face in the opposite direction. Visually, some compositions look more natural if the movement is from right to left. For images that face left, **Flip Horizontal** can be a useful compositional aid. If you apply this format to an image, however, you need to make sure that there is nothing in the image that should not be flipped, such as text.

WARNING!

You must be careful when using the flip option. The woman's wedding band is now on her right hand. To avoid this problem, you may simply crop that portion of the picture away, or flip only subjects that are symmetrical.

BEFORE Original Image.

AFTER Flipped Image.

USING THE CROP TOOL

BEFORE: The original image has no point of focus.

AFTER: Image cropped and balanced.

EXPLORING CROPPING

More often than not, all photographers need to make some subtle trimming—if not major cropping—to create a well balanced and dynamic composition. For the most part, you will want to get the image cropped to make the subject fill the composition, but you can also use the **Crop Tool** to create inspiring compositions from point-and-shoot photographs. To do this, you need to explore some of the arrangements that can be created by cropping into an image. Cropping is the art of creatively composing a photograph and relates directly to the process of framing your image in the camera viewer, only the difference is that in the camera, the frame is a fixed proportion. When you crop a subject in the editing process, you can crop without restriction. Artful cropping can create totally different arrangements in a composition, either by cropping to symmetrical proportions, or rotating and cropping so that no lines correspond to the edges of the composition.

USING THE MARQUEE TO CREATE A ROUND OR OVAL COMPOSITION

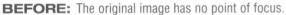

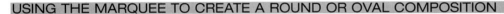

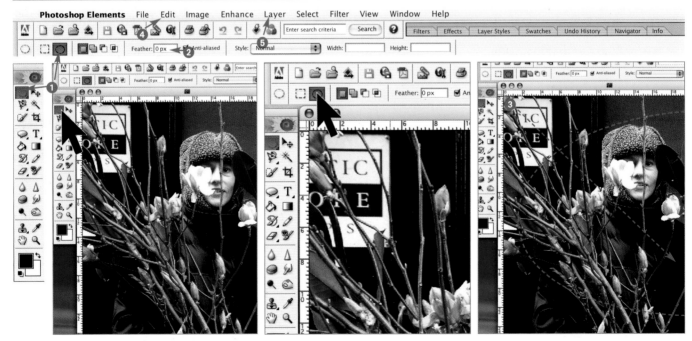

❶ Click on the **Marquee Tool** in the toolbox. Choose the elliptical **Marquee Tool** from the options bar.

❷ Add pixels to the **Feather** field in the options bar to create a softer edge when you crop.

❸ Draw the area you want to crop.

4 **Copy** the selected area, open a new document and **Paste** the image.

5 In the new document, click on **Layer** and scroll to **Flatten Image**.

6 After you flatten the image, the layers will combine and you will have a feathered oval composition.

USING THE CROP TOOL TO COMPOSE IMAGES

Adjusting the shield
The bounding box of your crop will be surrounded by a darker tone called a *shield*, aiding you to visualize the final crop. You can turn this shield on or off and also adjust the **Color** and **Opacity** of the shield in the toolbar.

1 Open the image you wish to crop and choose the **Crop Tool** from the toolbox.

2 Click on what will be the top left corner and pull down towards what will the bottom right corner with the mouse button pressed.

3 Press the **Enter** key on your keyboard to complete the crop.

EXAMPLES OF CROPPING

 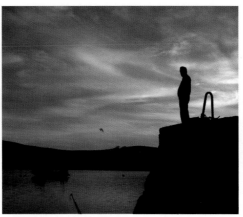 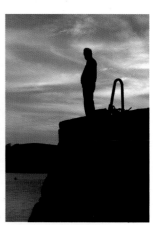

Before: Too much space around the figure.

After: Balance of shape and form.

Before: open composition.

After: Tighter shape.

USING QUICK FIX TO ADJUST TONES

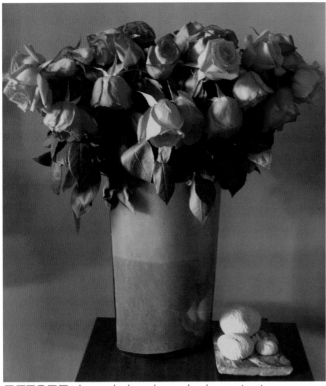

BEFORE: Image lacks value and color contrast.

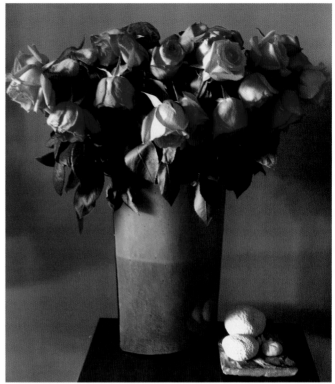

AFTER: Brightness/Contrast and **Auto Levels** corrected.

AUTO CONTRAST

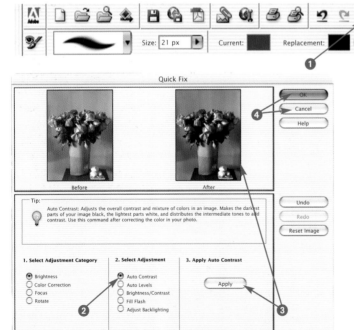

AUTO LEVELS

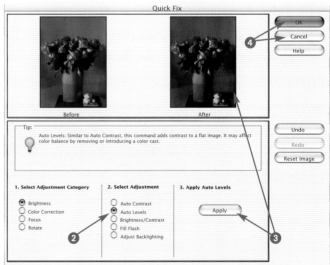

❶ Click on the **Quick Fix** icon in the shortcuts menu. ❷ Click on **Auto Contrast** under **Select Adjustment**. ❸ Click on **Apply**. You will see the effect of the **Auto Contrast** in the **After** box. ❹ If you are satisfied with the effect, click **OK**; if not, click **Cancel**.

❶ Click on the **Quick Fix** icon in the shortcuts menu. ❷ Click on **Auto Levels** under **Select Adjustment**. ❸ Click on **Apply**. You will see the effect of the **Auto Levels** in the **After** box. ❹ If you are satisfied with the effect, click **OK**; if not, click **Cancel**.

BRIGHTNESS/CONTRAST

FILL FLASH

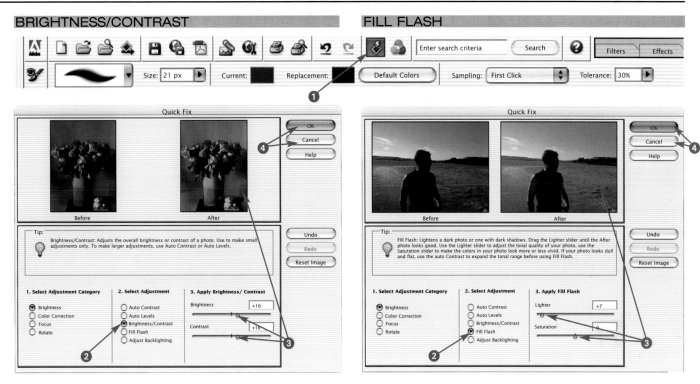

❶ Click on the **Quick Fix** icon in the shortcuts menu. ❷ Click on **Brightness/Contrast** under **Select Adjustment**. ❸ Click and drag the blue sliders under **Apply Brightness/Contrast** to attain your desired effect. As you do this, you will see the image change in the **After** box. ❹ If you are satisfied with the effect, click **OK**; if not, click **Cancel**.

❶ Click on the **Quick Fix** icon in the shortcuts menu. ❷ Click on **Fill Flash** under **Select Adjustment**. ❸ Click and drag the blue sliders under **Apply Fill Flash** to attain your desired effect. As you do this, you will see the image change in the **After** box. ❹ If you are satisfied with the effect, click **OK**; if not, click **Cancel**.

ADJUST BACKLIGHTING

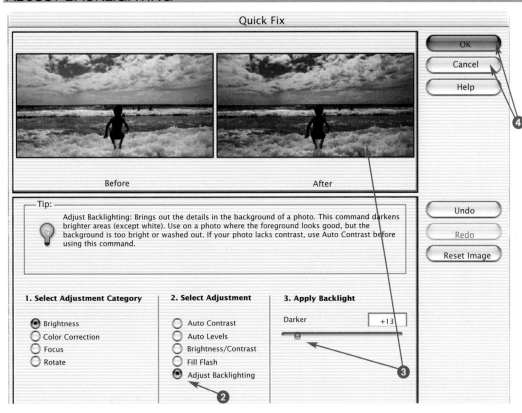

❶ Click on the **Quick Fix** icon in the shortcuts menu. ❷ Click on **Adjust Backlighting** under **Select Adjustment**. ❸ Click and drag the blue slider under **Apply Backlight** to attain your desired effect. As you do this, you will see the image change in the **After** box. ❹ If you are satisfied with the effect, click **OK**; if not, click **Cancel**.

COLOR VARIATIONS

BEFORE: Original image of flowers.

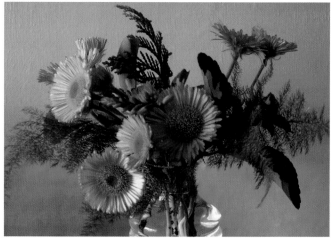

AFTER: Modified image using **Color Variations**.

THE COLOR VARIATIONS DIALOG BOX

The overall color bias in an image radically affects the feeling of a photograph; even a slight shift in color will create a feeling of coolness or warmth in the image. You are particularly aware of even the slightest nuance of color variation in someone's complexion: a reddening of facial features often denotes embarrassment, while a loss of color in the face can indicate tiredness or illness. **Color Variations** allows you to fine-tune the color in an image with a simple click of the mouse. It is also a quick and easy way to lighten or darken your image.

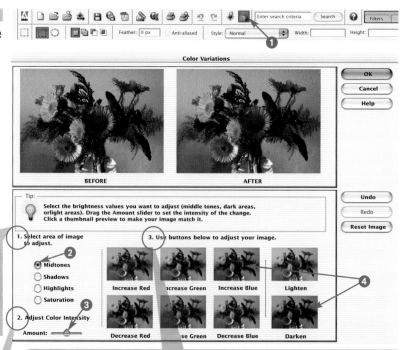

Section 1 allows you to select an area of the image to adjust—**Midtones**, **Shadows** or **Highlights**—as well as **Saturation**. You can effectively alter each of these areas in your image by cooling the highlights, or warming the shadows.

In **Section 2**, you can control the **Intensity** of color, allowing you to shift the color slightly or dramatically.

Section 3 contains eight thumbnails that illustrate the changes in your image as you click to increase or decrease either color or brightness.

❶ Click on the **Color Variations** button in the menu bar. This will open the dialog box.

❷ Select which range of the image you would like to adjust.

❸ Use the slider next to **Amount** to define the intensity of your adjustment.

❹ Click on the thumbnails to increase or decrease the color or tone.

CREATIVE COLOR VARIATIONS

Color Variations also allows you to play creatively with the color to enhance an image's color theme with subtlety or radically alter the color to create a more dramatic image. Note how a simple shift in color bias dramatically alters the mood of the image.

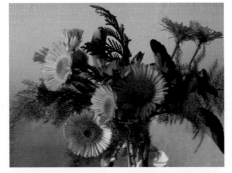
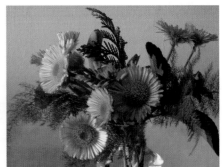

DETAILS, DETAILS: TONE & COLOR

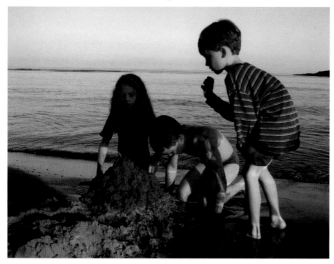

BEFORE: Red shirt is dull.

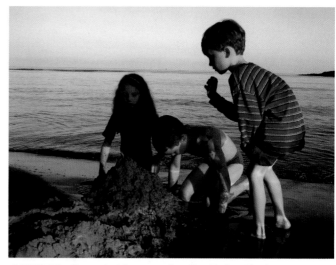

AFTER: Corrected image using the **Dodge Tool**.

DODGING

Dodging lightens the image, bringing out details that would otherwise be lost in the shadows.

❶ Click on the **Dodge Tool** in the toolbox. The cursor will transform into a circle. This circle is the size of the tool.

❷ Click on the blue arrow next to the **Brush** example and select a brush with a soft edge from submenu.

❸ Click on the blue arrow next to **Size** and adjust the size of the brush using the pop-up slider.

❹ Select which range you would like to **Dodge** from the submenu. For this example, **Highlights** was chosen to bring out the details of the boy's shirt.

❺ Click on the blue arrow next to **Exposure** and set the value to 20% using the pop-up slider. Any higher value would make the effect too drastic.

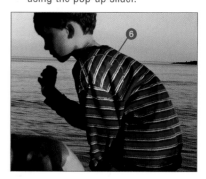

❻ Dab at the area in small increments of change rather than applying a constant flow. Avoid creating noticeable edge differences.

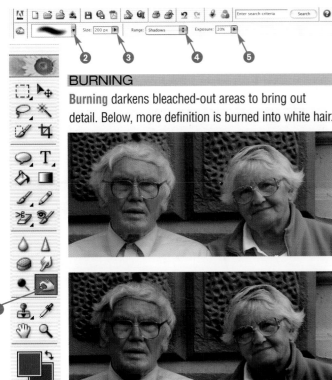

BURNING

Burning darkens bleached-out areas to bring out detail. Below, more definition is burned into white hair.

❶ Click on the **Burn Tool** in the toolbox. The cursor will transform into a circle. This circle is the size of the tool.

❷ Click on the blue arrow next to the **Brush** example and select a brush with a soft edge from submenu.

❸ Click on the blue arrow next to **Size** and adjust the size of the brush using the pop-up slider.

❹ Select which range you would like to **Burn** from the sub-menu. For this example, **Shadows** was chosen.

❺ Click on the blue arrow next to **Exposure** and set the value to 20% using the pop-up slider. Any higher value would make the effect too drastic.

❻ Dab at the area in small increments of change, rather than applying a constant flow. Avoid creating noticeable edge differences.

THE SPONGE TOOL

The **Sponge Tool** is useful to saturate or desaturate color from specific areas. Here it recedes the red bench.

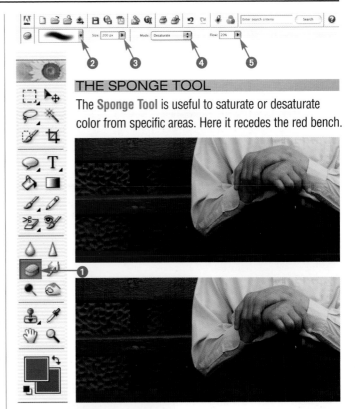

❶ Click on the **Sponge Tool** in the **Tool Box**. The cursor will transform into a circle. This circle is the size of the tool.

❷ Click on the blue arrow next to the **Brush** example and select a brush with a soft edge from submenu.

❸ Click on the blue arrow next to **Size** and adjust the size of the brush using the pop-up slider.

❹ Select which **Mode** you'll need from the submenu. For this example, **Desaturate** was chosen to recede the bench.

❺ Click on the blue arrow next to **Flow** and set the value to 20% using the pop-up slider. Any higher value would make the effect too drastic.

❻ Dab at the area in small increments of change, rather than applying a constant flow. Avoid creating noticeable edge differences.

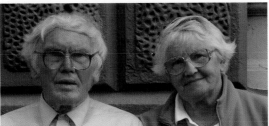

CREATING BLACK-AND-WHITE IMAGES

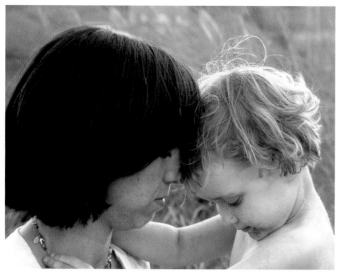

BEFORE: Color image.

AFTER: Image converted to black and white with more contrast.

WHY BLACK AND WHITE?

Although one of the most appealing visual qualities of digital photography is the heightened color, at times it gets in the way as eye candy. As the color emphasis in a composition can tend to be arbitrary at times, the emotional focus of the subject can get lost. De-saturating a color image to black and white displays the interplay between light and shadow as it reveals the form and texture in a composition. Because of the quiet and yet powerful intensity felt in a well-composed black-and-white photograph, many fine-art photographers choose to work exclusively in black and white.

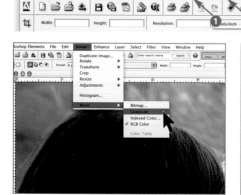

1 Go to **Image** in the menu bar and scroll to **Mode**. Select **Grayscale** from the submenu.

2 A window will appear asking if you want to discard color information. If you have a saved copy of your image, click **OK**.

3 Go to **Enhance** in the menu bar and scroll down to **Adjust Brightness/Contrast**.

4 Move the pointers on the slider to adjust the **Brightness** and the **Contrast**.

TAKE THE PICTURE IN COLOR FIRST

Although some cameras have a setting that allows you to take a photograph in black and white, generally this is not recommended. In most digital cameras, recording an image in black and white reduces the tonal range by using only one of three color channels. It is recommended to take a photograph in full color, which records tonal information in all three color channels and then convert the image using photo-editing software. When a camera records an image in full color, it records the full range of tones in the scene more accurately.

CREATING MONOCHROME IMAGES

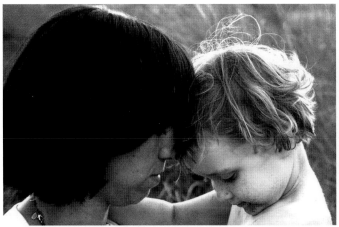

BEFORE: Black-and-white image.

AFTER: Adding a single color makes an image monochrome.

MAKING SEPIA AND MONOCHROME IMAGES

By reducing an image to black and white, you can then choose to gradually add a single color—such as a sepia tone—back into the image to create gentle color toning. The impact of monochrome lies in creating an atmosphere that reduces the starkness of a black-and-white image.

1 Select **Mode** under **Image** in the menu bar. Select **RGB Color** from the submenu. You can now can add color back to the black-and-white image.

2 Go to **Enhance** in the menu bar and scroll down to **Adjust Color**. Select **Hue/Saturation** from the submenu.

3 Click on the **Colorize** button in the lower right-hand corner of the window. The image will immediately gain color.

4 Move the pointer on the **Hue** slider and choose a color from the spectrum.

5 Adjust the **Saturation** and **Lightness** to control the strength of the color.

6 Click **OK** to apply.

USING BLACK AND WHITE TO CHECK COMPOSITION

Color photographers often switch a color photograph to black and white temporarily to evaluate the qualities of the composition. When they switch back to color, they can better evaluate where color is aiding or weakening the composition and edit the color accordingly.

ADJUSTING SHARPNESS AND SOFTNESS

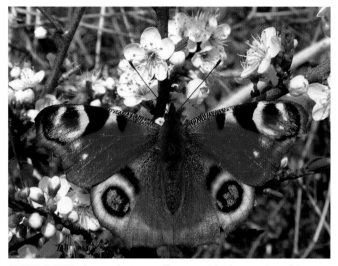

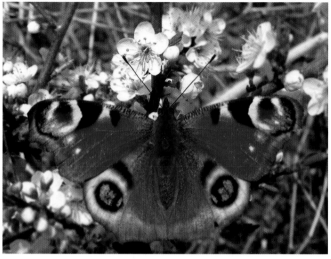

BEFORE: Image is too uniform and lacks a point of focus.

AFTER: Image enhanced using the **Sharpen** and **Blur Tools**.

SHARPENING

Sharpening brings details into focus and provides the illusion that they are closer to the viewer.

❶ Click on the **Sharpen Tool** in the tool box. The cursor will transform into a circle. This circle is the size of the tool.

❷ Click on the blue arrow next to the brush example and select a brush with a soft edge from the submenu.

❸ Click on the blue arrow next to **Size** and adjust the size of the brush using the pop-up slider.

❹ Select the **Mode** in which you would like to **Sharpen** from the submenu. For this example, **Normal** was chosen to affect the image in an overall manner.

❺ Click on the blue arrow next to **Strength** and set the value to 50% using the pop-up slider. Any higher value would cause the effect to be too drastic.

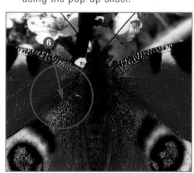

❻ Click on the areas that you would like to **Sharpen**. You may click on a specific area multiple times to increase the sharpening effect.

BLURRING

Blurring obscures details and provides the illusion that they are further away from the viewer.

❶ Click on the **Blur Tool** in the tool box. The cursor will transform into a circle. This circle is the size of the tool.

❷ Click on the blue arrow next to the brush example and select a brush with a soft edge from the submenu.

❸ Click on the blue arrow next to **Size** and adjust the size of the brush using the pop-up slider.

❹ Select the **Mode** in which you would like to **Blur** from the submenu. For this example, **Normal** was chosen to affect the image in an overall manner.

❺ Click on the blue arrow next to **Strength** and set the value to 50% using the pop-up slider. Any higher value would cause the effect to be too drastic.

❻ Click on the areas that you would like to **Blur**. You may click on a specific area multiple times to increase the blurring effect.

QUICK FIX

You can quickly adjust the overall sharpness or blur of your image using the **Quick Fix** dialog box.

❶ Click on the **Quick Fix** icon in the shortcuts menu. ❷ Click on **Focus** under **Select Adjustment Category**. ❸ Select either on **Auto Focus** or **Blur** under **Select Adjustment**. ❹ Click **Apply** to see the effect. You can apply the effect several times doubling the effect with each click. ❺ If you are satisfied with the effect, click **OK**. ❻ You may hit **Undo** if you wish to begin again, or **Cancel** to close the **Quick Fix** dialog box without applying any effect.

WARNING!

Applying blur and sharpness must be done carefully. Be aware that **Auto Focus** will only correct a limited amount of blur; if you continue to apply the command you will not increase the sharpness of definition, but spoil the image by introducing a high level of noise. In regards to blur, a little will remove the sharpness of the definition of texture and soften unwelcome highlights. Too much blur will just make the image look like a badly-taken photograph affected by camera shake.

REMOVING RED EYE

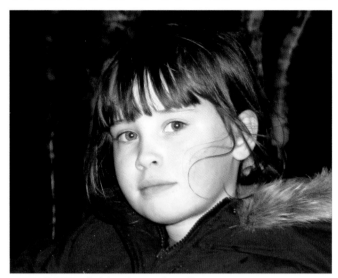

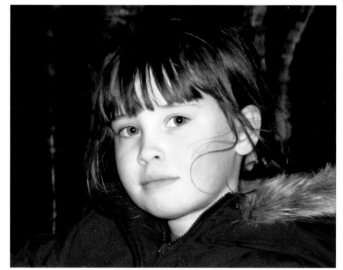

BEFORE: Subject has red pupils

AFTER: Red eye is eliminated

REMOVING RED EYE

Because red eye occurs with such regularity, it has prompted the design of a tool setting just to solve this particular problem. The **Red-Eye Brush Tool** is easy to master, making it valuable as a quick remedy to this common problem.

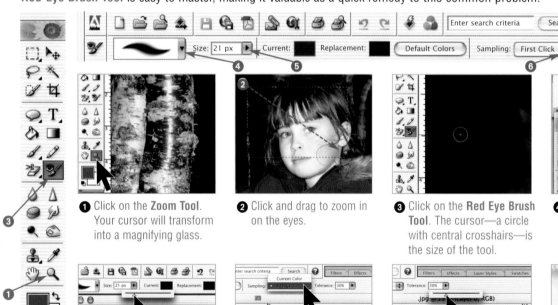

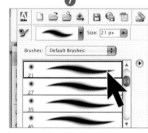

❶ Click on the **Zoom Tool**. Your cursor will transform into a magnifying glass.

❷ Click and drag to zoom in on the eyes.

❸ Click on the **Red Eye Brush Tool**. The cursor—a circle with central crosshairs—is the size of the tool.

❹ Select a brush with soft edges from the pop-up palette in the options bar.

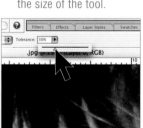

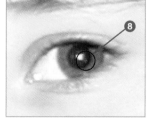

❺ Adjust the brush **Size** using the slider to a diameter just larger than the pupils.

❻ In the options bar, make sure that **Sampling** is set on **First Click**.

❼ Set the **Tolerance** at 30% or lower.

❽ Click on the red areas of the eye to change them to black.

WARNING! Do not position the cross of your cursor on either the surrounding iris, or any white highlight area, as this will cause the iris color or white—rather than the red—to be selected. You'll know you have it right when you see the red color appear in the **Current** window and the default color of black in the **Replacement** window.

DARKENING YOUR ADJUSTMENT

Depending on the tone of the original red in the eye, the replacement may be gray instead of black, which will not look dark enough.

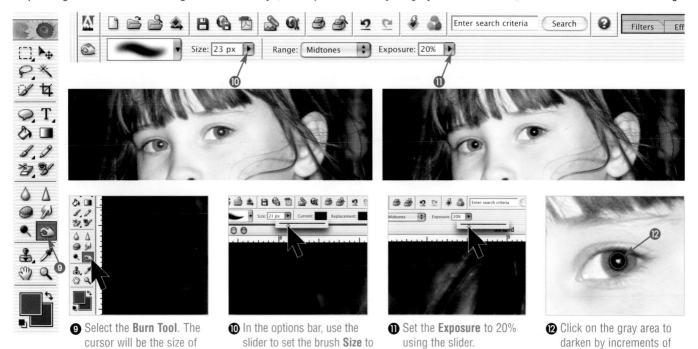

⑨ Select the **Burn Tool**. The cursor will be the size of the tool.

⑩ In the options bar, use the slider to set the brush **Size** to match the size of the pupil.

⑪ Set the **Exposure** to 20% using the slider.

⑫ Click on the gray area to darken by increments of 20% toward a dense black.

WHAT CAUSES RED EYE?

Red eye is caused by the light of the camera flash bouncing off the retina in the back of the eye. Red eye is often very pronounced in low light conditions, because the subject's pupils are fully dilated at this time. Also, built-in flash fires directly into the eyes, increasing the chance of producing an image with red eye.

HOW CAN I AVOID RED EYE?

To counter red eye, use the red-eye option in the flash settings on your camera. This reduces red eye by emitting a pre-flash that causes the subject's pupils to contract, preparing them for the main flash that follows. If you take a lot of flash photography using a **Prosumer camera**, it is well worth investing in an external-flash unit that changes the angle at which the light hits the eyes.

USING RED EYE TO YOUR ADVANTAGE

There are rare occasions when the effect of red eye adds to a photo, as in the Halloween image below, where an eerie red glow in the eyes adds to the mock-scary character of the image.

SIMPLE RETOUCHING

BEFORE: Image with undesired figure.

AFTER: Retouched image using the **Clone Tool**.

CLONING

Every so often a photograph is spoiled by an unwanted picture element—an object in the scene that could not be removed by repositioning the camera. This could be a person or car passing through while you are taking the shot. The **Clone Stamp Tool** allows you to remove all sorts of spoilers. This tool clones and copies an area of tone that you can then stamp onto the offending area.

❶ Click on the **Zoom Tool** in the toolbox. The cursor will transform into a magnifying glass.

❷ Click and drag to enlarge the area of the composition large enough to comfortably make adjustments.

❸ Select the **Clone Stamp Tool**, which shares a button with the **Pattern Stamp Tool**, from the toolbox.

❹ Select a brush with soft edges in the pop up palette of the options bar.

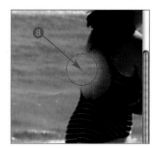

❺ Using the slider, adjust the brush **Size** to just larger than the area you want to cover.

❻ Using the slider, adjust the **Opacity**. 100% was chosen in this case to ensure full coverage.

❼ Hold down the **Alt** key on the keyboard and click the mouse over the area you want to clone.

❽ Click on the area to cover. The area under the crossed hairs will be cloned onto the image.

ALIGNED

If you prefer that the area being cloned is always parallel to the tool, select **Aligned** from the options bar.

❶ Make sure **Aligned** is checked.

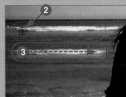

❷ Select your source area (hold down the **Alt** key and click)

❸ Click and drag to clone. This method of cloning is useful for extending or copying straight lines.

OPACITY

Sometimes it is better to reduce the **Opacity** of the clone to ensure a better blend with the surrounding tones.

❶ You can control the **Opacity** by using the pop-up slider.

❷ Select your source area (hold down the **Alt** key and click)

❸ Click and drag to clone. The resulting clone is less opaque than the original. Control opacity when cloning translucent objects.

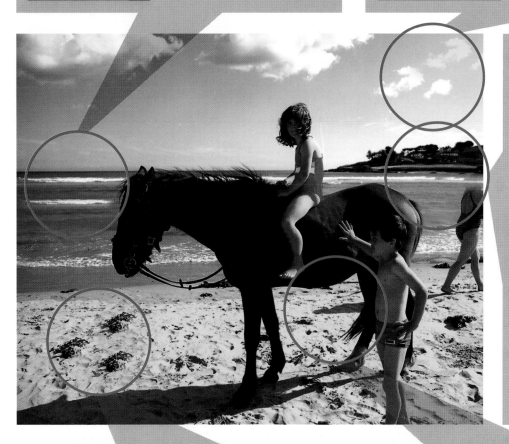

WARNING!

It is important to consider the angle from which you are cloning. In this scene it is important to make sure the clone is parallel to the horizontal line of the waves.

A clone applied at the incorrect angle.

A clone applied at the proper angle.

UNALIGNED

By not aligning the tool, the point you first select will be cloned wherever you move the stamp tool.

❶ Make sure **Aligned** is unchecked.

❷ Select your source area (hold down the **Alt** key and click)

❸ Click to clone. This method of cloning is useful for duplicating isolated objects such as this clump of seaweed.

WARNING!

You must be careful to remove all traces of a subject being cloned away, such as shadows and reflections.

Where's that mysterious shadow coming from?

Cloning the shadow away alleviates visual confusion.

IMAGE CORRECTION AND DISTORTION

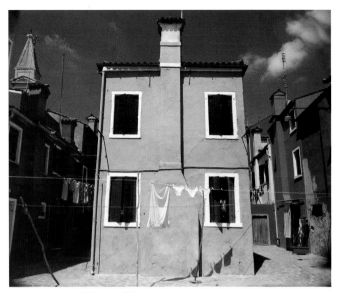

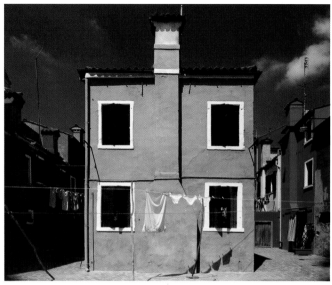

BEFORE: Distorted image.

AFTER: Corrected image using the **Distortion** and **Pinch Tools**.

CORRECTING IMAGE DISTORTION

Key stoning occurs when you photograph a scene at an acute angle. This perspective on the scene affects the vertical lines, causing them to appear to converge. This effect occurs more radically when you are taking a picture using a wide-angle setting on f 2.8, and less when using telephoto. Software offers the option of stretching the image to pull converging lines away from each other into a true vertical.

❶ Go to **View** in the menu bar and select **Grid** to see the verticals more clearly.

❷ Go to **Select** in the menu bar and choose **All**.

❸ Under **Image** in the menu bar, scroll down to **Transform** and choose **Distort.**

❹ Click and drag the corner of your image box until your image is surrounded by gray. You will need this extra space to see the shift.

❺ Pull the top right-hand handle of the bounding box to the right until the slanting line of the wall becomes parallel to the edge of the image.

❻ Repeat for the left-hand side of the image adjusting each as necessary. Press the **Return** key to apply.

PINCHING

Another by-product of using a wide-angle lens is that it will bow the verticals outward, creating a slight fish-eye lens effect—as if viewing the world through a goldfish bowl.

❼ Open **Filter** in the menu bar, scroll down to **Distort**, and select **Pinch**. The **Pinch dialog box** opens with a preview window.

❽ Click on the minus symbol until you are able to see the entire image in the preview window.

❾ Move the slider along until the image in the preview looks less bowed. This should be no more than 3–5%. Click **OK** to apply.

WHEN KEY STONING IS KEY

Key stoning will also add to the expressive impact of landscape—particularly forests, cliffs, cathedrals and skyscrapers—by enhancing the sense of distance and scale. For some portraits, this exaggerates the expressive drama in the composition.

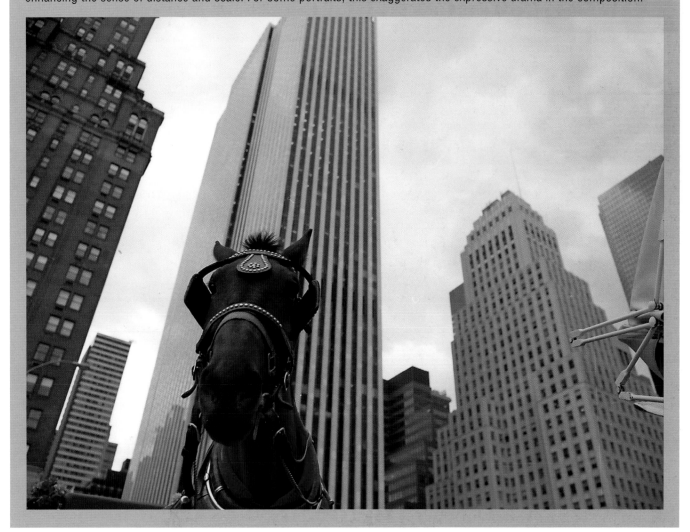

CLEANING UP IMPERFECTIONS

BEFORE: Original image with noise.

AFTER: Corrected image using the **Despeckle** filter.

REMOVING NOISE

There will be situations where the use of flash is inappropriate and shooting in low light is unavoidable. Such photographs often produce speckled patterns of color in the shadow areas. Instead of a uniform tone, the area of shadow has a clearly visible mosaic of red, green and blue patches. The effect—called **Noise** or **artefacts**—is caused by the camera shooting at a higher ISO. Digital photographers can edit out noise through the use of the **Despeckle filter**.

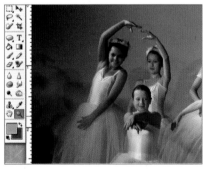

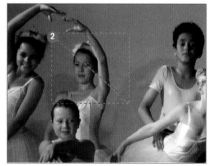

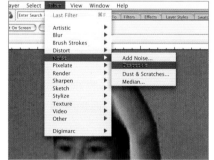

❶ Select the **Zoom Tool** from the toolbox.

❷ Click and drag the **Zoom Tool** to enlarge the image. You will be able to see the effect of the **Despeckle** filter better.

❸ Go to **Filter** and select **Despeckle** from the **Noise** submenu. Since there are no adjustments necessary in this filter, **Despeckle** will be automatically applied.

REMOVING DUST AND SCRATCHES FROM SCANNED PRINTS AND TRANSPARENCIES

BEFORE: Original image with dust specks.

AFTER: Corrected image using the **Dust and Scratches** filter.

❶ Select the **Zoom Tool** from the toolbox.

❷ Click and drag the **Zoom Tool** to enlarge the image. You will be able to see the effect of the **Despeckle** filter better.

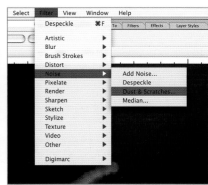

❸ Go to **Filter** and select **Dust and Scratches** from the **Noise** submenu. A dialog box will open with a preview window.

❹ Move the **Radius slider** forward to 1 pixel, then to 2, and so on. You will see that as you increase the pixel radius, larger particles disappear from your image.

❺ Move the **Threshold slider** forward slowly until just before the point at which the spots begin to come back into visibility. When applying this filter, you need to use the lowest radius and the highest threshold possible. Click **OK** to apply.

HELPFUL TIPS

The **Dust and Scratches** filter is best for eliminating small specks, but use the **Clone Stamp Tool** to remove anything larger than 2 or 3 pixels in diameter. You will retain a high definition in your image. Make sure to set the **Mode** to **Darken** in the options bar to remove any white spots and lines. This blending mode is the most efficient at removing spots without affecting the surrounding tones.

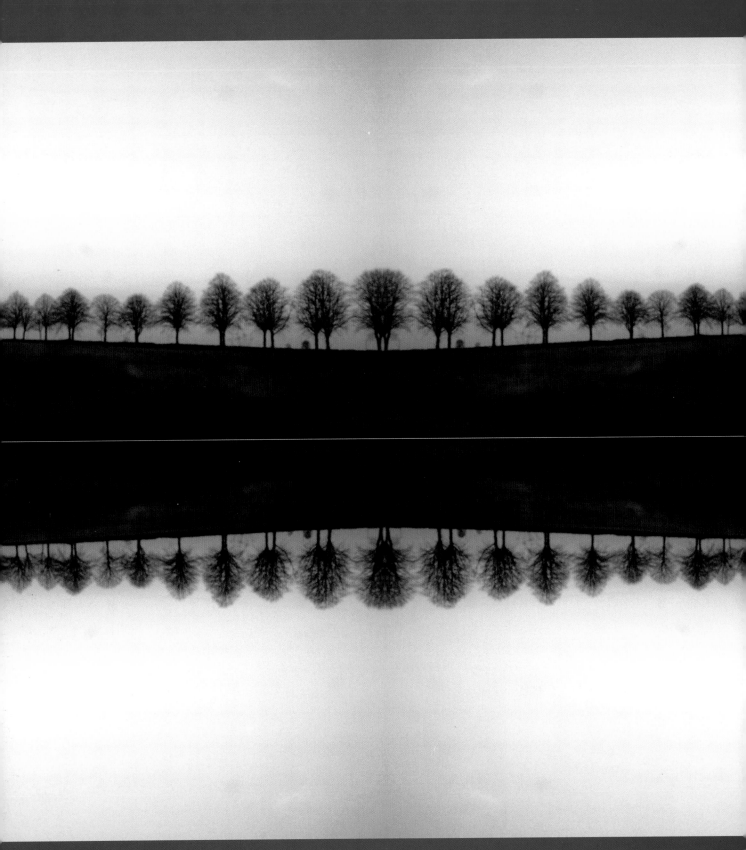

ADVANCED CORRECTION

AND CREATIVE EDITING

INTRODUCTION TO LAYERS

BEFORE: Untouched image of a flower.

AFTER: Image modified using **Layers**.

WHAT ARE LAYERS?

So far you have looked at fixing common problems in images by using the **Quickfix** options. You have also been introduced to some essential adjustments, tools and filters. To do more advanced editing, you will need to build your images using layers. Working with layers is not as complex as it first appears—you can add an adjustment layer with the click of a button. Then, it's a matter of using the very same adjustment dialog boxes that you have already used. **Layers** allows you to build images in transparent overlays—like sheets of images printed on glass stacked on top of each other. This allows you to digitally montage and collage different images.

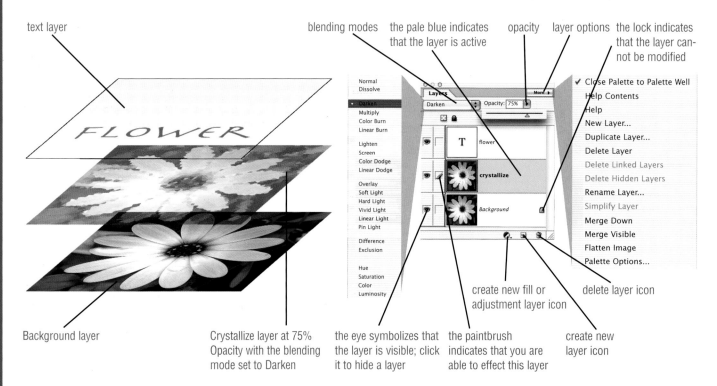

text layer

blending modes

the pale blue indicates that the layer is active

opacity

layer options

the lock indicates that the layer cannot be modified

Background layer

Crystallize layer at 75% Opacity with the blending mode set to Darken

the eye symbolizes that the layer is visible; click it to hide a layer

the paintbrush indicates that you are able to effect this layer

create new fill or adjustment layer icon

delete layer icon

create new layer icon

WORKING IN LAYERS

By overlaying layers and controlling the opacity of the upper layers, you may construct complex montages.

❶ Click and hold on the **More** button on the **Layers** palette and select **Duplicate Layer** from the pop-up menu.

❷ Type in the name of your new layer in the top field. This is important when you work in many layers.

❸ Select an effect from the **Filters** drop-down menu. In this example, **Crystallize** was chosen.

❹ Adjust the **Cell Size** by sliding the blue tab back and forth.

❺ Experiment with the many available blending modes. In this example, **Darken** was chosen.

❻ Adjust the **Opacity**. As your layer becomes less opaque, more of the background layer will become visible.

❼ Select a **Type Tool** from the toolbox.

❽ Click on the foreground color square. The **Color Picker** will open.

❾ Use the center color-bar slider and click in the large gradated box to select your text color. Then click **OK**.

❿ Click on the image and begin typing your text.

⓫ With the **Type Tool**, click and drag over the text to select it.

⓬ Choose a font from the top toolbar.

⓭ Choose a font size from the third blue tab. You may also simply type in a number into the field.

⓮ Select the **Move Tool** from the toolbox. This tool will allow you to move your type around the image.

⓯ Position your text. You may also adjust the size and shape of your type by clicking and dragging the eight handles.

⓰ Once you are satisfied with your image, you may **Flatten** it. This allows you to save your image in the jpg format.

ADJUSTMENT LAYERS AND LEVELS

BEFORE: Original Image.

AFTER: Image modified using **Layers**.

LAYER UPON LAYER

All the quick and simple adjustments covered in **Quickfix** can be applied at a more precise level by using **Adjustment Layers**. With Adjustment Layers, each adjustment to the image you are creating is a separate layer. You can turn this adjustment layer on and off and see the impact on the image and modify each layer at any time. This is very useful, because as you are applying different effects and alterations in layers, the impact of a subsequent layer alteration may cause you to want to alter a previous adjustment. You can move between the adjustments and fine tune each one in turn. Adjustment layer doesn't permanently alter the pixels.

Hue/Saturation Decide which colors you want to edit, then select values for Hue, Saturation, and Lightness.

Gradient Map Decide on your gradient and set gradient options.

Invert These layers don't have any options.

Threshold Choose a threshold level.

Posterize Choose the number of tonal levels for each layer.

Solid Color Choose your color.

Gradient Click the Gradient pop-up menu arrow to get a predefined gradient. You can also edit the gradient in the **Gradient Editor**, by clicking the color gradient.

Pattern Choose a pattern from your pop-up palette. Set additional pattern options if you wish.

Levels Choose values for highlights, shadows, and mid-tones.

Brightness/Contrast Decide on values for Brightness and Contrast.

ADJUSTMENTS AND THEIR OPTIONS

Solid Color
Use the sliders to select the color you wish to cast. Afterwards you can use the **Blending Modes** to combine the color with the appropriate layer.

Gradient
The **Gradient** drop menu arrow will show the presets. **Angle** will change the angle of the **Gradient**. The drop menu for **Style** changes the type of **Gradient** and **Scale** enlarges or decreases the **Gradient**.

Pattern Fill
Choose a **Pattern** from the drop menu and scale the tiling as desired. You can apply **Modes** to combine the layer and pattern.

Levels
To change the value of the high, mid and low **Levels**, move the sliders allotted for each level. The far-right slider is for lights, the center slider is for mid-levels, and the left-most slider is for lows.

Brightness/Contrast
Use the sliders to **Brighten** or **Darken** and add or subtract **Contrast** in the image.

Hue/Saturation
The three sliders in **Hue/Saturation** change the color scheme of the image—**Hue, Saturation,** and **Lightness** (how light or dark the image is).

Gradient Map
By clicking on the blue arrow, the **Gradient Map** presets will pop up. From there you can choose a preset, or define your own **Gradient Map**.

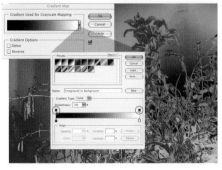

Invert
The **Invert** option inverts the picture to the opposite colors.

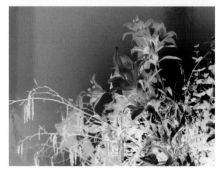

Threshold
Slide the arrow to increase or decrease **Threshold**.

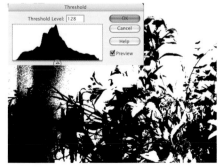

Posterize
Posterize works on value levels; this window lets you choose how many you want.

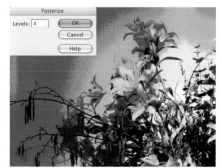

ADJUSTING IN LEVELS

BEFORE: Image has a color bias toward red.

AFTER: Image modified using **Levels**.

USING LEVELS TO FINE TUNE COLOR

The advantage of using **Adjustment Layers** over **Quickfix**, is that you are creating a layer that you can blend with the original image and you can control the transparency of the overlay. You can also see the effect on the image in detail using the preview option.

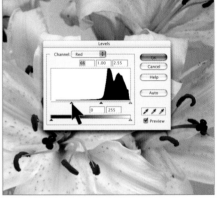

❶ Click and hold the **Create new fill or adjustment layer** icon and select **Levels** from the drop-down menu.

❷ Select which channel you wish to adjust from the **Channel** submenu.

❸ Use the leftmost slider to control the tonal range of darker areas.

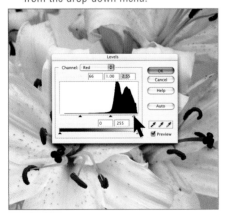

❹ Use the right slider to control the tonal range of highlights, and the middle slider for mid-tones.

❺ Use the **Opacity** slider to smoothly blend the adjustment layer with the background layer.

❻ When you are satisfied with your adjustment, go to **Layer** and choose **Flatten Image** to blend the layers together.

UNDERSTANDING COMPLEMENTARY COLORS

Each color channel has an opposite complementary color: cyan is opposite to red, magenta is opposite to green and yellow is opposite to blue. Therefore, colors balance and shift between these complementary pairs. If your image looks too blue, you would need to open the **Blue** channel and pull the mid-tone slider to the left; you'll see your image become more yellow. When adjusting color using **Levels**, you need to be aware that only a slight movement along the slider will significantly impact the image's color balance.

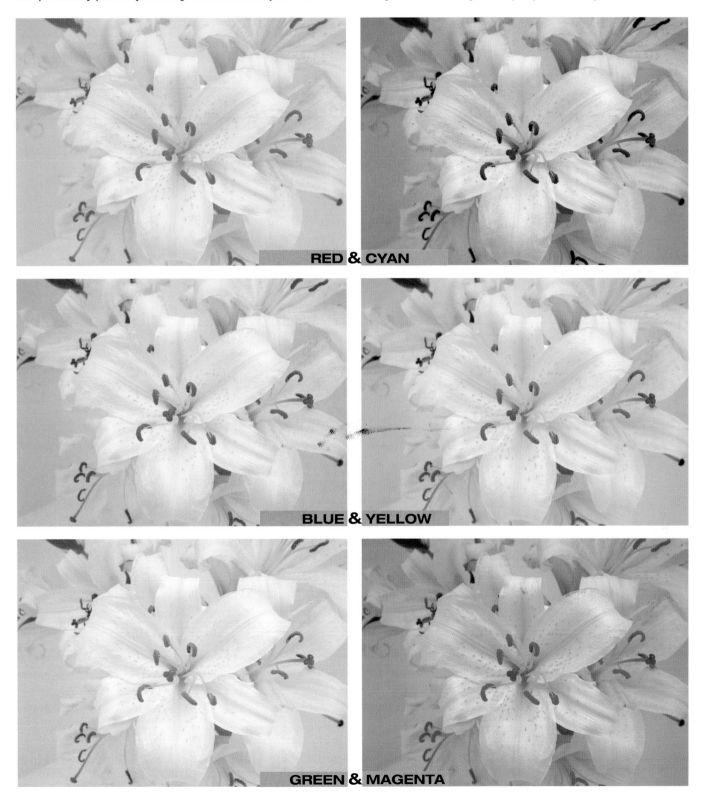

RED & CYAN

BLUE & YELLOW

GREEN & MAGENTA

USING THE SELECTION TOOLS

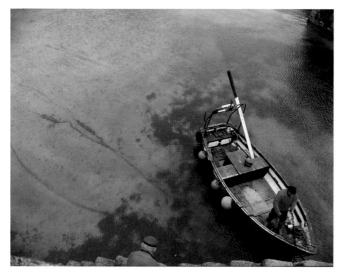

BEFORE: Original image lacks vibrancy.

AFTER: Image modified using the **Selection Tools**.

WHAT IS A SELECTION TOOL?

At the top of the tool box are six of the Selection Tools. Each of these tools lets you make a selection or move the selection in a different way in your image. Making a selection allows you to copy or apply an effect or adjustment to the specific area or pixels that you have selected.

THE MARQUEE TOOL
This tool allows you to make geometrical selections. To create perfect squares or circles, hold down the **Shift** key as you make the selection.

THE MOVE TOOL
This tool allows you to move selections.

THE LASSO TOOL
This tool allows you to make a selection by drawing around an irregular form in your composition. The **Lasso Tool** works by drawing freehand. The **Polygonal Lasso Tool** selects via straight lines. The **Magnetic Lasso Tool** searches and adheres to the edge of a form. This is the most useful tool for isolating a figure in a composition, because you don't have to be so precise in your drawing control.

THE MAGIC WAND TOOL
This tool makes a selection by selecting all related pixels. You can the set the tolerance level, which determines how close the pixels need to be related. You can also set whether the tool selects all those pixels that are the same over the whole composition, by choosing unaligned.

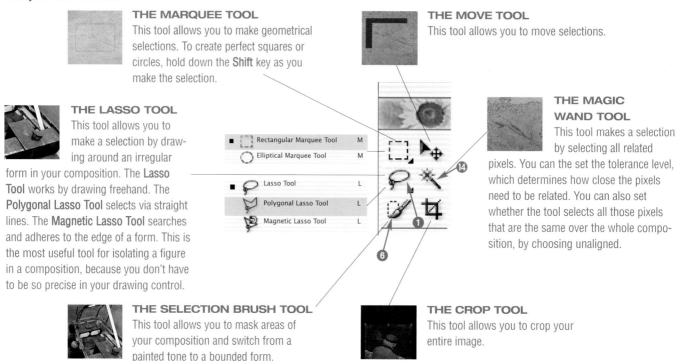

■ [] Rectangular Marquee Tool		M
○ Elliptical Marquee Tool		M
■ ♘ Lasso Tool		L
Polygonal Lasso Tool		L
Magnetic Lasso Tool		L

THE SELECTION BRUSH TOOL
This tool allows you to mask areas of your composition and switch from a painted tone to a bounded form.

THE CROP TOOL
This tool allows you to crop your entire image.

HELPFUL TIPS

- Use of the **Feather** option with the selection tools is necessary to make subtle transitions across altered to unaltered areas.

- Holding down the **Shift** key as you make a selection adds to an existing selection. Holding down the **Alt** key as you make a selection subtracts from an existing selection. This is useful when dealing with complex selections.

WORKING WITH SELECTIONS

The key to adjusting specific portions of your image is in mastering the selection tools.

1 Click and hold the **Lasso Tool** and select **Polygonal Lasso Tool** from the submenu.

2 Click on the corners of a straight-edge portion of your image. Finish the selection by clicking on the start point.

3 Go to **Enhance** and select **Hue/Saturation** from the **Adjust Color** submenu.

4 Adjust the color of your selection by moving the sliders under the three headings. Click **OK** when you are satisfied.

5 Go to **Select** and choose **Deselect** from the drop-down menu. You are now free to make another selection.

6 Click on the **Selection Brush Tool** from the toolbox.

7 Choose a brush from the drop-down menu.

8 Make sure the **Mode** is set to **Mask**.

9 When masking objects with hard lines, you'll want to set **Hardness** to 100%. This ensures a clean selection.

10 Begin painting over the objects you wish to mask. When masking in straight lines, holding down the **Shift** key helps.

11 In this example everything but the water has been masked.

12 Change the **Mode** from **Mask** to **Selection**. Everything not masked will now be selected.

13 Repeat steps **3** and **4**.

14 Select the **Magic Wand Tool** from the toolbox.

15 Click around your image and experiment with making various selections.

16 Once you have decided on a selection, apply steps **3** and **4**.

FIXING OVEREXPOSURE

BEFORE: Overexposed image.

AFTER: Overexposure corrected via **Layers** and **Multiply**.

FIXING OVEREXPOSED IMAGES

The process below is the most precise way to correct images that have been overexposed.

❶ Click and hold on the **More** button of the **Layers** palette and select **Duplicate Layer** from the pop-up menu.

❷ Type in the name of your new layer in the top field. This becomes important if you work in many layers.

❸ Set the **Blending** mode to **Multiply**. The image will immediately turn darker.

❹ Use the **Opacity** slider to control the strength of the **Multiply** blending mode. In most cases, 50–60% is best.

❺ Once you are satisfied with your adjustment, select **Flatten Image** by clicking and holding the **More** button in the **Layers** palette.

FIXING UNDEREXPOSURE

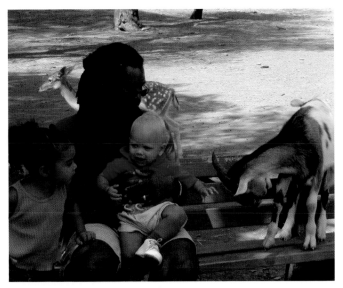

BEFORE: Underexposed image.

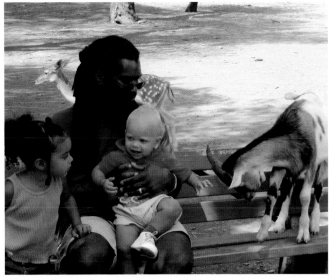

AFTER: Underexposed corrected via **Layers** and **Screen**.

FIXING UNDEREXPOSED IMAGES

The process below is the most precise way to correct images that have been underexposed.

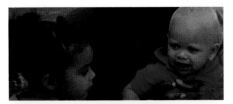

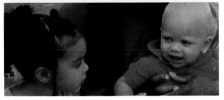

❶ Click and hold on the **More** button of the **Layers** palette and select **Duplicate Layer** from the pop-up menu.

❷ Type in the name of your new layer in the top field. This becomes important if you work in many layers.

❸ Set the **Blending** mode to **Screen**. The image will immediately turn lighter.

❹ Use the **Opacity** slider to control the strength of the **Screen** blending mode. In most cases, 50–60% is best.

❺ Once you are satisfied with your adjustment, select **Flatten Image** by clicking and holding the **More** button in the **Layers** palette.

REMOVING NOISE

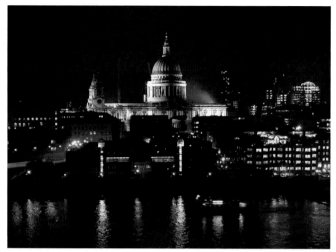

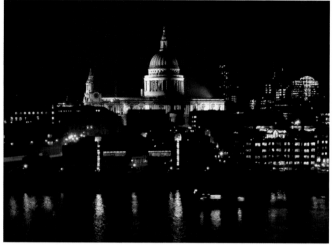

BEFORE: Original image with noise caused by low light.

AFTER: The noise has been significantly reduced.

REMOVING NOISE THROUGH LAYERING

It is common for images taken in low-level lighting to have areas of noise in the shadow areas. Instead of a smooth even tone, there is the distinctive speckling of red, green and blue pixels in the dark tones of the image. There will be many occasions when you will need to adjust the image to remove noise. In cases of extreme noise, the **Despeckle** filter is an inadequate solution.

THE COMPOSITE
Both layers shown together produce the finished photograph.

THE MULTIPLY LAYER
The **Multiply** blending mode typically darkens areas. In conjunction with **Median**, this blending mode is useful in removing noise. The white areas represent where the layer has been erased so that the details show through from the background layer.

THE BACKGROUND LAYER
The original noisy photograph.

REDUCING NOISE USING THE BLUR TOOL
In images where only small areas are affected by noise, a simple solution is to apply the **Blur** tool, which reduces the appearance of noise by smoothing the differences in the pixels in the area.

USING THE MAGIC WAND TOOL AND LEVELS
In images where small dark areas are affected by noise, another solution is to select these areas using the **Magic Wand** tool, and then using **Levels**, to reduce the saturation to eliminate the color.

REMOVING NOISE FROM THE SHADOWS IN AN IMAGE

The process below corrects a very common problem for digital photographers. The aim is to darken the shadow areas to remove noise, then to bring back detail using the **Eraser** tool. This process maximizes the amount of detail that can be retained.

❶ Click and hold on the **More** button on the **Layers** palette and select **Duplicate Layer** from the pop-up menu.

❷ Type in the name of the new layer in the top field. This becomes important if you work in many layers.

❸ Go to **Filter** and select **Median** from the **Noise** submenu.

❹ Adjust the **Radius** until most of the noise is blurred away, and click **OK**.

❺ Set the blending mode to **Multiply**.

❻ Adjust the **Opacity** of the layer to the point just before the noise begins to show through from the background layer.

❼ Select the **Eraser Tool** from the toolbox.

❽ For this process, it is usually best to select a brush with a soft edge.

❾ By erasing away portions of the top layer, the original background layer will show through. This will increase the brightness and detail of the highlights.

ADVANCED BLACK AND WHITE

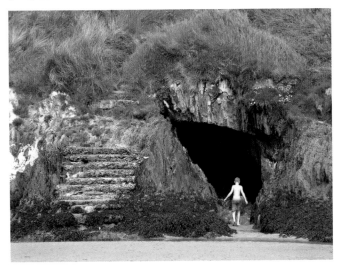

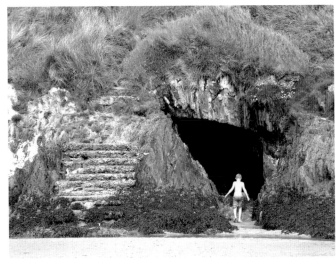

BEFORE: Color image with flat tonal range and poor contrast.

AFTER: Black-and-white image with improved contrast.

PRECISE CONTROL OF VALUES

Although you can turn a color image into black and white by converting to grayscale, the resulting image can lack depth of tonal contrast. By working with **Adjustment Layers**, you can alter the values of shadows, mid-tones, and highlights. For precise and rich tones in black and white, you need to work in **RGB** rather than grayscale and use the **Red**, **Green** and **Blue** channels in **Levels** after using **Hue/Saturation** to de-saturate the color image.

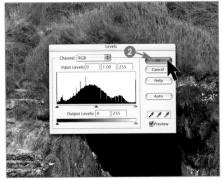

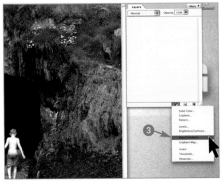

❶ Click and hold the **Create New Fill or Adjustment Layer** icon at the bottom of the **Layers** palette and select **Levels**.

❷ For now, simply click **OK** in the **Layers** dialog box. You'll return to this later.

❸ Click and hold the **Create New Fill or Adjustment Layer** icon at the bottom of the **Layers** palette, and select **Hue/Saturation**.

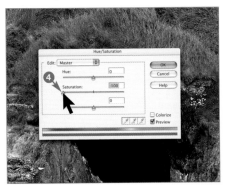

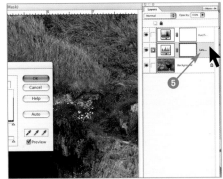

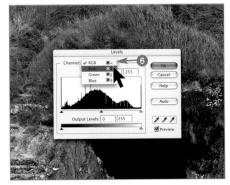

❹ Set the **Saturation** to −100 by dragging the middle slider all the way to the left. The color will vanish as you do this.

❺ Open the **Levels** dialog box by double clicking on the **Levels** thumbnail in the **Layers** palette.

❻ Click and hold the tab next to **Channel**, and release the mouse over **Red**, to work in the red channel.

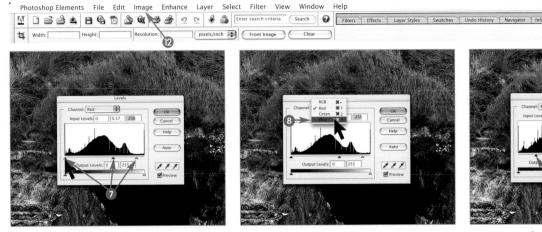

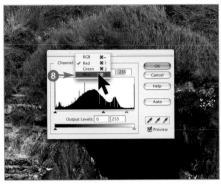

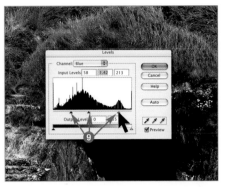

7 Make adjustments by moving the sliders located below the graph. The changes take place in real time, so you can see the effect of your adjustments.

8 Switch to the **Blue** channel.

9 Make further adjustments using the sliders.

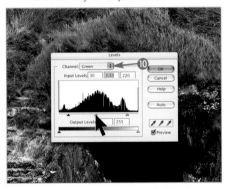

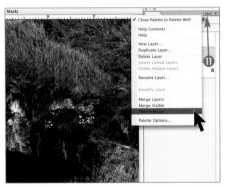

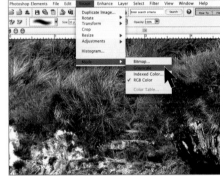

10 Repeat for the **Green** channel. Continue this process until you have maximized the tonal range and contrast.

11 Click and hold the **More** button on the **Layers** palette, and select **Flatten Image** from the pop-up menu.

12 Go to **Image** and select **Grayscale** from the **Mode** submenu.

IMAGES MAY BE SALVAGED BY CONVERTING THEM TO BLACK AND WHITE

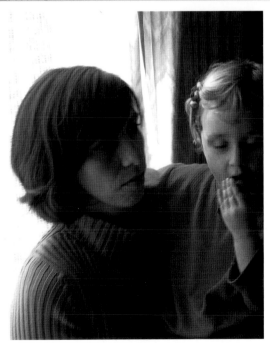

In this image of a mother and child by a window, an otherwise unsatisfactory color image can become powerful in black and white. Although the definition suffers from camera shake and the image is over-exposed, the composition has potential in black and white, if the tonal range is improved. The clever technique illustrated above was applied in order to increase the tonal contrast, and was devised by Scott Kelby, author of *The Photoshop Elements Book for Digital Photographers*.

COMBINING COLOR AND GRAYSCALE

BEFORE: Full color image.

AFTER: Image with both color and grayscale elements.

ERASING THROUGH A LAYER

A very simple and effective way to combine color and black and white is to create a grayscale image from a color image, and then place the grayscale image over the color image in the **Layers** menu. Then, use the **Eraser** tool to erase areas of the black-and-white image, which allows the color image to show through.

Photoshop Elements File Edit Image Enhance Layer Select Filter View Win

Size: 45 px Mode: Brush Opacity: 50%

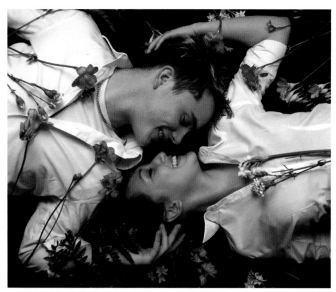

① Go to **Select** and choose **All** from the drop-down menu.

② Go to **Edit** and select **Copy** from the drop-down menu.

③ Go to **File** and select **New** from the drop-down menu.

④ In the **New** dialog box, make sure **Mode** is set to **Grayscale**.

⑤ Go to **Edit** and select **Paste** from the drop-down menu.

⑥ Drag the grayscale image onto the color image so that it aligns precisely.

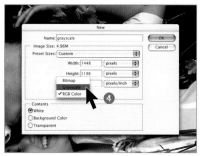

7 Select the **Eraser Tool** from the toolbox.

8 Select a brush with a soft edge from the **Brushes** drop-down menu.

9 Adjust the **Opacity** of the tool by moving the slider to 50%. This will aid in controlling the amount of color that will show through.

10 Erase over the areas that you want in color. Erasing over an area twice will double the amount of color that shows through.

11 You can quickly change the size of the tool by hitting the left- and right-bracket keys. You may need to do this to erase small areas.

12 Once you are satisfied with the image, go to **Layer** and select **Flatten Image**.

GENTLE COLOR

The images below illustrate the same concept outlined above. You can completely erase areas to let the full color show through, or only partially erase the grayscale layer, so that a gentle color shows through. This can be achieved by setting the **Opacity** of the **Eraser** tool to around 20%.

Full color layer.

Partially erased black-and-white layer.

The combined images.

CREATIVE CHANGING OF COLOR

BEFORE: Original image.

AFTER: Modified image using **Hue/Saturation**.

CREATIVE ALTERING OF COLOR

The quality of the color in a composition will have a profound affect on the overall meaning and atmosphere of the image. There will be times when you will want to replace a color in a composition either to create a different atmosphere or to create a new color harmony.

❶ Click and hold the **Create New Fill or Adjustment Layer** icon at the bottom of the **Layers** palette and select **Hue/Saturation**.

❷ Experiment by using the three sliders. Observe what effect each of the values has on your image. Click **OK** when you are satisfied.

CREATIVE REPLACEMENT OF COLOR

This photograph resembles the wonderful late paintings of water lilies by the painter Claude Monet. The original image inspired a series of color variations ranging from cool to warm hues.

BEFORE: Original image.

AFTER: Modified image using **Replace Color**.

SELECTIVE REPLACEMENT OF COLOR

Replacing a color for part of an image can be achieved with ease by using **Replace Color**. This allows you to make radical or subtle color changes to a precise range of pixels in an image. **Replace Color** is similar to the **Magic Wand Tool** in how it selects related pixels.

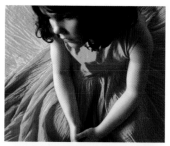

❶ Go to **Enhance** and select **Replace Color** from the **Adjust Color** submenu.

❷ When the cursor is placed over the image, it will turn into an eyedropper. Use it to select the color you wish to replace.

❸ Adjust the selection by moving the **Fuzziness** slider. When moved to the right, more pixels will be selected.

❹ The lower half of the **Replace Color** dialog box works exactly like the **Hue/Saturation** dialog box.

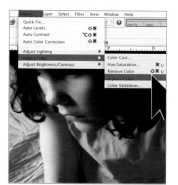

HAND TINTING

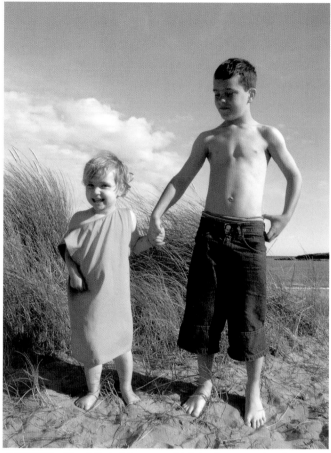

BEFORE: Original full-color image.

AFTER: Hand-tinted image, which looks more timeless.

HAND-TINTING PHOTOGRAPHS

Hand-tinting a photograph combines documentary truth and imaginative interpretation, fusing the photographic imprint of the subject with the intimate touch of a hand-painted work of art. The result gives the image a timeless, preserved quality. Creating this effect digital-ly is a matter of de-saturating the image of all color and then adding color back in by painting in washes or tints using the **Brush Tool**.

CREATING A TIMELESS IMAGE

The original image has the potential to be an attractive and atmospheric photograph, but the color is a bit flat and uninspired. This could be rectified using **Hue/Saturation**, but the timeless nature of this image suggests that a more radical makeover is needed.

❶ Go to **Enhance** and select **Remove Color** from the **Adjust Color** submenu.

❷ Click and hold the **Create New Adjustment Layer** icon and select **Hue/Saturation**.

❸ Click **Colorize** in the **Hue/Saturation** dialog box.

❹ In this example, the **Hue** was set to 215. The **Saturation** should be kept fairly low.

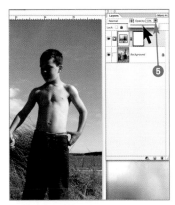

5 Set the **Opacity** of the adjustment layer to 50%.

6 Select the **Brush Tool** from the toolbox.

7 Click on the **Background** layer to make it active.

8 Select a medium-sized **Brush** with a soft edge.

9 Change the **Mode** to **Color**.

10 Set the **Opacity** of the **Brush Tool** to 50%.

11 Click on the foreground color box at the bottom of the tool-box. This will open the **Color Picker**.

12 Select a color by using the slider in the central color bar and clicking in the large gradated box. Then click **OK**.

13 Paint in the areas you wish to color. To intensify the color, simply repaint over a color area.

14 In this example, the clouds are tinted to a warm yellow. To quickly control the **Size** of the brush, press the left and right bracket keys.

15 Continue coloring until you are satisfied with the effect. Repeat steps **11** and **12** to change the color that you wish to apply.

16 Once you are finished coloring, select **Flatten Image** from the **Layer** in the menu. Flattening reduces the size of your image.

THE HISTORY OF HAND-TINTING

Early photographic processing created black-and-white prints. The method of hand-tinting photographs developed out of a desire to add color to these prints. The early photographers would take notes on the color of their subject's complexion and clothing, and their assistants would faithfully recreate the likeness by painting washes of color onto the lighter tones of the photograph.

SELECTIVE SHARPENING

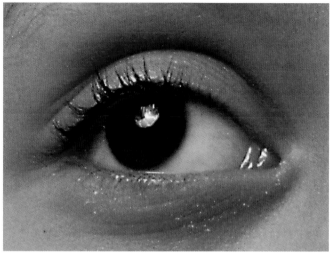

BEFORE: Original image.

AFTER: Modified image using **Unsharp Mask**.

THE SHARPEN FILTERS

The **Sharpen** filters add focus and clarity to an image. However, you need to apply this filter with moderation. Excessive application will create visual noise. *Noise* is the term used to refer to the speckled appearance created by too much tone and color difference in pixels. You will see this occurring in areas that should be more uniform, such as areas of skin tone. It is essential that you view the image close up as you apply the filter using the preview. Use the **Zoom Tool** to enlarge the details of your image to examine the effect.

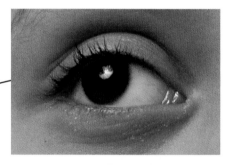

SHARPEN

The first sharpen filter automatically applies a set level of sharpening in the same manner as the **Quickfix** option. It is applied by highlighting and releasing the mouse.

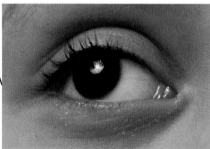

SHARPEN EDGES

This filter is applied in the same way as **Sharpen** but sharpens only the pixels at the edges of forms.

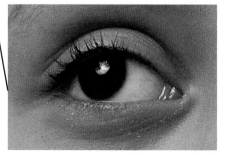

SHARPEN MORE

This filter works in the same way as **Sharpen** but applies a stronger sharpening effect.

UNSHARP MASK

This filter is explained on the opposite page.

QUICKFIX

You can apply the **Sharpen** filter simply by using **Quick Fix.** You can also selectively sharpen via the **Sharpen Tool** contained in the toolbox.

UNSHARP MASK

Unsharp Mask allows for a very precise control of sharpening. The three parameters of the filter are: **Amount**, **Radius** and **Threshold**. These parameters are set to default settings that you can adjust by moving the pointer on the slider bar. As you make adjustments, carefully examine the degree to which the pixels are sharpened and the amount at which visual noise begins to occur.

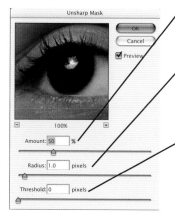

AMOUNT

In an image with good definition, you'll want to set the parameter between 50–100%. For extreme cases, use 300%.

RADIUS

In an image with good definition, leave the radius between 1 to 2 pixels. In the case of a blurry image, you can correct the blur to a degree by increasing the radius to 5.

THRESHOLD

This parameter is important in controlling where the sharpening is applied. In the case of skin tones and other large areas of uniform tone, applying any sharpen command will generate noticeable noise and break up the smoothness of the tones in these areas. By increasing the threshold, the sharpen filter is only applied to the edge areas of an image. This makes it a very useful parameter for portraits—the eyes and features are given extra definition.

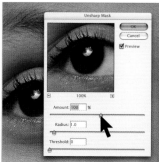

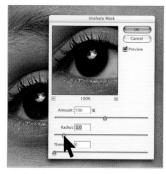

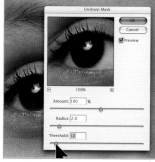

❶ Go to **Filter** and select **Unsharp Mask** from the **Sharpen** submenu.

❷ Set the **Amount** to 100%. You will see your image begin to sharpen.

❸ Set the **Radius** to 2.0. The sharpening effect will increase dramatically.

❹ Slide the Threshold slider to the right until most of the visual noise generated by the sharpening effect vanishes.

WHEN YOU CAN SHARPEN A LOT

With portraits, and subjects with flat areas of tone, sharpening needs to be applied very discreetly. However, with very busy subjects broken by pattern and contrasting areas, you can apply a much heavier sharpening to enhance the texture.

CREATIVE BLURRING

BEFORE: The focused background competes with subject.

AFTER: Background blurred with **Gaussian Blur**.

BLURRING BACKGROUNDS

You can gently reduce a texture in a portrait or more dramatically eliminate all of the background detail in a scene that is distracting from the foreground interest. The **Blur** filter also softens and smoothes skin texture, making it a really useful tool for portrait photography. You can also use the blur filter to create special motion effects, such as a figure jumping or running, or a fast-moving vehicle.

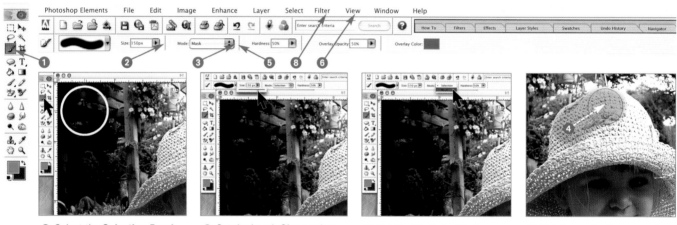

❶ Select the **Selection Brush Tool** from the toolbox.

❷ Set the brush **Size** so that you can comfortably paint over your foreground image.

❸ Set the **Mode** to **Mask**.

❹ Paint over the foreground image. To quickly change the size of your brush, press the left or right bracket keys.

❺ Set the **Mode** to **Selection**. The background will become selected.

❻ Go to Filter and select **Gaussian Blur** from the **Blur** submenu.

❼ Increase the **Radius** until the background recedes to your satisfaction.

❽ Go to **Select** and choose **Deselect**.

EXPLANATION OF THE BLUR FILTERS

Blur is usually a thing to avoid in photography. So it might initially strike you as a filter that you would rarely want to use. In actuality, it is a necessary filter for reducing distracting detail. Blur filters are useful for reducing the amount of focus and definition in areas of a composition. For example, it might be used to create a soft-focus effect to gently reduce a texture in a portrait.

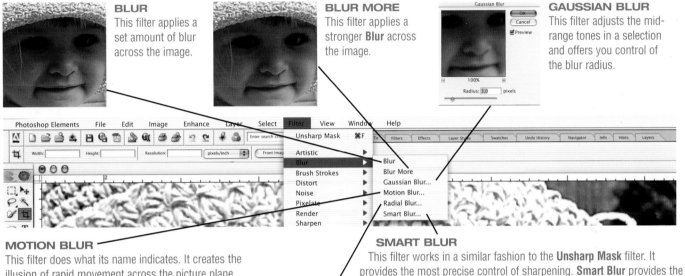

BLUR
This filter applies a set amount of blur across the image.

BLUR MORE
This filter applies a stronger **Blur** across the image.

GAUSSIAN BLUR
This filter adjusts the mid-range tones in a selection and offers you control of the blur radius.

MOTION BLUR
This filter does what its name indicates. It creates the illusion of rapid movement across the picture plane.

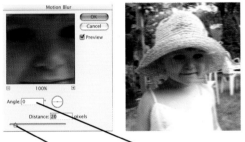

You can adjust the distance of the blur by pulling on the slider.

You can adjust the direction of the blur by typing in an angle from 0° to 360°.

SMART BLUR
This filter works in a similar fashion to the **Unsharp Mask** filter. It provides the most precise control of sharpening. **Smart Blur** provides the widest range of control for blurring an image. You can control the **Radius** of the pixels to be blurred. **Threshold** determines how different the pixels are to be blurred. You can also control the way the blur affects the edges in the image.

RADIAL BLUR
There are two **Blur Methods** to this filter: **Spin** and **Zoom**.

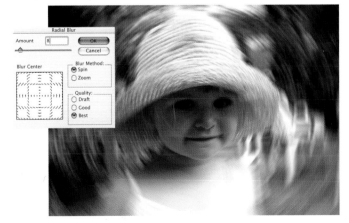

The **Spin Blur Method** creates the illusion that either the subject or the camera is spinning. It could also be used to focus the viewers' eye into the center of a composition.

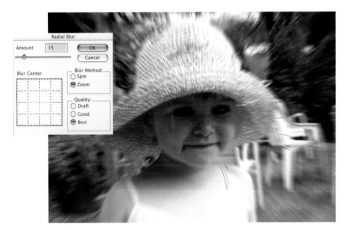

The **Zoom Blur Method** creates the illusion of rapid movement towards the lens. This gives the impression of a form such as a figure, animal or transport quickly moving towards you.

RETOUCHING PORTRAITS

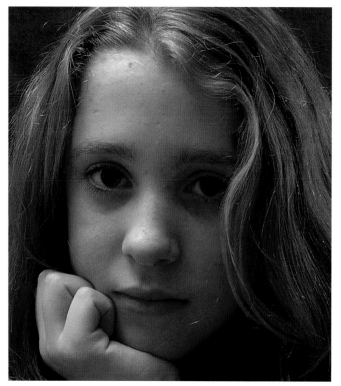

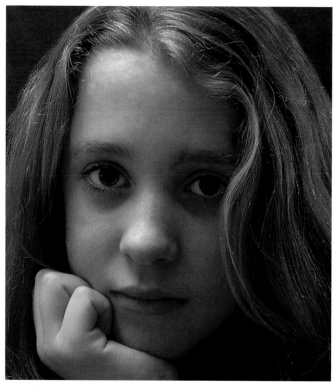

BEFORE: Original image with blemishes.

AFTER: Enhanced image with smooth skin and bright eyes.

IMPROVING ON NATURE

You will usually want to take a photograph that shows your subject at their most attractive. This means posing the subject to their best profile and using soft lighting. Often, you will shoot a really good portrait that is marred by noticeable skin blemishes. Using digital editing software, you can improve the look of your subject by applying subtle adjustments to skin, hair, eyes and teeth. You can also remove any distracting hairs, spots, blemishes and scars. Teenagers with blemishes are particularly image-sensitive, and young children—when they are active and adventurous—are rarely free of small bruises and grazes. Older subjects generally prefer to be flattered and feel hurt when an image makes them look heavier or older than they feel. All of these anxieties and expectations must be considered when you approach portrait photography. Well, not to worry: all of the details that can make-or-break a portrait can be addressed and resolved by using a few simple and highly effective techniques.

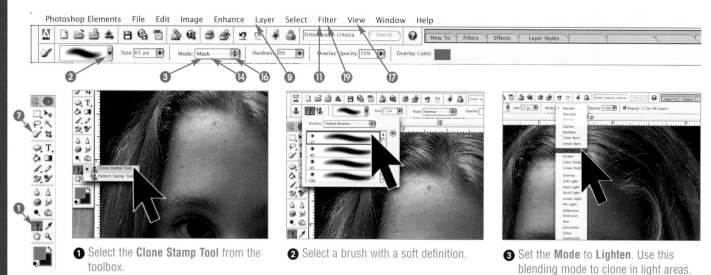

❶ Select the **Clone Stamp Tool** from the toolbox.

❷ Select a brush with a soft definition.

❸ Set the **Mode** to **Lighten**. Use this blending mode to clone in light areas.

4 Press the **Alt** key as you click the mouse to select the source pixels for your clone.

5 Click on the blemishes to clone over them. To quickly change the size of any tool, press the left and right bracket keys.

6 Clone away any loose hairs. It is best to use the **Normal** blending mode. (See step **3** to see how to change blending modes.)

7 Select the **Selection Brush Tool** from the toolbox. Adjust the size of the brush by pressing the left and right bracket keys.

8 Paint over the whites of the eyes to select them. You may deselect selected areas by holding down the **Alt** key.

9 Go to **Enhance** and select **Hue/Saturation** from the **Adjust Color** submenu.

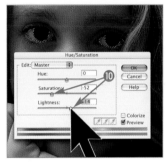

10 Decrease the **Saturation** and increase the **Lightness** of your selection. Be careful to not make the whites too bright.

11 Go to **Select** and choose **Deselect**. You are ready to make your next selection.

12 Paint over the color portion of the eyes to select them. You may deselect selected areas by holding down the **Alt** key.

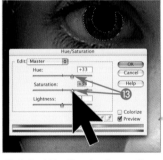

13 Adjust the **Hue** to change the color of eye. Increase **Saturation** to intensify the color.

14 Change the **Mode** to **Mask**.

15 Paint over any portions you wish to remain visually sharp, such as eyes, lips and hair.

16 Switch the **Mode** to **Selection**. All pixels not masked will be selected.

17 Go to Filter and select **Gaussian Blur** from the **Blur** submenu.

18 Increase the **Radius** until the skin appears smoother.

19 Go to **Select** and choose **Deselect**.

A FULL MAKEOVER

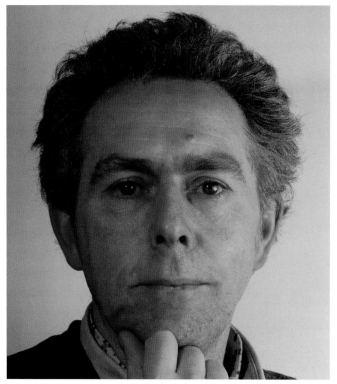

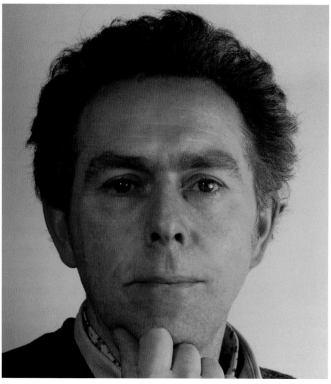

BEFORE: Image with blemishes.

AFTER: A complete makeover.

A STARTLING TRANSFORMATION

The previous pages outlined various methods of enhancing portrait features—either by removing skin blemishes, or heightening tone and color in eyes and teeth. You can really make a radical transformation to a portrait. The portrait on the left shows a serious photographer in a fairly run-down state: a mole on the forehead, a day's stubble, bloodshot eyes from scanning a million photographs and a host of worry lines—not to mention a scabby lip and a few burst blood vessels, capped by a frizzy head of graying hair and a few beads of perspiration. However, note that these natural facial flaws are remedied in the image on the right. Such a visual modification may seem like a serious challenge, causing you to wonder where to begin. However, as always, digital image-editing software makes it simple.

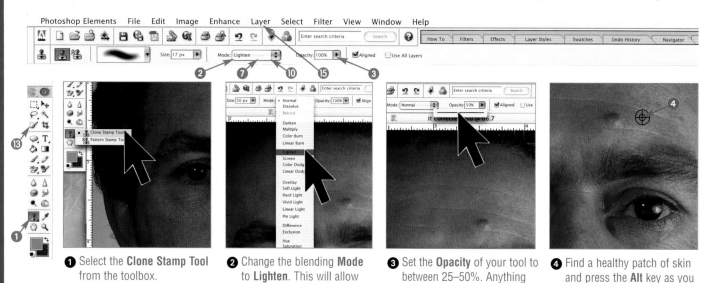

❶ Select the **Clone Stamp Tool** from the toolbox.

❷ Change the blending **Mode** to **Lighten**. This will allow you to clone over darker blemishes smoothly.

❸ Set the **Opacity** of your tool to between 25–50%. Anything more would cause the cloned parts to look unnatural.

❹ Find a healthy patch of skin and press the **Alt** key as you click the mouse to select the source pixels for your clone.

5 Click over the darker blemishes to clone them away. Repeat until all of the darker blemishes have been removed.

6 This method of cloning is perfect for removing stubble and other small dark particles.

7 Change the **Mode** to **Darken**. This blending mode is useful for removing light colored or darkening gray hair.

8 Press the **Alt** key and click the mouse to select the source pixels for your clone.

9 As you clone, you'll notice the hair getting darker.

10 Change the **Mode** to **Normal**. This blending mode is useful when cloning from a uniform set of pixels.

11 Press the **Alt** key and click the mouse to select the source pixels for your clone.

12 Clone away loose hairs, including any that are intruding the face. Make sure you change your clone source accordingly.

13 Select the **Selection Brush Tool** from the toolbox. Adjust the size of the brush by pressing the left and right bracket keys.

14 Paint over the whites of the eyes to select them. You may deselect selected areas by holding down the **Alt** key.

15 Go to **Enhance** and select **Hue/Saturation** from the **Adjust Color** submenu.

16 Decrease the **Saturation** and increase the **Lightness** of your selection. Be careful to not make the whites too bright.

CHANGING HAIR COLOR

Hair color can easily be changed. It's fun and easy to do!

BEFORE

Select the hair with the **Magic Wand Tool**.

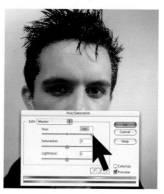

Use the **Hue** slider to see the hair change into different colors.

AFTER

CHANGING BACKGROUNDS

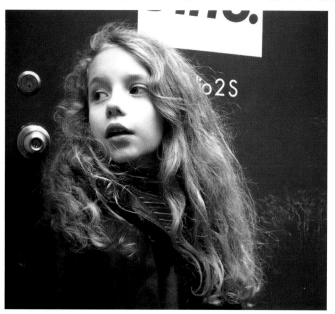

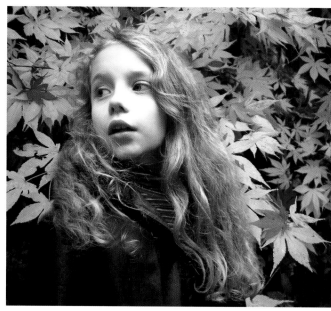

BEFORE: Original image has an uninspiring background.

AFTER: New image with a more pleasant background.

Photoshop Elements File Edit Image Enhance Layer Select Filter View Window Help

MONTAGES: CHANGING BACKGROUNDS

A method of montaging is to improve a photograph by replacing the original—yet unsympathetic—background with a more aesthetically pleasing setting. You can also apply abstract backgrounds by applying a fill and a gradient layer. Here you will learn the process of removing a background, and replacing it with a different image.

❶ Open the **Layers** palette.

❷ Click on the **More** button on the **Layers** palette and select **Duplicate Layer**.

❸ Click on the **Eye** symbol of the background layer to hide this layer.

❹ Click on the **Selection Brush Tool** in the tool box.

❺ Select a brush with a soft definition.

❻ Adjust your brush size using the pop-up slider.

❼ In the options bar, under **Mode**, select **Mask**.

❽ Set the **Hardness** of the brush to be around 50%.

⑨ Paint over the outline of the foreground image.

⑩ Click **Selection Mode** in the options bar. Press the **Delete** key to erase the background.

⑪ Go to **Select** and choose **Deselect** from the drop-down menu.

⑫ Hold down the **Eraser Tool** in the tool box and select the **Background Eraser Tool**.

⑬ Set this tool to a **Size** of 250px.

⑭ You have to set the tool at 20% or less because setting it too high will erase more of the image than you want.

⑮ Move the eraser and click over the edge of the image until you have removed all the background from the outline.

⑯ Open your chosen background image.

⑰ Click and drag the new background image into the foreground image window.

⑱ Move this new layer so that it is under your foreground layer, by clicking and dragging the thumbnail.

⑲ If your background is smaller than your fore-ground image, go to **Image** and select **Scale** from the **Resize** submenu.

⑳ Hold down **Shift** (this assures that the resize will occur with the proper proportions) and drag the corner until the background fills the window.

EXPLORING ALTERNATE BACKGROUNDS

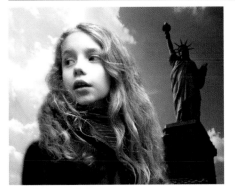 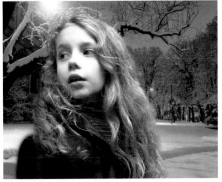

APPLYING A GRADIENT FILL

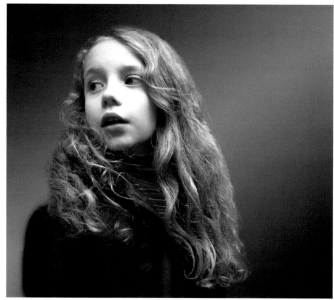

BEFORE: Image with no background.

AFTER: New image with a gradient fill applied to the background.

CREATING A BACKGROUND

Once you have extracted a figure from a scene or removed a background from a portrait photograph, you can create a background as an alternative to pasting in another image. The most effective method of building a background is to create a solid color fill in adjustment layers and then to a add a gradient. You can then use the gradient layer to modify the solid color so that it graduates from dark to light.

❶ Click and hold on the **Create New Fill or Adjustment Layer** symbol and select **Solid Color** from the drop-down menu.

❷ Select a color by using the slider in the central color bar and clicking in the large gradated box. Click **OK**.

❸ Click and drag the color fill layer and release the mouse when it is under the foreground image layer.

❹ Click and hold on the **Create New Fill or Adjustment Layer** symbol and select **Gradient** from the drop-down menu.

❺ Reveal the **Gradient** selection drop-down menu by clicking on the blue arrow. Click on a square to choose a gradient.

❻ There are five options in the **Style** tab. In this example, **Reflected** was selected.

❼ You may also adjust the **Angle** of the gradient by typing a number in the field, or by clicking and dragging the line in the circle.

❽ You may also adjust the **Scale** of the gradient by typing a number in the field, or by using the drop-down slider.

9 Click on the **Reverse** box to see the gradient reversed.

10 Explore the many blending modes. In this example, **Multiply** was applied.

11 You may also adjust the **Opacity** of the gradient fill by typing a number 0–100 in the field, or by using the drop-down slider.

12 To flatten your image, click the **More** tab of the **Layers** palette and select **Flatten Image**.

BLENDING A GRADIENT FILL ON A BACKGROUND

Once you have created the gradient fill over the solid color, you can begin to explore some of the amazing gradient effects in the **Gradient** dialog window. Click on the **Gradient Fill** submenu and a palette of gradient styles will drop down. Begin by exploring the first tonal gradient, which simply masks the image in a white tone gradated to transparency. Then explore the 5 options under **Style**. These are **Linear, Radial, Angle, Reflected** and **Diamond**. You can also angle or invert the gradient and adjust the scale. In the image below, a simple red/green gradient was applied. On the following pages, you will find a gallery that shows you what each of the options can do.

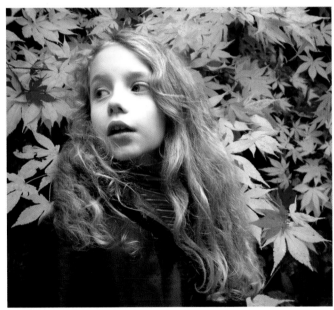

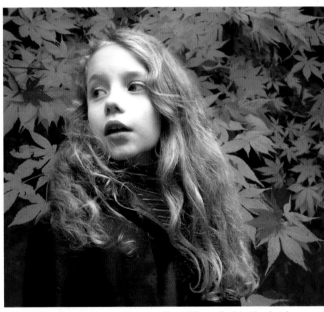

BEFORE: Image with new background.

AFTER: New image with a gradient fill applied to the background.

1 Click and hold on the **Create New Fill or Adjustment Layer** symbol and select **Gradient** from the drop-down menu.

2 Click and hold the blue arrow left of **OK** to reveal the **Gradient** submenu. Select one by clicking on the thumbnail.

3 Choose a gradient **Style** from the drop-down menu. In this case, **Linear** was chosen.

4 Use the **Opacity** slider to control the strength of the gradient fill.

MONTAGING IMAGES

BEFORE: Original image of girl with flowers.

AFTER: Montaged image adds a magical touch.

EXTRACTING AND MONTAGING

In this montage, an uninspiring image of child peering into a bouquet of flowers has been combined with another image of an art student dressed as a fairy. The picture was completed by adding fragments of images from an illustration. The image celebrates the child's little imaginative daydreams; that the fairies store their treasures—the pretty striped snails—among the rose's petals.

① Open the image and create a **Duplicate Layer** in the **Layers** palette and make this the active layer.

② Click the **Selection Tool** in the tool box. Make sure the **Mode** in the option bar is set on **Mask**.

③ Begin to **Mask** over the leaves, flowers and child.

④ Using a **Soft-Edge Brush**, soften the edges of your selection around the child's head. Use a hard edge where desired.

⑤ Switch back to **Selection Mode** and press the **Delete** button to delete the background.

⑥ Open the image of the hedgerow with the fairy bells. Go to **Select** and click **Select All**. Go to **Edit** and then click **Copy**.

7 **Paste** into the Child image by going to **Edit** (see **6**). Arrange the layer underneath the **Background Copy**.

8 Click on the **Magnetic Lasso** and trace the fairy. **Paste** into the Child image (see **7**) in front of the **Background Copy**.

9 Pull on the **Bounding Box** handles to enlarge or decrease the image of the fairy.

10 For the snail image, use the **Selection Tool** in **Mask Mode** to mask the snails. (see **2**)

11 After switching to **Selection Mode**, delete the rest of the image. (see **5**)

12 **Paste** the snails above all other layers in the Child image. (see **7**)

MONTAGING IMAGES

Montaging images has a great many uses. You can place people playfully in different contexts or use the montaging technique for more practical purposes. You can make your own posters, flyers, customized invitations, birthday and thank-you cards, as well as cards for special occasions such as weddings and anniversaries. [See the section on making cards, pp 218–219].

In this image, the umbrella and child were extracted from two different photographs and pasted onto four images of a poster joined together.

JUXTAPOSITION AND MIRRORING

BEFORE: Single leaf image.　　　　　　　　　　**AFTER:** Mirrored image.

CREATIVE PLAY MONTAGING BY JUXTAPOSITION AND MIRRORING

As well as using the **Layers** to montage images over each other, you can use **Layers** to montage images side by side. A simple but creative device is to create a **Mirror Image**. This is very easy to do, and results in some stunningly beautiful symmetrical and patterned compositions that will both delight and amaze as simple and prosaic images are transformed into geometric arrangements.

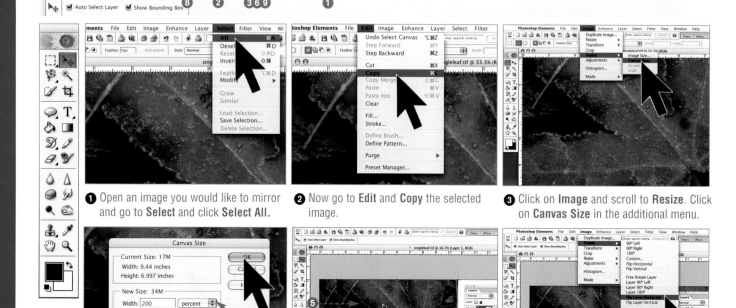

❶ Open an image you would like to mirror and go to **Select** and click **Select All.**

❷ Now go to **Edit** and **Copy** the selected image.

❸ Click on **Image** and scroll to **Resize**. Click on **Canvas Size** in the additional menu.

❹ Now double the **Width** (or height depending on orientation) and **Anchor** which direction to add from. Click **OK.**

❺ **Paste** in the copied image by going to **Edit** (see ❷). Move your image over to the edge of the canvas.

❻ Go to **Image** and scroll to **Rotate**, and click on **Flip Layer Horizontal** to flip the image and create the mirrored effect.

7 Flipping the image **Horizontally** turns the image to the right.

8 Enlarge your canvas (see **3**) for the lower quadrant and **Paste** in the image again (see **5**). Arrange your image in the lower corner.

9 Flip the the pasted image vertically using the **Flip Layer Vertical** option (see **6**) this time to mirror the image above.

10 **Paste** in the copied image (see **5**), **Flip Vertical** (see **9**) and move it to the lower corner to mirror the the first image. Repeat these steps until you are satisfied.

The child looking into the waterfall takes on the mysterious symmetrical quality of identical twins by using a single mirror image.

The rather ordinary row of trees now has a rather magical property as it has been mirrored both across and then below using four images.

PURGING THE HISTORY

If you have a limited amount of RAM (random-access memory), you may find that you will not have enough memory to complete the last command. With every action, the **History** will save your image at that command. This uses an enormous amount of memory. To remedy this, go to **Edit** and scroll to **Purge**. This clears all this temporary information and allows you to continue.

IMAGE SIZE

If you repeat the process beyond four, the image size will become very large and your computer will take longer to process the images. You will need to stop at this stage and resize your image to reduce the pixel count. Resize to fit the largest size your printer can print, either 8x11 for an A4 print or 11x16 for an A3 print. Set the resolution at a minimum of 150 pixels per inch if you want to print at photo-resolution quality.

DIGITAL PAINTINGS

CREATIVE USE OF THE PAINTING TOOLS

In the previous pages, you explored the different ways to montage images in layers, either over or beside one another. While it is true that the editing program is primarily designed for the editing of photographs, the program also provides all the tools you will need to create your own drawings and paintings. You can make a painting from scratch on an empty canvas or paint and draw over a photograph or any other image of your choosing. With the advent of digital editing in art schools, both fine-art and design students quickly realized the potential of this new and exciting medium. It is now commonplace to see students scanning in images to paint over, or using the screen as a blank canvas to explore composition. One of the great pleasures of using the painting tools on the computer screen is that you are actually painting with light rather than with physical paint. You will also find that the colors on the computer screen are extremely vibrant, which adds to the aesthetic appeal.

Digital painting is akin to the processes of silk-screen printmaking in which you can use a combination of photographic imagery with freehand drawing and painting. Just as with silk-screen printmaking, when you are painting in photoshop you can overlay layers of images, shapes, and brush strokes in any number of different color combinations. You can also start out with an interesting digital image you have taken with your camera and use any of the painting tools to overlay shapes, lines and color areas.

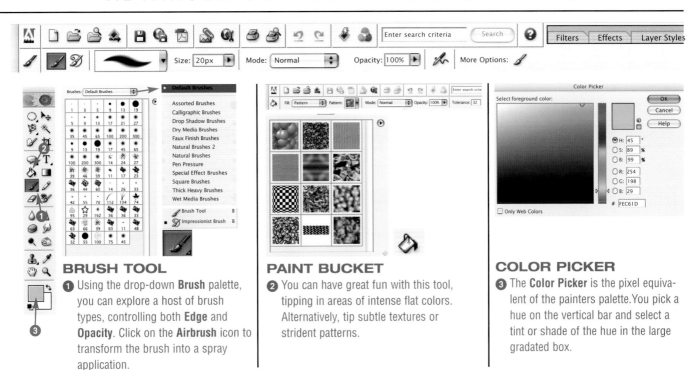

BRUSH TOOL

❶ Using the drop-down **Brush** palette, you can explore a host of brush types, controlling both **Edge** and **Opacity**. Click on the **Airbrush** icon to transform the brush into a spray application.

PAINT BUCKET

❷ You can have great fun with this tool, tipping in areas of intense flat colors. Alternatively, tip subtle textures or strident patterns.

COLOR PICKER

❸ The **Color Picker** is the pixel equivalent of the painters palette. You pick a hue on the vertical bar and select a tint or shade of the hue in the large gradated box.

USING THE PAINTING TOOLS AND LAYERS

The toolbox has a host of exciting painting effects to explore. Especially in the **Brush** palette, you will find a tremendous range of textures that you can use in combination with the delicate applications of a diffused **Airbrush Tool**, or with the flat color of the **Paint Bucket**. It is also possible to apply different texture effects with this tool. Play and experiment with complete and total freedom as, with all of these processes, you can undo anything you have done that you don't like, then start over again with something new.

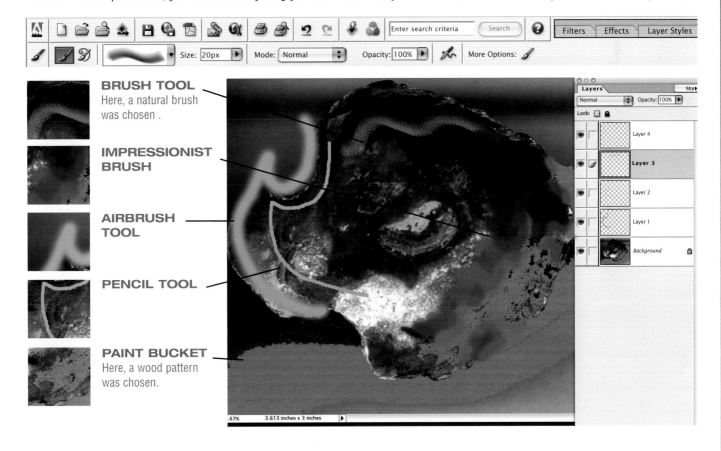

BRUSH TOOL
Here, a natural brush was chosen.

IMPRESSIONIST BRUSH

AIRBRUSH TOOL

PENCIL TOOL

PAINT BUCKET
Here, a wood pattern was chosen.

FILTER EFFECTS

BEFORE: Original image.

AFTER: Image with the **Plaster** filter at 100%.

WHAT IS A FILTER?

Filter effects refer back to the different types of colored glass sheets and treated lenses used by film-based photographers to modify the appearance of a scene. Digital-editing software recreates these filter effects digitally. The software also offers many visual effects that mimic artistic painting and drawing styles derived from the world of graphics, allowing you to enhance or create new qualities of light, color, texture and form. In the earlier sections of this book, you have already explored a number of filters using **Blur** and **Sharpen** to add subtle changes to the lighting or texture of your subject. This gallery is for your future reference and to help you navigate through the categories. Filter effects can add both subtle and radical texture enhancements to an image.

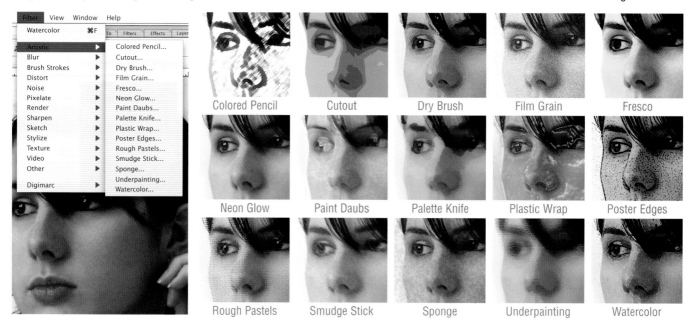

Colored Pencil	Cutout	Dry Brush	Film Grain	Fresco
Neon Glow	Paint Daubs	Palette Knife	Plastic Wrap	Poster Edges
Rough Pastels	Smudge Stick	Sponge	Underpainting	Watercolor

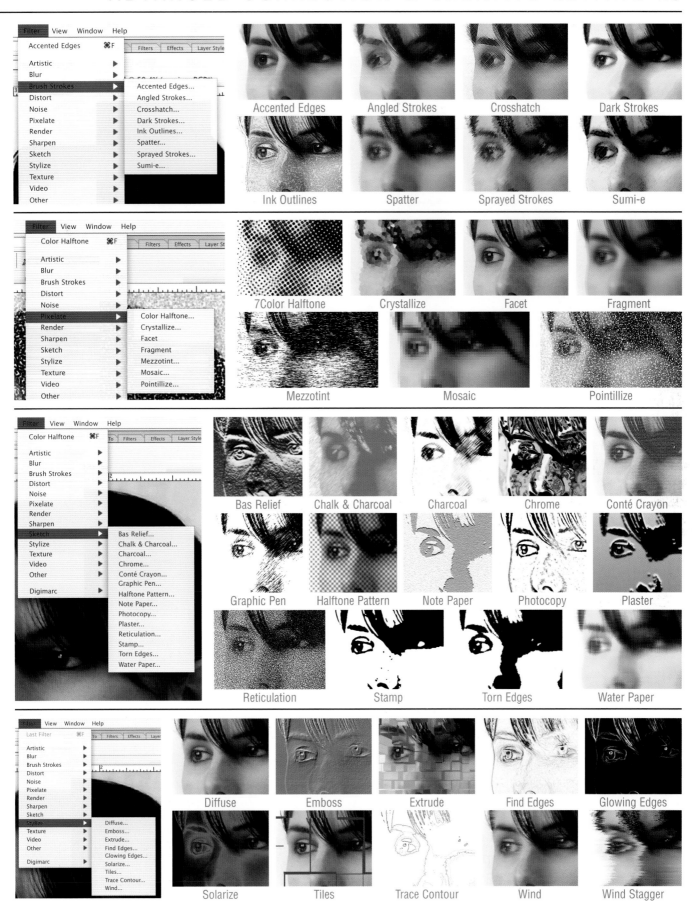

Accented Edges Angled Strokes Crosshatch Dark Strokes

Ink Outlines Spatter Sprayed Strokes Sumi-e

7Color Halftone Crystallize Facet Fragment

Mezzotint Mosaic Pointillize

Bas Relief Chalk & Charcoal Charcoal Chrome Conté Crayon

Graphic Pen Halftone Pattern Note Paper Photocopy Plaster

Reticulation Stamp Torn Edges Water Paper

Diffuse Emboss Extrude Find Edges Glowing Edges

Solarize Tiles Trace Contour Wind Wind Stagger

TEXTURIZING BACKGROUNDS

BEFORE: A straight photo.

AFTER: Image with **Canvas** background.

ADDING ARTISTIC TEXTURAL EFFECTS TO AN IMAGE

Texturizing a background is a process that adds subtle patterns of texture to your image in a way that alludes to fine-art photographic prints. You can give your photograph the illusory appearance of having been printed on canvas or textured paper.

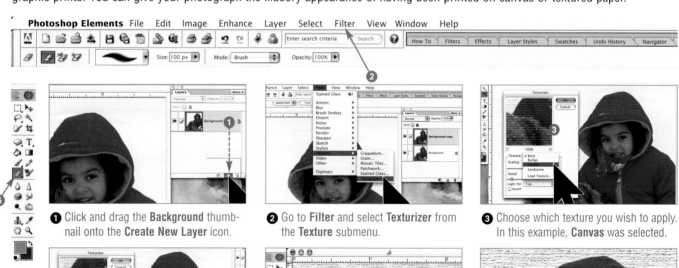

❶ Click and drag the **Background** thumbnail onto the **Create New Layer** icon.

❷ Go to **Filter** and select **Texturizer** from the **Texture** submenu.

❸ Choose which texture you wish to apply. In this example, **Canvas** was selected.

❹ Adjust the **Scaling** and **Relief** sliders to achieve your desired texture.

❺ Select the **Eraser Tool** from the toolbox.

❻ Erase the foreground image so that the background layer shows through.

GALLERY OF TEXTURES

There is a range of textures that can be applied at different scales to enhance the character of your image. For most images, you will need to keep the scale and degree of relief low, otherwise the image will be overly disrupted by the texture.

Whole image with **Craquelure.**

Background with **Craquelure.**

Whole image with **Grain.**

Background with **Grain.**

Whole image with **Mosaic Tiles**.

Background with **Mosaic Tiles**.

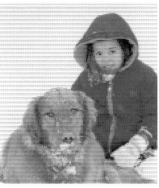

Whole image with **Patchwork**.

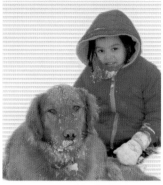

Background with **Patchwork**.

Whole image with **Stained Glass.**

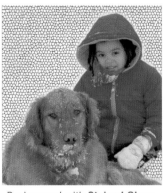

Background with **Stained Glass.**

Whole image with **Brick**.

Background with **Brick**.

Whole image with **Burlap**.

Background with **Burlap**.

Whole image with **Sandstone**.

Background with **Sandstone**.

CLASSICAL "PAINTED" PORTRAITS

BEFORE: Original image.

AFTER: Image becomes painting-like with a Watercolor filter.

PAINTING-LIKE PICTURES

You can use the range of **Filters** to create very particular visual effects that evoke associations with other media such as painting, printmaking and film. Here, an image is enhanced by adding a subtle application of the **Watercolor** filter, and then the **Texturizer** to create a canvas-painting appearance on your image. After you have followed the process outlined here, take the time to apply different textures and artistic painting and drawing effects to a copy of the same image. You can add these effects as layers in the **Layers** menu and then see how pairs of effects work in combination by turning on and off the different layers and adjusting the **Opacity** slider.

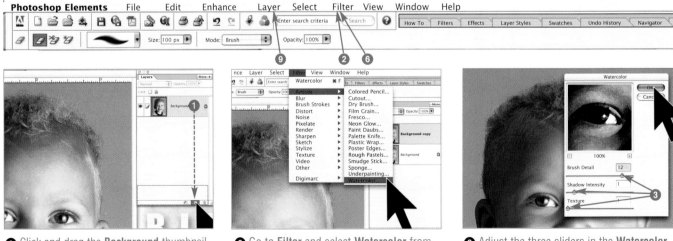

❶ Click and drag the **Background** thumbnail onto the **Create New Layer** icon.

❷ Go to **Filter** and select **Watercolor** from the **Artistic** submenu.

❸ Adjust the three sliders in the **Watercolor** dialog box to achieve a painterly effect in your portrait. Click **OK**.

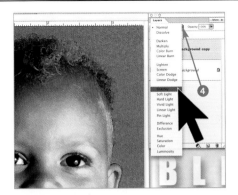

❹ Change the blending mode to **Overlay**.

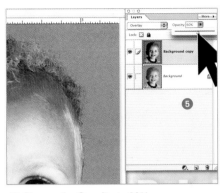

❺ Change the **Opacity** to 60%.

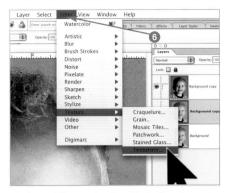

❻ Go to **Filter** and select **Texturizer** from the **Texture** submenu.

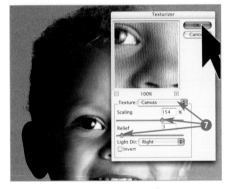

❼ Make sure **Texture** is set to **Canvas**. Adjust the **Scaling** and **Relief** sliders until you are satisfied with the texture. Click **OK**.

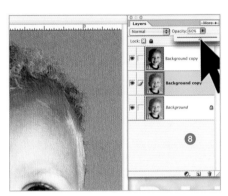

❽ Change the **Opacity** to 60%.

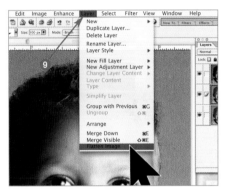

❾ Go to **Layer** and select **Flatten Image**.

PRINTING YOUR ART

You can print your images onto actual textured papers and even specialized canvas treated to accept inkjet printing ink. However, because of the uneven surface, printing on actual textured surfaces ironically often produces a less satisfactory image than applying a digital texture effect to photo-quality printing paper. A good compromise is to use a matte printing paper with a slight texture—your texture filters will look stunning, creating the appearance of a fine-art–quality print.

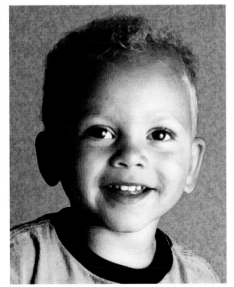

Artistic: Fresco

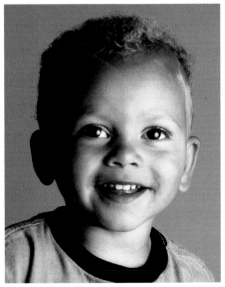

Sketch: Charcoal

Brush Strokes: Sumi-e

ADJUSTMENT MODES

BEFORE: Image before adjustment.

AFTER: Image with adjustments applied.

ADJUSTMENT MODES

As you become familiar with how to use the essential tools and filters in photo-editing programs, you will become increasingly confident and feel more comfortable about experimenting. You will learn as much by trying things out for yourself, as by following instruction. Ask yourself, "What would happen if I overlaid this on that?" and, "What if I added another layer? And another?" Here is an example of some of the combinations to be discovered by overlaying adjustments in layers and in combination with each other. The brilliant thing is that if you don't like what you've come up with, you can undo it immediately and start again with something else.

❶ To effectively look at **Adjustment** options, start with a duplicate of your **Background** layer. Go to **More** in the **Layers** palette and scroll to **Duplicate Layer** in the drop-down menu.

❷ Go to **Image** and scroll to **Adjustments** to choose an adjustment effect from the additional menu. There are five different adjustment effects: **Equalize, Gradient Map, Invert, Posterize** and **Threshold**.

EQUALIZE
Creates an equal distance between one tone and the next.

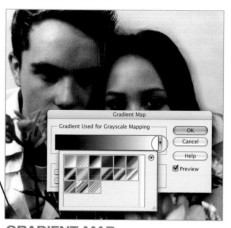

GRADIENT MAP
For **Gradient Map**, choose from the slider or the preset patterns.

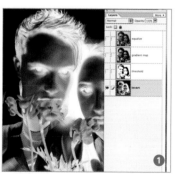

INVERT
Creates a negative of the original image.

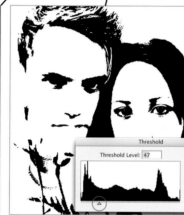

THRESHOLD
Use the slider to adjust the image in the **Threshold** window.

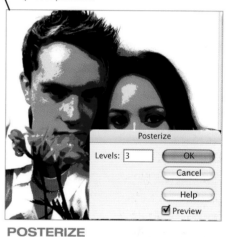

POSTERIZE
For **Posterize**, a window will open with a **Levels** field. Each level is a value-sensitive color field.

USING ADJUSTMENT MODES AND LAYERS

Here the adjustment modes were each applied in turn to the background image and saved as a layer in the **Layers** palette. Their order was then moved around to find the best combination. When you make an adjustment, on its own it will appear extreme and rather crude; placed either over the original image or overlaid on another adjustment, it will create a subtle combination of effects. By reducing the **Opacity**, you can then control the exact degree of visibility of each of the layers. Turn each of the layers on and off in combination with another adjustment layer and learn to trust your instincts.

❶ **Inverted** in the first layer.
❷ With **Threshold** used, and **Multiply** as the **Blend** setting.
❸ **Gradient** used with 56% **Opacity**.
❹ **Equalize** used with 50% **Opacity**.

GRADIENT MAPPING

BEFORE: Original image.

AFTER: Image altered with gradient blends.

COLOR

By using the **Gradient Map** command, you can transform a photograph into a fine-art print. The gradient automatically maps the tonal range and then you can apply any one of the available gradient styles to the image. This produces startling gradations of color across the image. You can use a single gradient or apply different gradient styles and overlay them using the **Layers** palette, adjusting the **Opacity** of each layer. You can also use different blending modes and experiment with combinations of gradients by switching the layers on and off and organizing them in different orders. It's a brilliant and simple way to explore expressive color. For a primer on color to help direct your experiments, refer to the pages on Color Theory, or simply follow your own tastes to make a variety of stunning images.

❶ Click and hold the **Create New Fill or Adjustment Layer** icon and release the mouse over **Gradient Map**.

❷ Choose a gradient from the pop-up menu and repeat the process to create new gradient map layers in the **Layers** palette.

❸ Experiment with the various blending modes.

GRADIENT MAPPING GALLERY

BLENDING MODES

BEFORE: Skater in mid-jump.

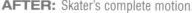
AFTER: Skater's complete motion.

BLENDING MODES

Blending Mode allows you to merge two layers in ways that enhance color or create a particular lighting effect. Under blending mode, there are 22 options in a drop-down menu that offer a palette of both subtle and creative visual blending effects that can transform the image, from simple overlay to radical color exclusions. You can also use these blending modes as options when applying painting and fill tools.

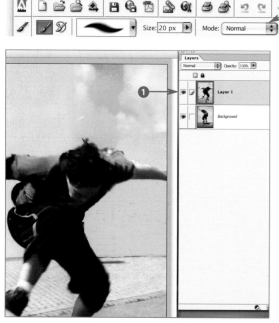

❶ Select the layer you want to blend. To blend successfully, you must pick a layer that is above another. ❷ In the drop menu under the **Layers** tab, choose a **Blending Mode**. Depending on the effect you desire, or how much of the bottom layer to show through, you can adjust the **Opacity** in the **Layers** palette. ❸ You can also use blending modes with the **Paintbrush** by selecting one from the option bar.

EXPLORING BLENDING MODES

The simplest way to understand how a blending mode works is to think of the original image as the *base* layer and the overlaid layer as the *blend* layer. The blend layer is the layer that is being blended into the base layer by the blending mode. Two images of the same subject have been placed within the **Layers** palette and overlaid to demonstrate the different and related qualities of each of the blending modes. Initially, the most important blending modes to try are **Overlay**, **Multiply**, **Soft Light**, and so that you can quickly see the range of blending mode effects on your image.

GALLERY OF BLENDING MODES

The blending modes are grouped in five related subsets of lighting effects. If you don't want to try all 22, select one or two from each of the five sub-categories of blending modes. Try applying each of the blending modes in turn and moving the **Opacity** slider from 100% down to 20% to see the effect of each blending mode on the image at different opacities. **Normal** is the default mode; changing the opacity simply fades the intensity of the blend layer. **Dissolve** combines the blend layer with the base layer in a random diffused pattern.

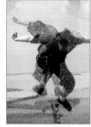

Normal **Dissolve**

Normal
● Dissolve
Darken
Multiply
Color Burn
Linear Burn
Lighten
Screen
Color Dodge
Linear Dodge
Overlay
Soft Light
Hard Light
Vivid Light
Linear Light
Pin Light
Difference
Exclusion
Hue
Saturation
Color
Luminosity

These blending modes darken the base layer either in parts or as a whole. They generally have no effect while blending with white.

 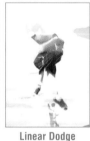

Darken **Multiply** **Color Burn** **Linear Burn**

These blending modes lighten the base layer, often making colors brighter in the blending layer. Blending with black has no effect.

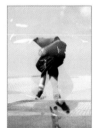 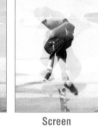 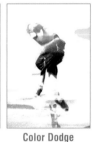 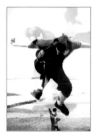

Lighten **Screen** **Color Dodge** **Linear Dodge**

Overlay superimposes the blend image onto the base image while preserving the highlights and shadows of the base color. The rest of the modes are all variations of overlay.

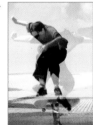 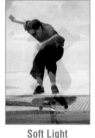 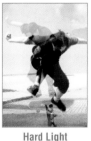 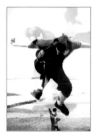

Overlay **Soft Light** **Hard Light** **Vivid Light** **Linear Light** **Pin Light**

The first two modes subtract the base color from the blend color or vice versa depending on which is brighter. The other modes preserve color, saturation or hue in the base layer.

Difference **Exclusion** **Hue** **Saturation** **Luminosity** **Color**

LIGHTING EFFECTS

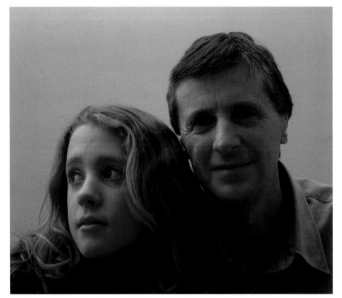

BEFORE: A totally flat image.

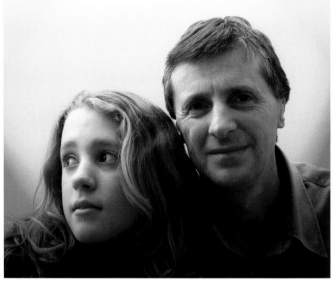

AFTER: Light effects enhance contrast.

THE LIGHTING EFFECTS DIALOG BOX

Lighting Effects is a sophisticated command for changing the appearance of the lighting in an RGB image. This filter lifts a tonally flat shot by applying a distinctive directional lighting either alone or in groups. You can alter the direction and intensity of the light to alter the existing ambient lighting in the image. As with most other filters, the lighting effects need to be applied carefully.

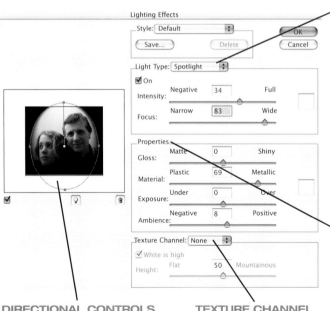

LIGHT TYPE

Choose a light type from the pop-up menu. **Omni** shines light in all directions like a light bulb suspended above the scene. **Directional** projects light from an angle that you can set. The **Spotlight** casts an elliptical beam of light. Drag the **Intensity** and **Focus** sliders to increase the effect of each. To alter the color of the light, click the **Color** box and use the **Color Picker**.

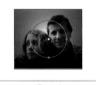

Directional

Omni

Spotlight

PROPERTIES

Use the sliders to adjust the properties listed under **Gloss Material, Exposure** and **Ambience**.

Matte - **Gloss** - Shiny Plastic - **Material** - Metallic

Under - **Exposure** - Over Negative - **Ambience** - Positive

DIRECTIONAL CONTROLS

The line controls the direction and angle of the light, while the handles control the edge of the ellipse. Pull on the handles to increase or decrease the size and shape of the ellipse. You can rotate the line of direction at any angle and pull on the handles to extend beyond the area of the image. As the size increases, the **Intensity** of the light diminishes .

TEXTURE CHANNEL

The **Texture Channel** option is for controlling how light reflects off of an image. See the section on texturizing backgrounds, for information on applying a texture map.

PUTTING A SPOTLIGHT IN YOUR IMAGE

You can choose from several lighting types and also add or delete spotlights from an image. To create a new light, drag the icon at the base of the dialog box into the preview area. You can do this for up to 16 lights in an image.

❶ Go to **Filter** and select **Lighting Effects** from the **Render** submenu. This will open the **Lighting Effects** dialog box.

❷ Change **Light Type** to **Spotlight**.

❸ Adjust the four handles to control the direction and angle of the spotlight.

❹ Adjust the sliders to control the spotlight strength and properties. Experiment to achieve your desired results. Click **OK** to apply.

LIGHTING EFFECTS GALLERY

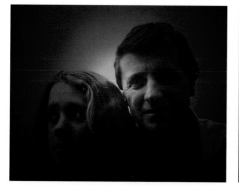

RESTORING PHOTOS

BEFORE: A damaged old photograph.

AFTER: A digitally remastered photograph.

RESTORING PHOTOGRAPHS

Photographs of childhood and important family events from the past are precious mementos. Many of these images become damaged with the passage of time, accumulating creases, scratches and fading from exposure to sunlight. There is a straightforward process to restore old and damaged photographs using the **Clone Tool** to copy undamaged areas onto damaged or missing parts of the image. You can either scan or take a digital photograph of the original, and once you have edited the composition, you will then have your image in a permanent form to be enlarged and reproduced in whichever way you want. You can apply these techniques outlined here to either color or black-and-white images. In this example, an old and faded image of a couple cutting the cake at their wedding is restored to a pristine photograph. These restored photographs make priceless gifts for family members.

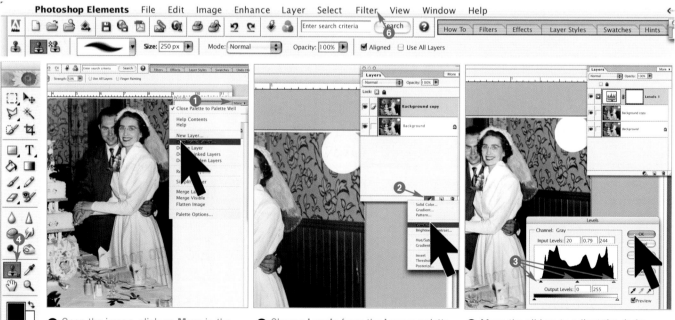

❶ Open the image, click on **More** in the **Layers** palette and choose **Duplicate Layer**.

❷ Choose **Levels** from the **Layers** palette options bar.

❸ Move the sliders to adjust the darks, mid-tones and lights. Click **OK** when finished.

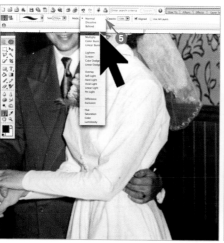

4 Choose the **Clone Tool**, hold the **Alt** key and click on the area you want to clone. Then click on the area you want to cover.

5 Use the **Mode** option in the options bar to select **Darken** to eliminate the white marks, and the **Lighten** mode for dark marks.

6 For small knicks on the surface of the photo, use the **Dust & Scratches** filter located in **Filter**.

7 Move the **Radius** and **Threshold** sliders to change the effect the filter has on the image. Click **OK** when you are finished.

8 Use the **Unsharp Mask** to tighten up the image after the **Dust & Scratches Filter**.

9 Use **Amount**, **Radius** and **Threshold** to achieve the desired effects and click **OK**.

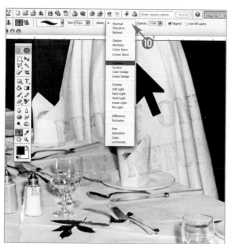

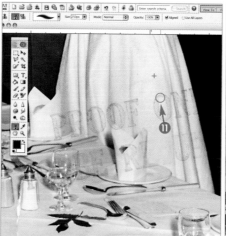

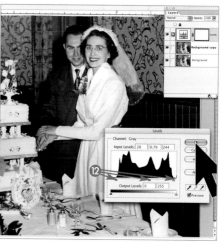

10 Choose **Lighten** (see **5**) to both eliminate the unwanted words on the dress, and blend with the light shade of the dress.

11 After picking the area from which you want to clone, carefully begin to **Clone** away all of the blemishes.

12 After you are finished with the cloning, open up the **Levels** again and make any final adjustments to the cleaned-up photo.

JOINING PANORAMICS

HOW TO BEGIN THE PHOTOMERGE PROCESS

Photomerge is an exciting software function that lets you create panoramic scenes by joining a line of shots into a single composition. Taking a panoramic photograph used to mean investing in a camera for this sole purpose. Now you can easily enjoy this photographic art form that stitches together a panoramic expanse of a landscape or cityscape. You can also use also tilt images vertically, as in a large interior space, like a cathedral interior. These images make spectacular large-format prints.

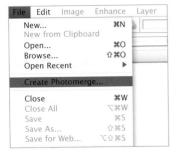

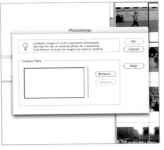

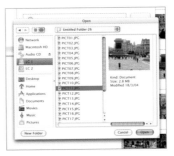

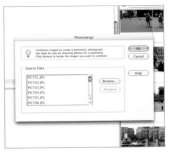

❶ Go to **File** and select **Photomerge.**

❷ Click on **Browse** to select your source files.

❸ Select images. Select multiple images by holding down shift and clicking on the file name.

❹ Once you have opened all of your source files, click **OK**.

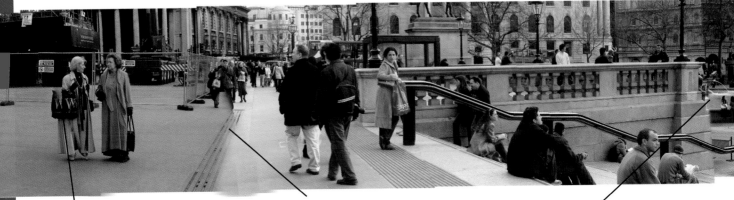

FIGURES
Avoid cropping a figure at the edge of the frame. You can see above that the figure has moved between the shots. Wait to shoot until the figure is a third of the way from the edge.

EXPOSURE
Avoid the transition from a dark space to a lighter space, as this will create a tonal jump between the shots. Set an exposure that averages between the darkest and lightest areas and maintain this for all the shots.

MOVEMENT
Avoid moving the camera up and down between shots. Pan the shots using a tripod or following a line in the scene. Ensure that your images overlap by between 20 and 30 % to avoid breaks like this one.

SUCCESS
You can see here how the image is successfully stitched when there is an overlap of 20% and an identical exposure setting for both shots.

This is a successful section of photomerge.

The completed panoramic photomerge

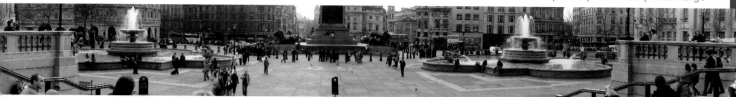

THE PHOTOMERGE DIALOG BOX

Photomerging in the software is a relatively easy process, as it automatically stitches together the images, referred to as *source files*, by searching for the overlap. If the program can't make a match with a source file, it will leave it in the image store called the **Lightbox** at the top of the photomerge window. You can then drag down and arrange and rearrange source files within the photo merge work area. Should you fail to create a successful merge you can use the clone tool to lighten or darken or to erase unsuccessful areas.

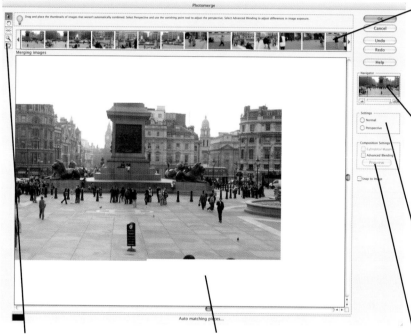

LIGHT BOX
Once you have imported the source files and applied the command to process the images, they will automatically be processed into a photomerge workspace. Source files that cannot be positioned will remain in the lightbox. Drag the source files down from the lightbox to the work area and insert in the photomerge.

NAVIGATOR
This aids your navigation backwards and forwards through a photomerged line of image. Use the arrow on the slider to pull the images through the work area and to view each section of the photomerge. To zoom in or out, click on either the zoom in or zoom out icons beneath the navigator. Or, to zoom in use the magnifying tool.

SETTINGS
How source images appear in the dialog box depends on the settings you choose. Click on **Normal** for the program to auto search and stitch the images. Select **Perspective** to alter the perspective (not shown here) using the **Vanishing Point** tool. This works for images composed through 120° and less.

TOOLS
Use the **Select-Image** tool to select and drag the source files. Use the **Rotate** tool to rotate images. Use the **Zoom** tool to increase the size of the image in the window.

THE WORK AREA
Source files are automatically merged in the work area. Files that cannot be merged are held in the lightbox. Drag the source files from the lightbox to the work area and insert in the photomerge.

COMPOSITIONAL SETTINGS
If you click on the **Advanced-Blending** button, the software will assess the tonal range in each of the images and seek to average any tonal difference. **Cylindrical Mapping** can also be applied to reduce the bow tie distortion that can occur when you apply perspective correction.

SHOOTING FOR PHOTOMERGE

Follow these basic rules:
• Use a tripod to pan the scene.
• Don't use wide-angle setting.
• Don't vary the focal length.
• Follow a line in the scene.
• Keep the same exposure.
• Set **Auto White Balance** to even out the color. • Overlap the shots by 25–30%.
• Make sure there are no moving figures at the edges of your images.

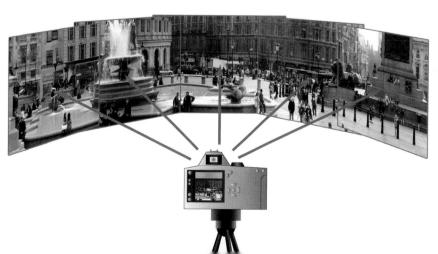

FIXING YOUR IMAGES

ELEMENTS 4

ROTATING AND STRAIGHTENING

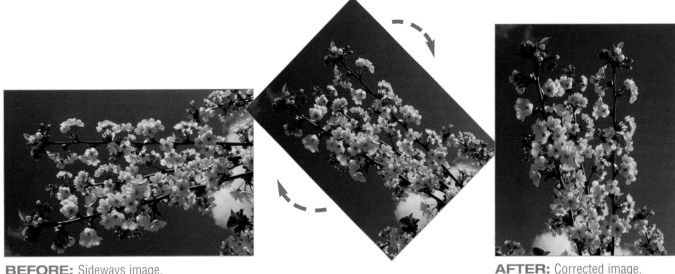

BEFORE: Sideways image.

AFTER: Corrected image.

ROTATING WITHIN THE BROWSER

❶ Open the **Photo Browser.**

❷ Locate your pictures by double clicking on the folder icons.

❸ Click on the image you'd like to rotate.

❹ Hold down the **Ctrl key** as you click to select multiple images.

❺ Click on the **Rotate** symbol.

ROTATING USING QUICK FIX

❶ Click on the **Quick Fix** icon.

❷ Click on the **Rotate** symbol.

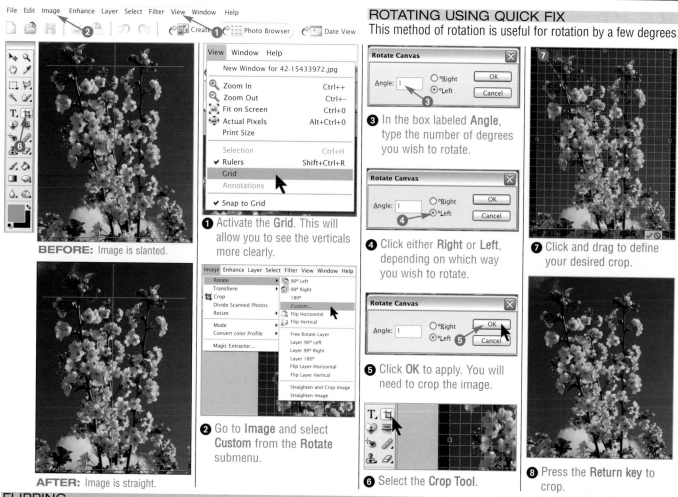

File Edit Image Enhance Layer Select Filter View Window Help

BEFORE: Image is slanted.

AFTER: Image is straight.

View Window Help
New Window for 42-15433972.jpg
Zoom In Ctrl++
Zoom Out Ctrl+−
Fit on Screen Ctrl+0
Actual Pixels Alt+Ctrl+0
Print Size
Selection Ctrl+H
✓ Rulers Shift+Ctrl+R
Grid
Annotations
✓ Snap to Grid

❶ Activate the **Grid**. This will allow you to see the verticals more clearly.

Image Enhance Layer Select Filter View Window Help
Rotate → 90° Left
Transform → 90° Right
Crop 180°
Divide Scanned Photos Custom...
Resize Flip Horizontal
Flip Vertical
Mode
Convert color Profile Free Rotate Layer
Layer 90° Left
Magic Extractor... Layer 90° Right
Layer 180°
Flip Layer Horizontal
Flip Layer Vertical
Straighten and Crop Image
Straighten Image

❷ Go to **Image** and select **Custom** from the **Rotate** submenu.

ROTATING USING QUICK FIX
This method of rotation is useful for rotation by a few degrees.

Rotate Canvas
Angle: 1 ○ °Right OK
○ °Left Cancel

❸ In the box labeled **Angle**, type the number of degrees you wish to rotate.

Rotate Canvas
Angle: 1 ○ °Right OK
⦿ °Left Cancel

❹ Click either **Right** or **Left**, depending on which way you wish to rotate.

Rotate Canvas
Angle: 1 ○ °Right OK
⦿ °Left Cancel

❺ Click **OK** to apply. You will need to crop the image.

❻ Select the **Crop Tool**.

❼ Click and drag to define your desired crop.

❽ Press the **Return key** to crop.

FLIPPING

Sometimes, images actually benefit from being flipped to face the opposite direction. Visually, some compositions look more natural if the movement is from right to left. For images that face left, Flip Horizontal can be a useful compositional aid. If you apply this format to an image, however, you need to make sure that there is nothing in the image that should not be flipped, such as text.

BEFORE Original Image.

Image
Rotate → 90° Left
Transform → 90° Right
Crop 180°
Divide Scanned Photos Custom...
Resize Flip Horizontal
Flip Vertical
Mode
Convert Color Profile Free Rotate Layer
Layer 90° Left
Magic Extractor... Layer 90° Right
Layer 180°
Flip Layer Horizontal
Flip Layer Vertical
Straighten and Crop Image
Straighten Image

WARNING!
You must be careful when using the flip option. The woman's wedding band is now on her right hand. To avoid this problem, you may simply crop that portion of the picture away, or flip only subjects that are symmetrical.

AFTER Flipped Image.

USING THE CROP TOOL

BEFORE: The original image has no point of focus.

AFTER: Image cropped and balanced.

EXPLORING CROPPING

More often than not, photographers need to make some subtle trimming—if not major cropping—to create a well balanced and dynamic composition. For the most part, you will want to get the image cropped to make the subject fill the composition, but you can also use the **Crop Tool** to create inspiring compositions from point-and-shoot photographs. To do this, you need to explore some of the arrangements that can be created by cropping into an image. Cropping is the art of creatively composing a photograph and relates directly to the process of framing your image in the camera viewer. The main difference is that in the camera, the frame is fixed proportion, and when you crop a subject in the editing process, you can do so without restriction. Artful cropping can create totally different arrangements in a composition, either by cropping to symmetrical proportions, or rotating and cropping so that no lines correspond to the edges of the composition.

USING THE MARQUEE TO CREATE A ROUND OR OVAL COMPOSITION

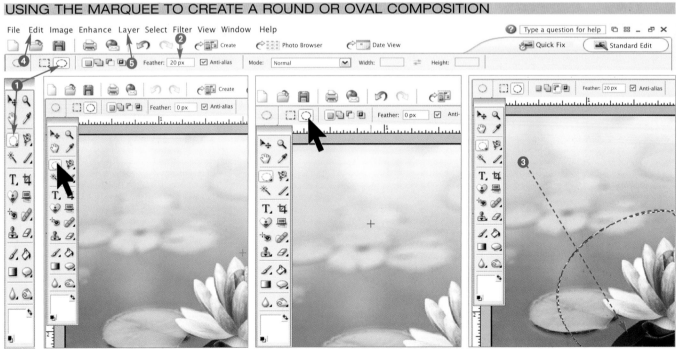

❶ Click on the **Marquee Tool** in the tool-box. Choose the elliptical **Marquee Tool** from the options bar.

❷ Add pixels to the **Feather** field in the options bar to create a softer edge when you crop.

❸ Add pixels to the **Feather** field in the options bar to create a softer edge when you crop.

❹ **Copy** the selected area, open a new document and **Paste** the image.

❺ In the new document, click on **Layer** and scroll to **Flatten Image**.

❻ After you flatten the image, the layers will combine and you will have a feathered oval composition.

USING THE CROP TOOL TO COMPOSE IMAGES

Adjusting the shield
The bounding box of your crop will be surrounded by a darker tone called a *shield*, aiding you to visualize the final crop. You can turn this shield on or off and also adjust the **Color** and **Opacity** of the shield in the toolbar.

❶ Open the image you wish to crop and choose the **Crop Tool** from the toolbox.

❷ Click on what will be the top left corner and pull down towards what will be the bottom right corner with the mouse button pressed.

❸ Press the **Enter** key on your keyboard to complete the crop.

EXAMPLES OF CROPPING

Before: Too much space around the figure.

After: Balance of shape and form.

Before: Open composition.

After: Tighter shape.

USING QUICK FIX TO ADJUST TONES

BEFORE: Image lacks value and color contrast.

AFTER: Brightness/Contrast and **Auto Levels** corrected.

GENERAL FIXES

LIGHTING

❶ Click **Quick Fix** button on the toolbar ❷ **Auto Smart Fix** Adjusts lighting and color or you can manually adjust by sliding the slider ❸ **Auto Red Eye Fix** automatically finds and fixes red eyes in the image.

❷ Click on the **Auto Levels** to adjust the overall contrast of an image. ❸ You can also apply contrast in the image by clicking on **Auto** Contrast button. ❹ Click and drag **Lighten Shadows** slider to attain your desired effect. ❺ Click and drag **Darken Highlights** slider to attain your desired effect. ❻ Click and drag **Midtone Contrast** slider to attain your desired effect.

COLOR

❶ Click **Quick Fix** button on the toolbar.
❷ Click the **Auto** button to adjust the contrast and color ❸ Click and drag **Saturation** slider to attain your desired effect. ❹ Click and drag **Hue** slider to attain your desired effect. ❺ Click and drag **Temperature** slider to attain your desired effect. ❻ Click and drag **Tint** slider to attain your desired effect.

SHARPEN

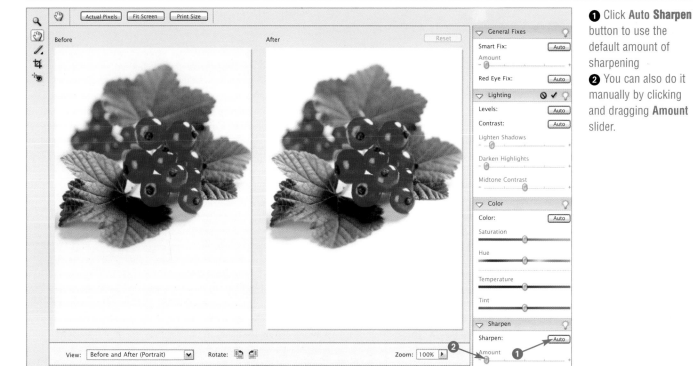

❶ Click **Auto Sharpen** button to use the default amount of sharpening
❷ You can also do it manually by clicking and dragging **Amount** slider.

COLOR VARIATIONS

BEFORE: Original image of leaf.

AFTER: Modified image using **Color Variations**.

THE COLOR VARIATIONS DIALOG BOX

The overall color bias in an image radically affects the feeling of a photograph; even a slight shift in color will create a feeling of coolness or warmth in the image. You are particularly aware of even the slightest nuance of color variation in someone's complexion: a reddening of facial features often denotes embarrassment, while a loss of color in the face can indicate tiredness or illness. **Color Variations** allows you to fine-tune the color in an image with a simple click of the mouse. It is also a quick and easy way to lighten or darken your image.

Section 1 allows you to select an area of the image to adjust—**Midtones**, **Shadows,** or **Highlights**—as well as **Saturation**. You can effectively alter each of these areas in your image by cooling the highlights, or warming the shadows.

In **Section 2**, you can control the **Intensity** of color, allowing you to shift the color slightly or dramatically.

Section 3 contains eight thumbnails that illustrate the changes in your image as you click to increase or decrease either color or brightness.

❶ Click on the **Color Variations** button in the menu bar. This will open the dialog box.

❷ Select which range of the image you would like to adjust.

❸ Use the slider next to **Amount** to define the intensity of your adjustment.

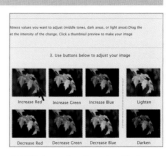

❹ Click on the thumbnails to increase or decrease the color or tone.

CREATIVE COLOR VARIATIONS

Color Variations also allows you to play creatively with the color to enhance an image's color theme. Either subtly or radically, you can alter the color to create a more dramatic image. Note how a simple shift in color bias dramatically alters the mood of the image.

DETAILS, DETAILS: TONE & COLOR

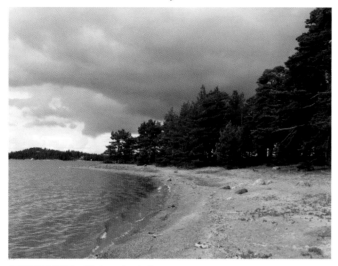

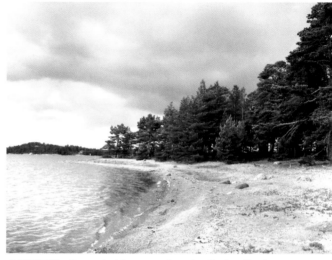

BEFORE: Picture is dull.

AFTER: Corrected image using the **Dodge Tool**.

DODGING

Dodging lightens the image, bringing out details that would otherwise be lost in the shadows.

① Click on the **Dodge Tool** in the toolbox. The cursor will transform into a circle. This circle is the size of the tool.

② Click on the blue arrow next to the **Brush** example and select a brush with a soft edge from the submenu.

③ Click on the blue arrow next to **Size** and adjust the size of the brush using the pop-up slider.

④ Select which range you would like to **Dodge** from the submenu. For this example, **Highlights** was chosen to bring out the details of the picture.

⑤ Click on the blue arrow next to **Exposure** and set the value to 20% using the pop-up slider. Any higher value would make the effect too drastic.

⑥ Dab at the area in small increments of change rather than applying a constant flow. Avoid creating noticeable edge differences.

BURNING

Burning darkens bleached-out areas to bring out detail. Below, more definition is burned into white hair.

THE SPONGE TOOL

The **Sponge Tool** is useful to saturate or desaturate color from specific areas. Here it recedes the red bench.

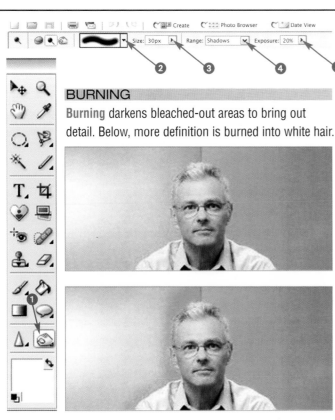

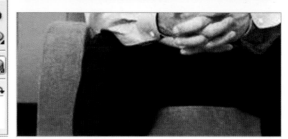

① Click on the **Burn Tool** in the toolbox. The cursor will transform into a circle. This circle is the size of the tool.

② Click on the gray arrow next to the **Brush** example and select a brush with a soft edge from the submenu.

① Click on the **Sponge Tool** in the **Tool Box**. The cursor will transform into a circle. This circle is the size of the tool.

② Click on the gray arrow next to the **Brush** example and select a brush with a soft edge from the submenu.

③ Click on the gray arrow next to **Size** and adjust the size of the brush using the pop-up slider.

④ Select which range you would like to **Burn** from the submenu. For this example, **Shadows** was chosen.

③ Click on the gray arrow next to **Size** and adjust the brush using the pop-up slider.

④ Select which **Mode** you'll need from the submenu. For this example, **Desaturate** was chosen to recede the bench.

⑤ Click on the gray arrow next to **Exposure** and set the value to 20% using the pop-up slider. Any higher value would make the effect too drastic.

⑥ Dab at the area in small increments of change, rather than applying a constant flow. Avoid creating noticeable edge differences.

⑤ Click on the gray arrow next to **Flow** and set the value to 20% using the pop-up slider. Any higher value would make the effect too drastic.

⑥ Dab at the area in small increments of change, rather than applying a constant flow. Avoid creating noticeable edge differences.

CREATING BLACK-AND-WHITE IMAGES

BEFORE: Color Image.

AFTER: Image converted to black and white with more contrast.

WHY BLACK AND WHITE?

Although one of the most appealing visual qualities of digital photography is the heightened color, at times it gets in the way as eye candy. As the color emphasis in a composition can tend to be arbitary at times, the emotional focus of the subject can get lost. Desaturating a color image to black and white displays the interplay between light and shadow as it reveals the form and texture in a composition. Because of the quiet and yet powerful intensity felt in a well-composed black-and-white photograph, many fine-art photographers choose to work exclusively in black and white.

① Go to **Image** in the menu bar and scroll to **Mode**. Select **Grayscale** from the sub-menu.

② A window will appear asking if you want to discard color information. If you have a saved copy of your image, click **OK**.

③ Go to **Enhance** in the menu bar and scroll down to **Adjust Brightness/Contrast**.

④ Move the pointers on the slider to adjust the **Brightness** and the **Contrast**.

TAKE THE PICTURE IN COLOR FIRST

Although some cameras have a setting that allows you to take a photograph in black and white, generally this is not recommended. In most digital cameras, recording an image in black and white reduces the tonal range by using only one of three color channels. It is recommended to take a photograph in full color, which records tonal information in all three color channels and then convert the image using photo-editing software. When a camera records an image in full color, it records the full range of tones in the scene more accurately.

CREATING MONOCHROME IMAGES

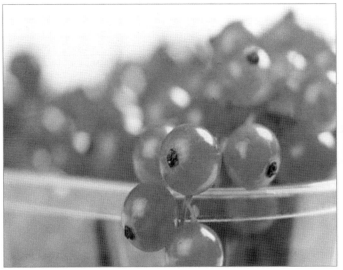

BEFORE: Black and white Image.

AFTER: Adding a single color makes an images monochrome.

MAKING SEPIA AND MONOCHROME IMAGES

By reducing an image to black and white, you can then choose to gradually add a single color—such as a sepia tone—back into the image to create gentle color toning. The impact of monochrome lies in creating an atmosphere that reduces the starkness of a black-and-white image.

❶ Select **Mode** under **Image** in the menu bar. Select **RGB Color** from the submenu. You can now add color back to the black-and-white image.

❷ Go to **Enhance** in the menu bar and scroll down to **Adjust Color**. Select **Adjust Hue/Saturation** from the submenu.

❸ Click on the **Colorize** button in the lower right-hand corner of the window. The image will immediately gain color.

❹ Move the pointer on the **Hue** slider and choose a color from the spectrum.

❺ Adjust the **Saturation** and **Lightness** to control the strength of the color.

❻ Click **OK** to apply.

ADJUSTING SHARPNESS AND SOFTNESS

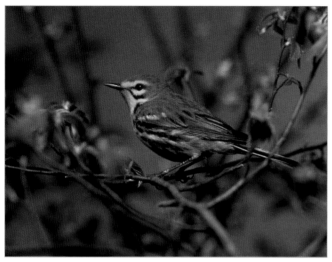

BEFORE: Image is too uniform and lacks a point of focus.

AFTER: Image enhanced using the **Sharpen** and **Blur Tools**.

SHARPENING

Sharpening brings details into focus and provides the illusion that they are closer to the viewer.

1 Click on the **Sharpen Tool** in the tool box. The cursor will transform into a circle. This circle is the size of the tool.

2 Click on the blue arrow next to the brush example and select a brush with a soft edge from the submenu.

3 Click on the blue arrow next to **Size** and adjust the size of the brush using the pop-up slider.

4 Select the **Mode** in which you would like to **Sharpen** from the submenu. For this example, **Normal** was chosen to affect the image in an overall manner.

5 Click on the blue arrow next to **Strength** and set the value to 50% using the pop-up slider. Any higher value would cause the effect to be too drastic.

6 Click on the areas that you would like to **Sharpen**. You may click on a specific area multiple times to increase the sharpening effect.

BLURRING

Blurring obscures details and provides the illusion that they are further away from the viewer.

❶ Click on the **Blur Tool** in the tool box. The cursor will transform into a circle. This circle is the size of the tool.

❷ Click on the blue arrow next to the brush example and select a brush with a soft edge from the submenu.

❸ Click on the blue arrow next to **Size** and adjust the size of the brush using the pop-up slider.

❹ Select the **Mode** in which you would like to **Blur** from the submenu. For this example, **Normal** was chosen to affect the image in an overall manner.

❺ Click on the blue arrow next to **Strength** and set the value to 50% using the pop-up slider. Any higher value would cause the effect to be too drastic.

❻ Click on the areas that you would like to **Blur**. You may click on a specific area multiple times to increase the blurring effect.

QUICK FIX

You can quickly adjust the overall sharpness of your image using the **Quick Fix** dialog box.

❶ Click on the **Quick Fix** button.
❷ Move the **Sharpen** slider to add **sharpness**.
❸ Click on the **Auto** button to automatically adjust **sharpness**.

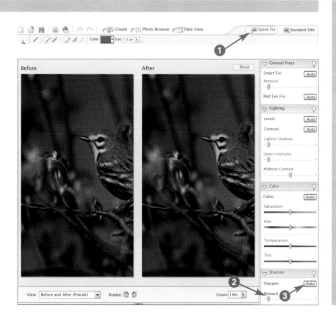

WARNING!

Applying sharpness must be done carefully. Be aware that Auto will only correct a limited amount of sharpness; if you continue to apply the command you will not increase the sharpness of definition, but spoil the image by introducing a high level of noise.

REMOVING RED EYE

BEFORE: Subject has red pupils

AFTER: Red eye is eliminated

REMOVING RED EYE

Because red eye occurs with such regularity, it has prompted the design of a tool setting just to solve this particular problem. The **Red-Eye Brush Tool** is easy to master, making it valuable as a quick remedy to this common problem.

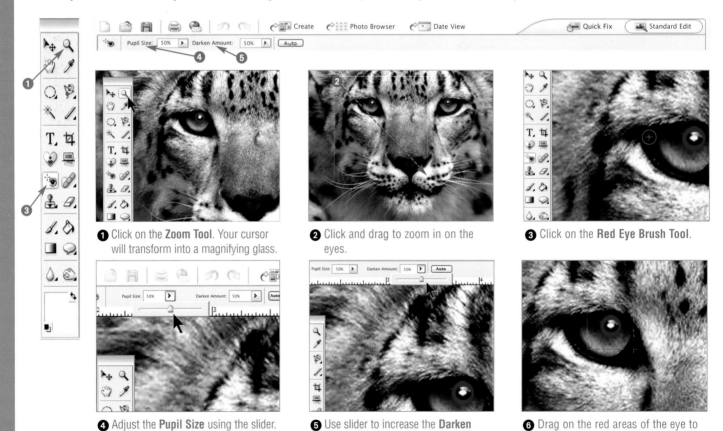

❶ Click on the **Zoom Tool**. Your cursor will transform into a magnifying glass.

❷ Click and drag to zoom in on the eyes.

❸ Click on the **Red Eye Brush Tool**.

❹ Adjust the **Pupil Size** using the slider.

❺ Use slider to increase the **Darken Amount** to 50% or adjust accordingly.

❻ Drag on the red areas of the eye to change them to black.

WARNING! Do not position the cross of your cursor on either the surrounding iris, or any white highlight area, as this will cause the iris color or white—rather than the red—to be selected.

DARKENING YOUR ADJUSTMENT

Depending on the tone of the original red in the eye, the replacement may be gray instead of black, which will not look dark enough.

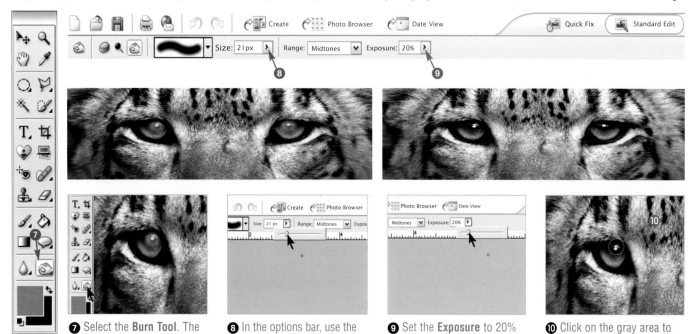

7 Select the **Burn Tool**. The cursor will be the size of the tool.

8 In the options bar, use the slider to set the brush **Size** to match the size of the pupil.

9 Set the **Exposure** to 20% using the slider.

10 Click on the gray area to darken by increments of 20% toward a dense black.

WHAT CAUSES RED EYE?

Red eye is caused by the light of the camera flash bouncing off the retina in the back of the eye. Red eye is often very pronounced in low light conditions, because the subject's pupils are fully dilated at this time. Also, built-in flash fires directly into the eyes, increasing the chance of producing an image with red eye.

HOW CAN I AVOID RED EYE?

To counter red eye, use the red-eye option in the flash settings on your camera. This reduces red eye by emitting a pre-flash that causes the subject's pupils to contract, preparing them for the main flash that follows. If you take a lot of flash photography using a **Prosumer camera** [pp 14–15], it is well worth investing in an external-flash unit thatchanges the angle at which the light hits the eyes.

USING RED EYE TO YOUR ADVANTAGE

There are rare occasions when the effect of red eye adds to a photo, as in the Halloween image below, where an eerie red glow in the eyes adds to the mock-scary character of the image.

SIMPLE RETOUCHING

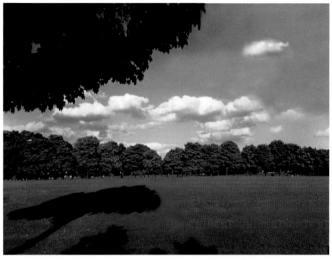

BEFORE: Image with undesired object.

AFTER: Retouched image using the **Clone Tool**.

CLONING

Every so often a photograph is spoiled by an unwanted picture element—an object in the scene that could not be removed by repositioning the camera. This could be a person or car passing through while you are taking the shot. The **Clone Stamp Tool** allows you to remove all sorts of spoilers. This tool clones and copies an area of tone that you can then stamp onto the offending area.

❶ Click on the **Zoom Tool** in the toolbox. The cursor will transform into a magnifying glass.

❷ Click and drag to enlarge the area of the composition large enough to comfortably make adjustments.

❸ Select the **Clone Stamp Tool**, which shares a button with the **Pattern Stamp Tool**, from the toolbox.

❹ Select a brush with soft edges in the pop up palette of the options bar.

❺ Using the slider, adjust the brush **Size** to just larger than the area you want to cover.

❻ Using the slider, adjust the **Opacity**. 100% was chosen in this case to ensure full coverage.

❼ Hold down the **Alt** key on the keyboard and click the mouse over the area you want to clone.

❽ Click on the area to cover. The area under the crossed hairs will be cloned onto the image.

OPACITY

Sometimes it is better to reduce the **Opacity** of the clone to ensure a better blend with the surrounding tones.

❶ You can control the **Opacity** by using the pop-up slider.

❷ Select your source area (hold down the **Alt** key and click).

❸ Click and drag to clone. The resulting clone is less opaque than the original. Control opacity when cloning translucent objects.

WARNING!

It is important to consider the angle from which you are cloning. In this scene it is important to make sure the clone is parallel to the horizontal line of the waves.

A clone applied at the incorrect angle.

A clone applied at the proper angle.

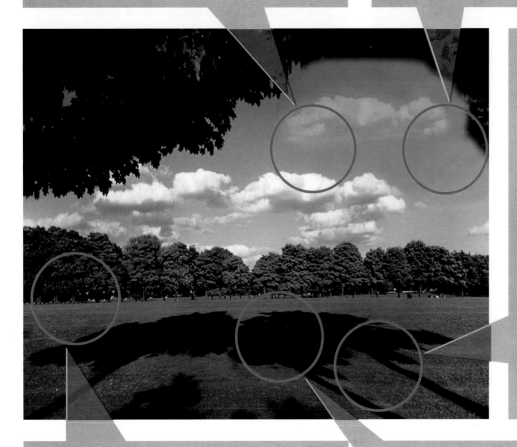

ALIGNED

If you prefer that the area being cloned is always parallel to the tool, select **Aligned** from the options bar.

❶ Make sure **Aligned** is checked.

❷ Select your source area (hold down the **Alt** key and click).

❸ Click and drag to clone. This method of cloning is useful for extending or copying straight lines.

UNALIGNED

By not aligning the tool, the point you first select will be cloned wherever you move the stamp tool.

❶ Make sure **Aligned** is unchecked.

❷ Select your source area (hold down the **Alt** key and click).

❸ Click to clone. This method of cloning is useful for duplicating isolated objects such as this clump of seaweed.

WARNING!

You must be careful to remove all traces of a subject being cloned away, such as shadows and reflections.

Where's that mysterious shadow coming from?

Cloning the shadow away alleviates visual confusion.

IMAGE CORRECTION AND DISTORTION

BEFORE: Distorted image.

AFTER: Corrected image using the **Distortion** and **Pinch Tools**.

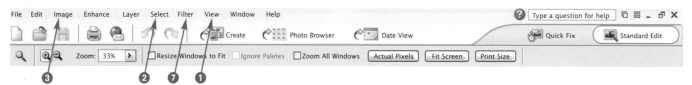

CORRECTING IMAGE DISTORTION

Key stoning occurs when you photograph a scene at an acute angle. This perspective on the scene affects the vertical lines, causing them to appear to converge. This effect occurs more radically when you are taking a picture using a wide-angle setting on f 2.8, and less when using telephoto. Software offers the option of stretching the image to pull converging lines away from each other into a true vertical.

❶ Go to **View** in the menu bar and select **Grid** to see the verticals more clearly.

❷ Go to **Select** in the menu bar and choose **All**.

❸ Under **Image** in the menu bar, scroll down to **Transform** and choose **Distort.**

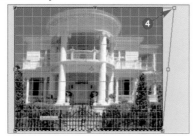

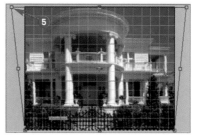

❹ Pull the top right-hand handle of the bounding box to the right until the slanting line of the wall becomes parallel to the edge of the image.

❺ Repeat for the left-hand side of the image adjusting each as necessary. Press the **Return** key to apply.

PINCHING

Another by-product of using a wide-angle lens is that it will bow the verticals outwards, creating a slight fish-eye lens effect—as if viewing the world through a goldfish bowl.

 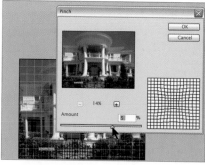

❶ Open **Filter** in the menu bar, scroll down to **Distort**, and select **Pinch**. The **Pinch dialog box** opens with a preview window.

❷ Click on the minus symbol until you are able to see the entire image in the preview window.

❸ Move the slider along until the image in the preview looks less bowed. This should be no more than 3–5%. Click **OK** to apply.

WHEN KEY STONING IS KEY

Key stoning will also add to the expressive impact of landscape—particularly forests, cliffs, cathedrals, and skyscrapers—by enhancing the sense of distance and scale. For some portraits, this exaggerates the expressive drama in the composition.

CLEANING UP IMPERFECTIONS

BEFORE: Original image with noise.

AFTER: Corrected image using the **Despeckle** filter.

REMOVING NOISE

There will be situations where the use of flash is inappropriate and shooting in low light is unavoidable. Such photographs often produce speckled patterns of color in the shadow areas. Instead of a uniform tone, the area of shadow has a clearly visible mosaic of red, green and blue patches. The effect—called **noise** or **artifacts**—is caused by the camera shooting at a higher ISO. Digital photographers can edit out noise through the use of the **Despeckle filter**.

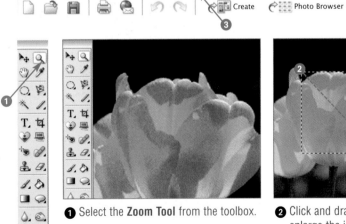

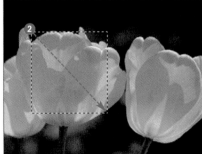

❶ Select the **Zoom Tool** from the toolbox.

❷ Click and drag the **Zoom Tool** to enlarge the image. You will be able to see the effect of the **Despeckle** filter better.

❸ Go to **Filter** and select **Despeckle** from the **Noise** submenu. Since there are no adjustments necessary in this filter, **Despeckle** will be automatically applied.

REMOVING DUST AND SCRATCHES FROM SCANNED PRINTS AND TRANSPARENCIES

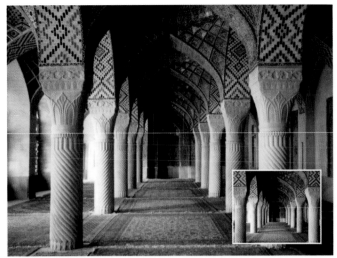

BEFORE: Original image with dust specks.

AFTER: Corrected image using the **Dust and Scratches** filter.

❶ Select the **Zoom Tool** from the toolbox.

❷ Click and drag the **Zoom Tool** to enlarge the image. You will be able to see the effect of the **Despeckle** filter better.

❸ Go to **Filter** and select **Dust and Scratches** from the **Noise** submenu. A dialog box will open with a preview window.

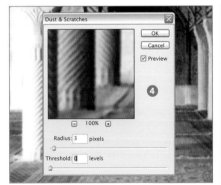

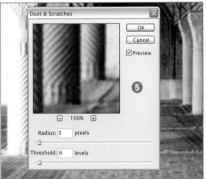

❹ Move the **Radius slider** forward to 1 pixel, then to 2, and so on. You will see that as you increase the pixel radius, larger particles disappear from your image.

❺ Move the **Threshold slider** forward slowly until just before the point at which the spots begin to come back into visibility. When applying this filter, you need to use the lowest radius and the highest threshold possible. Click **OK** to apply.

HELPFUL TIPS

The **Dust and Scratches** filter is best for eliminating small specks, but use the **Clone Stamp Tool** to remove anything larger than 2 or 3 pixels in diameter. You will retain a high definition in your image. Make sure to set the **Mode** to **Darken** in the options bar to remove any white spots and lines. This blending mode is the most efficient at removing spots without affecting the surrounding tones.

ADVANCED CORRECTION

AND CREATIVE EDITING

ELEMENTS 4

INTRODUCTION TO LAYERS

BEFORE: Untouched image of a flower.

AFTER: Image modified using **Layers**.

WHAT ARE LAYERS?

So far you have looked at fixing common problems in images by using the **Quickfix** options. You have also been introduced to some essential adjustments, tools and filters. To do more advanced editing, you will need to build your images using layers. Working with layers is not as complex as it first appears—you can add an adjustment layer with the click of a button. Then, it's a matter of using the very same adjustment dialog boxes that you have already used. **Layers** allows you to build images in transparent overlays—like sheets of images printed on glass stacked on top of each other. This allows you to digitally montage and collage different images.

text layer

blending modes The gray indicates that the layer is active

opacity layer options the lock indicates that the layer cannot be modified

background layer

Crystallize layer at 75% Opacity with the blending mode set to Darken

the eye symbolizes that the layer is visible; click it to hide a layer

create new layer icon

delete layer icon

create new fill or adjustment layer icon

WORKING IN LAYERS

By overlaying layers and controlling the opacity of the upper layers, you may construct complex montages.

❶ Click and hold on the **More** button on the **Layers** palette and select **Duplicate Layer** from the pop-up menu.

❷ Type in the name of your new layer in the top field. This is important when you work in many layers.

❸ Select an effect from the **Filters** drop-down menu. In this example, **Crystallize** was chosen.

❹ Adjust the **Cell Size** by sliding the blue tab back and forth.

❺ Experiment with the many available blending modes. In this example, **Darken** was chosen.

❻ Adjust the **Opacity**. As your layer becomes less opaque, more of the background layer will become visible.

❼ Select a **Type Tool** from the toolbox.

❽ Click on the foreground color square. The **Color Picker** will open.

❾ Use the center color-bar slider and click in the large gradated box to select your text color. Then click **OK**.

❿ Click on the image and begin typing your text.

⓫ With the **Type Tool**, click and drag over the text to select it.

⓬ Choose a font from the top toolbar.

⓭ Choose a font size from the third blue tab. You may also simply type in a number into the field.

⓮ Select the **Move Tool** from the toolbox. This tool will allow you to move your type around the image.

⓯ Position your text. You may also adjust the size and shape of your type by clicking and dragging the eight handles.

⓰ Once you are satisfied with your image, you may **Flatten** it. This allows you to save your image in the jpg format.

ADJUSTMENT LAYERS AND LEVELS

BEFORE: Original image.

AFTER: Image modified using **Layers**.

LAYER UPON LAYER

All the quick and simple adjustments covered in **Quickfix** can be applied at a more precise level by using **Adjustment Layers**. With Adjustment Layers, each adjustment to the image you are creating is a separate layer. You can turn this adjustment layer on and off and see the impact on the image and modify each layer at any time. This is very useful, because as you are applying different effects and alterations in layers, the impact of a subsequent layer alteration may cause you to want to alter a previous adjustment. You can move between the adjustments and fine tune each one in turn. Adjustment layer doesn't permanently alter the pixels.

Levels Choose values for highlights, shadows, and mid-tones.

Brightness/Contrast Decide on values for Brightness and Contrast.

Hue/Saturation Decide which colors you want to edit, then select values for Hue, Saturation, and Lightness.

Gradient Map Decide on your gradient and set gradient options.

Photo Filter NEW OPTION

Invert These layers don't have any options.

Threshold Choose a threshold level.

Posterize Choose the number of tonal levels for each layer.

Solid Color Choose your color.

Gradient Click the Gradient pop-up menu arrow to get a predefined gradient. You can also edit the gradient in the **Gradient Editor,** by clicking the color gradient.

Pattern Choose a pattern from your pop-up palette. Set additional pattern options if you wish.

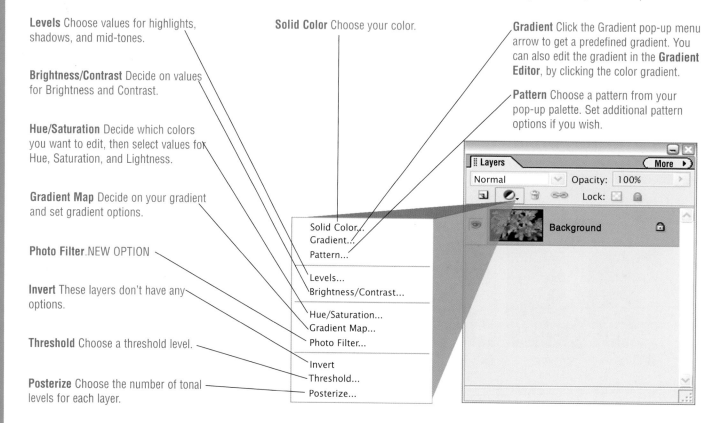

ADJUSTMENTS AND THEIR OPTIONS

Solid Color
Use the sliders to select the color you wish to cast. Afterwards you can use the **Blending Modes** to combine the color with the appropriate layer.

Pattern Fill
Choose a **Pattern** from the drop menu and scale the tiling as desired. You can apply **Modes** to combine the layer and pattern.

Brightness/Contrast
Use the sliders to **Brighten** or **Darken** and add or subtract **Contrast** in the image.

Gradient Map
By clicking on the blue arrow, the **Gradient Map** presets will pop up. From there you can choose a preset, or define your own **Gradient Map**.

Threshold
Slide the arrow to increase or decrease **Threshold**.

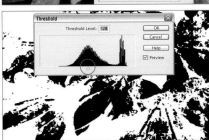

Photo Filter
Photo Filter Adjust the color balance and color temperature of the light transmitted through the lens and exposing the film using the **Photo Filter**.

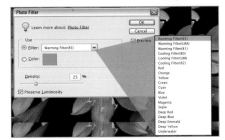

Gradient
The **Gradient** drop menu arrow will show the presets. **Angle** will change the angle of the **Gradient**. The drop menu for **Style** changes the type of **Gradient** and **Scale** enlarges or decreases the **Gradient**.

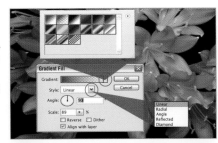

Levels
To change the value of the high, mid, and low **Levels**, move the sliders allotted for each level. The far-right slider is for lights, the center slider is for mid-levels, and the left-most slider is for lows.

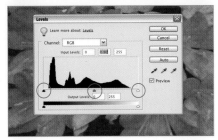

Hue/Saturation
The three sliders in **Hue/Saturation** change the color scheme of the image—**Hue, Saturation,** and **Lightness** (how light or dark the image is).

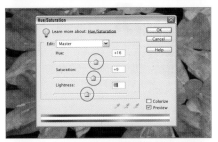

Invert
The **Invert** option inverts the picture to the opposite colors.

Posterize
Posterize works on value levels; this window lets you choose how many you want.

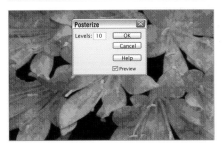

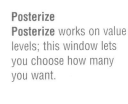

ADJUSTING IN LEVELS

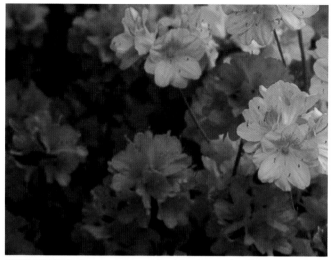

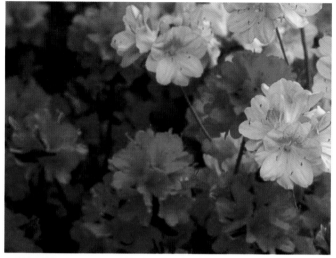

BEFORE: Image has a color bias toward red.

AFTER: Image modified using **Levels**.

USING LEVELS TO FINE TUNE COLOR

The advantage of using **Adjustment Layers** over **Quickfix** is that you are creating a layer that you can blend with the original image and you can control the transparency of the overlay. You can also see the effect on the image in detail using the preview option.

❶ Click and hold the **Create new fill or adjustment layer** icon and select **Levels** from the drop-down menu.

❷ Select which channel you wish to adjust from the **Channel** submenu.

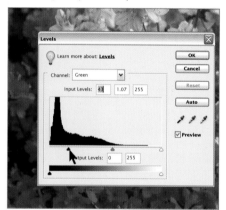

❸ Use the leftmost slider to control the tonal range of darker areas.

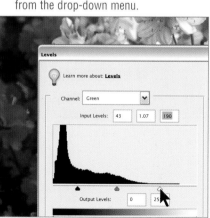

❹ Use the right slider to control the tonal range of highlights, and the middle slider for mid-tones.

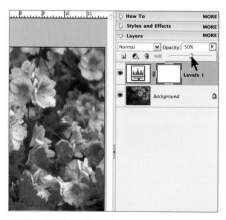

❺ Use the **Opacity** slider to smoothly blend the adjustment layer with the background layer.

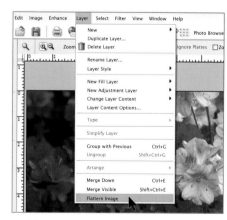

❻ When you are satisfied with your adjustment, go to **Layer** and choose **Flatten Image** to blend the layers together.

UNDERSTANDING COMPLEMENTARY COLORS

Each color channel has an opposite complementary color: cyan is opposite to red, magenta is opposite to green and yellow is opposite to blue. Therefore, colors balance and shift between these complementary pairs. If your image looks too blue, you would need to open the **Blue** channel and pull the mid-tone slider to the left; you'll see your image become more yellow. When adjusting color using **Levels**, you need to be aware that only a slight movement along the slider will significantly impact the image's color balance.

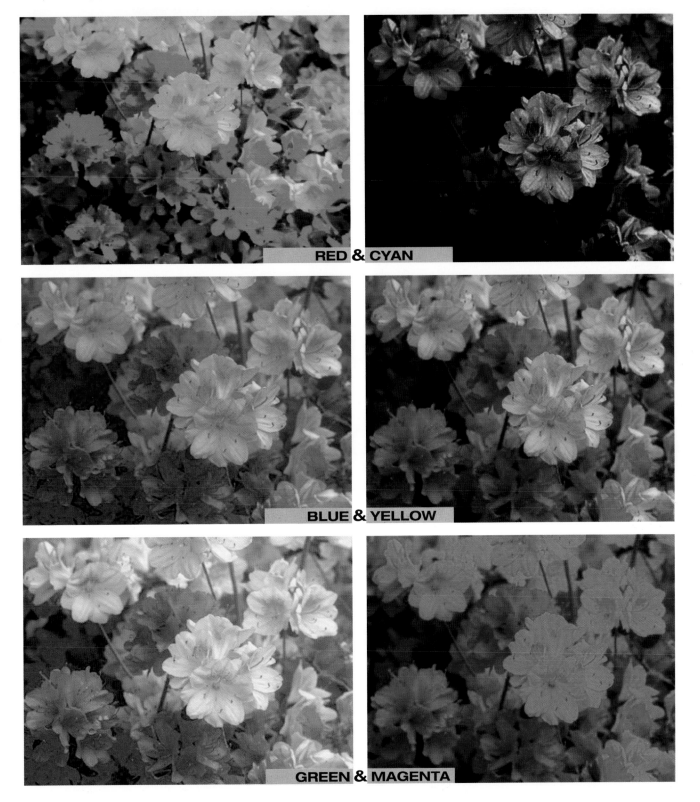

RED & CYAN

BLUE & YELLOW

GREEN & MAGENTA

USING THE SELECTION TOOLS

BEFORE: Original image lacks vibrancy.

AFTER: Image modified using the **Selection Tools**.

WHAT IS A SELECTION TOOL?

At the top of the tool box are six of the **Selection Tools**. Each of these tools lets you make a selection or move the selection in a different way in your image. Making a selection allows you to copy or apply an effect or adjustment to the specific area or pixels that you have selected.

THE MOVE TOOL
This tool allows you to move selections.

■ ⬚ Rectangular Marquee Tool	M
○ Elliptical Marquee Tool	M

THE MARQUEE TOOL
This tool allows you to make geometrical selections. To create perfect squares or circles, hold down the **Shift** key as you make the selection.

THE MAGIC WAND TOOL
This tool makes a selection by selecting all related pixels. You can the set the tolerance level, which determines how close the pixels need to be related. You can also set whether the tool selects all those pixels that are the same over the whole composition, by choosing unaligned.

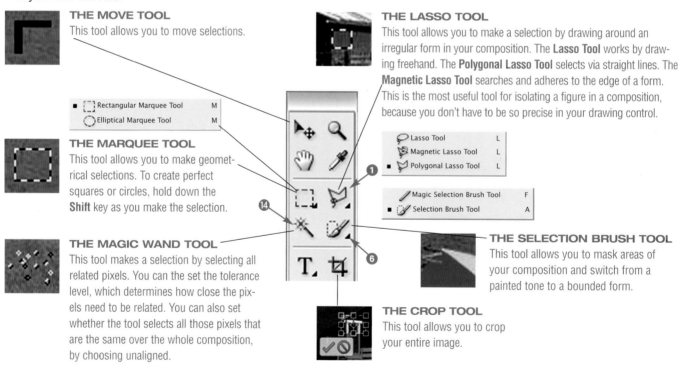

THE LASSO TOOL
This tool allows you to make a selection by drawing around an irregular form in your composition. The **Lasso Tool** works by drawing freehand. The **Polygonal Lasso Tool** selects via straight lines. The **Magnetic Lasso Tool** searches and adheres to the edge of a form. This is the most useful tool for isolating a figure in a composition, because you don't have to be so precise in your drawing control.

○ Lasso Tool	L
Magnetic Lasso Tool	L
■ Polygonal Lasso Tool	L

Magic Selection Brush Tool	F
■ Selection Brush Tool	A

THE SELECTION BRUSH TOOL
This tool allows you to mask areas of your composition and switch from a painted tone to a bounded form.

THE CROP TOOL
This tool allows you to crop your entire image.

HELPFUL TIPS

• Use of the **Feather** option with the selection tools is necessary to make subtle transitions across altered to unaltered areas.

• Holding down the **Shift** key as you make a selection adds to an existing selection. Holding down the **Alt** key as you make a selection subtracts from an existing selection. This is useful when dealing with complex selections.

WORKING WITH SELECTIONS

The key to adjusting specific portions of your image is in mastering the selection tools.

 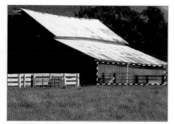 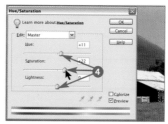

❶ Click and hold the **Lasso Tool** and select **Polygonal Lasso Tool** from the submenu.

❷ Click on the corners of a straight-edge portion of your image. Finish the selection by clicking on the start point.

❸ Go to **Enhance** and select **Hue/Saturation** from the **Adjust Color** submenu.

❹ Adjust the color of your selection by moving the sliders under the three headings. Click **OK** when you are satisfied.

❺ Go to **Select** and choose **Deselect** from the drop-down menu. You are now free to make another selection.

❻ Click and hold the **Selection Brush** Tool and select it.

❼ Choose a brush from the drop-down menu.

❽ Make sure the **Mode** is set to **Mask**.

❾ When masking objects with hard lines, you'll want to set **Hardness** to 100%. This ensures a clean selection.

❿ Begin painting over the objects you wish to mask. When masking in straight lines, hold down the **Shift** key.

⓫ In this example everything but the grass has been masked.

⓬ Change the **Mode** from **Mask** to **Selection**. Everything not masked will now be selected.

 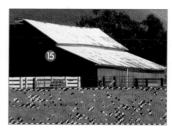 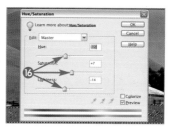

⓭ Repeat steps **❸** and **❹**.

⓮ Select the **Magic Wand Tool** from the toolbox.

⓯ Click around your image and experiment with making various selections.

⓰ Once you have decided on a selection, apply steps **❸** and **❹**.

FIXING OVEREXPOSURE

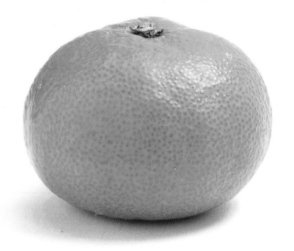

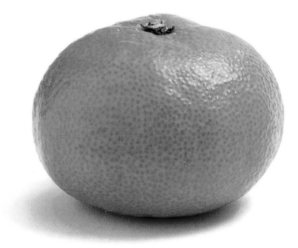

BEFORE: Overexposed image

AFTER: Overexposure corrected via **Layers** and **Multiply**

FIXING OVEREXPOSED IMAGES

The process below is the most precise way to correct images that have been overexposed.

❶ Click and hold on the **More** button of the **Layers** palette and select **Duplicate Layer** from the pop-up menu.

❷ Type in the name of your new layer in the top field. This becomes important if you work in many layers.

❸ Set the **Blending** mode to **Multiply**. The image will immediately turn darker.

❹ Use the **Opacity** slider to control the strength of the **Multiply** blending mode. In most cases, 50–60% is best.

❺ Once you are satisfied with your adjustment, select **Flatten Image** by clicking and holding the **More** button in the **Layers** palette.

FIXING UNDEREXPOSURE

BEFORE: Underexposed image

AFTER: Underexposed corrected via **Layers** and **Screen**

FIXING UNDEREXPOSED IMAGES

The process below is the most precise way to correct images that have been underexposed.

❶ Click and hold on the **More** button of the **Layers** palette and select **Duplicate Layer** from the Pop-up menu.

❷ Type in the name of your new layer in the top field. This becomes important if you work in many layers.

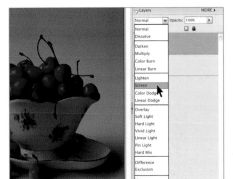

❸ Set the **Blending** mode to **Screen**. The image will immediately turn darker.

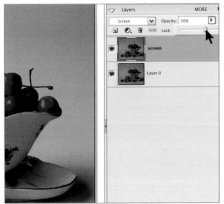

❹ Use the **Opacity** slider to control the strength of the **Screen** blending mode. In most cases, 50–60% is best.

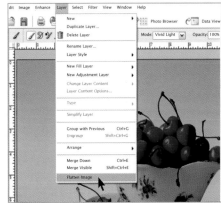

❺ Once you are satisfied with your adjustment, select **Flatten Image** by clicking and holding the **More** button in the **Layers** palette.

REMOVING NOISE

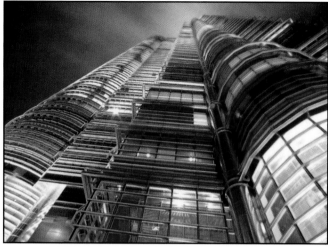

BEFORE: Original image with noise caused by low light.

AFTER: The noise has been significantly reduced.

REMOVING NOISE THROUGH LAYERING

It is common for images taken in low-level lighting to have areas of noise in the shadow areas. Instead of a smooth even tone, there is the distinctive speckling of red, green and blue pixels in the dark tones of the image. There will be many occasions when you will need to adjust the image to remove noise. In cases of extreme noise, the **Despeckle** filter is an inadequate solution.

THE COMPOSITE
Both layers shown together produce the finished photograph.

THE MULTIPLY LAYER
The **Multiply** blending mode typically darkens areas. In conjunction with **Median**, this blending mode is useful in removing noise. The white areas represent where the layer has been erased so that the details show through from the background layer.

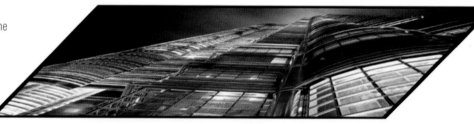

THE BACKGROUND LAYER
The original noisy photograph.

REDUCING NOISE USING THE BLUR TOOL
In images where only small areas are affected by noise, a simple solution is to apply the **Blur** tool, which reduces the appearance of noise by smoothing the differences in the pixels in the area.

USING THE MAGIC WAND TOOL AND LEVELS
In images where small dark areas are affected by noise, another solution is to select these areas using the **Magic Wand** tool, and then using **Levels**, to reduce the saturation to eliminate the color.

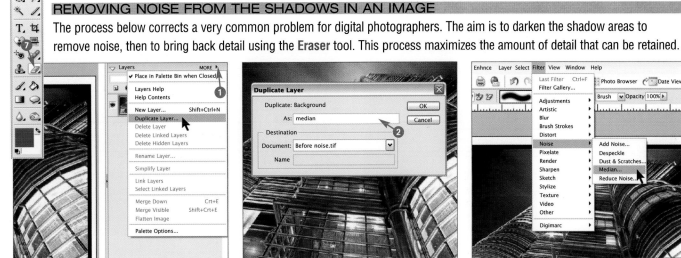

REMOVING NOISE FROM THE SHADOWS IN AN IMAGE

The process below corrects a very common problem for digital photographers. The aim is to darken the shadow areas to remove noise, then to bring back detail using the **Eraser** tool. This process maximizes the amount of detail that can be retained.

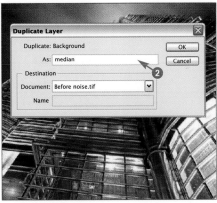

❶ Click and hold on the **More** button on the **Layers** palette and select **Duplicate Layer** from the pop-up menu.

❷ Type in the name of the new layer in the top field. This becomes important if you work in many layers.

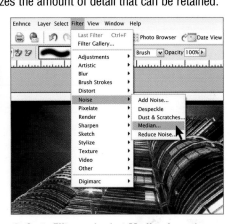

❸ Go to **Filter** and select **Median** from the **Noise** submenu.

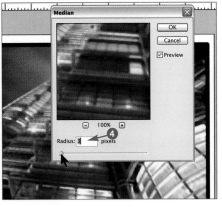

❹ Adjust the **Radius** until most of the noise is blurred away, and click **OK**.

❺ Set the blending mode to **Multiply**.

❻ Adjust the **Opacity** of the layer to the point just before the noise begins to show through from the background layer.

❼ Select the **Eraser Tool** from the toolbox.

❽ For this process, it is usually best to select a brush with a soft edge.

❾ By erasing away portions of the top layer, the original background layer will show through. This will increase the brightness and detail of the highlights.

ADVANCED BLACK AND WHITE

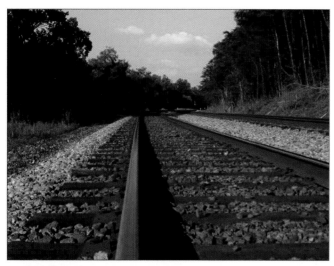

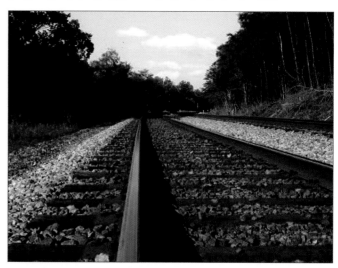

BEFORE: Color image with flat tonal range and poor contrast.

AFTER: Black-and-white image with improved contrast.

PRECISE CONTROL OF VALUES

Although you can turn a color image into black and white by converting to grayscale, the resulting image can lack depth of tonal contrast. By working with **Adjustment Layers**, you can alter the values of shadows, mid-tones, and highlights. For precise and rich tones in black and white, you need to work in **RGB** rather than grayscale and use the **Red**, **Green**, and **Blue** channels in **Levels** after using **Hue/Saturation** to de-saturate the color image.

❶ Click and hold the **Adjustment Layer** icon at the top of the **Layers** palette and select **Levels**.

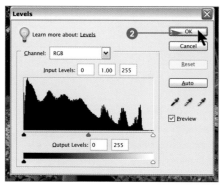

❷ For now simply click **OK** in the **Layers** dialog box. You'll return to this later.

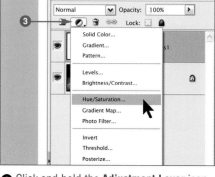

❸ Click and hold the **Adjustment Layer** icon at the top of the **Layers** palette and select the **Hue/Saturation**.

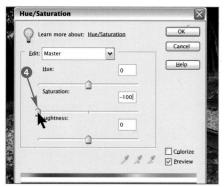

❹ Set the **Saturation** to −100 by dragging the middle slider all the way to the left. The color will vanish as you do this.

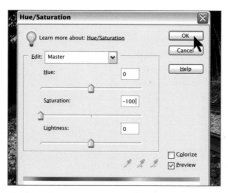

❺ Click **OK** in the **Hue/Saturation** dialog box.

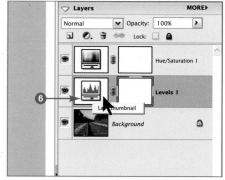

❻ Open the **Levels** dialog box by double clicking on the Levels thumbnail in the **Layers** palette.

File Edit Image Enhance Layer Select Filter View Window Help

 Create Photo Browser Date View

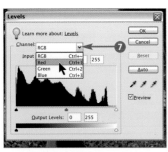

❼ Click and hold the tab next to **Channel** and release the mouse over **Red**, to work in the red channel.

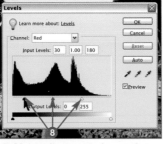

❽ Make adjustments by moving the sliders located below the graph.

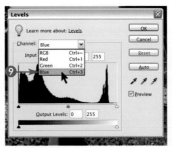

❾ Switch to the Blue channel.

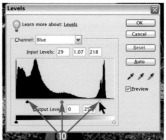

❿ Make further adjustments using the sliders.

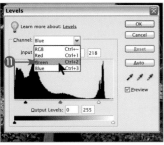

⓫ Switch to the Green channel.

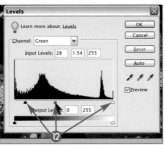

⓬ Make further adjustments by moving the sliders.

⓭ Click and hold the **More** button on the Layers palette and select **Flatten Image** from the pop-up menu.

⓮ Go to **Image** and select **Grayscale** from the **Mode** submenu.

IMAGES MAY BE SALVAGED BY CONVERTING THEM TO BLACK AND WHITE

An otherwise unsatisfactory color image can become powerful in black and white. Although the definition suffers from camera shaker and the image is over-exposed, the composition has potential in black and white, if the tonal range is improved. The technique illustrated above was applied in order to increase the tonal contrast.

COMBINING COLOR AND GRAYSCALE

BEFORE: Full color image.

AFTER: Image with both color and grayscale elements.

ERASING THROUGH A LAYER

A very simple and effective way to combine color and black and white is to create a grayscale image from a color image, and then place the grayscale image over the color image in the **Layers** menu. Then, use the **Eraser** tool to erase areas of the black-and-white image, which allows the color image to show through.

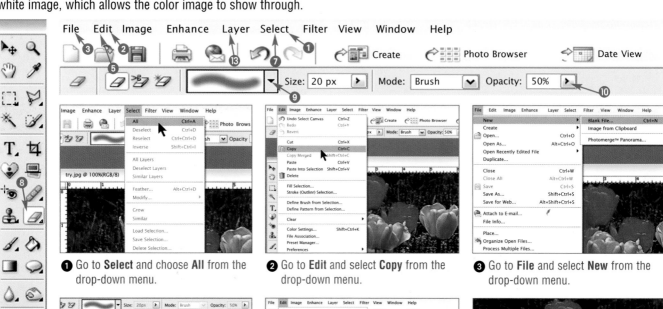

❶ Go to **Select** and choose **All** from the drop-down menu.

❷ Go to **Edit** and select **Copy** from the drop-down menu.

❸ Go to **File** and select **New** from the drop-down menu.

❹ In the **New** dialog box, make sure **Mode** is set to **Grayscale**.

❺ Go to **Edit** and select **Paste** from the drop-down menu.

❻ **Drag** the grayscale image onto the color image so that it aligns precisely.

7 Go to **Select** and choose **Deselect** from the drop-down menu and then align precisely.

8 Select the **Eraser Tool** from the toolbox.

9 Select a brush with a soft edge from the **Brushes** drop-down menu.

10 Adjust the **Opacity** of the tool by moving the slider to 50%. This will aid in controlling the amount of color that will show through.

11 Erase over the areas that you want in color. Erasing over an area twice will double the amount of color that shows through.

12 You can quickly change the size of the tool by hitting the left-and-right bracket keys. You may need to do this to erase small areas.

13 Once you are satisfied with the image, go to **Layer** and select **Flatten Image**.

GENTLE COLOR

The images below illustrate the same concept outlined above. You can completely erase areas to let the full color show through, or only partially erase the grayscale layer, so that a gentle color shows through. This can be achieved by setting the **Opacity** of the **Eraser** tool to around 20%.

Full color layer.

Partially erased black-and-white layer.

The combined images.

CREATIVE CHANGING OF COLOR

BEFORE: Original image.

AFTER: Modified image using **Hue/Saturation**.

CREATIVE ALTERING OF COLOR

The quality of the color in a composition will have a profound affect on the overall meaning and atmosphere of the image. There will be times when you will want to replace a color in a composition either to create a different atmosphere or to create a new color harmony.

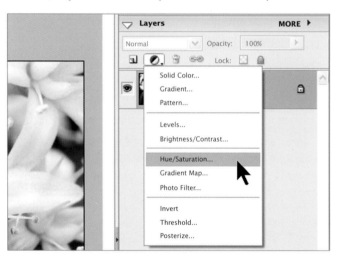

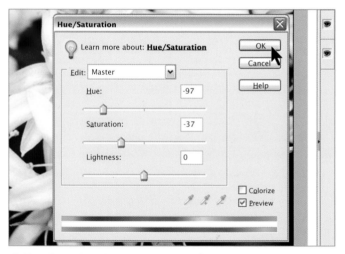

❶ Click and hold the **Adjustment Layer** icon at the top of the **Layers** palette and select **Hue/Saturation**.

❷ Experiment by using the tree sliders. Observe what effect each of the values has on your image. Click **OK** when you are satisfied.

CREATIVE REPLACEMENT OF COLOR

The original image inspired a series of color variations ranging from cool to warm hues.

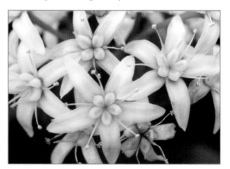

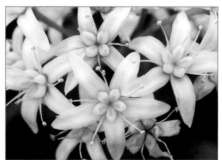

BEFORE: Original image.

AFTER: Modified image using **Replace Color.**

SELECTIVE REPLACEMENT OF COLOR

Replacing a color for part of an image can be achieved with ease by using Replace Color. This allows you to make radical or subtle color changes to a precise range of pixels in an image. Replace Color is similar to the Magic Wand Tool in how it selects related pixels.

❶ Click and hold the **Adjustment Layer** icon at the top of the **Layers** palette and select **Hue/Saturation.**

❷ Experiment by using the tree sliders. Observe what effect each of the values has on your image. Click **OK** when you are satisfied.

❸ Adjust the selection by moving the **Fuzziness** slider. When moved to the right, more pixels will be selected.

❹ The lower half of the **Replace Color** dialog box works exactly like the **Hue/Saturation** dialog box.

HAND TINTING

BEFORE: Original full-color image.

AFTER: Hand-tinted image, which looks more timeless.

HAND-TINTING PHOTOGRAPHS

Hand-tinting a photograph combines documentary truth and imaginative interpretation, fusing the photographic imprint of the subject with the intimate touch of a hand-painted work of art. The result gives the image a timeless, preserved quality. Creating this effect digitally is a matter of de-saturating the image of all color and then adding color back in by painting in washes or tints using the Brush Tool.

CREATING A TIMELESS IMAGE

The original image has the potential to be an attractive and atmospheric photograph, but the color is a bit flat and uninspired. This could be rectified using **Hue/Saturation,** but the timeless nature of this image suggests that a more radical makeover is needed.

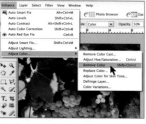

❶ Go to **Enhance** and select **Remove Color** from the **Adjust Color** submenu.

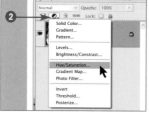

❷ Click and hold the **Create New Adjustment Layer** icon and select **Hue/Saturation**.

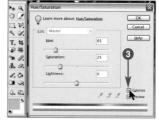

❸ Click **Colorize** in the **Hue/Saturation** dialog box.

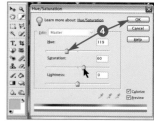

❹ In this example, the **Hue** was set to 119. The **Saturation** to 60 and click **OK**.

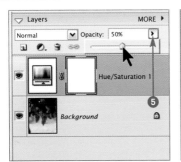

5 Set the **Opacity** of the adjustment layer to 50%.

6 Select the **Brush Tool** from the toolbox.

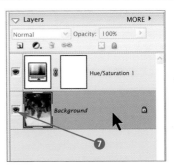

7 Click on the **Background** layer to make it active.

8 Select a medium-sized **Brush** with a soft edge.

9 Change the **Mode** to **Color**.

10 Set the **Opacity** of the **Brush Tool** to 50%.

11 Click on the foreground color box at the bottom of the toolbox. This will open the **Color Picker**.

12 Select a color by using the slider in the central color bar and clicking in the large gradated box. Then click **OK**.

13 Paint in the areas you wish to color. To intensify the color simply repaint over a color area.

14 In this example, the clouds are tinted to a warm yellow. To quickly control the **Size** of the brush, press the left and right bracket keys.

15 Continue coloring until you are satisfied with the effect. Repeat steps **11** and **12** to change the color that you wish to apply.

16 Once you are finished coloring, select **Flatten Image** from the **Layer** in the menu. Flattening reduces the size of your image.

THE HISTORY OF HAND-TINTING

Early photographic processing created black-and-white prints. The method of hand-tinting photographs developed out of a desire to add color to these prints. The early photographers would take notes on the color of their subject's complexion and clothing, and their assistants would faithfully recreate the likeness by painting washes of color onto the lighter tones of the photograph.

SELECTIVE SHARPENING

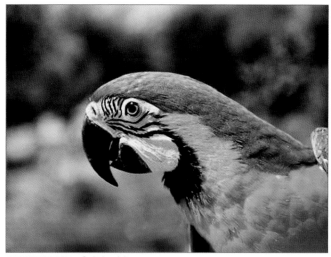

BEFORE: Original image.

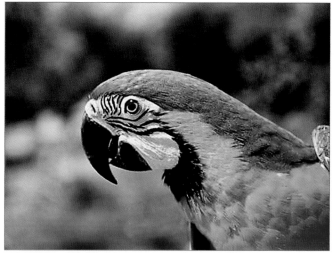

AFTER: Modified image using **Unsharp Mask**.

THE SHARPEN FILTERS

The **Sharpen** filters add focus and clarity to an image. However, you need to apply this filter with moderation. Excessive application will create visual noise. *Noise* is the term used to refer to the speckled appearance created by too much tone and color difference in pixels. You will see this occurring in areas that should be more uniform, such as areas of skin tone. It is essential that you view the image close up as you apply the filter using the preview. Use the **Zoom Tool** to enlarge the details of your image to examine the effect.

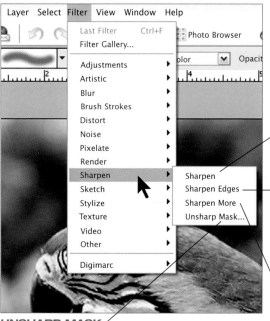

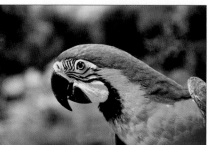

SHARPEN

The first sharpen filter automatically applies a set level of sharpening in the same manner as the **Quickfix** option. It is applied by highlighting and releasing the mouse.

SHARPEN EDGES

This filter is applied in the same way as **Sharpen** but sharpens only the pixels at the edges of forms.

SHARPEN MORE

This filter works in the same way as **Sharpen** but applies a stronger sharpening effect.

UNSHARP MASK
This filter is explained on the opposite page.

QUICKFIX

You can apply the **Sharpen** filter simply by using **Quick Fix**. You can also selectively sharpen via the **Sharpen Tool** contained in the toolbox.

UNSHARP MASK

Unsharp Mask allows for a very precise control of sharpening. The three parameters of the filter are: **Amount**, **Radius**, and **Threshold**. These parameters are set to default settings that you can adjust by moving the pointer on the slider bar. As you make adjustments carefully examine the degree to which the pixels are sharpened and the amount at which visual noise begins to occur.

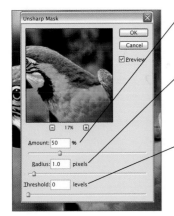
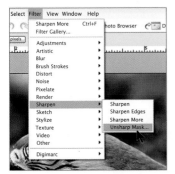

AMOUNT

In an image with good definition, you'll want to set the parameter between 50–100%. For extreme cases, use 300%.

RADIUS

In an image with good definition, leave the radius between 1 to 2 pixels. In the case of a blurry image, you can correct the blur to a degree by increasing the radius to 5.

THRESHOLD

This parameter is important in controlling where the sharpening is applied. In the case of skin tones and other large areas of uniform tone, applying any sharpen command will generate noticeable noise and break up the smoothness of the tones in these areas. By increasing the threshold, the sharpen filter is only applied to the edge areas of an image. This makes it a very useful parameter for portraits—the bird and features are given extra definition.

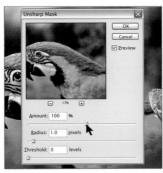
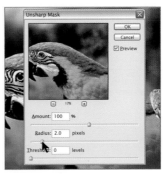
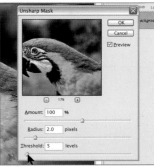

❶ Go to **Filter** and select **Unsharp Mask** from the **Sharpen** submenu.

❷ Set the **Amount** to 100%. You will see your image begin to sharpen.

❸ Set the **Radius** to 2.0. The sharpening effect will increase dramatically.

❹ Slide the **Threshold** slider to the right until most of the visual noise generated by the sharpening effect vanishes.

WHEN YOU CAN SHARPEN A LOT

With portraits, and subjects with flat areas of tone, sharpening needs to be applied very discreetly. However, with very busy subjects broken by pattern and contrasting areas, you can apply a much heavier sharpening to enhance the texture.

CREATIVE BLURRING

BEFORE: The focused surrounding competes with subject.

AFTER: Surrounding blurred with **Gaussian Blur**.

BLURRING BACKGROUNDS

You can gently reduce a texture in a portrait or more dramatically eliminate all of the background detail in a scene that is distracting from the foreground interest. The **Blur** filter also softens and smoothes skin texture, making it a really useful tool for portrait photography. You can also use the blur filter to create special motion effects, such as a figure jumping or running, or a fast-moving vehicle.

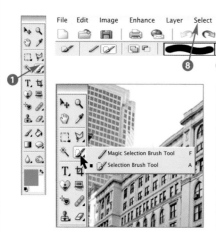

1 Select the **Selection Brush Tool** from the toolbox.

2 Set the brush **Size** so that you can comfortably paint over your foreground image.

3 Set the **Mode** to **Mask**.

4 Paint over the foreground image. To quickly change the size of your brush, press the left or right bracket keys.

5 Set the **Mode** to **Selection**. The surrounding area will become selected.

6 Go to Filter and select **Gaussian Blur** from the **Blur** submenu.

7 Increase the **Radius** until the background recedes to your satisfaction.

8 Go to **Select** and choose **Deselect**.

EXPLANATION OF THE BLUR FILTERS

Blur is usually a thing to avoid in photography. So it might initially strike you as a filter that you would rarely want to use. In actuality, it is a necessary filter for reducing distracting detail. Blur filters are useful for reducing the amount of focus and definition in areas of a composition. For example, it might be used to create a soft-focus effect to gently reduce a texture in a portrait.

AVERAGE
The **Average** filter finds the average color of an image or selection, and then fills the image or selection with the color to create a smooth look.

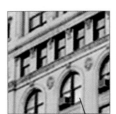

BLUR
This filter applies a set amount of blur across the image.

BLUR MORE
This filter applies a stronger **Blur** across the image.

GAUSSIAN BLUR
This filter adjusts the mid-range tones in a selection and gives you control of the blur radius.

MOTION BLUR
This filter does what its name indicates. It creates the illusion of rapid movement across the picture plane.

SMART BLUR
This filter works in a similar fashion to the **Unsharp Mask** filter. It provides the most precise control of sharpening. **Smart Blur** provides the widest range of control for blurring an image. You can control the **Radius** of the pixels to be blurred. **Threshold** determines how different the pixels are to be blurred. You can also control the way the blur affects the edges in the image.

You can adjust the distance of the blur by pulling on the slider.

You can adjust the direction of the blur by typing in an angle from 0° to 360°.

RADIAL BLUR
There are two **Blur Methods** to this filter **Spin** and **Zoom**.

The **Spin Blur Method** creates the illusion that either the subject or the camera is spinning. It could also be used to focus the viewers eye into the center of a composition.

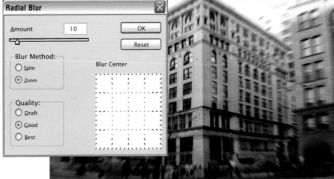

The **Zoom Blur Method** creates the illusion of rapid movement towards the lens. This gives the impression of a form such as a figure, animal, or transport quickly moving towards you.

RETOUCHING PORTRAITS

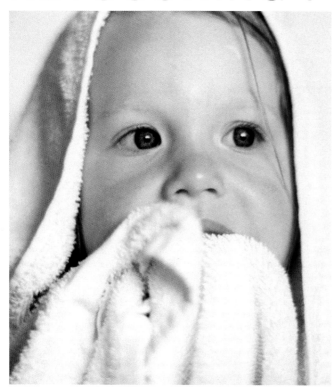

BEFORE: Original image with blemishes.

AFTER: Enhanced image with smooth skin and bright eyes.

IMPROVING ON NATURE

You will usually want to take a photograph that shows your subject at their most attractive. This means posing the subject to their best profile and using soft lighting. Often, you will shoot a really good portrait that is marred by noticeable skin blemishes. Using digital editing software, you can improve the look of your subject by applying subtle adjustments to skin, hair, eyes, and teeth. You can also remove any distracting hairs, spots, blemishes, and scars. Teenagers with blemishes are particularly image-sensitive, and young children—when they are active and adventurous—are rarely free of small bruises and grazes. Older subjects generally prefer to be flattered and feel hurt when an image makes them look heavier or older than they feel. All of these anxieties and expectations must be considered when you approach portrait photography. Well, not to worry: all of the details that can make-or-break a portrait can be addressed and resolved by using a few simple and highly effective techniques.

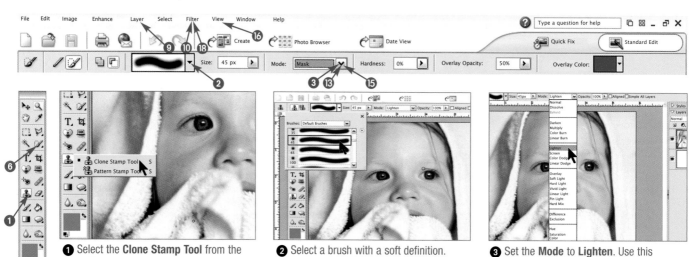

❶ Select the **Clone Stamp Tool** from the toolbox.

❷ Select a brush with a soft definition.

❸ Set the **Mode** to **Lighten**. Use this blending mode to clone in light areas.

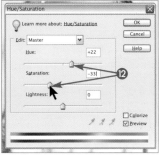

4 Press the **Alt** key as you click the mouse to select the source pixels for your clone.

5 Click on the blemishes to clone over them. To quickly change the size of any tool, press the left and right bracket keys.

6 Select the **Selection Brush Tool** from the toolbox. Adjust the size of the brush by pressing the left and right bracket keys.

7 Paint over the whites of the eyes to select them. You may deselect selected areas by holding down the **Alt** key.

8 Go to **Enhance** and select **Hue/Saturation** from the **Adjust Color** submenu.

9 Decrease the **Saturation** and increase the **Lightness** of your selection. Be careful to not make the whites too bright.

10 Go to **Select** and choose **Deselect**. You are ready to make your next selection.

11 Paint over the color portion of the eyes to select them. You may deselect selected areas by holding down the **Alt** key.

12 Adjust the **Hue** to change the color of eye. Increase **Saturation** to intensify the color.

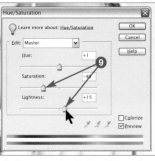

13 Change the **Mode** to **Mask**.

14 Paint over any portions you wish to remain visually sharp, such as eyes, lips, and hair.

15 Switch the **Mode** to **Selection**. All pixels not masked will be selected.

16 Go to Filter and select **Gaussian Blur** from the **Blur** submenu.

17 Increase the **Radius** until the skin appears smoother.

18 Go to Select and choose **Deselect**.

CHANGING BACKGROUNDS

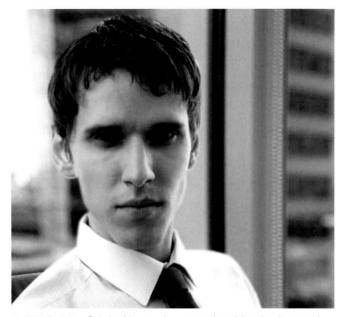

BEFORE: Original image has an uninspiring background.

AFTER: New image with a more pleasant background.

MONTAGES: CHANGING BACKGROUNDS

A method of montaging is to improve a photograph by replacing the original—yet unsympathetic—background with a more aesthetically pleasing setting. You can also apply abstract backgrounds by applying a fill and a gradient layer. Here you will learn the process of removing a background, and replacing it with a different image.

❶ Click on the **More** button on the **Layers** palette and select **Duplicate Layer**.

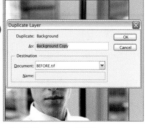

❷ Click on the **OK** button.

❸ Click on the **Eye** symbol of the background layer to hide this layer.

❹ Click and hold on the **Selection Brush Tool** and select **Selection Brush Tool**.

❺ Select a brush with a soft definition.

❻ Adjust your brush size using the pop-up slider.

❼ In the options bar, under **Modes**, select **Mask**.

❽ Set the **Hardness** of the brush to be around 50%.

 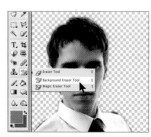

9 Paint over the outline of the foreground image.

10 Click **Selection Mode** in the options bar. Press the **Delete** key to erase the background.

11 Go to **Select** and choose **Deselect** from the drop-down menu.

12 Hold down the **Eraser Tool** in the tool box and select the **Background Eraser Tool**.

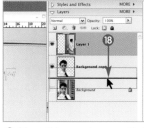 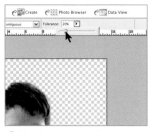

13 Set this tool to a **Size** of 250 px.

14 You have to set the tool at 20% or less because setting it too high will erase more of the image than you want.

15 Move the eraser and click over the edge of the image until you have removed all the background from the outline.

16 Open your chosen background image.

17 Click and drag the new background image into the foreground image window.

18 Move this new layer so that it is under your foreground layer, by clicking and dragging the thumbnail.

19 If your background is smaller than your foreground image, go to **Image** and select **Scale** from the **Resize** submenu.

20 Hold down **Shift** (this assures that the resize will occur with the proper proportions) and drag the corner until the background fills the window.

EXPLORING ALTERNATE BACKGROUNDS

APPLYING A GRADIENT FILL

BEFORE: Image with no background.

AFTER: New image with a gradient fill applied to the background.

CREATING A BACKGROUND

Once you have extracted a figure from a scene or removed a background from a portrait photograph, you can create a background as an alternative to pasting in another image. The most effective method of building a background is to create a solid color fill in adjustment layers and then to add a gradient. You can then use the gradient layer to modify the solid color so that it graduates from dark to light.

❶ Click and hold on the **Create Adjustment Layer** symbol and select **Solid Color** from the drop-down menu.

❷ Select a color by using the slider in the central color bar and clicking in the large gradated box. Click **OK**.

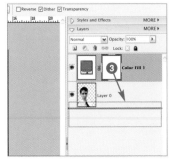

❸ Click and drag the color fill layer and release the mouse when it is under the fore-ground image layer.

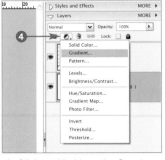

❹ Click and hold on the **Create Adjustment Layer** symbol and select **Gradient** from the drop-down menu.

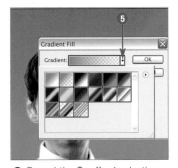

❺ Reveal the **Gradient** selection drop-down menu by clicking on the blue arrow. Click on a square to choose a gradient.

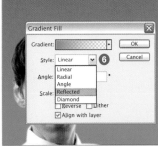

❻ There are five options in the **Style** tab. In this example, **Reflected** was selected.

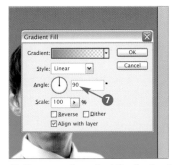

❼ You may also adjust the **Angle** of the gradient by typing a number in the field, or by clicking and dragging the line in the circle.

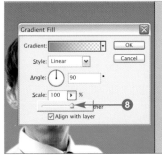

❽ You may also adjust the **Scale** of the gradient by typing a number in the field, or by using the drop-down slider.

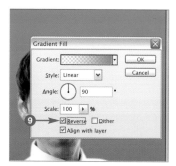

9 Click on the **Reverse** box to see the gradient reversed.

10 Explore the many blending modes. In this example, **Multiply** was applied.

11 You may also adjust the **Opacity** of the gradient fill by typing a number 0–100 in the field, or by using the drop-down slider.

12 To flatten your image, click the **More** tab of the **Layers** palette and select **Flatten Image**.

BLENDING A GRADIENT FILL ON A BACKGROUND

Once you have created the gradient fill over the solid color, you can begin to explore some of the amazing gradient effects in the **Gradient** dialog window. Click on the **Gradient Fill** submenu and a palette of gradient styles will drop down. Begin by exploring the first tonal gradient, which simply masks the image in a white tone gradated to transparency. Then explore the 5 options under Style. These are **Linear, Radial, Angle, Reflected,** and **Diamond**. You can also angle or invert the gradient and adjust the scale. In the image below, a simple red/green gradient was applied. On the following pages, you will find a gallery that shows you what each of the options can do.

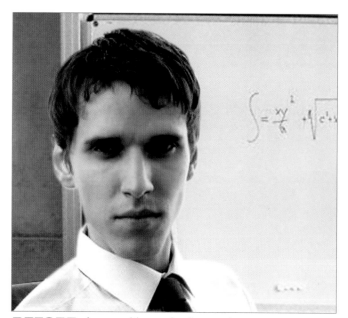

BEFORE: Image with new background.

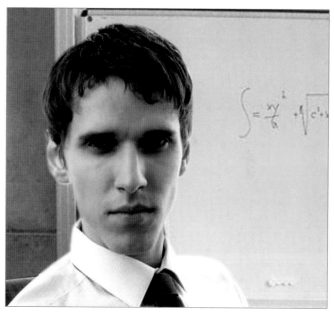

AFTER: New image with a gradient fill applied to the background.

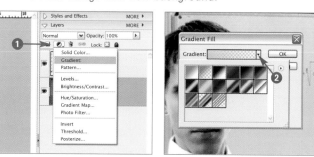

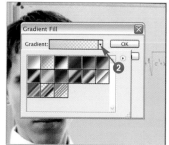

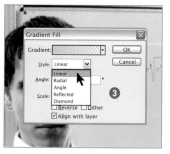

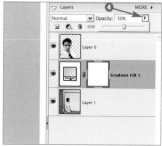

1 Click and hold on the **Create Adjustment Layer** symbol and select **Gradient** from the drop-down menu.

2 Click and hold the blue arrow left of **OK** to reveal the **Gradient** submenu. Select one by clicking on the thumbnail.

3 Choose a gradient **Style** from the drop-down menu. In this case, **Linear** was chosen.

4 Use the **Opacity** slider to control the strength of the gradient fill.

TRIPLE PORTRAIT

BEFORE: Three separate portrait studies.

AFTER: The three images are combined with cropping and a new color background to create a triple portrait.

CREATING A MONTAGE MULTIPLE PORTRAIT

Montaging portraits is a creative way to bring either a family group together, or different shots of one individual into a single image. With a family montage, you can put many images of family members together in ways that were not actually physically possible. One interesting idea is to put together images from previous generations—like a kind of visual family tree that will enable family members to compare the way that features and character traits have been handed down through the generations. Or you might use it to show a child's growth over the years from infant to teenager into adulthood. It's a great way to show a progression of many different kinds. The other interesting way to use a multiple montage is to take a series of shots of an individual and combine them into a single image. By carefully selecting the three most expressive images, you can create a more dynamic portrait of one person. This makes a great character study of an individual's unique personality in a way that would be impossible to do in a single image. The example above has one frontal shot and the other two in profile to the left and right. This arrangement balances the image.

❶ Open one of the images and click & hold on the **Lasso Tool** and select **Polygonal Lasso Tool**.

❷ Now go to **Edit** and **Copy** the selected image.

❸ Make a new document, then click on **File** and **Paste** the image into the new document (see ❷).

❹ Click on the **Eraser Tool** and select **Eraser Tool**.

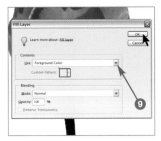

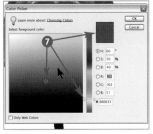

❺ Choose a **Soft-Edge Brush**. Use the **Opacity** option for an even softer erase.

❻ Click on the **Foreground Color** square.

❼ In the Color Picker window, choose the color you want using the slider arrows and then clicking on the color field. Click **OK**.

❽ With the background layer selected go to **Edit** and scroll to **Fill**.

❾ In the **Fill** window, choose the **Foreground Color** and click **OK**. Repeat all the steps for each additional image you want placed together.

❿ Once you are finished your setting, select **Flatten Image** from the **Layers, More button** in the menu.

⓫ Choose the circle **Marquee Tool** and add pixels to the **Feather** option.

⓬ Click on **Select** and choose **Inverse**.

⓭ Press the **Delete** key on your keyboard to clear the selection.

⓮ Click on the **Select** and choose **Deselect**.

MONTAGING IMAGES

BEFORE: Original image of flower.

AFTER: Montaged image adds a magical touch.

EXTRACTING AND MONTAGING

In this montage, an image of a lone flower has been combined with images of a butterfly and few other flowers. This picture was completed by adding fragments of images from an illustration.

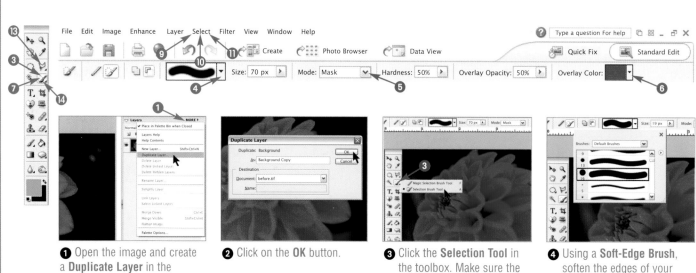

❶ Open the image and create a **Duplicate Layer** in the **Layers** palette and make this the active layer.

❷ Click on the **OK** button.

❸ Click the **Selection Tool** in the toolbox. Make sure the **Mode** in the option bar is set on **Mask**.

❹ Using a **Soft-Edge Brush**, soften the edges of your selection around the flower. Use a hard edge where desired.

❺ Adjust your brush size using the pop-up slider.

❻ You can change mask color by clicking on **Overlay Color**.

❼ Begin to **Mask** over the flower.

❽ Switch back to **Selection Mode** and press the **Delete** button to delete the background.

9 Select **Deselect** from the Select in the menu.

10 Open your chosen background image and go to **Select** and click **All**. Go to **Edit** and then click **Copy**.

11 **Paste** into the flower image by going to **Edit**. Arrange the layer underneath the **Background Copy**.

12 Pull on the **Bounding Box** handles to enlarge or decrease the image according to your preferences.

13 Click on the **Polygonal Lasso Tool** and trace the butterfly. Paste into the flower image in front of the **Background Copy**.

14 For the bee image, use the **Selection Tool** in **Mask Mode** to mask the bee.

15 After switching to **Selection Mode**, delete the rest of the image.

16 **Paste** the bee image above all other layers in the flower image.

MONTAGING IMAGES

Montaging images has a great many uses. You can place people playfully in different contexts or use the montaging technique for more practical purposes. You can make your own poster, flyers, customized invitations, birthday, and thank-you cards, as well as cards for special occasions such as weddings and anniversaries.

In this image the person and the garden were extracted from two different photographs and pasted into 2 images of a poster joined together.

JUXTAPOSITION AND MIRRORING

BEFORE: Image of leaves.

AFTER: Mirrored image.

CREATIVE PLAY MONTAGING BY JUXTAPOSITION AND MIRRORING

As well as using the **Layers** to montage images over each other, you can use **Layers** to montage images side by side. A simple but creative device is to create a **Mirror Image**. This is very easy to do, and results in some stunningly beautiful symmetrical and patterned compositions that will both delight and amaze as simple and prosaic images are transformed into geometric arrangements.

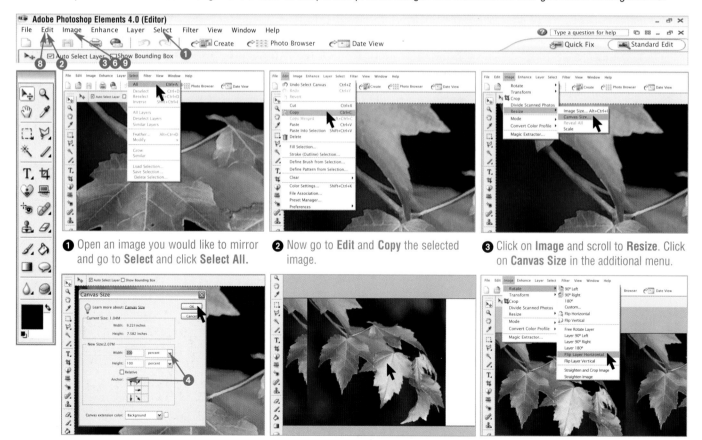

❶ Open an image you would like to mirror and go to **Select** and click **Select All.**

❷ Now go to **Edit** and **Copy** the selected image.

❸ Click on **Image** and scroll to **Resize**. Click on **Canvas Size** in the additional menu.

❹ Now double the **Width** (or height depending on orientation) and **Anchor** which direction to add from. Click **OK**.

❺ **Paste** in the copied image by going to **Edit** (see ❷). Move your image over to the edge of the canvas.

❻ Go to **Image** and scroll to **Rotate**, and click on **Flip Layer Horizontal** to flip the image and create the mirrored effect.

7 Flipping the image **Horizontally** turns the image to the right.

8 Enlarge your canvas (see **3**) for the lower quadrant and **Paste** in the image again (see **5**). Arrange your image in the lower corner.

9 Flip the pasted image vertically using the **Flip Layer Vertical** option (see **6**) this time to mirror the image above.

10 **Paste** in the copied image (see **5**). **Flip Vertical** (see **8**) and move it to the lower corner to mirror the first image. Repeat these steps until you are satisfied.

A man standing beside a wall creates a mysterious symmetrical quality of identical twins by using a single mirror image.

A row of men standing in a row has a rather magical property as it has been mirrored both across and then below using four images.

PURGING THE HISTORY

If you have a limited amount of RAM (random-access memory), you may find that you will not have enough memory to complete the last command. With every action, the **History** will save your image at that command. This uses an enormous amount of memory. To remedy this, go to **Edit** and scroll to **Purge**. This clears all this temporary information and allows you to continue.

IMAGE SIZE

If you repeat the process beyond four, the image size will become very large and your computer will take longer to process the images. You will need to stop at this stage and resize your image to reduce the pixel count. Resize to fit the largest size your printer can print, either 8x11 for an A4 print or 11x17 for an A3 print. Set the resolution at a minimum of 150 pixels per pinch if you want to print at photo-resolution quality.

DIGITAL PAINTINGS

CREATIVE USE OF THE PAINTING TOOLS

In the previous pages, you explored the different ways to montage images in layers, either over or beside one another. While it is true that the editing program is primarily designed for the editing of photographs, the program also provides all the tools you will need to create your own drawings and paintings. You can make a painting from scratch on an empty canvas or paint and draw over a photograph or any other image of your choosing. With the advent of digital editing in art schools, both fine-art and design students quickly realized the potential of this new and exciting medium. It is now commonplace to see students scanning in images to paint over, or using the screen as a blank canvas to explore composition. One of the great pleasures of using the painting tools on the computer screen is that you are actually painting with light rather than with physical paint. You will also find that the colors on the computer screen are extremely vibrant, which adds to the aesthetic appeal.

Digital painting is akin to the processes of silk-screen printmaking in which you can use a combination of photographic imagery with freehand drawing and painting. Just as with silk-screen printmaking, when you are painting in photoshop you can overlay layers of images, shapes and brush strokes in any number of different color combinations. You can also start out with an interesting digital image you have taken with your camera and use any of the painting tools to overlay shapes, lines, and color areas.

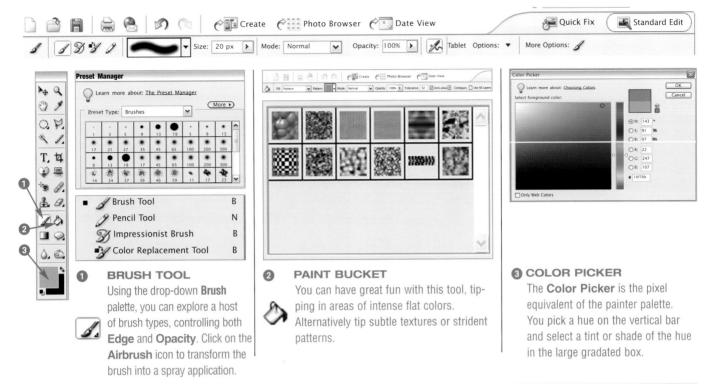

1 BRUSH TOOL

Using the drop-down **Brush** palette, you can explore a host of brush types, controlling both **Edge** and **Opacity**. Click on the **Airbrush** icon to transform the brush into a spray application.

2 PAINT BUCKET

You can have great fun with this tool, tipping in areas of intense flat colors. Alternatively tip subtle textures or strident patterns.

3 COLOR PICKER

The **Color Picker** is the pixel equivalent of the painter palette. You pick a hue on the vertical bar and select a tint or shade of the hue in the large gradated box.

USING THE PAINTING TOOLS AND LAYERS

The toolbox has a host of exciting painting effects to explore. Particularly in the **Brush** palette, you will find a tremendous range of textures that you can use in combination with the delicate applications of a diffused **Airbrush Tool**, or with the flat color of the **Paint Bucket**. It is also possible to apply different texture effects with this tool. Play and experiment with complete and total freedom as, with all of these processes, you can undo anything you have done that you don't like, then start over with something new.

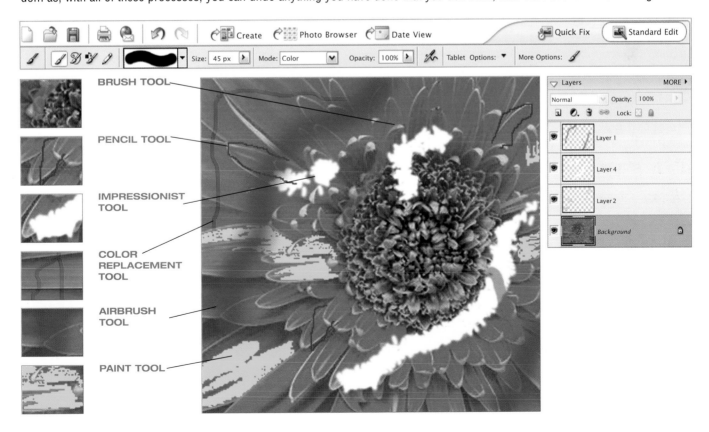

BRUSH TOOL

PENCIL TOOL

IMPRESSIONIST TOOL

COLOR REPLACEMENT TOOL

AIRBRUSH TOOL

PAINT TOOL

FILTER EFFECTS

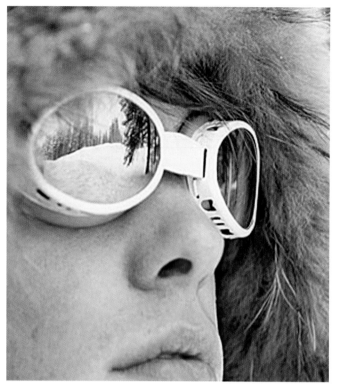

BEFORE: Original image.

AFTER: Image with the **Plaster** filter.

WHAT IS A FILTER?

Filter effects refer back to the different types of colored glass sheets and treated lenses used by film-based photographers to modify the appearance of a scene. Digital-editing software recreates these filter effects digitally. The software also offers many visual effects that mimic artistic painting and drawing styles derived from the world of graphics, allowing you to enhance or create new qualities of light, color, texture, and form. In the earlier sections of this book, you have already explored a number of filters using **Blur** and **Sharpen** to add subtle changes to the lighting or texture of your subject. This gallery is for your future reference and to help you navigate through the categories. Filter effects can add both subtle and radical texture enhancements to an image.

Select Filter View Window Help

| Plaster | Ctrl+F |
| Filter Gallery... | |

how Bo Photo Browser

Adjustments	▶	
Artistic	▶	Colored Pencil...
Blur	▶	Cutout...
Brush Strokes	▶	Dry Brush...
Distort	▶	Film Grain...
Noise	▶	Fresco...
Pixelate	▶	Neon Glow...
Render	▶	Paint Daubs...
Sharpen	▶	Palette Knife...
Sketch	▶	Plastic Wrap...
Stylize	▶	Poster Edges...
Texture	▶	Rough Pastels...
Video	▶	Smudge Stick...
Other	▶	Sponge...
		Underpainting...
Digimarc	▶	Watercolor...

Colored Pencil

Cutout

Dry Brush

Film Grain

Fresco

Neon Glow

Paint Daubs

Palette Knife

Plastic Wrap

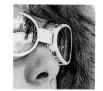

Poster Edges

Rough Pastels

Smudge Stick

Sponge

Underpainting

Watercolor

Accented Edges Angled Strokes Crosshatch Dark Strokes

Ink Outlines Spatter Sprayed Strokes Sumi-e

Color Halftone Crystallize Facet Fragment

Mezzotint Mosaic Pointillize

Bas Relief Chalk & Charcoal Charcoal Chrome Conté Crayon

Graphic Pen Halftone Pattern Note Paper Photocopy Plaster

Reticulation Stamp Torn Edges Water Paper

Diffuse Emboss Extrude Extrude Pyramids Find Edges

Glowing Edges Solarize Tiles Trace Contour Wind

TEXTURIZING BACKGROUNDS

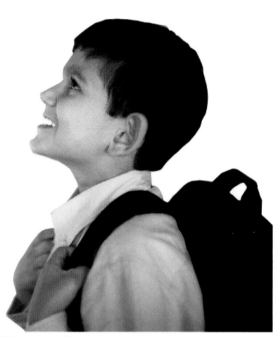

BEFORE: A straight photo.

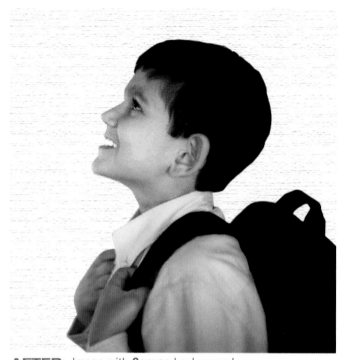

AFTER: Image with **Canvas** background.

ADDING ARTISTIC TEXTURAL EFFECTS TO AN IMAGE

Texturizing a background is a process that adds subtle patterns of texture to your image in a way that alludes to fine-art photographic prints. You can give your photograph the illusory appearance of having been printed on canvas or textured paper.

❶ Click and drag the **Background** thumbnail onto the **Create New Layer** icon.

❷ Go to **Filter** and select **Texturizer** from the **Texture** submenu.

❸ Choose which texture you wish to apply. In this example, **Canvas** was selected.

❹ Adjust the **Scaling** and **Relief** sliders to achieve your desired texture.

❺ Select the **Eraser Tool** from the toolbox.

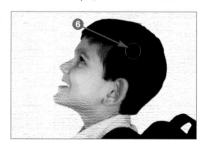

❻ Erase the foreground image so that the background layer shows through.

GALLERY OF TEXTURES

There is a range of textures that can be applied at different scales to enhance the character of your image. For most images, you will need to keep the scale and degree of relief low, otherwise the image will be overly disrupted by the texture.

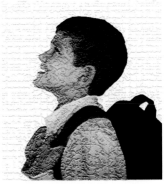
Whole image with **Craquelure.**

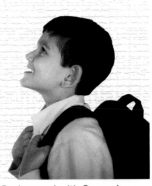
Background with **Craquelure**.

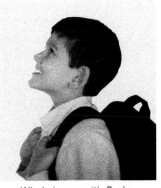
Whole image with **Grain**.

Background with **Grain**.

Whole image with **Mosaic Tiles**.

Background with **Mosaic Tiles**.

Whole image with **Patchwork**.

Background with **Patchwork**.

Whole image with **Stained Glass**.

Background with **Stained Glass**.

Whole image with **Brick**.

Background with **Brick**.

Whole image with **Burlap**.

Background with **Burlap**.

Whole image with **Sandstone**.

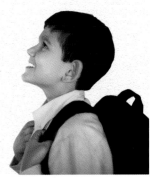
Background with **Sandstone**.

CLASSICAL "PAINTED" PORTRAITS

BEFORE: Original image.

AFTER: Image becomes painting-like with a **Watercolor** filter.

PAINTING-LIKE PICTURES

You can use the range of **Filters** to create very particular visual effects that evoke associations with other media such as painting, printmaking, and film. Here, an image is enhanced by adding a subtle application of the **Watercolor** filter, and then the **Texturizer** to create a canvas-painting appearance on your image. After you have followed the process outlined here, take the time to apply different textures and artistic painting and drawing effects to a copy of the same image. You can add these effects as layers in the **Layers** menu and then see how pairs of effects work in combination by turning on and off the different layers and adjusting the **Opacity** slider.

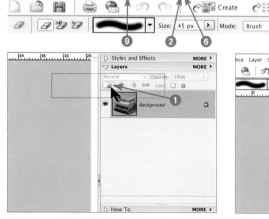

❶ Click and drag the **Background** thumbnail onto the **Create New Layer** icon.

❷ Go to **Filter** and select **Watercolor** from the **Artistic** submenu.

❸ Adjust the three sliders in the **Watercolor** dialog box to achieve a painterly effect in your portrait. Click **OK**.

4 Change the blending mode to **Overlay**.

5 Change the **Opacity** to 60%.

6 Go to **Filter** and select **Texturizer** from the **Texture** submenu.

7 Make sure **Texture** is set to **Canvas**.

8 Adjust the **Scaling** and **Relief** sliders until you are satisfied with the texture. Click **OK**.

9 Go to **Layer** and select **Flatten Image**.

PRINTING YOUR ART

You can print your images onto actual textured papers and even specialized canvas treated to accept inkjet printing ink. However, because of the uneven surface, printing on actual textured surfaces ironically often produces a less satisfactory image than applying a digital texture effect to photo-quality printing paper. A good compromise is to use a matte printing paper with a slight texture—your texture filters will look stunning, creating the appearance of a fine-art–quality print.

Artistic: Fresco

Sketch: Charcoal

Brush Strokes: Sumi-e

ADJUSTMENT MODES

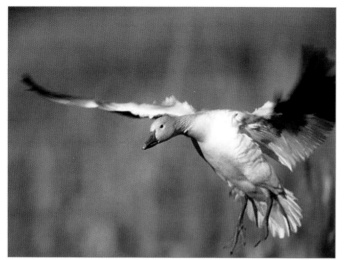

BEFORE: Image before adjustment.

AFTER: Image with adjustments applied.

ADJUSTMENT MODES

As you become familiar with how to use the essential tools and filters in photo-editing programs, you will become increasingly confident and feel more comfortable about experimenting. You will learn as much by trying things out for yourself, as by following instruction. Ask yourself, "What would happen if I overlaid this on that?" and, "What if I added another layer? And another?" Here is an example of some of the combinations to be discovered by overlaying adjustments in layers and in combination with each other. The brilliant thing is that if you don't like what you've come up with, you can undo it immediately and start again with something else.

1 To effectively look at **Adjustment** options, start with a duplicate of your **Background** layer. Go to **More** in the **Layers** palette and scroll to **Duplicate Layer** in the drop-down menu.

2 Click on the **OK** button.

3 Go to **Filter** and scroll to **Adjustments** to choose an adjustment effect from the additional menu. There are six different adjustment effects: **Equalize, Gradient Map, Invert, Posterize, Threshold,** and **Photo Filter**.

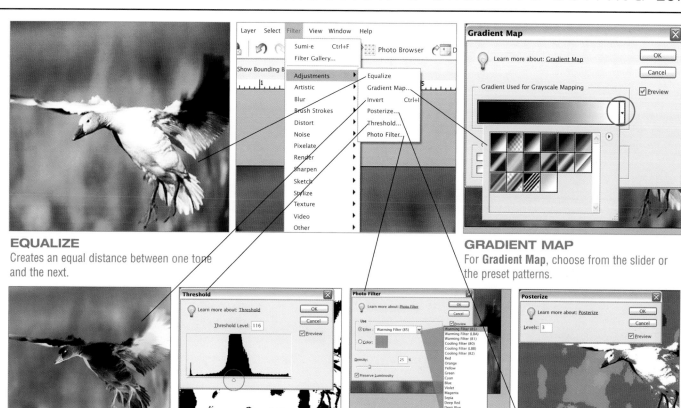

EQUALIZE
Creates an equal distance between one tone and the next.

GRADIENT MAP
For **Gradient Map**, choose from the slider or the preset patterns.

INVERT
Creates a negative of the original image.

THRESHOLD
Use the slider to adjust the image in the **Threshold** window.

PHOTO FILTER
Adjust the color balance and color temperature of the light transmitted through the lens and exposing the film.

POSTERIZE
For **Posterize**, a window will open with a **Levels** field. Each level is a value-sensitive color field.

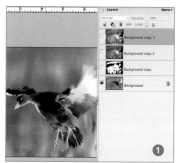

USING ADJUSTMENT MODES AND LAYERS

Here the adjustment modes were each applied in turn to the background image and saved as a layer in the **Layers** palette. Their order was then moved around to find the best combination. When you make an adjustment on its own it will appear extreme and rather crude; placed either over the original image or overlaid on another adjustment, it will create a subtle combination of effects. By reducing the **Opacity**, you can then control the exact degree of visibility of each of the layers. Turn each of the layers on and off in combination with another adjustment layer and learn to trust your instincts.

❶ **Inverted** in the first layer.
❷ With **Threshold** used, and **Multiply** as the **Blend** setting.
❸ **Gradient** used with 50% **Opacity**.
❹ **Equalize** used with 50% **Opacity**.

GRADIENT MAPPING

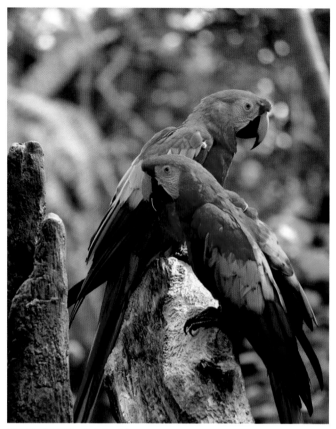

BEFORE: Original image.

AFTER: Image altered with gradient blends.

COLOR

By using the **Gradient Map** command, you can transform a photograph into a fine-art print. The gradient automatically maps the tonal range and then you can apply any one of the available gradient styles to the image. This produces startling gradations of color across the image. You can use a single gradient or apply different gradient styles and overlay them using the **Layers** palette, adjusting the **Opacity** of each layer. You can also use different blending modes and experiment with combinations of gradients by switching the layers on and off and organizing them in different orders. It's a brilliant and simple way to explore expressive color. For a primer on color to help direct your experiments, refer to the pages on Color Theory [pp 82–3], or simply follow your own tastes to make a variety of stunning images.

❶ Click and hold the **Create Adjustment Layer** icon and release the mouse over **Gradient Map**.

❷ Choose a gradient from the pop-up menu and repeat the process to create new gradient map layers in the **Layers** palette.

❸ Experiment with the various blending modes.

GRADIENT MAPPING GALLERY

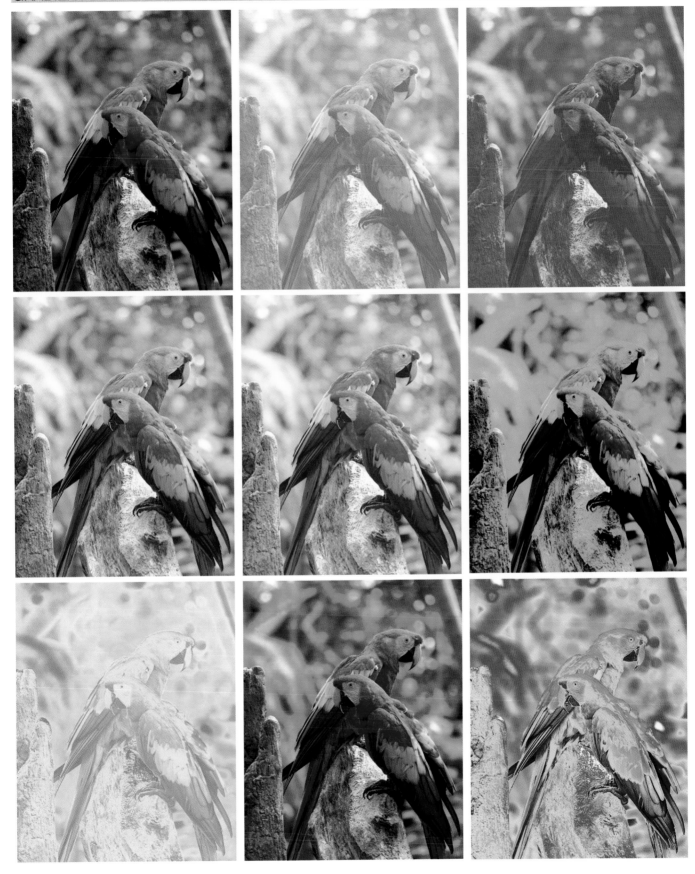

BLENDING MODES

Blending Mode allows you to merge two layers in ways that enhance color or create a particular lighting effect. Under blending mode, there are 22 options in a drop-down menu that offer a palette of both subtle and creative visual blending effects that can transform the image, from simple overlay to radical color exclusions. You can also use these blending modes as options when applying painting and fill tools.

BEFORE: Image of a flower.

AFTER: Blended with another image of a flower.

① Select the layer you want to blend. To blend successfully, you must pick a layer that is above another. **②** In the drop menu under the **Layers** tab, choose a **Blending Mode**. Depending on the effect you desire, or how much of the bottom layer to show through, you can adjust the **Opacity** in the **Layers** palette.

EXPLORING BLENDING MODES

The simplest way to understand how a blending mode works is to think of the original image as the base layer and the overlaid layer as the blend layer. The blend layer is the layer that is being blended into the base layer by the blending mode. Two images of the same subject have been placed within the **Layers** palette and overlaid to demonstrate the different and related qualities of each of the blending modes. Initially, the most important blending modes to try are **Overlay, Multiply, Soft Light**, and so that you can quickly see the range of blending mode effects on your image.

GALLERY OF BLENDING MODES

The blending modes are grouped in five related subsets of lighting effects. If you don't want to try all 22, select one or two from each of the five sub-categories of blending modes. Try applying each of the blending modes in turn and moving the Opacity slider from 100% down to 20% to see the effect of each blending mode on the image at different opacities. Normal is the default mode; changing the opacity simply fades the intensity of the blend layer. Dissolve combines the blend layer with the base layer in a random diffused pattern.

Normal **Dissolve**

Normal
Dissolve

Darken
Multiply
Color Burn
Linear Burn

Lighten
Screen
Color Dodge
Linear Dodge

Overlay
Soft Light
Hard Light
Vivid Light
Linear Light
Pin Light
Hard Mix

Difference
Exclusion

Hue
Saturation
Color
Luminosity

These blending modes darken the base layer either in parts or as a whole. They generally have no effect while blending with white.

Darken **Multiply** **Color Burn** **Linear Burn**

These blending modes lighten the base layer, often making colors brighter in the blending layer. Blending with black has no effect.

 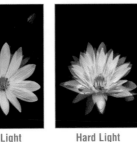

Lighten **Screen** **Color Dodge** **Linear Dodge**

Overlay **Soft Light** **Hard Light** **Vivid Light** **Linear Light** **Pin Light** **Hard Mix**

Overlay superimposes the blend image onto the base image while preserving the highlights and shadows of the base color. The rest of the modes are all variations of overlay.

Difference **Exclusion** **Hue** **Saturation** **Color** **Luminosity**

The first two modes subtract the base color from the blend color or vice versa depending on which is brighter. The other modes preserve color, saturation or hue in the base layer.

LIGHTING EFFECTS

BEFORE: A totally flat image.

AFTER: Light effects enhance contrast.

THE LIGHTING EFFECTS DIALOG BOX

Lighting Effects is a sophisticated command for changing the appearance of the lighting in an RGB image. This filter lifts a tonally flat shot by applying a distinctive directional lighting either alone or in groups. You can alter the direction and intensity of the light to alter the existing ambient lighting in the image. As with most other filters, the lighting effects need to be applied carefully.

LIGHT TYPE

Choose a light type from the pop-up menu. **Omni** shines light in all directions like a light bulb suspended above the scene. **Directional** projects light from an angle that you can set. The **Spotlight** casts an elliptical beam of light. Drag the **Intensity** and **Focus** sliders to increase the effect of each. To alter the color of the light, click the **Color** box and use the **Color Picker**.

Directional Omni Spotlight

PROPERTIES

Use the sliders to adjust the properties listed under **Gloss**, **Material, Exposure,** and **Ambience**.

DIRECTIONAL CONTROLS

The line controls the direction and angle of the light, while the handles control the edge of the ellipse. Pull on the handles to increase or decrease the size and shape of the ellipse. You can rotate the line of direction at any angle and pull on the handles to extend beyond the area of the image. As the size increases, the Intensity of the light diminishes.

TEXTURE CHANNEL

The **Texture Channel** option is for controlling how light reflects off of an image.

Matte - **Gloss** - Shiny Plastic - **Material** - Metallic

Under - **Exposure** - Over Negative - **Ambience** - Positive

PUTTING A SPOTLIGHT IN YOUR IMAGE

You can choose from several lighting types and also add or delete spotlights from an image. To create a new light, drag the icon at the base of the dialog box into the preview area. You can do this for up to 16 lights in an image.

1 Go to **Filter** and select **Lighting Effects** from the **Render** submenu. This will open the **Lighting Effects** dialog box.

2 Change **Light Type** to **Spotlight**.

3 Adjust the four handles to control the direction and angle of the spotlight.

4 Adjust the sliders to control the spotlight strength and properties. Experiment to achieve your desired results. Click **OK** to apply.

LIGHTING EFFECTS GALLERY

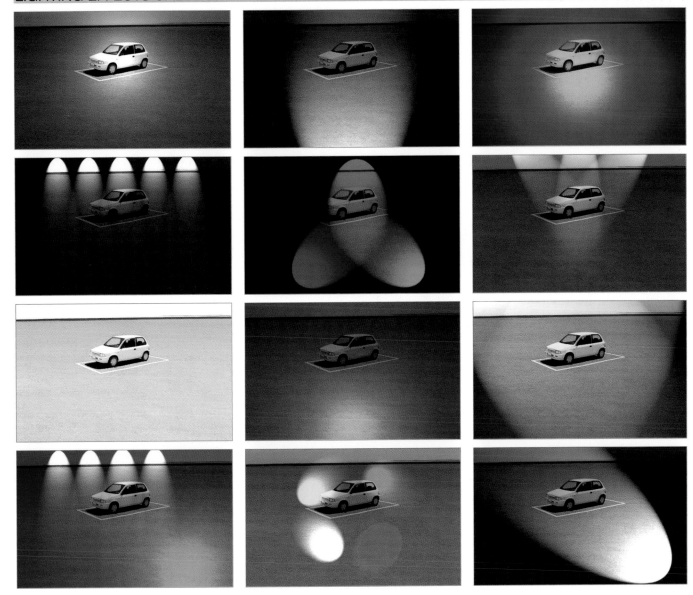

RESTORING PHOTOS

BEFORE: A damaged old photograph.

AFTER: A digitally remastered photograph.

RESTORING PHOTOGRAPHS

Photographs of childhood and important family events from the past are precious mementos. Many of these images become damaged with the passage of time, accumulating creases, scratches and fading from exposure to sunlight. There is a straightforward process to restore old and damaged photographs using the **Clone Tool** to copy undamaged areas onto damaged or missing parts of the image. You can either scan or take a digital photograph of the original and once you have edited the composition, you will then have your image in a permanent form to be enlarged and reproduced in whichever way you want. You can apply these techniques outlined here to either color or black-and-white images. In this example, an old and faded image of an old lady sitting on the sofa is restored to a pristine photograph. These restored photographs make priceless gifts for family members.

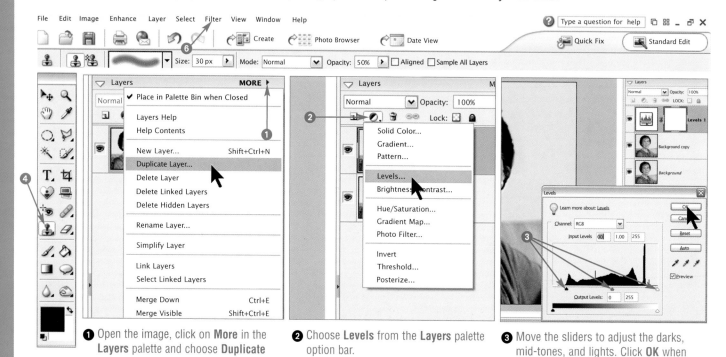

❶ Open the image, click on **More** in the **Layers** palette and choose **Duplicate Layer** and then press **OK**.

❷ Choose **Levels** from the **Layers** palette option bar.

❸ Move the sliders to adjust the darks, mid-tones, and lights. Click **OK** when finished.

❹ Choose the **Clone Tool**, hold the **Alt** key and click on the area you want to clone. Then click on the area you want to cover.

❺ Use the **Mode** option in the options bar to select **Darken** to eliminate the white marks and the **Lighten** mode for dark marks.

❻ For small knicks on the surface of the photo, use the **Dust & Scratches** filter located in **Filter**.

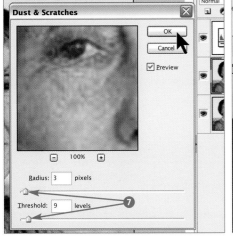

❼ Move the **Radius** and **Threshold** sliders to change the effect the filter has on the image. Click **OK** when you are finished.

❽ Use the **Unsharp Mask** to lighten up the image after the **Dust & Scratches Filter**.

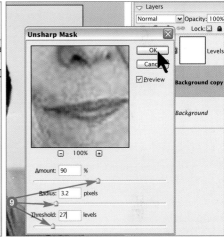

❾ Use **Amount**, **Radius,** and **Threshold** to achieve the desired effects and click **OK**.

❿ Choose **Darken** to both eliminate the unwanted words on the dress, and blend with the light shade of the dress.

⓫ After picking the area from which you want to clone, carefully begin to **Clone** away all of the blemishes.

⓬ After you are finished with the cloning, open up the **Levels** again and make any final adjustment to the cleaned-up photo.

JOINING PANORAMICS

HOW TO BEGIN THE PHOTOMERGE PROCESS

Photomerge is an exciting software function that lets you create panoramic scenes by joining a line of shots into a single composition. Taking a panoramic photograph used to mean investing in a camera for this sole purpose. Now you can easily enjoy this photographic art form that stitches together a panoramic expanse of a landscape or cityscape. You can also tilt images vertically, as in a large interior space, like the inside of a cathedral. These images make spectacular large-format prints.

❶ Go to **File,** then **New** and select **Photomerge Panorama** from the submenu.

❷ Click on **Browse** to select your source files.

❸ Select images. Select multiple images by holding down Ctrl and clicking on the file name. Press **Open** after selection.

❹ Once you have opened all of your source files click **OK**.

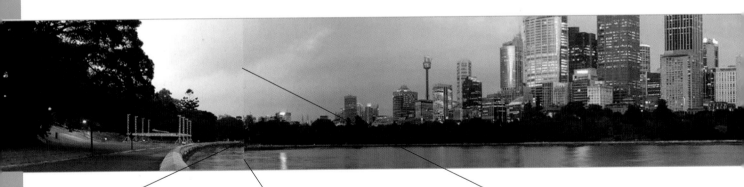

FIGURES
Avoid cropping a figure at the edge of the frame. You can see above that the scene has moved between the shots.

MOVEMENT
Avoid moving the camera up and down between shots. Pan the shots using a tripod or following a line in the scene. Ensure that your images overlap by between 20 and 30% to avoid breaks like this one.

EXPOSURE
Avoid the transition from a dark space to a lighter space, as this will create a tonal jump between the shots. Set an exposure that averages between the darkest and lightest areas and maintain this for all the shots.

SUCCESS
You can see here how the image is successfully stitched when there is an overlap of 20% and an identical exposure setting for both shots.

This is a successful section of photomerge.

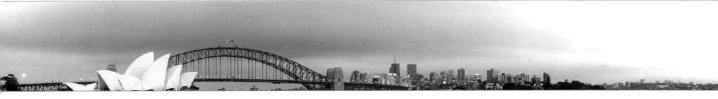

THE PHOTOMERGE DIALOG BOX

Photomerging in the software is a relatively easy process, as it automatically stitches together the images, referred to as *source files*, by searching for the overlap. If the program can't make a match with a source file, it will leave it in the image store called the **Lightbox** at the top of the photomerge window. You can then drag down and arrange and rearrange source files within the photo merge work area. Should you fail to create a successful merge you can use the clone tool to lighten, or darken, or erase unsuccessful areas.

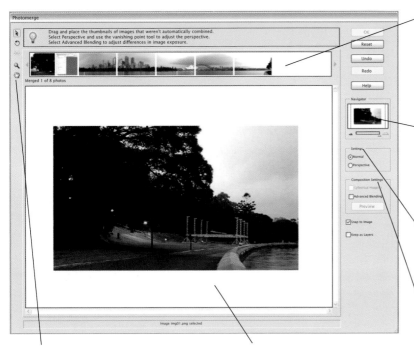

LIGHT BOX

Once you have imported the source files and applied the command to process the images, they will automatically be processed into a photomerge workspace. Source files that cannot be positioned will remain in the light-box. Drag the source files down from the lightbox to the work area and insert in the photomerge.

NAVIGATOR

This aids your navigation backwards and forwards through a photomerged line of image. Use the arrow on the slider to pull the images through the work area and to view each section of the photomerge. To zoom in or out, click on either the zoom in or zoom out icons beneath the navigator. Or, to zoom in, use the magnifying tool.

SETTINGS

How source images appear in the dialog box depends on the settings you choose. Click on **Normal** for the program to auto search and stitch the images. Select **Perspective** to alter the perspective using the **Vanishing Point** tool. This works for images composed through 120º and less.

TOOLS

Use the **Select-Image** tool to select and drag the source files. Use the **Rotate** tool to rotate images. Use the **Zoom** tool to increase the size of the image in the window.

THE WORK AREA

Source files are automatically merged in the work area. Files that cannot be merged are held in the lightbox. Drag the source files from the lightbox to the work area and insert in the photomerge.

COMPOSITIONAL SETTINGS

If you click on the **Advanced-Blending** button, the software will assess the tonal range in each of the images and seek to average any tonal difference. **Cylindrical Mapping** can also be applied to reduce the bow tie distortion that can occur when you apply perspective correction.

SHOOTING FOR PHOTOMERGE

Follow these basic rules:

- Use a tripod to pan the scene.
- Don't use wide-angle setting.
- Don't vary the focal length.
- Follow a line in the scene.
- Keep the same exposure.
- Set **Auto White Balance** to even out the color.
- Overlap the shots by 25–30%.
- Make sure there are no moving figures at the edges of your images.

ADDING TEXT TO IMAGES

Photoshop has sophisticated graphics capabilities that offer a world of exciting possibilities. This feature of the program enables you to use your images in everything from posters and custom-designed cards to newsletters and personalized family stationery. In the toolbox, you will find an easy-to-use text tool that allows you to combine text with your images in a variety of ways. Each application of text is held on a separate layer so you can move them around independently using the **Move Tool** so as to rearrange or overlap the text.

① Select the **Type** tool from the toolbox.

② With the **Type** tool selected, choose a font using the menu on the toolbar.

③ Select a font style.

④ Select a font size.

⑤ Make sure you have selected the **Anti-aliasing** button.

⑥ Click the color square to access the **Color Picker** and select a color for your type.

⑦ Click on the image to enter your text over the image. Note that a new layer will be formed.

⑧ Clicking the **Warp Text** button will access a dialog box of warp settings.

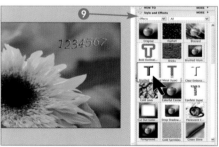

⑨ Click the **Effects** folder in the upper toolbar and select a effect to apply to your type layer.

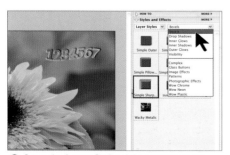

⑩ Open the **Layer Styles** folder in the upper toolbar and select a style category.

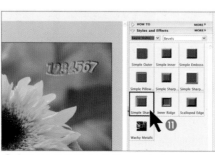

⑪ Select a style to apply to your text.

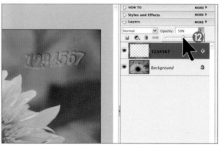

⑫ With your text layer selected, use the **Opacity** slider to change the opacity, creating faded text.

The **Effects** folder in the upper toolbar.

TEXT EFFECTS

There are a number of interesting effects that can be applied to the text layers that you have laid over your image. To apply these effects. Simply select the **Text tool** and then type your desired caption or message in your image. This text is then added as a new layer. After that, you choose whatever suits you, and then drag effect onto the text in your image. Once you have applied this new layer, you can reposition your text in any way you can apply any number of text effects in a single image.

Bold Outline.

Brushed Metal.

Cast Shadow.

Clear Emboss.

Confetti.

Medium Outline.

Running Water.

Sprayed Stencil.

Thin Outline.

Water Reflection.

Wood Paneling.

PHOTOSHOP CS: ADDITIONAL TOOLS 1

Photoshop 7 and CS is the full version of Photoshop and is the editing program preferred by professional photographers and graphic designers who manipulate photographic imagery. It is considerably more expensive than **Photoshop Elements**, but is recommended if you want to develop your editing skills to their full capability. Photoshop Elements contains about 70% of all the tools and techniques that are in Photoshop 7 and CS. As you will have seen from exploring Elements, there is a huge list of possible ways to edit, improve and creatively manipulate your images, enough to keep you busy for a lifetime of editing. So why bother with the upgrade? In Photoshop 7 and CS there are some additional tools and techniques that are indispensable for advanced editing and creative work. These features include: **Curves**, which is a precise and quick way to alter both the color and tone of an image; **Vector paths**, which lets you create very precise selections around a form and the **Healing Tool**, which is a much more sophisticated clone tool.

CURVES

The **Curves tool** is similar to the **Levels tool,** only it adjusts color and tone using anchor points that facilitate very subtle alterations in smooth transitions between the points. It is a precise and quick way to make alterations to both the color and tone of the image.

For the photographer, it is the first and most frequently used of all the tools when editing the overall light and color in an image. Use it for fine tuning, creative color mixing, and radical tonal alterations by pulling the light tones to dark and the dark tones to light.

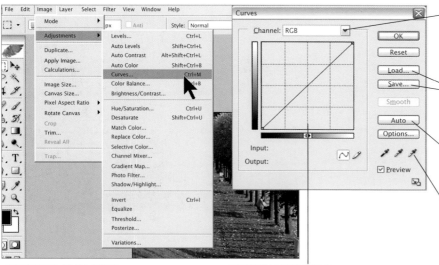

COLOR CHANNEL MENU
This defines which color channel you are adjusting. Depending on which color mode you are in, you can choose from the combination of colors or from each individual color.

LOAD AND SAVE
If you have made a curve that you wish to apply to other pictures, you can save the curve and load it later for a different image.

AUTO
Auto will apply an **Automatic Curve** to the image. If it is not what you wanted, you can still adjust the curve in the **Curve Window**.

EYE DROPPER
Eye Droppers define the darkest dark, the median value, or the the lightest light by clicking the appropriate dropper and clicking on the area in the image to which you want to assign the value.

GETTING STARTED
Curves is located in the Adjustments submenu under **Image** in Photoshop 7 and Photoshop CS.

CURVE WINDOW
This is the **Curve Window**. You can adjust the curve line to affect the levels of colors and values in the image. You can click on the curve and add anchor points to make finer adjustments.

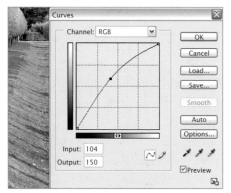

CONVEX CURVE
A simple pull upwards creates greater contrast.

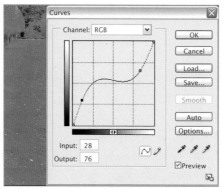

FINER ADJUSTMENTS
A serpentine with anchor points is used to bring the details of the garden.

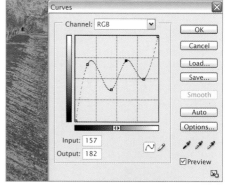

EXTREME ADJUSTMENTS
You create effects by pulling the curves up and down to extreme points.

HEALING TOOL

The **Healing Tool** is applied in the same way as the **Clone Tool**. However, it assesses the target area and applies pixels of a related tone. This makes the healing tool an easier and more refined tool for healing areas of an image such as a skin blemish in which an area of uniform skin tone has been broken by pixels of a dissimilar tone to the immediate surrounding area.

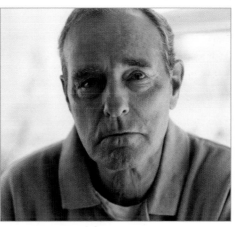

BEFORE: Without the Healing Tool.

AFTER: Healing Tool applied to the man's forehead.

USING THE HEALING TOOL

The **Healing Tool** works like a smart **Clone Tool**. The same steps you take to operate the **Clone Tool** [pp. 136–137] are used with the **Healing Tool**. Because the **Healing Tool** works best with skin, find an area of skin tone to use as a base to take from and click on that area while holding the **Option** key. Move the tool to the area to be healed and click over it, healing as you go.

❶ **Pen Tool** By clicking, you create anchor points to make the pen path. When you click back on your first anchor, you close the path.

❷ **Shape Layers** Makes everything you create with the Pen Tool a shape layer.

❸ **Paths** Creates paths from your Pen Tool selection.

❹ **Freeform Pen Tool** Lets you draw with the Pen Tool.

❺ **Add Anchor Point Tool** For adding anchor points to your pen path.

❻ **Delete Anchor Point Tool** Deletes any unwanted anchor points.

❼ **Convert Point Tool** Allows you to move and bend the anchor points.

❶	Pen Tool	P
❹	Freeform Pen Tool	P
❺	Add Anchor Point Tool	
❻	Delete Anchor Point Tool	
❼	Convert Point Tool	

THE PEN TOOL

If you want to make precise selections in your image, you will need to use the **Pen Tool**, which creates a vector layer over the pixel layer. This is necessary, because if you look at the edge of a curved form in pixel mode, it will be aliased, or made of small stairs. The vector layer is made of linear paths, thus there is no aliasing. Therefore, the **Pen Tool** is invaluable for selecting smooth-edge forms. Be forewarned: this tool takes considerable practice to master.

MAKE SELECTION Once your path has been closed, you can choose from the **Path Options**. **Make Selection** turns the path into a selection.

FILL PATH
After you have closed your path, you can fill with your **Foreground Color** or **Background Color** by going to the **Path Options** and selecting **Fill Path**.

STROKE PATH
With your path closed you can choose **Stroke Path** and pick a tool to apply to your path's outline.

PHOTOSHOP CS: ADDITIONAL TOOLS II

What follows are additional tools and techniques in Photoshop 7 and CS. The software gives you access to color channels that enable you to edit using the red, green, and blue channels from which an image is constructed. Another great feature is its ability to import and edit detailed 16-bit color files. **Color Matching** lets you match color balance in a suite of images; and the extract tool is a more sophisticated and faster addition to the selection tools. **Duotone** allows you to create beautiful color blends over black-and-white images.

EXTRACT

Extract is a selection tool that works like a hybrid of the **Selection Brush** and **Lasso Tool**. Extract is a more advanced method for extracting a selection from an image. Open your image on the desk top and go to **Filters**. Scroll down to **Extract** and the **Extract** window opens with your image in view. Select a **Marker** tool and set its width, then draw around the outline of the form you are extracting. Switch to the **Fill** tool, which works like the **Paint Bucket**. Tip in a tone and click **OK**. The background is removed, revealing your extracted image on a transparent layer.

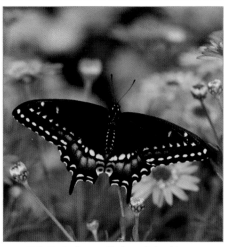

BEFORE: Butterfly in original image.

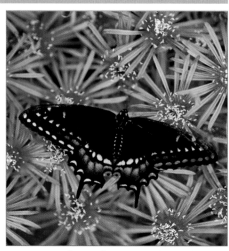

AFTER: Butterfly extracted and placed on a new background.

❶ Click on **Filter** and scroll to **Extract**.

❷ In the **Extract Window**, outline the portion you want to extract with the **Marker Tool**.

❸ When you have finished outlining, choose the **Fill** tool and click inside the outline. Click **OK**.

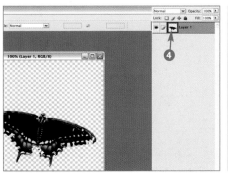

❹ You will then return to the extracted portion as a layer.

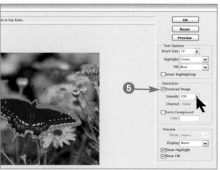

❺ **Textured Image** will give you a soft edge. The sliders in **Smooth** adjust how soft the edge is.

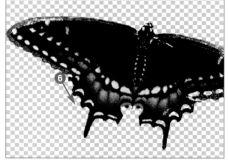

❻ After you click **OK**, you will notice a slightly smoother edge on the extracted image.

BEFORE: Image before the Channel Mixer.

AFTER: Image after the Channel Mixer

CHANNEL MIXER

Channels is accessed by clicking on **Windows** or the **Channels** tab in the menu dock. When you open the **Channels** menu, you will see red, green, and blue as three separate layers. By opening the channel mixer and choosing an output channel of either red, green, or blue, you can change the amount of color applied for each channel. This lets you explore a more sophisticated mode of color mixing.

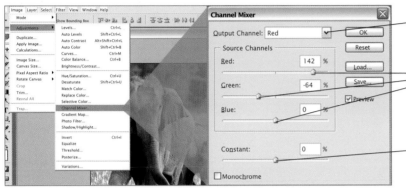

OUTPUT CHANNEL
Defines which color channel your adjustments will output through.

SOURCE CHANNEL COLOR SLIDERS
Changes the amount of color applied for each color channel.

CONSTANT
Applies an overall addition or subtraction of the color selected in **Output Channel** to the image.

Channel Mixer is located in **Image**, in the **Adjustments** submenu.

USING DUOTONES

Duotone is a must for the photographer who wants to specialize in black-and-white imagery. Using **Duotone**, you can combine color to enhance a black-and-white image, creating overlays of color atmosphere that give warm and cool blacks and grays a richer depth of tone. To begin, make a copy of your original image and apply **Grayscale** to de-saturate the image. Then select **Duotone** from **Mode** in the **Image** drop-down folder, and it will ask you to flatten layers. When the **Duotone** window opens, you will see that **Duotone** is one of three options. **Duotone**, **Tritone** and **Quadtone**. Leave the first tone Ink 1 in the **Duotone** window as the default black and then click on Ink 2 to open a **Color Picker**. Select an ink hue on the vertical color bar and a window displays **Pantone** variations of the hue in descending order of density of tone. Click on an ink tone and the effect will appear on the desktop image. You can use one ink tone with black to create a duotone or click on **Tritone** and select Ink 3. Repeat the process to create **Quadtone**. Following this procedure, you can create an exquisitely subtle depth of tone in an image.

❶ Open a **Grayscale** image.

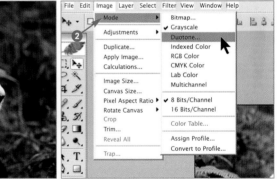

❷ Click on **Image**, go to **Mode** and scroll to **Duotone** and the **Mode** submenu.

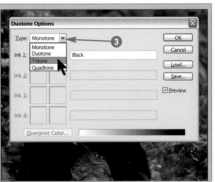

❸ In the **Duotone Options** window, you can choose from **Monotone**, **Duotone**, **Tritone**, or **Quadtone**.

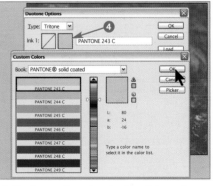

❹ To change the color, double click on the color square and the **Custom Colors** window will open. Use the color slider to pick the **Pantone Color** you want to apply.

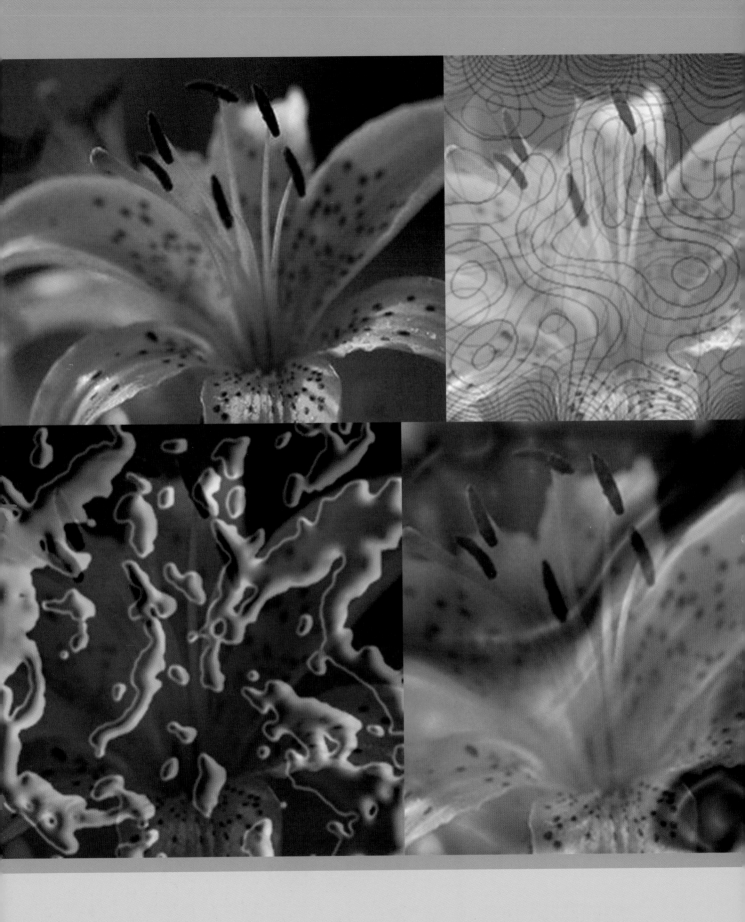

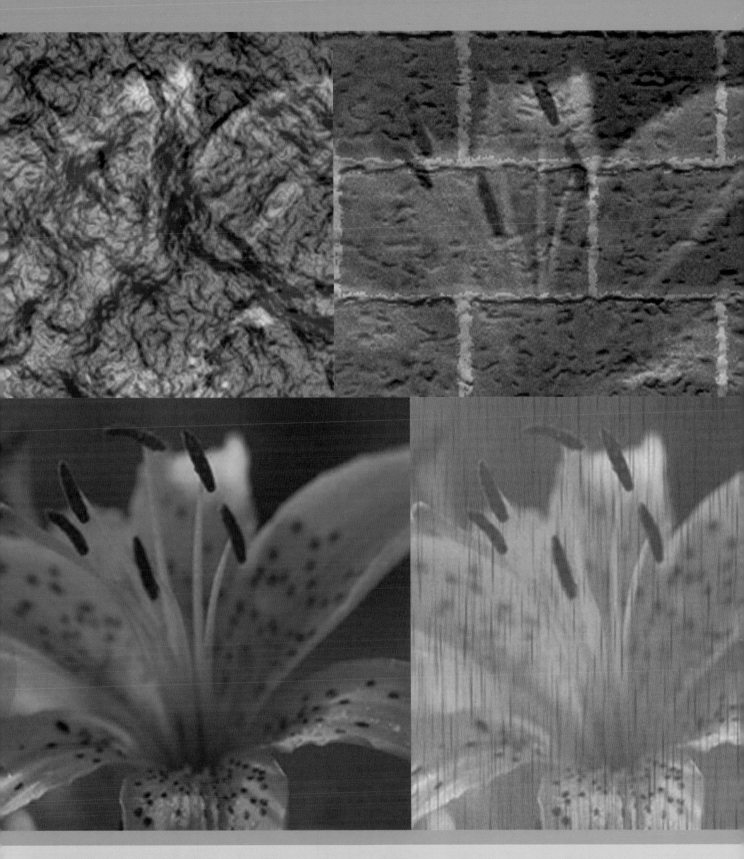

PRINTING AND SHARING

MAKING CARDS (MAC)

BEFORE: Image of snow on a branch.

AFTER: Finished card.

TURNING IMAGES INTO MORE

Making cards is both useful and fun. You can use personalized imagery and combine it with text in a way that looks really professional. The software is a formidable design tool that lets you organize text and images like a professional graphic designer. Once you have applied the text to your image, all that remains is doubling the canvas size so that you have a back and a front to your folded card.

❶ Go to **Image** and select **Image Size** from the **Resize** submenu. This will open the **Image Size** dialog box.

❷ Make sure **Resample Image** is not checked. Type 300 into the **Resolution** box, (the standard resolution for printing).

❸ Go to **View** and select **Rulers**. Rulers will appear on the top and left edges of your image.

❹ Select the **Crop Tool** from the toolbox.

❺ Starting from the upper left corner, click and drag the tool to 7 inches wide and 5 inches tall. Press the **Return** key to crop.

❻ Click on the background color square at the bottom of the toolbox. This will open the **Color Picker**.

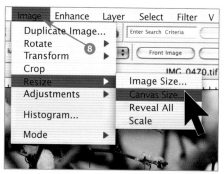

7 Define the **Background** color by using the slider in the central color bar and clicking in the large gradated box. Then click **OK**.

8 Go to **Image** and select **Canvas Size** from the **Resize** submenu. This will open the **Canvas Size** dialog box.

9 In the grid of nine squares next to **Anchor**, click on the bottom center box.

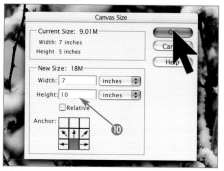

10 Type 10 (double the previous number) into the **Height** box. Click **OK**. You image will double in size. The upper half will be the back.

HELPFUL HINTS

- It's best to print the file on glossy paper. The thicker the paper, the better.
- Make sure that your printer can print on glossy paper. If not, you may need to print on matte paper. Most home printers have an option to print on glossy paper.
- In the print dialog box, be sure to check **Crop Marks**. This will help you to trim your card. It's best to trim (cut out) your card before you fold it.
- The maximum size of your card is determined by what paper sizes your printer supports. It's a good idea to stick to standard sizes if you want to mail the cards in standard card envelopes. You may also use the process shown above to create portrait format cards. Simply rotate the image 90° clockwise.

AFTER: Completed Card

Back of Card

Front of Card

You can have different colors for the front and back of the card. Explore the various possibilities of creating memorable and personalized cards.

ANOTHER CARD IDEA

Back of Card Front of Card

Inside Left Inside Right

Dear

You are invited to my Party

on............

at Lullabelles

3.00 to 6.pm

Saturday

love from Grace xxx

To create the inside of the card keep the front of the card open on the desktop and click command> A and command>C to copy. Then press command > N to create a new document and this will set the new document to the same size as the front of the card.

To add text to the inside of the card position the cursor on the right-hand half of the new document and then select the text tool and follow the procedure for applying text outlined in the previous pages.

MAKING CARDS

BEFORE: Image of a landscape.

AFTER: Finished card.

TURNING IMAGES INTO MORE

Making cards is both useful and fun. You can use personalized imagery and combine it with text in a way that looks really profession-al. The software is a formidable design tool that lets you organize text and images like a professional graphic designer. Once you have applied the text to your image, all that remains is doubling the canvas size so that you have a back and a front to your folded card.

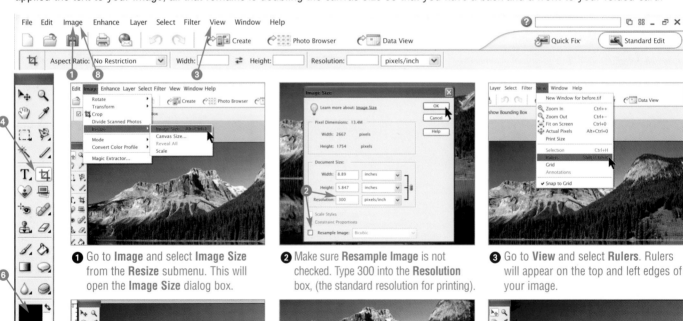

❶ Go to **Image** and select **Image Size** from the **Resize** submenu. This will open the **Image Size** dialog box.

❷ Make sure **Resample Image** is not checked. Type 300 into the **Resolution** box, (the standard resolution for printing).

❸ Go to **View** and select **Rulers**. Rulers will appear on the top and left edges of your image.

❹ Select the **Crop Tool** from the toolbox.

❺ Starting from the upper left corner, click and drag the tool to 7 inches wide and 5 inches tall. Press the **Return** key to crop.

❻ Click on the background color square at the bottom of the toolbox. This will open the **Color Picker**.

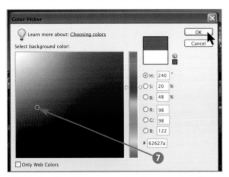

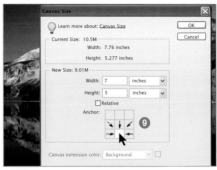

7 Define the **Background** color by using the slider in the central color bar and clicking in the large gradated box. Then click **OK**.

8 Go to **Image** and select **Canvas Size** from the **Resize** submenu. This will open the **Canvas Size** dialog box.

9 In the grid of nine squares next to **Anchor**, click on the bottom center box.

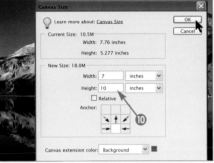

10 Type 10 (double the previous number) into the **Height** box. Click **OK**. You image will double in size. The upper half will be the back.

HELPFUL HINTS

- It's best to print the file on glossy paper. The thicker the paper, the better.
- Make sure that your printer can print on glossy paper. If not, you may need to print on matte paper. Most home printers have an option to print on glossy paper.
- In the print dialog box, be sure to check **Crop Marks**. This will help you to trim your card. It's best to trim (cut out) your card before you fold it.
- The maximum size of your card is determined by what paper sizes your printer supports. It's a good idea to stick to standard sizes if you want to mail the cards in standard card envelopes. You may also use the process shown above to create portrait format cards. Simply rotate the image 90º clockwise.

AFTER: Completed Card

Back of Card

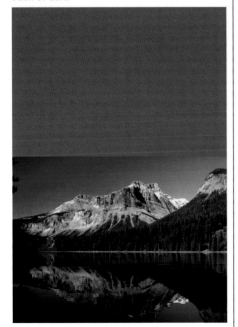

Front of Card

You can have different colors for the front and back of the card. Explore the various possibilities of creating memorable and personalized cards.

MONTAGING IMAGES

Back of Card Front of Card

To create the inside of the card keep the front of the card open and press Ctrl > A and Ctrl > C to copy. Then press Ctrl > N to create a new document and this will set the new document to the same size as the front of the card.

Back of Card Front of Card

To add text to the inside of the card position the cursor on the right hand half of the new document and then select the text tool and follow theprocedure for applying text outlined in the previous pages.

GALLERY OF EFFECTS

Under Filters, you can explore a variety of effects closely related to the artistic painting. These are in subsets of Frames, Image effects, and Textures. **Frames** are visually appealing ways to create the illusion of a photograph being mounted in a frame. This is an effective application for an image that will sit in a clip frame that has no actual frame. **Image** effects include combinations of lighting and painting effects. **Textures** provide effects that mimic an array of material surfaces and some additional lighting effects. For example, these texture effects can be used to apply a simulated appearance of wood or stone. Each of these subsets of effects has been applied to the same image of a lily to make comparing the effects easier.

FRAMES

Aside from the simulated appearance of an actual frame, there are subtle edging effects that break the severity of the rectangular edge of the image. Without affecting the main image, they create the illusion of being overdrawn, painted or printed at the edges.

The **Effects** palette

Brushed Aluminum

Cut Out

Drop Shadow

Foreground Color

Photo corners

Recessed frame

Ripple Frame

Spatter Frame

Strokes Frame

Text Panel

Vignette

Waves Frame

Wild Frame

Wood Frame

IMAGE EFFECTS

The **Image** effects extend the repertoire of effects in painting and drawing and combine these effects with lighting effects. They are pre-blended combinations of other filter effects.

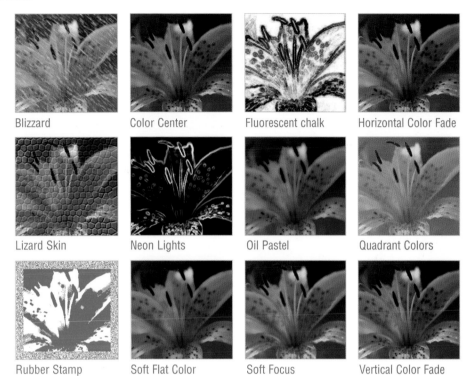

Blizzard	Color Center	Fluorescent chalk	Horizontal Color Fade
Lizard Skin	Neon Lights	Oil Pastel	Quadrant Colors
Rubber Stamp	Soft Flat Color	Soft Focus	Vertical Color Fade

TEXTURES

Each of these textures was applied at 50% **Opacity** so that the underlying lily image appears to be imprinted with the texture. The Belgian Surrealist painter Rene Magritte would have delighted in the possibilities of combining a lily with a brick wall!

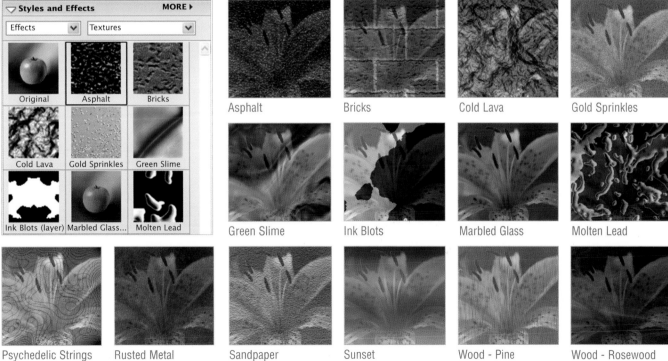

Asphalt	Bricks	Cold Lava	Gold Sprinkles		
Green Slime	Ink Blots	Marbled Glass	Molten Lead		
Psychedelic Strings	Rusted Metal	Sandpaper	Sunset	Wood - Pine	Wood - Rosewood

PRINTING (MAC)

As you see your images in all their sharpness and color on the computer monitor, you will be impatient to print them. You can have your images printed for you, or you can invest in a printer. Inkjet and laser printers are the most common. The quality of your prints will depend on the quality of the printer, but if you own a newer printer, it will likely be capable of photo-quality images. There are various photo-quality papers to choose from that come in different weights and finishes and are available in photography and stationery stores.

❶ Under **File**, click **Print Preview** icon. The **Print Dialog** box appears.

❷ Check **Scale to fit Media**, **Center Image** and **Show Bounding Box**.

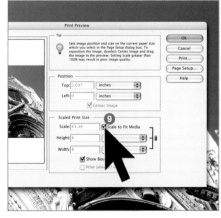

❸ Select **Page Setup**.

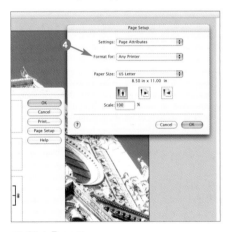

❹ Click **Format**.

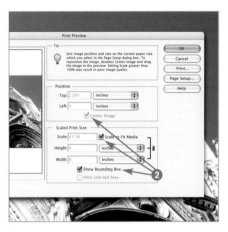

❺ Select Printer.

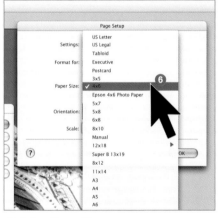

❻ Select **Paper Size**.

❼ Select **Orientation**.

❽ Click **OK**.

❾ Check **Scale to Fit Media**.

⑩ Click **Print**. The print dialog box appears.

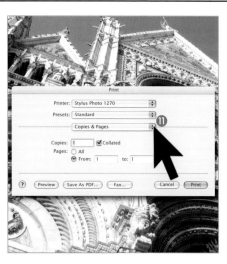

⑪ Select **Copies & Pages**.

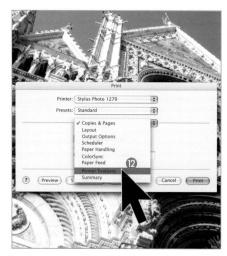

⑫ Select **Printer Features**.

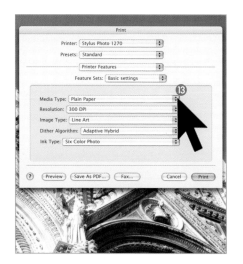

⑬ Select **Media Type**.

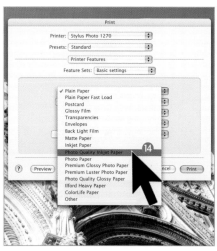

⑭ Select **Photo Quality Inkjet Paper**.

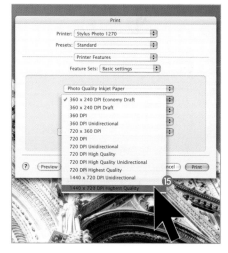

⑮ Select **Image Resolution**.

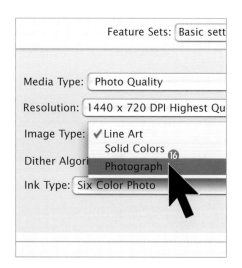

⑯ Select **Image Type**. Select **Photograph**.

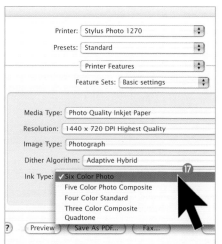

⑰ Select **Ink Type**. Select **Six Color Photo**.

⑱ Click **Print**.

PRINTING 2 (MAC)

MAKING A PICTURE PACKAGE

Using the **Picture Package** command lets you select an image of which you want to make multiple prints. The software will automatically duplicate, size and format the image to fit your paper format. Once you select your image from a folder, the **Picture Package** window will present you with options. Under **Document** select the paper size and under **Layout** a drop-down menu will provide you with combinations of sizes that will fit your paper. You might choose two 5x7's, and four 3x5's, or one 5x7, two 3x5's and four 2x2's. Now you have different sizes of your image to use as you like. You could, for instance, send a wallet-sized image with a thank-you note. This feature is fast and easy and reduces paper waste.

❶ Open **Picture Package** from **Print Layouts** under **File** in the menu bar.

❷ Select **Page Size**.

❸ Select a **Layout** from the list.

❹ Select **Image Resolution**.

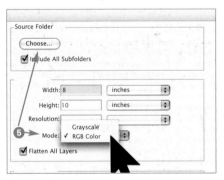

❺ Select your image by clicking on **Choose** in **Source Folder** and select either **Grayscale** or **RGB Color**.

❻ Select the folder containing your image file.

❼ Select the image file from the folder and click on **Open**.

❽ If the layout looks right, click **OK**. If not, choose another combination. When you've hit upon the right one, and click **OK**.

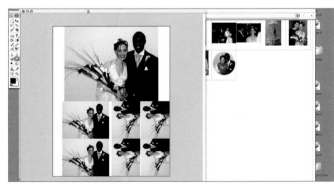

❾ Completed **Picture Package**: Go to **Print** in **File** and click on **Print** to print sheet.

MAKING A CONTACT SHEET

A contact sheet is a very useful aid when you are storing your images. If you make a contact sheet of all the images on a file before you burn the folder to CD, you then have a print of all the images that you can then attach to the CD. If you store the CD and contact print together as you accumulate CDs, you will be able to quickly see what it contains without opening it.

1 Open **Contact Sheet** from **Print Layouts** in the menu bar.

2 Click **Choose** to select your source folder.

3 Under **Document** select page size and resolution.

4 Choose to run images across in rows or down the page in columns.

5 Click **Use Filename As Caption**.

6 Click **OK** to apply automated processing of images.

7 Completed contact sheet appears on desktop. Select **Print** to print contact sheet. Click **Save** to save contact sheet and type in your title before closing.

PPI AND PRINT SIZE

There is a direct correspondence between the file size of the photograph you take, and the size and quality of the image you can print. Think of a balloon with writing on it: the more you blow up the balloon, the more the text becomes stretched. With digital photographs, the larger you make the print, the larger the pixels will appear in the image, making the print less detailed. This is why you need to set your camera at its highest pixel count, that is its highest picture resolution, if you want to print large images.

RESAMPLING TO ENLARGE

If your original file size is too small, to enlarge the image to the size you want, you can resample your image by clicking on the **Resample** button in the **Resizing** window. There you can increase the pixel count to achieve the dimensions you need for the size of the image. For best results, resize in increments of 10%, so that you add 10% to the 100% image size. Type the number 110% into the box, and if you need to add more, you would type in 120, 130, etc.

PPI AND DPI: THE DIFFERENCE

Inkjet printers work by spraying fine dots of ink and dpi stands for how many dots are sprayed per inch. You can print quickly at a lower dpi resolution or slowly at a higher dpi. The higher the dpi, the finer the print detail. If you formatted an image to a high-ppi resolution and then printed the image at a low-dpi resolution, you would lose the high definition of the image.

RULES OF THUMB

Approximate Image File Size in Pixels	Image Dimension	Print Size
1.5 million pixels	1000 x 1500	4 x 6 inches
2 million pixels	1250 x 1750	5 x 7 inches
3 million pixels	1500 x 2000	6 x 8 inches
5 million pixels	2000 x 2500	8 x 10 inches
10 million pixels	2500 x 4000	10 x 16 inches

PRINTING (PC)

As you see your images in all their sharpness and color on the computer monitor. You will be impatient to print them. You can have your images printed for you, or you can invest in a printer. Inkjet and laser printers are the most common. The quality of your prints will depend on the quality of the printer, but if you own a newer printer, it will likely be capable of photo-quality images. There are various photo-quality papers to choose from that come in different weights and finishes and are available in photography and stationery stores.

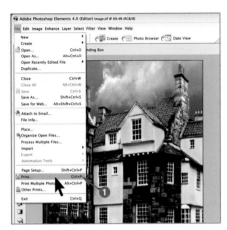

1 Under **File** click **Print.**

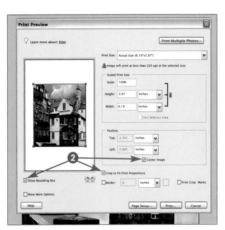

2 The **Print Dialog** box appears. Check **Crop to Fit, Print Proportions, Center Image,** and **Show Bounding Box.**

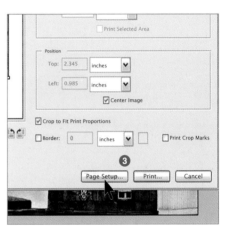

3 Select **Page Setup.**

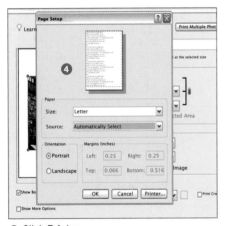

4 Click **Printer.**

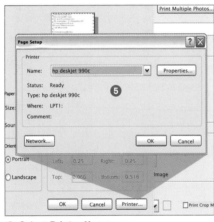

5 Select **Printer Name.**

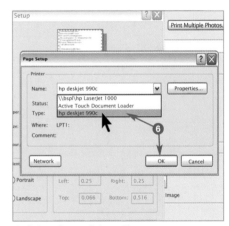

6 Select **Paper Printer Type.**

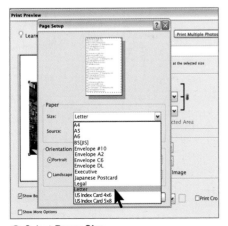

7 Select **Paper Size.**

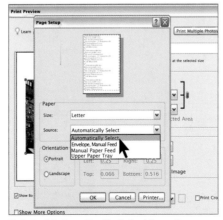

8 Select **Automatically Select** from **Source** drop down menu.

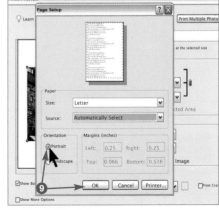

9 Select **Orientation.**

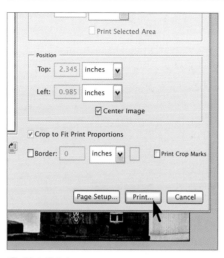

10 Crop to Fit Print Proportions. This option will automatically crop image so that your image fits on the paper when you take print.

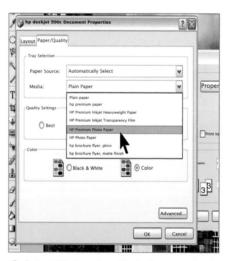

11 Click **Print**.

12 Click **Properties.**

13 Select **Paper Quality** tab.

14 Select **HP Premium Photo Paper**.

15 Select **Best** for **Quality Setting**.

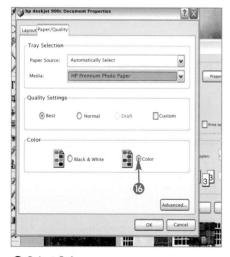

16 Select **Color**.

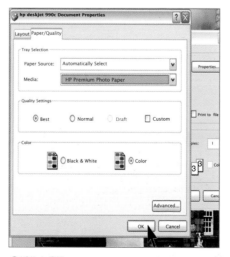

17 Click **OK**.

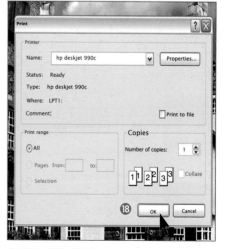

18 Click **OK** to **Print**.

PRINTING 2 (PC)

PRINTING PHOTOGRAPHS

There are different options for printing images in Photoshop Element. Once you have selected the images to be printed, you will be presented with options window. You can select the type of print, size of print, layout, frames and text labels. This feature is fast and convenient and reduces paper waste.

❶ Under the File menu click Print Multiple Photos.

❷ In Print Photo window click Add button.

❸ Select the Photographs to be printed from the Add Photos window and click Add Selected Photos button.

INDIVIDUAL PRINTS

❶ Select the Individual Prints from the Type of Print, drop-down menu.

❷ Select the size of the print as 4" x 6" from the drop-down list.

❸ You can click the checkbox next to One Page Per Photo to select the photo to be printed per page and click Print.

CONTACT SHEET

❶ You can also select Contact Sheet as the type of print.

❷ You have the option to select the numbers of Columns in Select Layout. Select 3 as the option.

❸ You can add a Text Label on your Image from Add a Text Label Menu. Check different options to be added.

PICTURE PACKAGE

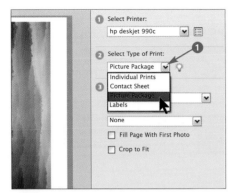

1 Now, Select Picture Package as the Type of Print.

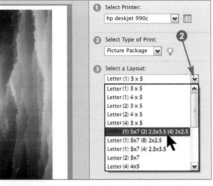

2 Select a layout size for your image from Layout drop-down list.

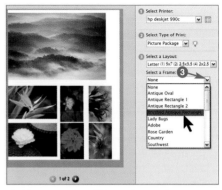

3 You can select different frames for your images from Frames drop-down list.

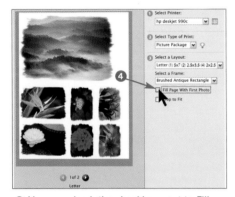

4 You can check the checkbox next to Fill Page with First Photo to convert all images as the first Image.

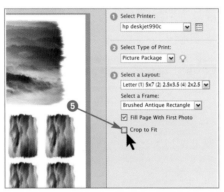

5 Check Crop to Fit checkbox to fit the image in a single page.

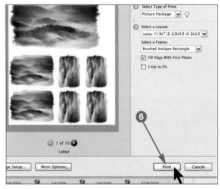

6 Click Print to print the page.

LABELS

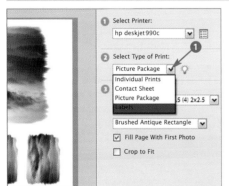

1 Select Labels as the Type of Print from the drop-down list.

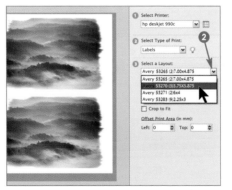

2 Select Layout for the Images to be printed from the Layout drop-down list.

3 You can also select the Offset Print Area and finally click Print.

CREATING SLIDE SHOWS (MAC)

The images that you have organized into folders can be viewed as a slide show using Photoshop, Adobe Acrobat Reader or Microsoft Office Power Point. The software presents the photographs as a slow moving picture show and each image lingers just long enough for you to study and absorb the feeling of the photograph and then moves you onto the next. The digital version of the slide show effectively replaces the old slide shows that were a favorite of previous generations of photo enthusiasts. You can modify the rate of change from 1–5 seconds.

❶ In **File,** scroll down to **Automation Tools** and click **PDF Slideshow** in the submenu.

❷ You can either drag the files into the window or use the **Browse** button.

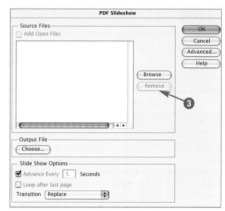

❸ If you import a file and wish to remove it, select it and click the **Remove** button.

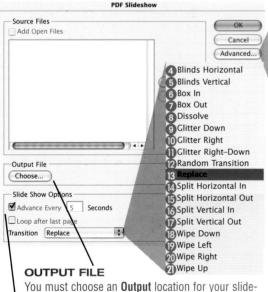

OUTPUT FILE
You must choose an **Output** location for your slide-show file. This button lets you browse for the location you want.

SLIDE SHOW OPTIONS
Check the **Advance Every** box and enter a number of seconds to view each file. If you check the **Loop after last page** box, your slide-show will loop endlessly over.

PDF OPTIONS
You can choose to encode your PDFs as **JPEG**s or **ZIP** files. You can also define the quality using either the drop menu or the slider arrow.

TRANSITION

❹ **Blinds Horizontal** Emulates blinds turning horizontally.

❺ **Blinds Vertical** Emulates blinds turning vertically.

❻ **Box In** Creates a box closing in.

❼ **Box Out** Creates a box growing out.

❽ **Dissolve** Dissolves one picture into the next.

❾ **Glitter Down** a sparkling effect using the other image.

❿ **Glitter Right** a sparkling effect using the other image that moves to the right.

⓫ **Glitter Right-Down** moves across the page diagonally.

⓬ **Random Transition** uses multiple transition options at once.

⓭ **Replace** simply replaces the past image with the next.

⓮ **Split Horizontal In** Closes in on the the image horizontally.

⓯ **Split Horizontal Out** Divides the image in half horizontally by moving out.

⓰ **Split Vertical In** Closes in on the image from the left and right.

⓱ **Split Vertical Out** Divides the image out from the left and right.

⓲ **Wipe Down** Wipes across the image from top to bottom.

⓳ **Wipe Left** Wipes across the image from left to right.

⓴ **Wipe Right** Wipes across the image from right to left.

㉑ **Wipe Up** Wipes across the image from bottom to top.

BURNING CD'S (MAC)

Once you have created a slide show, you can burn the PDF document to CD using a CD burner. If your computer does not have a built-in CD burner, you can buy a separate CD burner that attaches to your computer via Firewire. The advantage of burning your images onto a disk is that CDs are the cheapest storage source for saving images—and they hold 700 MB worth of imagery. More and more people now burn their images to disk and view their photographs as slide shows.

BURNING CD'S WITH MAC OS X

This process could not be easier—insert a CD and drag your files for burning onto the disk. Drag the disk to the Trash can, which transforms to a burn icon; burn it and go!

❶ Open your cd drive, using the keyboard **Open/Eject** button or an **Open/Eject** button on the drive and insert a burnable disc.

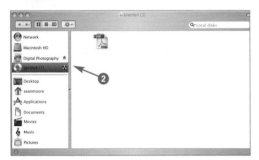

❷ After the CD icon appears on your desktop, double click it and drag the files you want to burn into the **CD Window**.

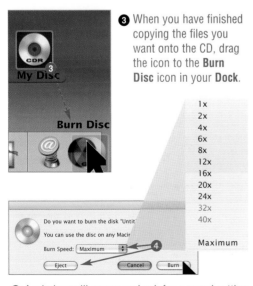

❸ When you have finished copying the files you want onto the CD, drag the icon to the **Burn Disc** icon in your **Dock**.

1x
2x
4x
6x
8x
12x
16x
20x
24x
32x
40x
Maximum

❹ A window will popup and ask for a speed setting from the **Burn Speed** drop menu, or if you want to just **Eject** the CD. Once you have set the speed, click **Burn** and you disc will start burning.

BURNING CD'S WITH TOAST

Toast allows you to set a number of variables including: burning music CDs and using **Buffer Underrun** to ensure the CD is burned at the right speed for the disk.

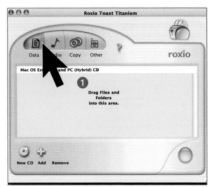

❶ Open **Toast**, and choose the type of CD you want to burn– **Data** or **Audio**.

❷ Click on the **New CD** icon.

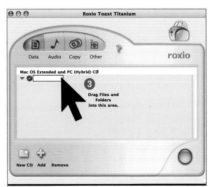

❸ Title your CD and drag and drop in the files you wish to burn.

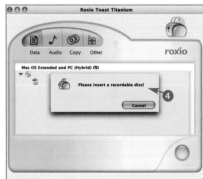

❹ After you insert a burnable disc in the drive, **Toast** will check the disc for space.

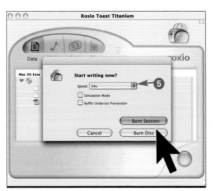

❺ After **Toast** finishes checking the disc, a **Burn Options** window will ask for a speed in the drop menu. Click **Burn Disc** or **Burn Session** when you are finished.

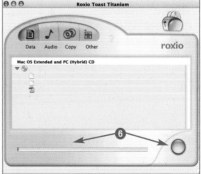

❻ **Toast** will start burning your CD. If you need to, you can stop the CD by clicking **Abort**.

CREATING SLIDE SHOWS

The images that you have organized into folders can be viewed as a slide show using Photoshop, Adobe Acrobat Reader or Microsoft Office Power Point. The software presents the photographs as a slow moving picture show and each image lingers just long enough for you to study and absorb the feeling of the photograph and then moves you onto the next. The digital version of the slide show effectively replaces the old slide shows that were a favorite of previous generations of photo enthusiasts. You can modify the rate of change from 1–5 seconds.

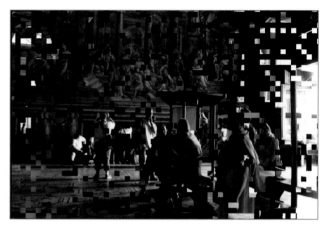

1 In **File** click on **Create** and **Slide Show** submenu.

2 You can either drag the files into the window or use the **Add Media** button.

3 If you import a file and wish to remove it select it and click the **Delete** command.

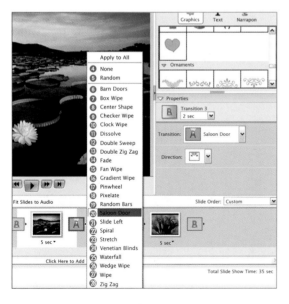

4 None: A transition will not be applied.

5 Random: Uses multiple transition options at once.

6 Barn Door: This transition will wipe image in horizontal as well as vertical opposite directions.

7 Box Wipe: Wipes across the image. You can choose by selecting Directions from Direction menu.

8 Center Wipe: This transition will add different shapes to apply transition with its anchor point in the center.

TRANSITION

9 Checker Wipe: Across the image one to another.

10 Clock Wipe: This transition will wipe images in a circular motion with its anchor point in the center.

11 Dissolve: Dissolves one picture in the next.

12 Double Sweep: This transition will use two wipes to apply transition. You can change its directions from Direction menu.

13 Double Zig Zag: Wipes image in a Zig Zag motion. You can also change its direction.

14 Fade: This transition adds fading effect to your images.

15 Fan Wipe: Wipes image in a circular motion.

16 Gradient Wipe: This transition allows you to give smooth transitions using gradation.

17 Pinwheel: This transition will wipe images in a circular motion with its anchor point in the center.

18 Pixelate: This transition will transform image from one to another by generating pixels.

19 Random Bar: Randomly generated bars will be used to give this transition.

20 Saloon Door: Large tinted sliding deck saloon door for easy transition between cabin and cockpit.

21 Slide Left: Across the image from left to right.

22 Spiral: This transition allows you to give spiral effect in your slide. You can choose direction and number of spirals from Direction menu.

23 Stretch: This transition gives impression of stretching image over another slide.

24 Venetian Blinds: This transition wipes image with multiple blinds.

25 Waterfall: The transition will add rain wipe effect. You can choose directions from Direction menu.

26 Wedge Wipe: The image will be wiped in a triangular shape. You can choose your preferred options from Direction menu.

27 Wipe: Wipes image in only four direction. You can choose direction from direction menu.

28 Zig Zag: Wipes image in a single Zig Zag motion. You can change its directions from Direction menu.

BURNING CD'S

Once you have created a slide show, you can burn the PDF document to CD using a CD burner. The advantage of burning your images onto a disk is that CD's are the cheapest storage source for saving images-and they hold 700 MB worth of imagery. More and more people burn their images to disk and view the photograph's as slide shows.

BURNING WITH WINDOWS XP

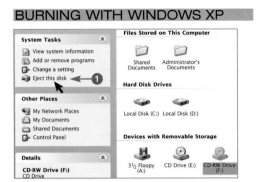

❶ Click **Eject this Disk** to open CD drive and insert a blank disc.

❷ Copy Paste the files to be burned in the right panel.

❸ Click **Write these files to CD** to start burning disc.

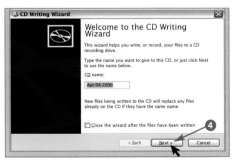

❹ Enter the CD name and Click **Next** to burn the CD.

BURNING WITH NERO

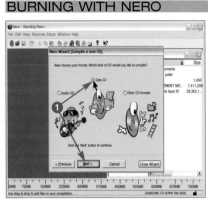

❶ Select the Type of CD to be created and click **Next**.

❷ Click **Finish** after selecting the type of CD to be burned.

❸ Drag the files to be burned in the left window as shown.

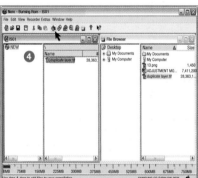

❹ Click the **Burning Icon** on the menu to start burning the disc.

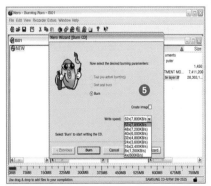

❺ Select the writing speed from **Write Speed** drop-down list.

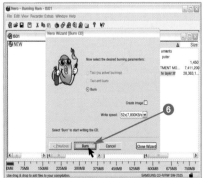

❻ Finally, click the **Burn** button to burn your disc.

CREATING A PHOTO WEB GALLERY (MAC)

Many of the Internet providers now offer website services. If you are in a business, your friends, relatives and potential customers can access this website at any time to see your latest images, and you can update the images at regular intervals. Until now, creating a website required some computer programming skills—but the system is rapidly becoming user-friendly. Photoshop Elements

incorporates an easy-to-use program that helps you organize a web photo gallery, which is a website that features a homepage with thumbnail images and gallery pages with full-size images. Each page contains links that allow visitors to navigate the site. The Photoshop Elements web photo gallery provides a range of options for presenting your images in a professional presentation. You can customize the gallery to display the images in different ways— using styles such as **Antique Paper**, **Horizontal Dark**, **Museum**, **Office**, and **Theater**.

❶ To create your **Photo Web Gallery**, go to **File** and scroll to **Create Photo Web Gallery**.

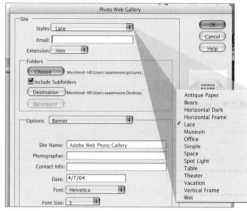

❷ In the **Web Gallery** window, choose a **Style** for your Web Gallery.

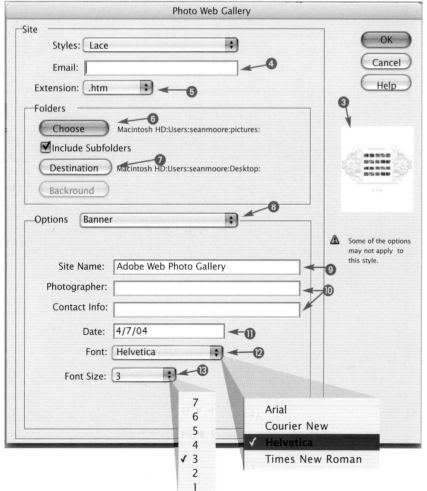

Ⓐ Some of the options may not apply to this style.

❸ After you choose your **Style**, a thumbnail of the style will appear below the **Help** button.

❹ Next, fill in your email address if you want it to be on the page.

❺ Choose the **File Extension** for the index and image pages: **.html** or **.htm**.

❻ Click on the **Choose** button to choose the folder of images you want in the gallery.

❼ Now click on the **Destination** of the gallery folders and files on your computer. The **Photo Web Gallery** generates three folders and an index file. It is generally best to make a new folder and choose it as your **Destination** folder.

❽ In the **Options** area, set the drop menu to **Banner**. The **Banner** is where the title, photographer's name and date are located.

❾ Name your gallery.

❿ Next, type in the photographer's name and contact information.

⓫ Add the date of the event.

⓬ From the drop menu, select a font to be used on your **Web Gallery**. Arial, Courier New, Helvetica and Times New Roman are common fonts found on most computers. When the page loads, it will load the font you have chosen or its closest replacement.

⓭ Choose a **Font Size** for your gallery. Note: the web font-size system is different than point sizes in graphics programs. Here, 3 represents about 12pt or the default size of most text. The largest text size is 7, the smallest text size is 1.

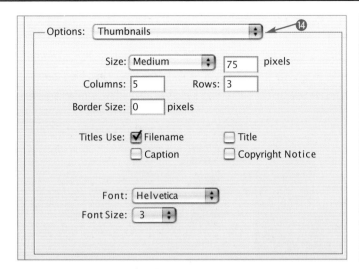

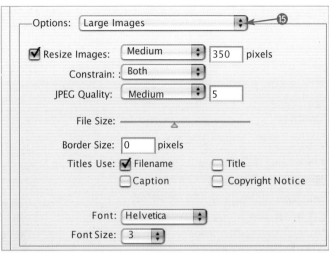

⓮ Scroll to **Thumbnails** in the drop menu (see ❽). Here, you can personalize the **Size** of your thumbnails, how many **Columns** and **Rows** and what **Title** they will have, as well as the **Font** you want for the text.

⓯ Scrolling to **Large Images** (see ❽), you can personalize the large images that coincide with the thumbnails. **Sizing**, **Quality**, **Border**, **Caption** and **Font** are all changeable.

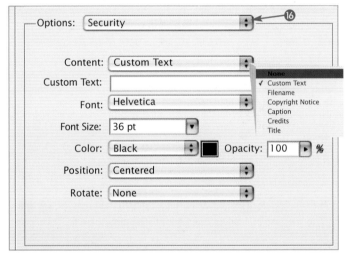

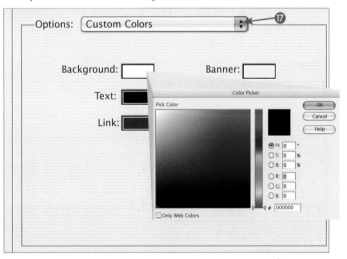

⓰ Scroll to **Security** in the drop menu (see ❽). This option is for people who don't want their images used by other people. You can write text, such as your name, over the pictures so they are unusable by others.

⓱ In the **Custom Colors** option (see ❽), you can personalize the color scheme of your **Photo Web Gallery**.

⓲ After all your options have been defined, and you have clicked **OK**, your Web Gallery will be generated. This is the **Lace Style** index page.

⓳ This is a single page from the **Lace Style** gallery.

CREATING A HTML PHOTO GALLERY

Many of the Internet providers now offer website services. If you are in a business, your friends, relatives and potential customers can access this website at any time to see your latest images, and you can update the images at regular intervals. Until now, creating a website required some computer programming skills—but the system is rapidly becoming user-friendly. Photoshop Elements incorporates an easy-to-use program that helps you organize a web photo gallery, which is a website that features a homepage with thumbnail images and gallery pages with full-size images. Each page contains links that allow visitors to navigate the site. The Photoshop Elements web photo gallery provides a range of options for presenting your images in a professional presentation. You can customize the gallery to display the images in different ways—using styles such as **Antique** paper, **Horizontal** dark, **Museum**, **Office**, and **Theater**.

❶ To create your **Html Photo Gallery**, go to **File, Create** and scroll to **Html Photo Gallery**.

❷ In the **Html Gallery window**, choose a **Gallery Style** for your **HTML Gallery**.

❸ After you choose your **Gallery Style**, a thumbnail view of the style will appear.

❹ Click **Add** button to add the image in the gallery.

❺ Click **Browse** button and choose a destination to save your file.

❻ Click on the **Banner** tab. Here title, sub-title, and e-mail address are located.

❼ In the title bar give a name to your gallery.

❽ In the subtitle bar give a subtitle to your gallery.

❾ Add E-mail address in the E-mail address bar.

❿ From the size drop-down menu select the size.

⓫ Select font from the font drop-down list.

⓬ Click **Save** button to save your settings.

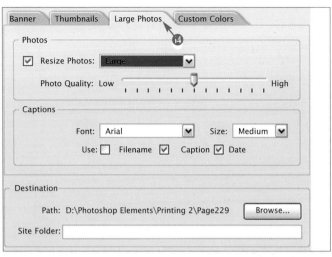

13 Click on **Thumbnails** tab to personalize the size of your thumbnails and also select the **Font** and **Font size** for the text.

14 Click on the **Large Photos** tab to resize the images that coincides with thumbnails. You can also choose photo quality along with font and font size for the text.

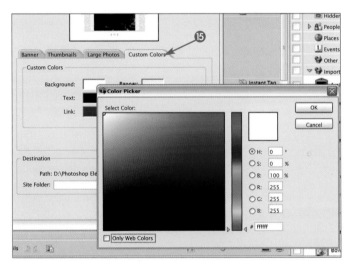

15 To choose the color scheme for your gallery you need to click on **Custom Color**.

16 After you have saved your settings, your Web Gallery will be generated. This is a **Simple Style** Gallery.

17 This is a single Image seen in **Simple Style** gallery.

35MM EQUIVALENT: The equivalent focal length of a lens on a standard 35mm camera.

ALIASING: The jagged appearance of diagonal lines in an image, caused by the square shape of pixels.

APERTURE: The opening between the lens and the shutter that controls the amount of light falling on the CCD sensor. Apertures are referred to as F-stops and rise in increments from f22 to f2.8, with f2.8 being the largest.

APERTURE PRIORITY: Part of the PSAM control. An exposure mode that allows the user to set the aperture, while the camera sets the shutter speed for accurate exposure. If aperture is adjusted or the light level changes, the shutter speed is automatically reset to maintain correct exposure.

ASA (American Standards Association), ISO (International Standards Organization): A measure of film speed that is also known as ISO. A higher number ASA rating represents faster film and an increased sensitivity to light. These measures have been transferred across from film-based photography and refer to comparable levels of sensitivity to light settings in digital photography.

AUTO-FOCUS (AF): The camera's automatic focusing system.

AUTO-EXPOSURE LOCK (AEL): A function that allows the user to take and temporarily hold a precise light reading using the TTL (through-the-lens) light-metering system. The scene is reframed and shot maintaining the light reading.

BACKLIGHTING: The effect of a picture taken with the light shining behind the subject facing the photographer. The subjects appear darker with less detail in the shadows.

BRACKETING: The process of taking a set range of exposures of the same subject. This provides a choice of a set of 3 variable exposures: one under, one over and one mid-exposed.

BRIGHTNESS: The tone of a color, whether it is light or dark.

CCD: Charge-coupled device. The digital equivalent of film; the imaging sensor that converts the light passing through a lens into an electronic equivalent of the original image.

CENTER-WEIGHTED METERING: A method of light metering that establishes a correct exposure based on the reading at the center portion of the image as it is framed in the camera viewer.

CLONING: The process of copying pixels from one part of an image and pasting it onto another part, covering that part of the image. Used in digital-editing.

CMYK (CYAN, MAGENTA, YELLOW, BLACK): The physical inks or equivalent screen-based color mode. CMYK are the colors used in combination to print a digital image.

COIL-SYNC CORD: An extension cord for an accessory (shoe-mount) flash unit that facilitates the positioning of the flash at a distance to the camera.

COMPACT CAMERA: Any small camera with either basic or advanced features from point-and-shoot to zoom-lens capabilities.

COMPACT FLASH CARD: A removable memory card that stores digital images.

COMPLEMENTARY COLORS: Oppositional colors that create maximum contrast. The complementaries of physical color are visualized in the color wheel: red-green, blue-orange, and yellow-violet. The complementaries of CMYK colors are: cyan-red, magenta-green, and yellow–blue. The complementary colors of RGB are: red-blue, magenta-green and yellow-blue.

COMPRESSION: After an image is processed, it is converted using a compression method so that it can be successfully stored on the camera. Digital cameras commonly use JPEG compression, which effectively reduces the file size of the image so as to maximize the available space for picture storage. You can select the degree of compression depending on the quality variables selected in the camera menu, (i.e., Superfine, Extrafine, Fine or Standard). JPEG is characterized as a "lossy" technique that removes some details in the compression process in ratio to quality selected (i.e., on Extrafine, there will be minimal detail loss and on Standard the loss will be more noticeable).

CONTRAST: The juxtaposition of opposite extremes of brilliance (e.g., a light and a dark tone) or a complementary color.

CONTINUOUS AUTO-FOCUS: An automatic-focusing system that constantly monitors a moving subject.

CPU (CENTRAL PROCESSING UNIT): The in-camera computer that interpolates the information from the light sensor and reduces the information to a digital stream.

CROPPING: The digital-editing process of resizing an image by taking parts of the image out that you don't want.

DEPTH OF FIELD: The measure of the zone of sharp focus in a photograph. Depth of field is affected by the aperture, the lens focal length and the distance from the lens to the image. In general terms, a smaller aperture and wide-angle setting increases depth of field.

DIGITAL ZOOM: A feature that creates the effect of zooming in and magnifying a subject. The primary difference between a digital zoom and an optical zoom is that a digital zoom is computer generated and increases zoom by cropping into the center of the image, reducing the image file size and quality by 50%; in contrast, an optical zoom uses a variety of lenses to magnify an image.

EXPOSURE: A measure of the amount of light in a photograph created by a combination of aperture, ISO, and shutter speed.

F-STOP: A number that indicates the size of the lens opening. Average f-numbers are f2.8, f4, f5.6, f8, f11, f16, and f22; f2.8 is the largest lens opening and f22 is the smallest. Aperture is measured in F-stops.

FILTER: An accessory lens placed over a camera lens. Daylight lens protect the lens from accidental damage. There is a range of lenses that filter and modify light, of which Polaroid lenses are the most commonly used, since they reduce glare and deepen color. In-camera digital filters can be used to modify color and tone after a photograph is captured.

FILL FLASH: Flash setting that provides an extra burst of light, which reduces contrast and shadows in bright light situations.

FIXED-FOCUS LENS: This fixed lens has only one focal length.

FLASH: Electronic unit that produces a burst of artificial light to add light to the scene. In most cameras, this is built in. You can also attach an external flash unit to the camera's hot shoe or fire the external unit by a sync lead or slave flash.

FLASH FALL-OFF RATE: The rate at which flash diminishes in a scene, since flash will only cover a specified distance.

FOCAL LENGTH: The distance in millimeters, between the center of the lens and its point of focus when the lens is focused on infinity.

FOCUS: The point at which the light rays converge on the CCD or film to create the sharpest image possible.

GIF (GRAPHIC INTERCHANGE FORMAT): A compressed file format made for use on the web.

GOLDEN SECTION: A specifically proportioned rectangle that is "aesthetically perfect". The LCD monitor either roughly or precisely corresponds to the dimensions of the Golden Section.

GRAYSCALE: The scale of gray tones ranging from white to black.

HOT SHOE: The external flash unit attaches into this fitting on top of a camera.

INTERPOLATION: A procedure used when resizing a bitmap image to maintain resolution. When the number of pixels is increased from the number in the image, interpolation creates new pixels to fill in the gaps by comparing the values of adjacent pixels.

IS (IMAGE STABILIZATION): Certain cameras and telephoto lenses have a feature that reduces camera shake and improves image focus.

ISO (INTERNATIONAL STANDARDIZATION ORGANIZATION): See ASA.

JPEG (JOINT PHOTOGRAPHIC EXPERTS GROUP): A data compression method that reduces file size and stores photographic images. This method increases image storage capacity, as images are transferred to the memory cards. The downside of the JPEG is that a greater compression ratio causes a loss of information.

LANDSCAPE: Term used for an image taken horizontally.

LCD: Liquid crystal display. A panel on a camera that previews photographs and acts as a viewfinder. LCD monitors can also be found on laptops.

MACRO LENS: A lens used for photographing extreme close-ups. Some camera zoom-lens systems feature macro facility.

MANUAL: Part of the PSAM control. This mode facilitates the user to physically set both the shutter speed, f-stop, and focus.

MEGAPIXEL: One megapixel equals one million pixels. Also the rating for a digital camera's resolution. The higher the megapixel rating, the higher the resolution of images created by the camera.

MEMORY CARD: A removable card used to store digital images. Common types include: Compact Flash, SmartMedia, SD Memory Card and XD Memory Card.

NOISE: Disturbances that appear as "grain" in digital-image files. Digital noise is caused by high ISO used to compensate for low-light conditions. Noise increases as ISO increases.

OVEREXPOSURE: An image that appears too bright because it has been excessively exposed. Overexposed images are referred to as having been "bleached out".

PANNING: Moving the camera to keep pace with a moving subject so as to maintain focus on the subject.

PIXEL (PICTURE ELEMENT): The smallest units of color information that can be displayed on a computer's screen. Viewed normally, pixels combine to construct a photographic image.

PLUG-IN: Enhancing additions (code) to an image-editing application. Most plug-ins use image processing filters or visual effects.

POLARIZING FILTER: This filter is a valuable accessory when photographing in bright light or photographing reflective surfaces—particularly water. The degree of polarization is altered by rotating the filter. It will darken and add depth of tone skies, whiten clouds, and reduce glares on certain surfaces.

PORTRAIT: Term for an image taken in vertical position.

PPI (PIXELS-PER-INCH): A measurement of an image's resolution.

PROSUMER (PROFESSIONAL CONSUMER): Brand of cameras that are professional-quality but lower in price, marketed to the growing number of amateur photographers.

RAM (RANDOM ACCESS MEMORY): A common type of computer memory that temporarily stores information. Digital-editing software requires significantly more RAM than word processing.

RECIPROCITY: The relationship between aperture and shutter speed. As you alter either the aperture or shutter speed, the other is automatically adjusted to maintain the correct exposure. As the aperture size decreases, the shutter speed slows and vice versa.

RED-EYE: An effect caused by light from a camera's flash bouncing off the back of the eye back into the camera's lens, making the pupils appear red in the photograph.

RED-EYE REDUCTION: A flash mode that attempts to prevent the problem of red-eye by shooting a series of lights before the actual picture is taken, which dilate the pupils.

RESOLUTION: The number of visible dots per inch (dpi) or pixels per inch (ppi). The more pixels an image contains, the higher the resolution, and the better the image quality.

RGB (RED, GREEN, BLUE): These additive primary colors combine to produce all visible colors. Digital cameras handle all color information as shades of red, green, and blue. As RGB colors are combined, they increase in brilliance.

SATURATION: A characteristic of color or the intensity of a hue; generally the more saturated the color in an image is, more intense the color will appear in relation to a neutral gray.

SELECTION TOOL: Tools in an image-enhancement program that are used to define an area of pixels in order to either copy or apply an effect to an image or a portion of an image.

SHADE: The tone of hue toward black.

SHUTTER: The mechanism in a camera that controls the amount of light that reaches the image sensor.

SHUTTER LAG: The time delay between pressing the shutter release on a digital camera and the exposure being made. The length of this delay was a problem with early digital cameras.

SHUTTER PRIORITY: Part of the PSAM control. This exposure mode facilitates the photographer to select the shutter speed (the camera will automatically adjust the aperture).

SHUTTER SPEED: The length of time the shutter is open.

SILHOUETTE: The dark outline of a figure that is all shadow and contains no details; emphasizes the form of the subject.

SLAVE FLASH: Unit used to trigger an external flash unit positioned away from the camera. As the built-in or another external flash unit attached to the camera fires, it triggers the external flash unit positioned away from the camera simultaneously to fire.

SLR (SINGLE-LENS REFLEX): a camera that transmits the same image through a mirror to the film and viewfinder, ensuring that you get exactly what you see in terms of focus and composition.

SPOT METERING: A light meter reading system that takes a precise reading of a scene positioned at the center point of the lens.

SYNC-CHORD FLASH: Method of attaching the external flash to the camera through the use of a sync lead.

TINT: The tone of a hue toward white.

TRIPOD: a device used to hold the camera with three legs for maximum balance. Helps eliminate camera shake in low-light conditions.

TTL METERING (THROUGH-THE-LENS): Refers to a camera's built-in mechanism that determines a scene's exposure by reading the light passing through the lens.

UNDEREXPOSURE: This attribute in an image occurs when the brightness level is too low.

VIEWFINDER: This feature on the camera is a window that displays the actual image or an electronic view. The viewer is also used for reviewing images and all menu data.

VIGNETTING: A method in which edges of pictures are darkened or faded to create a shape within the rectangle, usually circular or oval. Can also refer to the fading of the edges of a photograph caused by the image being cropped by the lens hood or filter.

WHITE BALANCE: A camera feature that compensates color cast in an image created by the color of the ambient light. Auto White Balance searches the image for color imbalance and adjusts the image to appear as taken in neutral white light. You can adjust the white balance to the degree of color cast or custom color balance.

WIDE-ANGLE LENS: A lens that has a shorter focal length and a wider field of view than a normal lens.

ZOOM LENS: A lens that allows focal lengths to be adjusted over a wide-range from wide angle to telephoto.

ZOOM LENS REFLEX: A zoom reflex system that imitates an SLR system digitally. The image is viewed electronically on a monitor.

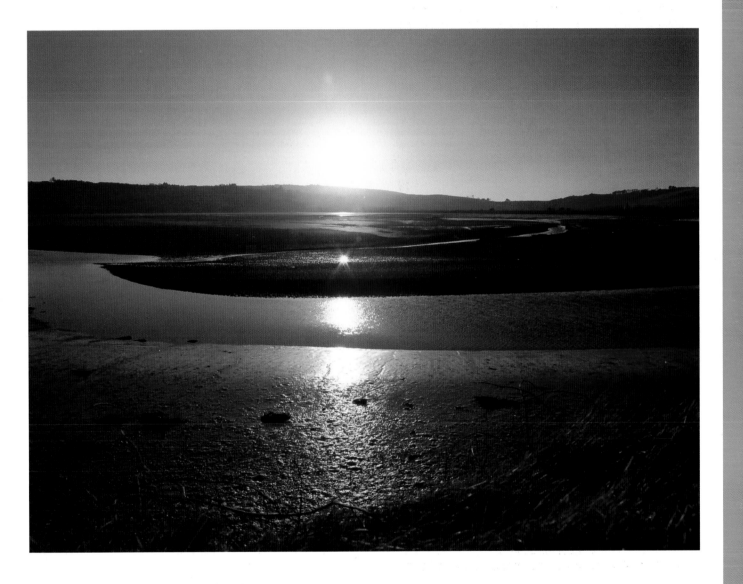

The creation of this book has been an exciting collaborative venture, which has been realized through the research and design experience embodied in the Hylas Team. The Hylas design ethos has transformed what could otherwise have been yet one more "how-to" book into a beautifully functional guide to
digital photography.

My sincere thanks go to Sean Moore for his creative vision and forbearance; Karen, for her brilliant design management; Gus, for his great skills in resolving the many design changes and Edwin and Tom for the drawings. I also wish to thank Angda for her patient guidance and insightful editing; Eric, for directing
us to the finish line; and the whole team for their truly astonishing energy and commitment: Rachel, Sheena, Sarah, Lily, Mie, Randi, Hannah, Marina and Gail (who arrived in the nick of time to contribute great editing and white tea); and my sister Tricia for inspiration and accommodating me on my extended visits to New York. I must also thank my colleagues in the Faculty of Art and Design, University of Hertfordshire for supporting me in my absences to work on the book, and individuals who kindly posed for the photographs. Lastly, and most affectionately, I must thank Norma for her enduring patience and support.

Michael Wright

PICTURE CREDITS